PELICAN BOOKS

RADICAL PERSPECTIVES IN THE ARTS

Lee Baxandall graduated in Comparative Literature
from the University of Wisconsin. In 1960 he
joined the editorial board of the pioneering
journal of the New Left, *Studies on the Left*; the
articles he wrote for that journal have been widely
reprinted. He has translated plays by Bertolt
Brecht and Peter Weiss and has contributed
articles to *The Drama Review*, *Partisan Review*,
Journal of Aesthetics and Art Criticism, *The Village
Voice*, *Science and Society* and other journals.
He is a member of the American Society for
Aesthetics and author of *Marxism and Aesthetics*
(1968). He is at present working on a history of
Marxist attitudes to art and literature.

Edited by Lee Baxandall

Radical
Perspectives
in the Arts

Penguin Books

Penguin Books Ltd, Harmondsworth,
Middlesex, England
Penguin Books Inc., 7110 Ambassador Road,
Baltimore, Maryland 21207, U.S.A.
Penguin Books Australia Ltd, Ringwood,
Victoria, Australia

Published in Pelican Books 1972
Selection copyright © Lee Baxandall, 1972

Printed in the United States of America
Set in Monotype Ehrhardt

Contents

Acknowledgements

For permission to reprint articles in copyright, thanks are due to the
following:

LEE BAXANDALL: first published in *The Drama Review*, Vol. 13,
No. 4 (T44), Summer 1969. Copyright © 1969, *The Drama
Review*.

JOHN BERGER: first published in *Labour Monthly*, March 1961 and
April 1961; reprinted by permission of the author.

FIDEL CASTRO: from *The Revolution and Cultural Problems of Cuba*,
Havana, 1962. The Cuban government has announced a policy of
copyright waiver.

CULTURAL THEORY PANEL ATTACHED TO THE CENTRAL COM-
MITTEE OF THE HUNGARIAN SOCIALIST WORKERS' PARTY:
reprinted from *New Hungarian Quarterly*, Autumn 1965, with that
journal's permission.

ERNST FISCHER: from *Streets*, May–June 1965. Copyright © 1965,
by *Streets* Magazine.

CARLOS FUENTES: first published in 1962 as an introduction to
Moby Dick by Herman Melville, in the collection 'Nuestros
Clásicos' of the National University of Mexico, directed by Pablo
Gonzalez Casanova. Translated by Asa Zatz and reprinted with the
author's permission.

ROGER GARAUDY: reprinted from *New Hungarian Quarterly*, Spring
1967, with that journal's permission.

EDOUARD GOLDSTÜCKER: from *Streets*, May–June 1965. Copyright
© 1965, by *Streets* Magazine.

STEFAN HEYM: first published in the *New York Times*, Op-Ed page,

2 January 1971. Copyright © 1971 by the *New York Times* Company. Reprinted by permission.

JOHN ILLO: reprinted from *Columbia University Forum*, Summer 1965, with the permission of the author. Copyright © 1965, *Columbia University Forum*.

ARNOLD KETTLE: first printed in *Essays on Socialist Realism and the British Cultural Tradition*, Arena publication, n.d., and reprinted with the author's permission.

MILAN KUNDERA: from *Streets*, May–June 1965. Copyright © 1965, by *Streets* Magazine.

HERBERT MARCUSE: first published in *Arts Magazine*, May 1967. Copyright © 1967, *Arts Magazine*.

HANS MAYER: Copyright © 1969 by Hans Mayer. Reprinted with the author's permission and that of the translator, Jack D. Zipes.

STEFAN MORAWSKI: reprinted with the author's permission.

CARL OGLESBY: first printed in *Middle Earth* of Iowa City, I, iv (1967), and reprinted with the permission of the author.

JEAN-PAUL SARTRE: from *Streets*, May–June 1965. Copyright © 1965, by *Streets* Magazine.

JORGE SEMPRUN: reprinted from *New Left Review*, No. 30, March–April 1965, with that journal's permission.

DARKO SUVIN: first published in *The Drama Review*, Vol. 12, No. 1 (T37), Fall 1967. Copyright © 1967, *The Drama Review*. Reprinted by permission. All rights reserved.

Lee Baxandall **Foreword**

RADICAL: 1. of or relating to the root: proceeding directly from
the root . . . 2. of or relating to the root or origin . . . 3. marked
by a considerable departure from the usual or traditional.
(*Webster's 3rd Unabridged International Dictionary*)

Radical does not mean extremist. Or way-out and marginal –
and therefore irrelevant to the mainstream of concerns and
events. On the contrary; it would be more accurate to regard
'fundamental' as the proper synonym. The above definition
from *Webster's* is hereby entered in evidence.

Who, in that case, promotes the corruptions of the word
'radical' in daily usage? Generally the corruption is promoted
by the foes of a political radicalism. The commercial mass media
are literally shameless employers of the language: their extreme
misuses of its meanings cannot be admitted as the norm. The
exact and, particularly, the mathematical sciences continue to
use the word 'radical' in its correct sense: why should we not do
so? The question is not a quibble. I insist on the importance of
getting a firm grip on the idea of radical, to define meaningfully
the concomitant perspectives in this book. For if we surrender all
the anchor meanings of the words in our language, then we are
totally at the mercy of a one-dimensional individual spontaneity
and of these manipulators.

This book is addressed to the promotion of radical perspec-
tive in the arts, which is understood to be synonymous with a

concern for fundamental or root aspects of aesthetic objects and activity and experience.

The perspective is oriented around several problems which we may list compactly. The discussion of these problems recurs throughout the book, and this schematic presentation is only meant to put the themes firmly before the reader in their most generalized statement and to bring out some ultimate coherences. The complexities will not be entered into here but have been left for elaboration within the frameworks of the individual essays. Needless to say, perhaps, this volume is too brief to allow a comprehensive elaboration of any of the particular matters of radical concern.

What, then, are these fundamental matters in the arts?

First in the order of mention must be those *structures of sensory elements* which compose certain objects and processes that have provided us with the realities to which we attach the word 'art'. We could scarcely go on to discuss the problems at the root of art if we did not first analyse its material manifestation. Nor is this primordial question of a purely formal or academic interest – as the concise, wide-ranging essay by Stefan Morawski makes particularly evident.

Art, and the human activities to which it pertains or which it can depict, possesses historically transacted yet repeatedly recurring traits which enable us to surmise some so-called '*universally human*' aspects of individual artworks. While this topic must be approached with caution, due to the unhistorical nonsense that has often been uttered, it would be equally ill-conceived to ignore the most deeply-rooted biological, psychological and social attractivenesses of artworks – confirmed by their survival in our attention long after the eras of their historical origins. This indeed is what Ernst Fischer has termed 'the necessity of art'.

On the other hand the historical transcendency of artworks, their aesthetic and social freedom from the failures and traces of their time of creation, is very often grossly exaggerated. This is

a fact especially registered in criticism written by Marxists. The proof of it is given time and again in this book; the two sides in Shakespeare's case – transcendency and limitations – are well brought out in the essay by Arnold Kettle and the one about Aimé Césaire's play *A Tempest*. The historical limitation on 'universality' and also on intensity in art is generally given formulation in terms of the crippling effects of the *class attitudes* held by the artists, which prove to be less than socially disinterested. Elucidation of the class-equivalents of such limiting attitudes in artworks is offered here by, for example, Meredith Tax and Carl Oglesby; while the observations of Herbert Marcuse, Jean-Paul Sartre, and Ernst Fischer help to indicate the definite limits on how far the arts may be contained within a class analysis. Meanwhile, Jorge Semprun and Stefan Heym, among others, begin to suggest that this tangent of analysis may be usefully developed on the further side of the lines conventionally drawn between capitalist and socialist social organization.

The broader structures in which class attitudes are effective towards the arts, for good and for ill, are those of *patronage* and *social control* – which may be implemented by, say, a monarchy, a petty nobility, a commercial and impersonal market, or a party bureaucracy. The historically earlier aspects of this matter are illuminated here by Hans Mayer and John Illo; while the acute problems of artistic freedom and the political responsibilities of a socialist party leadership are considered in unusual detail from the latter standpoint by a committee report of the Hungarian Socialist Workers' Party and by Fidel Castro.

The flaw at the very root of the arts in a class-hierarchical society of whatever era may be most penetratingly described in terms of Marx's concept of *alienation*. Class attitudes and class oppression are the interpersonal manifestation of it; but alienation permeates the individual to the marrow of his or her potential to realize personal abilities and to live happily. It is a psychological phenomenon with socio-economic foundations which

affect – to stick only to the arts and to touch only highlights – the capacity to utilize one's aesthetic potential, the artmaking or the craft process, and the market or patronage for art. The greatest analyst of the Marxian notion of alienation in the arts is George Lukács; his essay here touches in part on the question, while nearly every text implicitly assumes the phenomenon.

The reader will notice the degree to which historical analysis is cited as the underpinning to each of the radical themes already named. This awareness becomes a positive artistic asset in the idea of *a modern realist art*, which will be informed by the understanding of alienation and social class, and politically positive in the sense that it depicts, in some individualized manner, the increasingly conscious tendency among historical classes and individuals to secure their liberty from class-fostered deprivation. The case for such art is argued compellingly by Oglesby, Lukács, and Darko Suvin. Moreover, Roger Garaudy and John Berger are represented by texts which, among other matters, reject a Stalinist corruption of the potential of realist imagination.

Many discussions of the anti-alienation possibilities in art have stopped with the mention of realist literary works that depict a revolutionary socialist trend. But art itself has not stopped with this; nor, for many years, have numerous socialists. In this present volume, we explicitly raise the question whether *the future of culture* – often a partially repressive phenomenon, as this book shows – *will mean an end, a supplanting, of the culture overwhelmingly devoted to masterpiece art-objects to be contemplated*: aesthetic experience as we have largely known it in 'civilization'. In this regard, Marcuse discusses the transcendence inherent in beauty, Form, *per se*; while a final section of texts inquires into *aesthetic activity overcoming alienation in the dawning passage of history*, and the dangers and questions that are here involved.

In outline – those are the major elements of the enduring radical perspective in the arts. Experience always shows, how-

ever, that regardless of how much one stresses the historical *contingency* of the radical perspectives, they can scarcely be grasped by the critical powers of historical individuals in the fullness of the radical meaning of that contingency. That is: persons who seek to be the intelligence of history scarcely ever descend to its roots to become a 'historical subject' . . . they become entangled instead somewhere in the branches of history, as one of its objects, another captive of alienation, of class-deformed experiences and attitudes, which because they are historically always contingent and new are ever-deceptive . . . A major Marxist aesthetician, Walter Benjamin, not represented here, has made a trenchant observation linking the ambition of modern individuals to liberate and be liberated with their humiliating historical limitations; Benjamin dialectically meshes our tendency to conceit and our condemnation to semi-failures until alienation is obliterated (if it is ever) as a human condition on the foundation of an entire historical epoch; he does this with the deceptively quiet remark: 'Every document of culture is, at the same time, a document of barbarism.'

What will it mean – to transcend the class-structured societies of alienation on the foundation of a new historical epoch? Certainly it will not mean a 'revolution' in aesthetic practices alone. Without the productive and the social evolution of humanity, aesthetic experiments – which Marx also mentioned as being sophisticated even in Greek antiquity well beyond the general stage of social evolution – can in no way find their appropriate human realization. Not even in the lives of the experimental artists, as many biographies sadly prove. On the other side, to dismiss therefore out of hand the eventual effulgence of aesthetic integrations at planes of human experience previously untried, would amount to a denial of the changes that material human progress must enable in the quality of social life. What is to be stressed is the continual interaction of the more 'advanced' and 'backward' values – the way that politics continually pulls down aesthetic aspirations to quite base class-limited results, for

example; and yet also, the increasing role that aesthetic activism achieves – at first through 'committed' artworks and now through what is committed by the 'dramaturgy of radical activity' – in raising the plane of politics. The radical perspective is more complex than our experience can totally encompass; but the following pages give a certain idea of its scope and elements.

1

Meredith Tax

Introductory: Culture is not Neutral, Whom Does it Serve?

The thesis I wish to present here is that culture is not neutral politically, and that it is as impossible for it to be so as it is impossible for any other product of human labour to be detached from its conditions of production and reception. All culture serves someone's interest. Cultural products which present foreign wars as the heroic effort of a master race to ennoble mankind are, to the degree that they are successful as art, objectively in the interests of imperialists, who are people who make foreign wars against other races for profit. Cultural products that present people who have no money or power as innately stupid or depraved, and thus unworthy of money or power, are in the interests of the ruling class and the power structure as it stands. Cultural products which present women who do not want to be household slaves or universal mothers or

MEREDITH TAX is from Milwaukee. She took up literary criticism at Brandeis University. She then attended the University of London on a Fulbright scholarship and a Woodrow Wilson dissertation fellowship; her doctoral thesis concerns Congreve and the transitional stage comedy following the Revolution of 1688. She taught English at Brandeis University in 1968-9, and during this time she became involved in the New University Conference. Since then, Meredith Tax has chiefly been active with the women's movement (Bread and Roses, in Boston), and is writing a book on the left wing of the women's movement in the United States, 1880-1920. The present essay was delivered as a talk at the October 1969 conference on criticism of the New England College English Association.

sex objects as bitches or sexual failures objectively aid male supremacy.

Some writers are overtly political – though to be so in America has taken more courage or vision than most writers since the Second World War have had. Most writers avoid mentioning overtly political issues. But this does not mean they are disengaged from them. In our times, to refrain from mentioning genocide, racism, cultural schizophrenia, sexual exploitation, and the systematic starvation of entire populations is itself a political act. For no one in our time can be awake enough to write and have avoided noticing these phenomena – though he may not recognize them for what they are. As our bankrupt civilization draws to its close, and as the violence of the powerful against the weak, of the rich against the poor, of the few against the many, becomes more and more apparent, until it becomes impossible to watch a news broadcast and remain unaware of it for a second – as this situation becomes exacerbated, to refrain from mentioning it becomes more and more clearly a political act, an act of censorship or cowardice.

Yet very few of our establishment writers and artists, let alone of our literary critics, think these things are important enough to mention in their work. They may bear witness as private individuals, but they do not allow their private concern to interfere with business as usual. Let us paraphrase any well-adjusted academic critic's attitude toward the poet's method of dealing with this problem.

'A poet's job is to do his thing,' he will say. 'Naturally he will write about what is important or central to him personally, and who am I to interfere with another man's system of values? If Wallace Stevens chooses to write about arpeggios and pineapples rather than about racial tensions in Hartford or the practices of the insurance company he was vice-president of in regard to people on welfare, this was his decision; what's it to me? And as for the implication that his position as a member of the ruling class may have governed his perception of the

importance of such problems, or led him to fear dignifying them by the poetic process, why, I think that's extremely unfair and full of all kinds of critical fallacies.'

And, perhaps, considered from the strictly *professional* point of view of keeping up standards within the criticism business, and not rocking the boat, this may be so. But let us, for the moment, consider the problem from a *human* rather than a *professional* point of view.

Bertolt Brecht, a German Communist poet, wrote an essay in 1935 entitled: 'Writing the Truth: Five Difficulties'. In it he states:

Nowadays, anyone who wishes to combat lies and ignorance and to write the truth must overcome at least five difficulties. He must have the *courage* to write the truth when truth is everywhere opposed; the *keenness* to recognize it, although it is everywhere concealed; the *skill* to manipulate it as a weapon; the *judgement* to select those in whose hands it will be effective; and the *cunning* to spread the truth among such persons. These are formidable problems for a writer living under Fascism, but they exist also for those writers who have fled or been exiled; they exist even for writers working in countries where civil liberty prevails.

Brecht goes on to discuss the problem of *what* truths are worth telling, a problem of peculiar relevance to us.

First of all we strike trouble in determining *what* truth is worth the telling. For example, before the eyes of the whole world one great civilized nation after the other falls into barbarism. Moreover, everyone knows that the domestic war which is being waged by the most ghastly methods can at any moment be converted into a foreign war which may well leave our continent a heap of ruins. This, undoubtedly, is one truth, but there are others. Thus, for example, it is not untrue that chairs have seats and that rain falls downward. Many poets write truths of this sort. They are like a painter adorning the walls of a sinking ship with a still life. . . . Those in power cannot corrupt them, but neither are they disturbed by the cries of the oppressed. . . . At the

same time, it is not easy to realize that their truths are truths about chairs or rain; they usually sound like truths about important things. For it is the nature of artistic creation to confer importance. But upon closer examination it is possible to see that they say merely: a chair is a chair; and: no one can prevent the rain from falling down.

I went through a respectable liberal education, one purpose of which was to outfit me as a literary critic and teacher of literature. We studied a great many monuments of culture in my classes. We discussed the form of these works, either in itself, or in relation to other things written at the time; we occasionally speculated as to whether there were any eternal truths concealed in these works; or whether they had any relation to works of art in other genres; but mostly we just discussed the form of these works in exhaustive detail – the words, how they operated in tension with each other, the length of the poetic line, the use of symbols, etcetera.

The one thing we never discussed about any cultural monuments was their *meaning* – just their barefaced everyday philistine literal meaning. I think that if any of us had thought to bring this problem up we would have been laughed at. Of course, none of us ever did bring it up, because we wanted the approval of our teachers, and because we had never heard that one should take literature seriously enough to worry about what it meant in terms of one's own life. At most, we had heard that form and content were the same in great works, so that there was clearly no importance to discussing anything but form.

And so we went through all the great works of literature, works which were often, at least until the modern period, passionately ideological, as if we had blinkers on. It is indeed a characteristic of the modern period that reality in it is so intolerable that most artists and critics cannot bear to deal with it directly. But some of them, at least, allude to it if not confront it. Take, for instance, the poem 'Easter 1916' by Yeats, a poem frequently studied in school.

We know their dream; enough
To know they dreamed and are dead;
And what if excess of love
Bewildered them till they died?
I write it out in a verse –
MacDonagh and MacBride
And Connolly and Pearse
Now and in time to be,
Wherever green is worn,
Are changed, changed utterly:
A terrible beauty is born.

What are the political implications of this verse? What does it mean? What is he trying to get us to think or to do? And how is it that such questions so seldom arise in the consideration of a poem?

What Yeats is getting at becomes clearer when his poem is put next to Brecht's 'To Posterity', another great poem, which is however never taught in literature classes. Brecht's poem ends:

You, who shall emerge from the flood
In which we are sinking,
Think –
When you speak of our weaknesses,
Also of the dark time
That brought them forth.
For we went, changing our country more often than our shoes,
In the class war, despairing
When there was only injustice and no resistance.
For we knew only too well:
Even hatred of squalor
Makes the brow grow stern.
Even anger against injustice
Makes the voice grow harsh. Alas, we
Who wished to lay the foundations of kindness
Could not ourselves be kind.

> But you, when at last it comes to pass
> That man can help his fellow man,
> Do not judge us
> Too harshly.

Brecht and Yeats are talking of the same phenomena, of what happens to people who commit themselves to revolutionary politics. Their ordinary life is transformed; and personal values, as trivially defined, become less important to them than the good of all people. This involves certain kinds of sacrifice that often seem bizarre or incomprehensible to people who do not get the point. Brecht speaks of this, and of what he has missed out on in his personal life, in an earlier stanza of the same poem:

> I ate my food between massacres.
> The shadow of murder lay upon my sleep.
> And when I loved, I loved with indifference.
> I looked upon nature with impatience.
> So the time passes away
> Which on earth was given me.

Yeats is talking about the same withdrawals and austerities in his central metaphor of the stone in the midst of the living stream:

> Hearts with one purpose alone
> Through summer and winter seem
> Enchanted to a stone
> To trouble the living stream.
> The horse that comes from the road,
> The rider, the birds that range
> From cloud to trembling cloud,
> Minute by minute they change;
> A shadow of cloud on the stream
> Changes minute by minute;
> A horse-hoof slides on the brim,
> And a horse plashes within it;
> The long-legged moor-hens dive,
> And hens to moor-cocks call;

> Minute by minute they live:
> The stone's in the midst of all.
>
> Too long a sacrifice
> Can make a stone of the heart.

Brecht devoted his life and his work to making sure, to the best of his ability, that certain things happened in the world. He ends his poem by looking ahead with absolute confidence to a time after the revolution, when people will have changed, when circumstances will have ceased to require that they be as hard and purposeful as he needed to be. This is what is important to him, that the quality of life will change, and that people will cease to have to be deformed by their environment as he was.

In Yeats's poem, what is important is not whether the revolutionaries he writes about win or lose, not whether their political ideas are right or wrong, but whether individual heroism and aesthetic beauty are the products of their struggle. 'O when may it suffice?' he asks of their sacrifice, and answers, leave it to heaven, we can't know; our job is to make verses which tell how they have been personally ennobled.

> We know their dream; enough
> To know they dreamed and are dead . . .
> Are changed, changed utterly:
> A terrible beauty is born.

What does this mean but that, in the end, aesthetic values are the most important; and beauty of a certain noble kind is more important than success? And what is this but to focus on a few heroes, as if the whole meaning of the struggle dwelt in their features, and forget the thousands that followed behind them, peasants, workers, not aristocrats, and less beautiful than themselves, but to whom an end of colonialism was literally a matter of life or death. Their lives do not come into the poem; and this fact determines its political meaning – it is a beautiful

expression of a certain kind of romantic élitism, and a betrayal of the Irish Revolution.

The ideas that aesthetic values are primary, and that personal heroism is the kind to focus on, are typical of late bourgeois poetry, in that they express the privatization of bourgeois life, and the divorcement of modern art from the base of society.

Let us take a longer look at the philosophy of art-for-art's-sake: that is, at the ideology that art is justified by its existence, that it does not and should not serve any social purpose, that it frequently has no reference to anything outside itself, and that it is expressive of the vision of the individual poet, if of anything. The accompanying critical doctrine is that any criticism of a poem in terms other than these is an importation of irrelevant values: 'A poem should not mean but be.'

The thing we tend to forget is that this aesthetic philosophy developed at a certain historical moment – it didn't always exist, and is in fact fairly recent. 'Art-for-art's-sake' was the response of the producers of art to a market which was as mysterious and alienating to them as it was to the producers of other commodities. In most cultures prior to that of industrial capitalism, artists have had a well-defined and clearly under-stood relation to some part of their society, some group of con-sumers. In a primitive tribe or collective, art is the expression of the whole tribe – later, some people may be specially good at it, or hereditarily trained to it, and take on the production of artifacts as their work, but they work surrounded by the com-munity, and work for the community's immediate and obvious benefit. In other periods of history, the artist has produced for a court, for a personal patron, for a religious sect, or for a political party. It is only with the dominance of the capitalist system that the artist has been put in the position of producing for a *market*, for strangers far away, whose life styles and beliefs and needs are completely unknown to him, and who will either buy his works or ignore them for reasons that are equally inscrutable and out of his control.

In the sphere of production, Marxists call the attitude that results from this process 'commodity fetishism'. The processes of production and distribution – that is: the gathering of raw materials, the inventing of machines and processes, the organization of labour into successive stages of work on the different stages of manufacture, distribution, marketing, advertising, and all the rest – all make up a process so infinitely complex that neither the consumer who buys the finished product nor the producer of any one stage of it, has any clear idea what is going on. You buy a chair. You have no idea who made it, what the materials in it are and where they came from and what they originally cost, how much the labour in it cost, and how much the price of the chair has been jacked up by profit and by waste like advertising. All of this is no more mysterious to you than it is to the factory worker who made one ingredient of the plastic that the seat of the chair is made of. In this kind of economy, objects are regarded as though they had originated by magic and appeared in the shops, not as if they were made by people for other people to use.

Most critical theory as currently practised is an extension of this commodity fetishism into the realm of culture. A poem is not thought of as something made by a man for other men to use – it is thought of as having come about by some incomprehensible process, and for no clear end but its own existence. It is thought of in this way even by its producer, the poet. Like the factory worker he sends his product out into an unfriendly void. The use of his product, if any, is conjectural; he probably thinks it has none to anyone but himself. How can he be other than alienated from his work? How can he justify its existence, when he cannot *see* or *know* the people who use it, except by making its clear lack of relation to his society into an artistic creed, which becomes in its turn a critical dogma?

Art has not always been isolated in this way. An Italian fresco painter knew exactly who he was decorating a church for – who would pay him and what families would worship in that church.

Voltaire knew who he wanted to reach with *Candide*, and what he wanted them to think. Even Samuel Richardson managed to get in touch with a circle of correspondents, whose reaction to his books he could judge as he went along and thus determine whether he was achieving the desired moral effects. And contemporary Soviet poets are in touch with mass audiences who will flock to hear them read their latest. Writers in conditions like these are not alienated from their own work to the extent that they think it isn't good for anything, and isn't meant to reach anyone but a few friends.

In the period of bourgeois culture that is drawing to a close, two kinds of art have been produced: 'high-brow' and 'low-brow' as they are often called. Both have served the political end of pacifying or immobilizing parts of the population potentially hostile to the system as it stands.

'High-brow' culture is directed at the upper middle class, students, and intellectuals, who tend to take jobs such as teachers, health workers, social workers, etc., whose social function in our society is to control the lives and minds of others. This form of culture militates against the perception of the political solutions of political problems by purveying ideas which are in their implications and social use, if not in the motives of the people who produced them, reactionary. These are the central ideas of the art of the modern period, expressed in its form as well as its content. Some of them are:

1. That life is absurd, meaningless.
2. That we are all victims, and to be conscious is to despair.
3. That any communication or understanding between human beings is *a priori* impossible because the human condition is one of quintessential isolation.
4. That one's perception of reality is both subjective and uncontrollably fragmented; that there is no way of integrating the different parts of one's experience and the external world.

5. That most of life and most people are disgusting, vulgar and stupid. The class bias inherent in the word 'vulgar' is quite conscious in this formulation.
6. That there are no real objective truths, including the above.

This is what most serious modern literature teaches us. It's no accident. The extreme inhumanity of our civilization – its class system, its racism, its gross commercialism, its male chauvinism, its institutionalized violence, its imperialist wars – all these factors make consciousness almost unbearable to people who have not looked behind these symptoms to their causes and cure, who do not see that they make up the fabric of a particular social and economic system which is different from those of the past and can be superseded in the future. What has been made by people can, in the long run, be understood and changed by them.

The other kind of culture purveyed in our society is 'low-brow' or mass culture – a kind we are taught to despise as we are taught to despise those who consume it. This art, in fact, expresses nothing about the people who consume it but their deprivation. It is a mass-produced means of social control by manipulation of the national fantasy life. It is no more a product of any working-class culture than are the can-openers and Fords produced in our factories. I'm talking about TV, Westerns, Mickey Spillane and Erle Stanley Gardner, drugstore romances, sexy novels, Mantovani and Muzak, Norman Rockwell and the Keuhns. This is proletarianized art: it implicitly expresses its consumers' consciousness of their oppression, while at the same time preventing them from changing it. Christopher Caudwell described it thirty years ago in his book *Illusion and Reality*:

Because art's role is now that of adapting the multitude to the dead mechanical existence of capitalist production, in which work sucks them of their vital energies without awakening their instincts, where leisure becomes a time to deaden the mind with the easy fantasy of

films, simple wish-fulfilment writing, or music that is mere emotional massage – because of this the paid craft of writing becomes as tedious and wearisome as that of machine-minder . . . [this art] is at once an expression of real misery and a protest against the real misery. This art, universal, constant, fabulous, full of the easy gratifications of instincts starved by modern capitalism, peopled by passionate lovers and heroic cowboys and amazing detectives, is the religion of today, as characteristic an expression of proletarian exploitation as Catholicism is of feudal exploitation. It is the opium of the people; it pictures an inverted world because the world of society *is* inverted.

But times are changing. And in certain small ways, art is beginning to reflect these changes. For the first time since the Industrial Revolution it has become possible for artists to define themselves against the values of capitalist society and at the same time have an audience, a definite and large subgroup of the population, that they are producing for, an audience that also defines itself in opposition to the dominant culture. We have the makings of a revolutionary culture, that tells the truth about our society, demonstrates opposition to what is going on, and sometimes even poses alternatives. I'm not saying this *is* a revolutionary culture yet – you don't get a revolutionary culture until you get a revolution. But something is happening here.

There are three things about this new counter-culture that I find especially interesting and positive in terms of the social values they imply.

The first is that this culture is in many cases the product of collective effort rather than of bourgeois individualism. Rock groups, street theatre groups, poster workshops, art crews for demonstrations – all of these are forms of creativity that are social and shared.

The second thing is that many of these cultural forms are conceived of as participatory; these would include a lot of theatre which demands audience participation and response; poetry which demands being read out loud; and music that needs dance to fulfil it, and which is participated in by people who dance.

The third thing is that many of these new art expressions mix media and genres to a new extent. The rock groups that combine posters, slides, light shows, music, poetry, dance and special effects are one example. Such art breaks down very old divisions of labour; and any breakdown of the division of labour in the arts seems a hopeful sign of our growing ability to integrate different kinds of experience.

This new art is often explicitly political, political in a sense that embraces all of experience, not just the narrow realm defined by poli. sci. Take for instance The Cream's song called 'Politician', which begins, 'Come on, baby, get into my big black car, I'm going to show you just what my politics are.'

The conditions of production and even more of distribution of this poetry are a long way from being ideal. Rock performers are exploited by their merchandisers and preyed upon by their public to a degree unusual even in the mass performing arts. There is much that is religious about mass art, and some rock performers have become to some degree human sacrifices; the confusion between the demands of their art, of their public, and of the business, and the confusion between their public-performing and private selves is alienating in the extreme. But this very alienation, in artists that can hold out (and most groups are short-lived) produces a degree of political consciousness and explicitness that is incredible when you realize that it is marketed by the very forces it is battling against, and that it is accepted wholeheartedly by millions of people. Bob Dylan is the most striking example of this consciousness. He writes for kids in a language they can understand, that is hip and full of symbols of the things that oppress all of us. As in 'Subterranean Homesick Blues':

> Johnny's in the basement
> Mixing up the medicine
> I'm on the pavement
> Thinking about the government

The man in the trenchcoat
Badge out, laid off
Says he's got a bad cough
Wants to get paid off
Look out kid
It's something you did
God knows when
But you're doin' it again . . .

Ah, get born, keep warm
Short pants, romance, learn to dance
Get dressed, get blessed
Try to be a success
Please her, please him, buy gifts
Don't steal, don't lift
Twenty years of schoolin'
And they put you on the day shift
Look out kid they keep it all hid
Better jump down a manhole
Buy yourself a candle, don't wear sandals
Try to avoid the scandals
Don't wanna be a bum
You better chew gum
The pump don't work
Cause the vandals took the handles.

Dylan is a mass poet. People follow his work and wait for his latest releases with an eagerness that no poet has received in this country since at least the Industrial Revolution. People talk about his work and his changes as if they had participated in them. They see his poetry as a *process* – a living, growing thing – not as a mysterious product in an aesthetic universe apart from life.

This sense of art as process is crucial to the revitalization of it. As politics must teach people the ways and give them the means to take control over their own lives, art must teach people, in the most vivid and imaginative ways possible, how to take con-

trol over their own experience and observations, how to link these things with theory, and how to connect both with the experience of others.

This essay is deeply indebted to two books, *Illusion and Reality* by Christopher Caudwell, and *Art and Revolution* by John Berger. Everyone interested in such things should read both.

The Arts
and Capitalism

2
Carl Oglesby

The Deserters:
The Contemporary
Defeat of Fiction

A personal confession: I don't read novels or poems or plays now with any of the excitement that I remember feeling ten years ago. That was a time, in fact, in which I not only read but wrote the things – two novels, one finished twice but not the third time, three plays, each of them performed, for better or worse, in a number of places, and now and then a poem, usually for a lady who was flashing for a meteoric moment in my life. (I'd always understood that writing poems is most elementally a lecherous act.)

It was a very serious matter for me in those days, this literature. If one didn't know it, one was ignorant. It was where it was

CARL OGLESBY was the elected President of Students for a Democratic Society (SDS) in 1965–6 – the term in which this catalytic organization of a New Left in the United States went from reform liberalism to a revolutionary democratic socialism. As much as anything, Oglesby's speech at a Washington anti-Vietnam-War demonstration guided as well as marked the change (he defined 'the system' as corporate liberalism, and called on humanistic liberals to come out from it). His book *Containment and Change* (with Richard Shaull) has been the most comprehensive and acute critique of the American body politic to come from the New Left. A choice of texts important to 'the movement' is contained in Oglesby's *New Left Reader*. He has written well-received plays, poems, and songs (the latter on Vanguard Records, performed by himself). Oglesby has taught literature at several colleges; the essay included here was produced while he was writer-in-residence at the University of Iowa, and was initially published in the underground *Middle Earth* of Iowa City.

happening; it was what made a difference. That I no longer feel this way about it, and that I have stopped – or at least for a long time postponed – the writing of it, means, to be sure, most simply that I have changed. But the situation has changed, too. It has become very wild, very confusing, and seems everywhere to bespeak most clearly our individual impotence and unimportance. And fiction, it seems to me, has responded to this change at least in the respect that it, too, has become very wild, even grotesque, and very confused.

I've called this paper 'The Contemporary Defeat of Fiction'. But I don't intend to argue that this defeat was unavoidable or that it is suffered everywhere or that there is some cultural force which absolutely obstructs its reversal. Any minute, somebody might bowl me over. What I mean to talk about, rather, is my sense that the kind of strategic thought one encounters in certain important novels is a strategy of defeat and desertion – appropriate yesterday, perhaps, when the world was different, but not appropriate now.

I have the perhaps mistaken idea that I could argue this view in the context of a number of important writers, the line of argument of course being different with each: Genet, Beckett, or Robbe-Grillet; LeRoi Jones or Baldwin; or the Bellow of *Herzog*, or perhaps the Ken Kesey of *One Flew Over the Cuckoo's Nest*. For a variety of reasons, I've decided to talk about Camus and Heller's *Catch-22*: first, because each is important, relevant, and exciting to engage with; and second, because Camus seems to me paradigmatic of a type of failure which I suspect pervades contemporary American fiction, and because Heller's good novel is a convenient and interesting instance of this failure.

That is, I claim to find in *Catch-22* a résumé of an immense historical, cultural problem of ours, an embodiment of a dilemma which the informed artist is virtually compelled to pose, and which, once posed, forces the artist to confront a responsibility that may transcend the efficacies of fiction itself. Most coldly,

the question I want to get at is this: When the house is burning down around the poet's head, on grounds of what if any dispensation can the poet continue the poem?

Since I want to put all my cards on the table, I should at least describe my view of fiction. After a rather long episode with the New Criticism, I at last came to my senses and decided that literature is most essentially a form of history, something which makes propositions about the human experience of a time and a place. Whether or not these propositions are also elegant, they ought to be in the first place significant and in the second place true.

It follows that I hold the writer responsible for his time – trying to know what's in it, what it's about; and to the extent that a large part of our experience is a witness of injustice, if not direct complicity in it, it follows that the writer has no exemption from the political meanings of choices which he can in no case avoid making. In our time and place, one simply *is* a partisan – of something, of some cause; even silence is no escape. The business of the critic is to grasp and elucidate the fullness of all these circulating partisanships and – like the writer he scrutinizes – to take a stand. It should go without saying that the stand will be complex always and often ambivalent. No American novel published in 1963, for example, can be excused for the almost racist stereotyping and the dilute elixir of fascism which one finds in Ken Kesey's *Cuckoo's Nest*; yet that novel is resonant with a nostalgia, an aspiration, and a man-centred commitment which I not only share, but in fact find enlarged and re-energized by my experience of that book. More complex and ambivalent yet is my attitude toward *Catch-22*, as will be clear in a moment. Good enough: one works it out. Neither a novel nor its critique is something one can go shouting out in the streets. The point is to know that novels imply worlds, make assertions about the nature of social reality, embody summations, prophecies, and demands which are manifest in the very process of selection of material and assumption of stance. It is

the politics of an artwork which we have to elucidate, explore, and – finally – judge.

I suppose this view of art is neither fashionable nor very glamorous, although the current decline throughout the humanities of the spirit of positivism no doubt makes it easier at least to re-examine the idea that a work of literature amounts to so many mimetic and value-charged statements about man's experience of himself in the world, and the companion idea that the values and methods appropriate to criticism ought to be integral with the values and methods appropriate to living in a time in which social conflict is ubiquitous and sharp.

That men are in trouble, that the trouble may be grave, is neither a foolish nor an especially electrifying notion. It seems by now to be simply a routine commonplace. The interesting questions are the subordinate ones: How is this trouble to be explained and described? What should men do about it?

A drama is all but composed when its cast of characters has been assembled: What sort of hero is being pitted against what sort of villain? For Camus, the central figures are Man, who stands on one side of the line of battle armed with his solitude and passion, and over on the other side, in the opposite corner, the Absurd Cosmos, armed with its silence, its indifference, and its mystery – all of which, however, turn out to be not exactly what they seem. For if, with Camus's acuity, you listen a moment more to this silence, it becomes a curse flung in the face; the indifference becomes contempt; the mystery becomes arrogance and spite. For Camus, even the stars seem sometimes to amount only to so much sinister celestial grafitti. Hence, for example, the air of melodramatic showdown with which *The Myth of Sisyphus* opens: 'There is but one truly serious philosophical problem,' he writes, 'and that is suicide.'

Camus never seems to have surpassed the most prosaic meaning of a much younger Sartre's dictum, 'Man is a useless passion.' Samuel Beckett has somewhere noted the essential ignobility of such a stance: 'The microcosm,' he says, 'cannot

forgive the relative immortality of the macrocosm.' Perhaps a good deal of Camus's melancholy bravura boils down, then, to a hyped-up and vastly more sophisticated 'Invictus'. A common jealousy, mingling with fright and pride, yearns to be transfigured, to demonstrate its perfect bravery, by taking on the cosmos, nothing less. Camus's moral philosophy seems in this case to be an extensive elaboration of a single rather uninteresting lesson, namely, that the enemy of life is death, and that life appears frequently to lose. At the scene of that defeat, confronting his absurd destiny face to facelessness, Camus's Rebel undergoes that apotheosis which alters nothing – that is, becomes totally lucid, almost like Wallace Stevens's man of glass, as to the divine and poignant uselessness of lucidity.

But there is much more to Camus's moral strategy than this strangely Byronic pursuit of disappearing ultimates. It satisfies also the political function of destroying the challenge of historical risk. It relegates history, the mundane affairs of *men*, to an inferior plateau of moral experience. To be in history, to spend one's time with it, becomes a sadly unavoidable violation of one's higher possibilities. 'For years now,' Camus wrote to a German friend who had become a Nazi soldier, 'you have tried to make me enter History.' History: in a familiar gesture, he capitalizes the initial and turns it thus into something abstract and remote, a category among other categories. He had wanted to live outside this History apparently, not quite in the wilderness, but at least in a distant suburb, fixing his attention upon the absurdity of his oncoming death with a despair sometimes jubilant and always graceful. When he finally does enter History in 1941, it is not in order to change it that he does so, or to provide it with a new purpose or even to defend an old meaning, but almost, rather, as if he aimed to resist events in themselves, to repulse History's impudent incursion upon his own private moral space, that inner sanctum in which the unsuspenseful but elegant struggle with the Absurd was to be resumed once the impostor had been banished again. Camus is

rebellious only toward that perfectly innocuous Nothingness which indeed is so radically passive as to comply immediately with all his stage directions, to become a menacing and hostile Nothingness as soon as he so regards it. Toward History, the collisions of men in their pursuit of objectives, Camus undertakes no more than the provisional, temporary role of the resistant. If only History would not interfere, if only there were no Nazi soldiers and no revolutionaries, if only men undertook no more objectives, then he could perhaps have time enough for his real life – a life, that is, in which victory is no doubt unthinkable, but in which the varieties of defeat rank themselves from the noble to the wretched and serve in any case to make a man's career conclusive, to relieve it of that disorder and incompleteness which no merely historical existence can ever escape.

In trying thus to improve upon Napoleon, Camus has changed the meaning of Elba: instead of exile, it now means reunion. Escape from the contingent and the changing becomes the overriding purpose of political action: such escape alone restores the possibility of the encounter with silence. The despair that goes with this encounter becomes nothing else than the most glamorous mood of the most glamorous man, the ghostly Don Quixote whose eyes were opened, and whose self-dramatization is only the more poignant because he calls our attention to it in terms so unstintingly self-deprecatory. 'Covered with ashes,' says the judge-penitent Clarence toward the end of *The Fall*, 'tearing my hair, my face scored by clawing, but with piercing eyes, I stand before all humanity recapitulating my shames without losing sight of the effect I am producing and saying: "I was the lowest of the low."'

This is the pose which classical and conservative thought is apparently required to assume in our time. Camus is important precisely because, in refusing historical rebellion – in refusing, that is, to accept the concreteness, the continuation, and thus the impurities of the revolutionist's life – he presents us with the

best of cases against revolution, the most humane and compassionate case. 'Passionately longing', as he put it, 'for solitude and silence', he is important because he has renovated with exceptional power if not lucidity that idea of exile as self-reunion which reappears in our time as the one alternative to an always terrifying political violence, the one sanctuary for that Western and highly individualistic innocence which chooses above all its own self-preservation.

His work embodies the nearest resolution of a predicament which in the end seems to remain quite intact, namely: if you choose to answer injustice by standing with historical revolution, you become the forced confederate of an evidently automatic terror. If you choose on such grounds to answer terror by siding with the régime, becoming first and foremost the partisan of traditions and institutions and continuity rather than suffering men, you become the forced confederate of the old privilege and its injustices. If foreknowledge of both disasters persuades you to answer terror and injustice by standing critically above the battle, confronting each historical mode with its opposition's ideal, condemning terror in the name of order and oppression in the name of justice, then you become forced again, at least the practical confederate of the moral sycophant. For your accusations, however sincerely moved, will always be most overheard and exploited by incumbent authority. A France busy making the most ruthless war against Algerian rebels, a France about to produce the infamous OAS conspiracy, scarcely hears when Camus – rather softly, to be sure – reprimands the colonialist for his outrages; but this same France is suddenly all ears when he denounces with his severest passion the Soviet Union's slave-labour camps, giving us a sorry spectacle indeed as the counter-revolutionaries try to conceal their ecstasy with a few crocodile tears; it was not for the Turkestani victims that France shared Camus's angry grief, it was rather at the expense of a chronically malformed revolution, which remains nevertheless the only hope of the wretched, that

this France celebrated, behind its tears, another victory for reaction.

The function of Camus's metaphysical priorities, of his setting Man against the Absurd, of his concomitant suggestion that to fight within history for historical objectives amounts to being waylaid, ambushed on the road to the only really important encounter – the practical function of this is a politics of disengagement which pretends to be the opposite. This is Camus's one really important shame; and it is at last the one which, for all his candour, he never confesses. He does not rebel within history, but against it. He does not rebel in the name of what man's world might become, but rather in the name of what it never can become, a world in which men have no objectives. He thereby guarantees his permanent disappointment with men, guarantees moreover that men's historical failures will always have all the features of a personal betrayal. In effect, he has written into his contract with men an escape clause which will never fail to become operative: a remarkable strategy which allows him at one and the same time to seem both engaged and innocent. His definition of rebellion, in fact, requires him only to reveal for us again and again his moral superiority to both combatants, to the permanent crisis of Western history. That the West widely considers him to be both engaged and lucid only reveals the extent to which his partisanship is rootedly Western – conservative, sometimes all but royalist: the new Edmund Burke disguised as Humphrey Bogart; and reveals further the extent to which his obscurities, his intellectual and moral failures, exactly coincide with what an illiberal Western liberalism prefers left in shadow.

There was always, and there remains, quite another way of visualizing our experience, another way of drawing up the cast of characters: the historical way. In place of the exquisite and subtle struggle of Man against the Absurd, a struggle which is in fact not turbulent at all but perfectly still, consisting mainly of a certain mood, a certain gaze, a metaphysics, the historical

imagination gives us instead something a good bit uglier and more lethal, a struggle of men against men pursuing their different historical purposes. Camus always had wanted the cosmos to offer him a meaning, or at least an explanation; perhaps an apology. He never seems to have recognized that this cosmic silence – absurdity – was in fact the very ground of freedom, the indispensable precondition of the morality which he so passionately desired. If the cosmos has no meaning, if it is in itself absurd, then men are at liberty to produce meaning: to assemble alternatives, to make choices, and to act creatively. As for this history, as Sartre observes, 'the problem is not to *know* its objective, but to *give* it one'. But to say as much, obviously, is to reconstitute, beneath the dainty dancer's feet of the ideal, the rough and most uncertain ground of the practical. One might even become – who knows? – a murderer, like everyone else. Appalled, Camus decided to forgo, even to denounce, the battle of men against men. He devoted all his considerable skill to the task of proving that the real battle lay elsewhere and was to be fought in solitude. In redefining rebellion in this way, in providing it with a radically metaphysical and antipolitical meaning, he concludes with a silent subversion of his own moral thrust; his choice of political silence, in the end, amounts to a vote for oppression. And it makes it only all the sadder that this vote is cast in the name of those human values which otherwise require exactly the creation of a new society.

It seems to me that something like this happens in *Catch-22*, and that the moral and historical categories by which it is brought off in that novel correspond to those I have claimed to see in Camus.

Except for *Moby Dick*, which will remain the supreme critique of America until America redefines and surpasses itself, I can think of no important American novel whose primary conflict is more deeply class-structured than *Catch-22*. Heller could hardly have made things clearer; the Second World War, at one

level the clash of rival nationalisms, of vertically unified class societies, at another and apparently more important level was an intra-societal clash of rival classes – the men against the officers, the young against the old, the people against the ruling establishment, neither one sharing or even recognizing the other's aims, the one aiming consciously to extend and consolidate its power, the other aiming fitfully and in semi-darkness to break free of the hold and to redefine social value in its own terms. By the time Milo Minderbinder, that gargoyle entrepreneur, has contracted with the Germans to defend the same bridge which he has contracted with the Americans to destroy, this central point has been made brutally clear. But it was there all along. Fairly early, for example, when Cadet Clevinger, 'one of those people with lots of intelligence and no brains', is sent up for trial before the Action Board for stumbling while marching to class, he finds that his defence attorney, his prosecutor, his accuser, and one of his judges are one and the same man. Towards the end of this trial, Clevinger is 'militantly idealist' enough to point out that the court cannot find him guilty and still remain faithful to what he calls 'the cause of justice'. This provokes the following outburst from the bench:

'That's not what justice is,' the colonel jeered, and began pounding the table with his big fat hand. 'That's what Karl Marx is. I'll tell you what justice is. Justice is a knee in the gut from the floor on the chin at night sneaky with a knife brought up down on the magazine of a battleship sandbagged underhanded in the dark without a word of warning. Garroting. That's what justice is when we've all got to be tough enough and rough enough to fight Billy Petrolle. From the hip. Get it?'

Cadet Clevinger does not get it:

It was all very confusing to Clevinger. There were many strange things taking place, but the strangest of all, to Clevinger, was the hatred, the brutal, uncloaked, inexorable hatred of the members of the Action Board . . .

Clevinger recoiled from their hatred as though from a blinding light. These three men who hated him spoke his language and wore his uniform, but he saw their loveless faces set immutably into cramped, mean lines of hostility and understood instantly that nowhere in the world, not in all the fascist tanks or planes or submarines, not in the bunkers behind the machine guns or mortars or behind the blowing flame throwers, not even among all the expert gunners of the crack Hermann Goering Anti-aircraft Division or among the grisly connivers in all the beer halls in Munich and everywhere else, were there men who hated him more.

Clevinger approaches but does not capture the central, organizing insight of the novel, namely, that this entire little world on Pianosa is crazy – 'something was terribly wrong,' writes Heller, 'if everything was all right' – and that this craziness springs from the fact that one group of men repeatedly exposes itself to death in the service of another group, whose aims are not only different but fiercely competitive. Over and over, in this novel which has been so highly praised by *Time* and *Life* and other left-wing journals, Heller drives home the point that the officers and the men might as well come from two different nations, that they are united only as the officers are successful in their deceit and deception. 'Almost hung,' wrote Thomas Nashe in the sixteenth century, 'for another man's rape' – and we have in that phrase the crazy close calls and the crazy deaths which the crazy men of *Catch-22* endure.

Heller does not qualify this opposition so much as a comma's worth. It is stark and unrelieved. Whenever we meet in this novel a recognizably sympathetic emotion – a moment of compassion or agony – we are among the slaves. Not that the men are sentimentalized: there is frailty enough in their ranks. But the officers, the rulers, are entirely despicable. Lacking even the bitter merits of their violence, they are not even bold or cunning. There is nothing new in the military slave's hatred of his military master; we have been hearing about that since *The Naked and the Dead*. But Norman Mailer at least endowed

his General Cummins with a well-shaped and sometimes commanding intellect. In *Mister Roberts*, Thomas Heggin gave us a ship's captain who would be perfectly at home in *Catch-22*, but on the horizon of that world there were other ships and other captains whose goodness and legitimacy were in fact praised in the hero's death. *From Here to Eternity* has its share of officer lunatics, but their madness is never something to laugh at. In *Catch-22*, the officers are denied even the marginal virtues they might appear to possess. Culture, for example, that standard shield of class, is allowed to surface only in order to become more evidence of the officers' vanity and small-mindedness. When Nately is killed and Yossarian therefore refuses to fly any more missions, Colonel Korn says, 'Who does he think he is – Achilles?' Not a bad comparison, in fact: Korn knows something about Achilles besides the thing about the heel and applies what he knows justly, if contemptuously, to Yossarian's rebellion. But Heller destroys the effect by letting us in on a secret: 'Colonel Korn was pleased with the simile and filed a mental reminder to repeat it the next time he found himself in General Peckham's presence.' So instead of being impressed, we are amused: in his unrelieved vanity, and ambition, Korn has been caught in the act of fondling his knowledge.

These officers, moreover, are not merely officers, for the reason mainly that this army is not merely an army. The army of *Catch-22* is rather a little world which mirrors the larger, over-arching world of which it is an offspring and a function. It is an image of America. The values in the name of which the officers direct their peculiar little wars of ambition and betrayal are identical with the values by which the naïve maniac of capitalism, Milo Minderbinder, is exonerated by an America he had seemed to betray.

'Won't you fight for your country?' Colonel Korn demanded of Yossarian, emulating Colonel Cathcart's harsh, self-righteous tone. 'Won't you give up your life for Colonel Cathcart and me?'

Yossarian tensed with alert astonishment when he heard Colonel Korn's concluding words. 'What's that?' he exclaimed. 'What have you and Colonel Cathcart got to do with my country? You're not the same.'

'How can you separate us?' Colonel Korn inquired with ironical tranquility.

'That's right,' Colonel Cathcart cried emphatically. 'You're either for us or against us. There's no two ways about it.'

'I'm afraid he's got you,' added Colonel Korn, 'you're either *for* us or against your country. It's as simple as that.'

'Oh, no, Colonel. I don't buy that.'

Colonel Korn was unruffled. 'Neither do I, frankly, but everyone else will. So there you are.'

What is it exactly that everyone else is buying when he buys the inseparability of the country and the colonels? In the first place, he buys the ethic of mindless ambition and cut-throat deceit. 'Why does he, Cathcart, want to be a general?' asks Yossarian, and Korn answers: 'Why? For the same reason that I want to be a colonel. What else have we got to do? Everyone teaches us to aspire to higher things. A general is higher than a colonel, and a colonel is higher than a lieutenant colonel. So we're both aspiring.' And in the second place, he buys capitalism, a very pure, very unGalbraithian variety with all its old impulses toward monopoly and Mammonism wholly intact; along with the Korns, the Cathcarts, and the Packhams, that is, he buys Milo Minderbinder. Not exactly an appealing purchase.

It is no doubt because the purchase is in fact so terribly unappealing that *Catch-22* has so often been taken as a satirical or even a farcical novel. Maybe there is some technical sense, invisible to me, in which such terms can account for the book. But it seems to me, on the contrary, that calling it a satire is merely a way to avoid the disgusting truthfulness. There really *is* a system, and the system does behave more or less exactly in the ways *Catch-22* describes. If the system seems crazy as

described in this book, that is because it really *is* crazy. Exaggeration here does not provide the function of substituting a fantasy for reality. Rather, it serves the function of saturating with light the real and essential features of an existing and very nearly unendurable situation. Heller, in fact, seems to be very careful to avoid that exaggeration or that kind of grotesque, which would snap his story's connection with an objective, historical world. Milo's extravagant capitalism and the extravagantly banal evil of the officer class are permissible because they refer to real social phenomena. The rebellion of the men, on the other hand, which in and of itself would even be much less extravagant, far more plausible psychologically, than Milo's bombing of his own base, is never allowed to happen. Until the very end of the book, that is, when Orr, that machine-age Sancho Panza, is found to have escaped to neutral Sweden, and Yossarian is about to join him, rebellion is limited to mutinous mutterings in dark corners or transient moments of individual refusal.

This comes close to what I take to be the central moral dilemma – and failure – of *Catch-22*. This dilemma is concentrated in the little drama that takes place around the figure of Colonel Cathcart.

Of a very bad lot, Cathcart is the worst. He combines all the standard virtues of his class: ruthlessness, stupidity, avarice, cowardice, and so on; Heller persuades us that Cathcart will indeed make general one day – five-star, no doubt. But besides this, Cathcart is a centrally placed actor, someone whose decisions directly hit the lives of the men under his command. It is Cathcart who keeps raising the number of missions the men must fly, Cathcart who gleefully anticipates casualties among his men on grounds that this will be a proof to the higher-ups of his own greater dedication and bravery, Cathcart who consciously punishes the fliers by volunteering them for exceptionally dangerous missions, Cathcart who demands the pointless bombing of an undefended and perhaps friendly

mountain village. He is a ridiculous person, but also consequential – a monstrous combination. Heller quite methodically refuses us the opportunity of being for one moment mistaken about this Cathcart. He is a criminal all around, everyone's executioner: a clear and present danger.

The question is: Why is Cathcart not assassinated? In a chapter opening with the cold horror of Snowden's death and the pushing of the number of missions up to sixty, the terrified and angry Dobbs proposes Cathcart's assassination to Yossarian, who need only tell Dobbs that it's a good idea. Yossarian clearly thinks it is; Cathcart should be punished, removed. But he cannot or will not tell Dobbs to proceed. A bit later, the roles are reversed, and this time it is Dobbs, who now has his sixty missions under his belt, who will not conspire with Yossarian.

The men are unable to generate any coherent opposition to those who victimize and, in the crudest sense, exploit them. Something keeps Cathcart alive. One feels its presence as soon as Dobbs lays his proposal before Yossarian; one knows already that Cathcart is secure, that even if Yossarian had assented to the plan, Dobbs would have muffed its execution, wound up no doubt killing himself. Cathcart seems to wear a charm, the same charm that all the other officers seem to wear and which none of the men of the squadron apparently can ever possess. What is this charm?

The charm, I believe, is a special version of Camus's Absurd Cosmos. And it is hanging, in fact, not around Cathcart's neck, but around Yossarian's. It is on the men of the squadron. It is on Heller and his situation. And perhaps – but perhaps not – it is also on the world.

Recall the way in which *Catch-22* tells its story. The technique could hardly be further removed from that of the Homeric poem or even the mainline novel of the nineteenth and twentieth centuries: there is no sequential, step-by-step development through time of an increasingly charged situation, and one does not have the sense that a world is coming into being or is being

altered before one's eyes; there is hardly any sense at all of the massing of contradictory pressures or of a build-up for a conventional climax or denouement. Rather, the narrative stream wanders from thread to thread as if each were a line on an initially invisible map, and with each touching of each story line its dimensions and meanings are spread outwards towards the others more and more, so that by the last page, they all touch, and we have the feeling that a world, a unified body of experience, has been finally disclosed.

Thus, the circulating narrational structure of the novel, moving with the degrees of freedom in time which are customarily reserved for space, has in itself prepositioned a world which is already in being, a complete, tense but essentially static world whose larger form is proof against all assaults: a world which is not in the process of being changed. And the effect of this digressive, apparently undisciplined narrative pattern is to persuade us that in this novel history is not about to take place; we are not about to witness the transfiguration of a world. Impossible to endure as it is, the world of *Catch-22* is not under siege. There is no other moral or practical world which threatens to supplant it.

The world of *Catch-22*, that is, is one in which the possibility of political, historical rebellion has already been foreclosed. There can be no revolution here. Only try to imagine what happens to the psychological ambience of the book, its tone and spirit, if Yossarian – a bombardier after all who kills people every day – should actually bring off the assassination of the war criminal, Cathcart. We have been able to smile with derision at this immune and safeguarded Cathcart who kills and kills with impunity. As soon, however, as *he* is killed, that superior smile seems no longer possible. Everything becomes suddenly very serious; almost automatically, a search for the mode of his assassin's tragic downfall shoots immediately into the book. Yossarian who makes his rebellion political and real – revolutionary – is a Yossarian who can no longer be focused by means

of the underlying assumptions of the novel. Such a Yossarian breaks the bounds of reality which the novel has made implicit and in terms of which it realizes its formal coherence. And this would of course be all the clearer were Yossarian to be joined in this revolution by his co-victims: a crucial action would in this case have transcended and surpassed the practical limits of action which Heller's perception of the world has put into place.

At first, this may seem to say nothing more than that Heller's novel is all of a piece. In fact, one may for a moment almost see in this refusal of the revolutionary option a proof of the novel's authenticity. That a revolution, a massive change in the moral and social order, should at one and the same time be both mandatory and impossible may actually be the most important element of our situation. A novel that expressed and explored this definitive predicament would be a novel which one could not write without great experience and agony – a novel very much worth having.

But Heller has not written this novel. At the last minute, he in fact kills the dilemma which he had seemed to pose by introducing a third term. If historical revolution is impossible, he says, private rebellion is not. A rebellion which amounts only to an escape is produced at the very moment the last dice are being rolled. It turns out to be the reverse side of the twenty-second catch, or perhaps it is catch-23: to an unthinkable revolution and an unendurable régime, Heller suddenly adds the alternative of desertion. If men cannot remake their social destinies by acting together in history, then each man, it seems, can avoid social destiny altogether by escaping history – by escaping politics, by taking asylum in this nonaligned Sweden which Yossarian is headed for at the unconvincingly festive and to my mind disastrous close of the novel. Nonaligned: that is, a country without politics, presumably therefore without Colonel Cathcarts, a country in which social history is no longer individually contingent. One is reminded again of Camus's 'passionate longing for solitude and silence'.

Heller's crazy world, as in different ways perhaps with Kesey's insane world and the early Salinger's phony one, originates in the same disaffiliation from history as the absurd world of Camus. Just as Camus evades history by redefining rebellion as a metaphysical act, so Heller evades it by redefining rebellion as privatistic. A Yossarian in neutral Sweden – perhaps what Heller really wants to say here, by the way, is Eden – is a Kilroy without objectives, a McMurphy without Big Nurse, an Ishmael without Captain Ahab.

And of course it is well known that one need not migrate to arrive in this Sweden. It is nearly everywhere. It is in the East Village and the Haight-Ashbury. It is in camp art and the newer team art, the art without signature. It is in the sanctum of Optical and Acrylic constructivism and the machine aesthetic of the hard and efficient surface. It is in an art culture of once ironic iron which today has apparently abandoned its original subversive content in favour of sheer enthusiasm for a world without people, a very clean and orderly utopia. It is in the new preoccupation with sensibility and the McLuhanite extension of the senses. It is in the new grotesque, which offers to cover up the hour's malaise, the time's bleeding conscience, through the expedient of a so-called black laughter which turns out to be only all too long-suffering, servile, and pale. All of them pretending to be avant-garde and rebellious, all of them at the same time increasingly addicted to what *is*, increasingly alien from that which is not *yet*, these new Swedens, these Wonderlands without contents, without histories and futures, these Expos of polite defeat, are everywhere.

In the end, very like Camus, Heller has tried to buy time for himself and his culture, snarled with lunacy and injustice as it is, by wrapping up everything in a tissue of cynicism and privileged impotence. History being insufferable but unchangeable, he says the good man is therefore morally reprieved from the awful sentence of having to change it. In the company of Camus's solitary rebel, he need only desert.

What Heller finally offers us super-sensitive Westerners is a contemporary world in which we may ignore what threatens us by its example, what challenges us to change our lives. A world, that is, in which there is no Fanny Lou Hamer, no Schwerner, Chaney or Goodman, no Castro or Guevara or Nguyen Huu Tho; a world without fundamental tension, one which is not destined for significant transformation, a world in which the summons to partisanship has been muffled if not ridiculed by a nihilism which has recently discovered gaiety, a despair which has learned how to frolic in the ruins of a certain hope.

Maybe this was a remotely defensible posture in that decade before the First World War when another solitary rebel deserted another homeland 'to forge', as he put it in a tone now forbidden, 'in the smithy of my soul the uncreated conscience of my race'. But several wars and revolutions have changed the situation. The conscience exists, standing before us now asking not to be created or perfected but to be chosen and defended, in need of champions, not exiles. Any fiction which refuses that request is henceforth a collaborationist fiction, a fiction which tells the terrible lie that Carmichael and Bravo and Montes do not exist. It will require indeed a 'post-realistic' fiction to tell this lie, a fiction which suddenly wants to toy with the notion that after reality there might still be something left. There will not be. There will only be men who can catch an eternally difficult reality and those who cannot. Those who cannot will continue to conceal their desertion beneath an historical sadness endlessly more intricate in design and in decoration even lovely: we shall continue to hear the sighs of an expiring culture whose self-confidence is being permanently broken. And those, on the other hand, who will have the courage to see what is there in the world and to see moreover what that world needs to become – these people, putting their own comfort last and labouring to acquire skills which come far from naturally to the modern Westerner, will concentrate all their power on that moment when the good man in hell, acting in acute foreknowledge of

probable defeat, nevertheless acts -- the true existentialist who chooses his history, who chooses his situation, and who chooses to change it; who declines exile and desertion, and who declines to be defeated by a despair which he nevertheless refuses to reject. Such people will have no interest in a fiction of post-realism. They will decide and again decide to live as fully as they can in that eternal hour before the eternal revolution which is eternally the moment of a man's communion with his brothers.

3

Herbert Marcuse

Art in the One-Dimensional Society

As a kind of personal introduction, I would like to say a few words about how I came to feel the need for occupying myself with the phenomenon of art. I use the term 'art' throughout in the general sense which covers literature and music as well as the visual arts. Similarly, 'language' (of art, artistic language) is meant to refer to the picture, sculpture, and tone as well as to the word.

It was some sort of despair or desperation. Despair in realizing that all language, all prosaic language, and particularly the traditional language somehow seems to be dead. It seems to me incapable of communicating what is going on today, and archaic and obsolete compared with some of the achievements and force of the artistic and the poetic language, especially in

HERBERT MARCUSE has become the best-known representative of the so-called Frankfurt School of Marxist thought. This has been due to the world-wide publicity given in the commercial press to the impact of his books, especially *One-Dimensional Man* and *Eros and Civilization*, on the ideas of the New Left. Marcuse's personal connections with such radical leaders as Rudi Dutschke and Angela Davis have contributed to strained relations with the trustees of Brandeis University and the University of California in San Diego, where he has taught in recent years. Marcuse has also produced *Reason and Revolution*, *Soviet Marxism*, *An Essay on Liberation*, *Five Lectures*, and *Negations*, in the American phase of an academic career begun with studies at Berlin and Freiburg. The transcendental potential of art and aesthetic experience has become increasingly important in Marcuse's thought.

the context of the opposition against this society among the protesting and rebellious youth of our time. When I saw and participated in their demonstration against the war in Vietnam, when I heard them singing the songs of Bob Dylan, I somehow felt, and it is very hard to define, that this is really the only revolutionary language left today.

Now, this may sound romantic, and I often blame myself for perhaps being too romantic in evaluating the liberating, radical power of art. I remember the familiar statement made long ago about the futility and perhaps even about the crime of art: that the Parthenon wasn't worth the blood and tears of a single Greek slave. And equally futile is the contrary statement that only the Parthenon justified slave society. Now, which one of the two statements is correct? If I look at Western civilization and culture today, at the wholesale slaughter and brutality it is engaged in, it seems to me that the first statement is probably more correct than the second. And still, the survival of art may turn out to be the only weak link that today connects the present with hope for the future.

In many a discussion I've had, the question was raised about the survival of art in our times. The very possibility of art, the truth of art was questioned. And it was questioned because of the totalitarian character of our 'affluent society' which easily absorbs all non-conformist activities, and by virtue of this very fact invalidates art as communication and representation of a world other than that of the Establishment. I would like to discuss here whether this statement is actually correct, whether the closed society, the omnipresent, overwhelming society in which we live today, whether this is really the reason for the agony of art in our times. And discussing this question involves the larger question as to the historical element in all art. And if we look at this historical element in art, we would have to say that the crisis of art today is only part of the general crisis of the political and moral opposition to our society, of its inability to define, name and communicate the goals of the opposition to a

society which, after all, delivers the goods. It delivers the goods bigger and perhaps even better than ever before and it exacts, for the delivery of these goods, the constant sacrifice of human lives; death, mutilation, enslavement. But they occur far away enough so that it doesn't really touch the majority of us very much.

The traditional concepts and the traditional words used to designate a better society, that is, a free society (and art has something to do with freedom), seem to be without any meaning today. They are inadequate to convey what man and things are today, and inadequate to convey what man and things can be and ought to be. These traditional concepts pertain to a language which is still that of a pre-technological and pre-totalitarian era in which we live. They do not contain the experience of the thirties, forties and sixties, and their rationality itself seems to militate against the new language which may be capable of communicating the horror of that which is and the promise of that which can be. Thus, since the thirties, we see the intensified and methodical search for a new language, for a poetic language as a revolutionary language, for an artistic language as a revolutionary language. This implies the concept of the *imagination* as a cognitive faculty, capable of transcending and breaking the spell of the Establishment.

In this sense, the Surrealist thesis as it was developed during this period elevates the poetic language to the rank of being the only language that does not succumb to the all-embracing language spoken by the Establishment, a 'meta-language' of total negation – a total negation transcending even the revolutionary action itself. In other words, art can fulfil its inner revolutionary function only if it does not itself become part of any Establishment, including the revolutionary Establishment. This, I believe, is most clearly presented in a statement by Benjamin Péret, made in 1943:

The poet can no longer be recognized as such unless he opposes to the world in which he lives a total non-conformity. He stands against

all, including the revolutionaries who place themselves into the political arena only, which is thereby arbitrarily isolated from the whole of the cultural movement. These revolutionaries thus proclaim the submission of culture to the accomplishment of the social revolution.

In contrast, the Surrealists proclaim the submission of the social revolution to the truth of the poetic imagination. However, this Surrealistic thesis is undialectical inasmuch as it minimizes the extent to which the poetic language itself is infested and infected with the general falsity and deception; it does not remain pure. And Surrealism has long since become a saleable commodity.

And yet, art, in spite of this infection and absorption, continues. The language of the imagination remains a language of defiance, of indictment and protest. Reading an article in *Ramparts* on 'The Children's Crusade' and Bob Dylan, I came across the following lines from a poem by Arthur O'Shaughnessy. I did not have the slightest idea who Arthur O'Shaughnessy was. I am told he is a pretty bad poet indeed, and to my horror I saw that the very same poem by O'Shaughnessy is quoted at length in the Blue Book of the John Birch Society. Nevertheless, and that may show you how little I know about art, I love these verses. I think they say something and I think they say something important and I will not be ashamed to repeat them to you.

> One man with a dream, at Pleasure
> Shall go forth and conquer a crown;
> And three with a new song's measure
> Can trample an empire down.

Apart from the poetic merits of these verses (at least they rhyme), they are simply untrue, incorrect. Because what actually happened was that the Children's Crusades, ever since the Middle Ages, with guitars or without guitars, have always been trampled down by the empires, and not the other way around, as these verses want to say.

But still, in spite of this fact, the poems and the songs persist;

the arts persist, and they even seem to assume a new Form and function: namely, they want to be consciously and methodically destructive, disorderly, negative nonsense anti-art. And today, in a world in which sense and order, the 'positive', must be imposed with all available means of repression, these arts assume by themselves a political position: a position of protest, denial and refusal.

As this objective political content of art may assert itself, even there where, instead of a Form of disruption, negation and nonsense, classical and traditional Forms are revived; for example, in the celebration of legitimate love and liberty in the poetry of the French Resistance – the poetry which Péret rejects. It seems that today, elements enter into art (now enter into art more than ever before) which are usually considered extraneous and alien to art, that art by itself in its own inner process and procedure tends toward the political dimension, without giving up the form of art itself. And in this dynamic process, the aesthetic dimension is losing its semblance of independence, of neutrality. Or, the historical situation of art has changed in such a manner that the purity, even the possibility of art *as art* becomes questionable. The artist is driven to formulate and communicate a truth which seems to be incompatible with and inaccessible to the artistic Form.

I said that art today responds to the crisis of our society. Not merely certain aspects and Forms of the established system of life are at stake but the system as a whole, and the emergence of qualitatively different needs and satisfactions, of new goals. The construction of a qualitatively new environment, technical and natural, by an essentially new type of human being seems necessary if the age of advanced barbarism and brutality is not to continue indefinitely.

This means that art must find the language and the images capable of communicating this necessity *as its own*. For how can we possibly imagine that new relationships between men and things can ever arise if men continue to see the images and

to speak the language of repression, exploitation, and mystification. The new system of needs and goals belongs to the realm of possible experience: we can define it in terms of the negation of the established system, namely, forms of life, a system of needs and satisfactions in which the aggressive, repressive, and exploitative instincts are subjugated to the sensuous, assuasive energy of the life instincts.

Now what can possibly be the role of art in the development and realization of the idea of such a universe? The definite negation of the established reality would be an 'aesthetic' universe, 'aesthetic' in the dual sense of pertaining to sensibility and pertaining to art, namely the capacity of receiving the impression of Form: beautiful and pleasurable Form as the possible mode of existence of men and things. I believe that the image and the imaginatory realization of such a universe is the end of art, that the language of art speaks into such a universe without ever being able to reach it, and that the right and truth of art were defined and validated by the very irreality, non-existence of its objective. In other words, art could realize itself only by remaining illusion and by creating illusions. But, and that I think is the significance of the present situation of art, today art, for the first time in history, is confronted with the possibility of entirely new modes of realization. Or the place of art in the world is changing, and art today is becoming a potential factor in the construction of a new reality, a prospect which would mean the cancellation *and* the transcendence of art in the fulfilment of its own end.

In order to make clearer what I want to say, I want to discuss first in what sense art is a cognitive faculty with a truth of its own, and in what sense the language of art discovers a hidden and a repressed truth. I would like to propose to you that art in an extreme sense speaks the language of discovery.

Art (primarily, but not exclusively, the visual arts) discovers that there are *things*; things and not mere fragments and parts of matter to be handled and used up arbitrarily, but 'things in

themselves'; things which 'want' something, which suffer, and which lend themselves to the domain of Form, that is to say, things which are inherently 'aesthetic'. Thus art discovers and liberates the domain of sensuous Form, the pleasure of sensibility, as against the false, the formless and the ugly in perception which is repressive of the truth and power of sensibility, of the sensuous dimension as erotic dimension.

I quote from one of the great Russian 'Formalists' who wrote at the time of the Bolshevik Revolution:

Art exists in order to give the sensation of life, to feel the object, to experience that a stone is a stone. The aim of art is the sensation of the object as vision and not as familiar object. Art 'singularizes the object'; it obscures the familiar Forms, and it increases the difficulty and the duration of perception. In art, the act of perception is an end in itself and must be prolonged. Art is a means of experiencing the becoming of the object; that which is already there is of no importance to art.

The artistic process thus is the 'liberation of the object from the automatism of perception' which distorts and restricts what things are and what things can be. Accordingly, we may say that art discovers and creates a new immediacy, which emerges only with the destruction of the old. The new immediacy is attained in a process of recollection: images, concepts, ideas long since 'known' find, in the work of art, their sensuous representation and – verification.

It seems that art as cognition and recollection depends to a great extent on the aesthetic power of *silence*: the silence of the picture and statue; the silence that permeates the tragedy; the silence in which the music is heard. Silence as medium of communication, the break with the familiar; silence not only at some place or time reserved for contemplation, but as a whole dimension which is there without being used. Noise is everywhere the companion of organized aggression. The narcissistic Eros, primary stage of all erotic and aesthetic energy, seeks above

all tranquillity. This is the tranquillity in which the senses can perceive and listen to that which is suppressed in the daily business and daily fun, in which we can really see and hear and feel what we are and what things are.

These propositions may indicate to what extent the aesthetic dimension is a potential dimension of reality itself and not only of art as contrasted with reality. Or we can say that art is tending toward its own realization. Art is committed to sensibility: in the artistic Forms, repressed instinctual, biological needs find their representation – they become 'objectified' in the project of a different reality. 'Aesthetic' is an existential and sociological category, and as such, it is not brought to bear on art 'from outside' but it belongs to art as art.

But then the question arises: why has the biological and existential content of 'aesthetic' been sublimated in the unreal, illusory realm of art rather than in the transformation of *reality*? Is there perhaps some truth in the vulgar proposition that art, as a special branch of creative activity, divorced from material social production, pertains to what Marx called the 'prehistory' of mankind, that is, the history of man prior to his liberation in a free society? And is this the reason why an entire dimension of reality remained 'imaginary', 'illusion'? And it is tempting to ask a related question: has now perhaps come the time to free art from its confinement to mere art, to an illusion? Has the time come for uniting the aesthetic and the political dimension, preparing the ground in thought and action for making society a work of art? And is perhaps in this sense the notion of the 'end of art' historically justified? Do not the achievements of technological civilization indicate the possible transformation of art into technique and technique into art? In the very complete sense of a controlled experimentation with nature and society in order to give nature and society their aesthetic Form, that is to say, the Form of a pacified and harmonious universe?

To be sure, 'political art' is a monstrous concept, and art by itself could never achieve this transformation, but it could free

the perception and sensibility needed for the transformation. And, once a social change has occurred, art, Form of the imagination, could guide the construction of the new society. And inasmuch as the aesthetic values are the non-aggressive values par excellence, art as technology and technique would also imply the emergence of a new rationality in the construction of a free society, that is, the emergence of new modes and goals of technical progress itself.

Here, however, I would like to insert a warning. Any attempt to explain aesthetic categories in terms of their application to society, to the construction of the social environment, suggests almost inevitably the swindle of beautification campaigns or the horror of Soviet realism. We have to remember: the realization of art as principle of social reconstruction *presupposes* fundamental social change. At stake is not the beautification of that which is, but the total reorientation of life in a new society.

I spoke of the cognitive power of art in this context, of art as expressing and communicating a specific mode of perception, knowledge, understanding, even science, of art as conveying a specific truth applicable to reality. In other words, I took up again the familiar cliché of the kinship between truth and beauty. In discussing this cliché I want to ask the following question. Why the traditional definition of art in terms of beauty, when so much of art, and of great art, is evidently not beautiful in any sense? Is the beautiful perhaps to prepare the mind for the truth, or is the kinship between truth and beauty meant to denote the harmony between sensibility and understanding, of sensuousness and reason? But then we remember that sensuousness and reason, the receptivity for beauty and the activity of knowledge seem to be opposites rather than akin. Knowledge of the truth is painful and ugly in most cases, and truth in turn can be called beautiful only in a highly desensualized, sublimated manner, for example, if we speak of the beauty of a mathematical solution. Or is beauty perhaps meant to be the sensuous medium for a truth otherwise and still

unaccomplished, namely, that harmony between man and nature, matter and spirit, freedom and pleasure, which indeed would be the end of the prehistory of man? Hegel in his *Philosophy of Fine Art* has a vision of a state of the world in which un-organic as well as organic nature, things and men partake of a rational organization of life, in which aggression has come to rest in the harmony between the general and the particular. Is this not also the vision of society as a work of art, the historical realization of art?

This image of art as technique in building or guiding the building of the society calls for the interplay of science, technique and imagination to construct and sustain a new system of life. Technique as art, as construction of the beautiful, not as beautiful objects or places but as the Form of a totality of life – society and nature. The beautiful as Form of such a totality can never be natural, immediate; it must be created and mediated by reason and imagination in the most exacting sense. Thus it is the result of a technique, but of a technique which is the opposite of the technology and technique which dominate the repressive societies of today, namely, a technique freed from the destructive power that experiences men and things, spirit and matter as mere stuff of splitting, combining, transforming, and consuming. Instead, art – technique – would liberate the life-protecting and life-enhancing potentialities of matter; it would be governed by a reality principle which subjugates, on the social scale, aggressive energy to the energy of the life instincts. By virtue of what quality can the beautiful possibly counteract the destructive power of instinctual aggression and develop erotic sensibility?

The beautiful seems to be in a half-way position between unsublimated and sublimated objectives; it is not germane to the unsublimated drive; rather is it the sensuous manifestations of something other than sensuous. And that, I think, is the traditional definition of beauty in terms of *Form*.

What does Form actually accomplish? Form assembles,

determines, and bestows order on matter so as to give it an end. End in a literal sense, namely, to set definite limits within which the force of matter comes to rest within the limits of accomplishment and fulfilment. The matter thus formed may be organic or un-organic, Form of a face, Form of a life, Form of a stone or a table but also Form of a work of art. And such Form is beautiful to the degree to which it embodies this coming to rest of violence, disorder and force. Such Form is order, even suppression, but in the service of sensibility and joy.

Now, if Form in this sense is essential to art, and if the beautiful is an essential Form element of art, it would follow that art was in its very structure false, deceptive and self-defeating; art is indeed an illusion: it presents as being that which is *not*. Thus, art pleases; it provides substitute gratification in a miserable reality. The cliché of substitute gratification contains more than a mere kernel of truth. Not the psyche of the artist is meant here; I suggest that the structure of art itself is vicarious. And this vicarious structure shaped the relation of art to the recipient, to the consumer. Precisely the most authentic works of art testify to this objective vicariousness of art. The great artist may capture all the pain, horror, all the sorrow and despair of reality – all this becomes beautiful, even gratifying by grace of the artistic form itself. And it is only in this transfiguration that art keeps alive the pain and the horror and the despair, keeps them alive as beautiful, satisfying for eternity. Thus a *catharsis*, a purification really occurs in art which pacifies the fury of rebellion and indictment and which turns the negative into the affirmative. The magic staff of the artist brings to a standstill the horror as well as the joy: transformation of pain into pleasure and entertainment; transformation of the fleeting moment into an enduring value, stored in the great treasure house of culture which will go underground in times of war to come up again when the slaughter is over.

Art cannot do without this transfiguration and affirmation. It cannot break the magic catharsis of the Form; it cannot de-

sublimate the horror and the joy. This painting which represents nothing or just a piece of something is still a painting, framed even if it has no frame, potential merchandise for the market. Nor would de-sublimation help. Such de-sublimation in art can obliterate the difference between the meta-language of art and ordinary language. It can capture and it can take pride in capturing the happenings of the bedroom and the bathroom but the shock has long since worn off and is also bought up and absorbed. In one way or another, in the setting of the lines, in the rhythm, in the smuggling in of transcending elements of beauty the artistic Form asserts itself and negates the negation. Art seems condemned to remain art, culture for a world and in a world of terror. The wildest anti-art remains faced with the impossible task of beautifying, of forming the terror. It seems to me that the Head of Medusa is the eternal and adequate symbol of art: terror as beauty; terror caught in the gratifying form of the magnificent object.

Is the situation of art today different? Has art become incapable of creating and facing the Head of Medusa? That is to say, all but incapable of facing itself? One has said that it is impossible to write poems after Auschwitz; the magnitude of the terror today defies all Forms, even the Form of formlessness.

But my question is: Has the terror of reality ever prevented the creation of art? Greek sculpture and architecture coexisted peacefully with the horror of slave society. The great romances of love and adventure in the Middle Ages coincided with the slaughter of the Albigensians and the torture of the Inquisition; and the peaceful landscapes painted by the Impressionists coexisted with the reality represented in Zola's *Germinal* and *La Débâcle*.

Now, if this is true, and if it is not the magnitude of the terror which accounts for the futility of art today, is it the totalitarian, one-dimensional character of our society which is responsible for the new situation of art? Here too we have to be doubtful.

The *elements* of the artistic Form have always been the same as those of the established reality. The colours of the painter, the materials of the sculptor, are elements of this common universe. Why does the artist today seem incapable of finding the transfiguring and transubstantiating Form which seizes things and frees them from their bondage in an ugly and destructive reality?

Again, we have to direct our attention to the historical character of art. Art as such, not only its various styles and forms, is a historical phenomenon. And history perhaps now is catching up with art, or art is catching up with history. The historical locus and function of art are now changing. The *real, reality*, is becoming the prospective domain of art, and art is becoming technique in a literal, 'practical' sense: making and remaking things rather than painting pictures; experimenting with the potential of words and sounds rather than writing poems or composing music. Do these creations perhaps foreshadow the possibility of the artistic Form becoming a 'reality principle' – the self-transcendence of art on the basis of the achievements of science and technology, and of the achievements of art itself?

If we can do everything with nature and society, if we can do everything with man and things – why can one not make them the subject-object in a pacified world, in a non-aggressive, aesthetic environment? The know-how is there. The instruments and the materials are there for the construction of such an environment, social and natural, in which the unsublimated life instincts would redirect the development of human needs and faculties, would redirect technical progress. These pre-conditions are there for the creation of the beautiful not as ornaments, not as surface of the ugly, not as museum piece, but as expression and objective of a new type of man: as biological need in a new system of life. And with this possible change in the place of art and in its function, art transcending itself would become a factor in the reconstruction of nature and

society, in the reconstruction of the polis, a political factor. Not political art, not politics as art, but art as the architecture of a free society.

As against this technical possibility of a free society, the established repressive societies mobilize, for their defence, aggressiveness on an unprecedented scale. Their tremendous power and productivity bar the roads to liberation – and to the realization of art.

The present situation of art is, in my view, perhaps most clearly expressed in Thomas Mann's demand that one must revoke the Ninth Symphony. One must revoke the Ninth Symphony not only because it is wrong and false (we cannot and should not sing an ode to joy, not even as promise), but also because it is there and is true in its own right. It stands in our universe as the justification of that 'illusion' which is no longer justifiable.

However, the revocation of a work of art would be another work of art. As far as one can go in revocation of the Ninth Symphony, I think Stockhausen has achieved it. And if the revocation of the great art of the past can only be another work of art, then we have the process of art from one Form to another, from one style to another, from one illusion to another.

But perhaps something really happens in this process. If the development of consciousness and of the unconscious leads to making us see the things which we do not see or are not allowed to see, speak and hear a language which we do not hear and do not speak and are not allowed to hear and to speak, and if this development now affects the very Form of art itself – then art would, with all its affirmation, work as part of the liberating power of the negative and would help to free the mutilated unconscious and the mutilated consciousness which solidify the repressive Establishment. I believe that art today performs this task more consciously and methodically than before.

The rest is not up to the artist. The realization, the real change which would free men and things, remains the task of

political action; the artist participates not as artist. But this extraneous activity today is perhaps germane to the situation of art – and perhaps even germane to the achievement of art.

EDITOR'S NOTE: *This article is based on a lecture given at the School of Visual Arts in New York City on 8 March 1967.*

4
Darko Suvin

The Mirror and the Dynamo

ON BRECHT'S AESTHETIC POINT OF VIEW

The time has come to give art, by a pitiless method, the precision of the natural sciences. But the principal difficulty for me is still the style, the indefinable Beauty resulting from the conception itself.

FLAUBERT, *Correspondence*

In the preface to his most famous theoretical essay, the *Little Organon for the Theatre*, Brecht in part retracted his early vituperations against aesthetics, which in the 1920s had led him to ask (as the title of an article of his goes): 'Shouldn't we liquidate aesthetics?' With the growing maturity and complexity of his poetry and plays, the feedback from practice to theory which was a permanent feature of Brecht's work led him to recognize that those vituperations – which he never wholly abandoned – were directed at the bourgeois German aesthetics of his epoch, at 'the heirlooms of a depraved and parasitic class' (*SzT*, VII. 8),[1]

1. All quotations from Brecht have been taken from the collected Suhrkamp edition. Having no English translations at hand, I translated them all anew.

DARKO SUVIN is a Yugoslavian scholar. His areas of specialization are the drama (notably but by no means exclusively Brecht), and science fiction and utopian literature. In English he has published *Other Worlds, Other Seas*; *Science Fiction Stories from Socialist Countries*; and numerous essays, particularly in *The Drama Review*. He has taught at the University of Zagreb, the Universities of Indiana and Massachusetts, and McGill University, Montreal.

and not at a philosophical and sociological discipline dealing with the pleasing and the beautiful (mainly in art), as such or as a whole. For, by the end of the 1930s, Brecht had in his lyrics and dramas, as well as in his theoretical writing,[2] recognized that his own work was also pleasurable – if pleasure were no longer opposed to learning. This assumed a redefinition of aesthetics which refused to recognize the divorce between entertainment and learning, between the aesthetic and cognitive function of artistic signs (*SzT*, III. 81–3), but on the contrary insisted that aesthetic standards were linked to the cognitive adequacy of a work of art. Such a new aesthetics involved a radical departure from any attitude of indifference to practical experience. It posed anew questions concerning the relationship of a pleasure-provoking object to 'external reality'. The new aesthetics redefined imagination as creative, the aesthetic attitude as a significant *activity*, and the aesthetic response as a constructive and interpretive event. Cognitive meaning was thus recognized as a no less important element of 'style' than, say, sensuous surface.

Within such a context Brecht felt that his 'theatre of a scientific age' could take up its abode in aesthetics. Even natural sciences, he explains somewhat curtly in the *Organon* preface, create an aesthetics of their own, and he quotes approvingly Oppenheimer's dictum about a scientific stance 'having its own beauty and being well suited to man's position on Earth'. Brecht concludes this preface (in the dignified first person plural which he affected as a semi-humorous form of acknowledging his mistakes):

Brecht's essays on theatre, *Schriften zum Theater*, will be indicated in the text by a *SzT* in brackets, with the roman numeral indicating the volume and the arabic the page.

2. This is already clear in one of his fundamental essays, *The Street Scene* (1938; see *SzT*, V. 69–70), with another landmark, *Theatre for Pleasure or Theatre for Learning?* (1936; see *SzT*, III. 51–2), marking the visible transition towards it.

Let us therefore, probably amidst general sorrow, revoke our intention to emigrate from the kingdom of the Pleasing, and let us, probably amidst even more general sorrow, manifest our intention to take up our abode in this kingdom. Let us treat the theatre as a place of entertainment, as proper in aesthetics, and let us examine which kind of entertainment suits us! (*SzT*, VII. 9)

In this essay I will try to demonstrate, first, that this attitude of Brecht's should be taken seriously, and that the distinctive values of his work and its enduring qualities are to be found in the ambitious building up of a specific Brechtian beauty, pleasure, or aesthetics. His work should be analysed using – and where necessary modifying – some classical aesthetic categories. Second, I wish to show that the most significant of these categories is a *look backward* from an imagined Golden Future of justice and friendliness to his (and our) cold world and dark times. Brecht's central aesthetic device, the technique of estrangement (*Verfremdungseffekt*), and the whole estranging arsenal of Brechtian poetics flow logically out of such an angle of vision.

I

The basis of Brecht's world-view is a Marxian horror at our present state and a firm orientation towards changing it: '. . . Einstein said that he has, ever since his childhood, thought only about the man hurrying after a ray of light and the man in a falling elevator. And just look how complicated this grew! I wanted to apply to the theatre the saying that one should not only interpret but change the world' (*SzT*, VII. 143). The references to Einstein and to Marx's eleventh thesis on Feuerbach locate the starting point of the new aesthetics. Beyond this is implied an awareness of *what* needs to be changed (an alienated world) and an awareness of *how* theatre could represent the changing of the world (through awareness of the work of art as a 'symbolic action' or as a de-alienating pleasure-in-

cognition); in other words, two closely connected aspects of Brecht's vision: a theory of man's reality and a theory of art as an autonomous understanding of reality. Both of these may have been aspects of an artistic vision rather than systematically formulated doctrines, and the term 'theory' should doubtless here be taken primarily in its etymological sense of *theoria*, an understanding look or viewing – nonetheless, they were constantly informing Brecht's aesthetic practice. It is a measure of his relevance that these are the foundations upon which *any* radical renewal in aesthetics has to base itself.

Brecht's mature aesthetic *theoria* presents us again with the problem of the relationship between Art and Nature, known in aesthetics as the Aristotelian question of mimesis. From the very beginning of *Poetics*, where Aristotle defines most poetry and singing as mimesis, this central concept is susceptible to three principal translations: *copying*, *representing* (performing), and *expressing*. Though Aristotle's use, in spite (or because) of his professorial pleasure in neat definitions, oscillates among these meanings, the above example indicates what has also been found by Koller's examination[3] of the use of the term in Aristotle's time (say in Plato or Lysias): that the central meaning of mimesis includes an active relation of the *mimoumenoi*, the 'representers' or 'performers', to the model. It is sufficiently clear that singing about an event, or dancing it, cannot be taken as a straight copy of that event, but only as an expression according to autonomous musical (or choreographic) conventions. The central position of the term *representation* for mimesis can perhaps be clinched by Aristophanes' use in the *Thesmophoriazusai*, where Mnesilochus wants to meet Euripides as the protagonist of his latest play, *Helen*, and sets about performing a little play-within-the-play, dressed as Helen: 'I'll *represent* [Euripides'] brand-new Helen.'

The changing fortunes in the use and abuse of mimesis, from

3. cf. H. Koller, *Die Mimesis in der Antike: Nachahmung, Darstellung, Ausdruck* (Berne, 1954).

Sophocles and Plato to Stanislavski and Zhdanov, offer material for fascinating studies in the history of aesthetics, philosophy, and politics, which would (together with the equally fascinating history of catharsis) explain why Brecht persisted in calling his dramaturgy 'non-Aristotelian'. From all that emerged in this long debate we here are concerned simply with the fact that even in Aristotle's time mimesis fundamentally meant *representing* (in theatre: performing, showing). This means that both the model to be represented *and* the ways of representing it (technologically, through the medium, and socially, through the accepted conventions of representation) were admitted to be co-determining elements of the mimesis. Throughout the centuries, creators and theoreticians of art not wholly blinded by ideologies have seen that art was no magic window opening on reality but itself a specific reality – neither a photographic nor a symbolist copy of Nature but a representation of processes in reality, parallel to scientific or philosophical ways of representation, and interacting with a changing world. In this light, Brecht's formulation of a modern Marxian or Einsteinian epistemology 'merely' took up and refashioned the mimetic tradition which middle-class aesthetic practice and theory had interrupted. In the words of Marx, which became the basic orientation of 'The Philosopher in the Theatre' (as Brecht liked to call himself), this is: 'Philosophers have only *interpreted* the world in various ways, the point is – to *change* it.'

Or, as one might formulate the position of Einstein (whom Brecht also took as an exemplary figure, liked to compare himself with, and was preparing to write a play on): there is no specially favoured coordinate system or reference-point; each coordinate system has its own time dimension; yet the general laws of Nature are equivalent for all reference systems. In other words, though the old notion of an eternal, essential identity of reference systems has to be abandoned, yet through modification – which can in each case be analysed and grasped – general principles of Nature remain valid in a new, dialectical way for

all reference systems. Marx's disdain for the old ways of interpreting the world as something given – as a text to be reproduced by an indifferent actor of the World Play – and Einstein's insistence that though Nature was not chaotic there was no absolute perspective from which all events were scaled up or down both represent fresh strategies of grasping reality, closely akin to Brecht's own. (One could also place within that kindred family of visions those of Picasso or Eisenstein – but that would be matter for another essay.)

By the nineteenth century, bourgeois aesthetics had wholly forgotten the traditional implications of mimesis – reacting with a sterile denial of any relation between art and nature. In most of the nineteenth and in the early twentieth century, it rested on the twin axioms of *individualism* – conceiving the world of the individual as the ultimate reality, and *illusionism* – taking for granted that an artistic representation in some mystic way directly reproduces or 'gives' man and the world. Against this, Brecht took up a position of productive *critique*, showing the world as changeable, and of what I shall for want of a better term call *dialectics*: conceiving the world as a process and man as emergent. In contrast to the idea of a one and only Nature – and Human Nature – to be found in or beneath existing relationships, Brecht's work is based on an emergent human history within which all variants of Nature – and of Human Nature – are specific social alienations. No existing social relations (including the ones in the first Communist states) are unique or final; all of them should be met by dialectic critique, keeping in mind the possibility and necessity of change. Art is not a *mirror* which reflects the truth existing outside the artist; art is not a static presentation of a given Nature in order to gain the audience's empathy; Brecht sees art as a *dynamo*, an artistic and scenic vision which penetrates Nature's possibilities, which finds out the 'co-variant' laws of its processes, and makes it possible for critical understanding to intervene into them. This attitude attempts to raise art to an ontologically – or at least

epistemologically – higher plane of creative significance than illusionism. The estrangement (*Verfremdung*) of ways of speaking, for example, 'makes it easier to translate the natural into the artistic (*ins Künstliche*); moreover, it translates according to the meaning' (*SzT*, III. 193): to Brecht, art is a Meta-Nature with its own language, yet not in the sense of a negative of nature (in the *l'art-pour-l'art* fashion) but participating in the meaning of reality. Art is no beautiful Platonic lie, but an autonomous, 'artful' (*Künstlich* is a pun uniting 'artistic' and 'artificial') reality; and its productive stance is analogous to that of modern cosmology and anthropology. It is experimental, testing its own presuppositions – in theatre, by feedback from the effect in practice of its text and performance. Seeing the world as sets of changing possibilities, it is a reflection *on*, not *of* nature – including human nature as it is developing within history.

Borrowing a Brechtian method of exposition (which he took from German philosophy), the following table may be useful:

Illusionist and Individualist Aesthetic Attitudes (THE MIRROR)	Critical and Dialectical Aesthetic Attitudes (THE DYNAMO)
Reality is seen as an ensemble of visible and calculable commodities (including Man).	Reality is seen as interacting processes in an experience of painful humanization.
Nature – including Human Nature – is universal, eternal, and unchangeable; surface differences are so much local colour.	Nature – including Human Nature – is historically conditioned and changeable; different forms of behaviour are reflections of tensions between a humanizing possibility and specific social alienations.
Mimesis copies Nature as the only reality; art (and theatre) is a reflected, purified Nature, a *Pseudo-Nature*.	Mimesis brings forth a specific reality; art (and theatre) is a simile of Nature, a *Meta-Nature*.
The work of art suggests the existence of previously known objects.	The work of art proves its own existence as a creative vision and object.

Illusionist and Individualist Aesthetic Attitudes (THE MIRROR)	Critical and Dialectical Aesthetic Attitudes (THE DYNAMO)
Art (and theatre) transmits insights into a subjectively reflected objective reality.	Art (and theatre) creates insights into the subject-object relations in possible realities.
Ideas and ideology are the basis of aesthetic being: philosophical idealism.	Historical reality is the basis of aesthetic being: philosophical materialism.
The universe is monistic and deterministic: growing awareness leads to tragedy, lack of awareness to comedy (Ibsen, Strindberg, O'Neill).	The universe is pluralistic and possibilistic : growing awareness leads to comedy, lack of awareness to tragedy (Shaw, O'Casey, Brecht).
Man is seen as a 'three-dimensional' *character* revealed psychologically through conflict with environment; the unity of such a character is a metaphysical axiom.	Man is seen as a contradictory *ensemble* of several possibilities and qualities, intersecting in his actions; the unity of such an ensemble is a datum of social action.
Highest ideal: eternity (nirvana); fulfilment in noble dying.	Highest ideal: liberty (classless society); fulfilment in productive living.
Patriarchal, authoritarian strength.	Matriarchal, liberating suppleness.
To feel a magical aesthetic illusion fully is to penetrate into an eternal human experience.	To understand a critical aesthetic showing fully is to gain insight into the possibilities and social limitations of human experience.
The 'well-made' play's *closed form* is composed of a chain of situations linked by deterministic causation and moving to a climax on the same plane.	The well-made play's *open form* is composed of fixed points of a process distributed in various planes with a climax calculated to happen beyond it, in the spectator.
Indispensable arbiter as an aspect of a principal character: Policeman, Royal Messenger (*Rosmersholm, The Inspector General*).	Indispensable arbiter as a special *dramatis persona*: Judge, Wise Fool (*Saint Joan, Caucasian Chalk Circle*).

Illusionist and Individualist Aesthetic Attitudes (THE MIRROR)	Critical and Dialectical Aesthetic Attitudes (THE DYNAMO)
Ideal synoptic point of the play: a look through the eyes of main characters (the presuppositions of the play are given).	Ideal synoptic point of the play: a look at all characters from outside the play (the presuppositions of the play are tested).
Ideal onlooker: he to whom all unfamiliar things are familiar, because he sees their eternal essence through surface appearances – God.	Ideal onlooker: he to whom all familiar things are unfamiliar because he looks for the unrealized potentialities in each stage of human development – man of blessed classless Future.

The 'mirroring' attitude corresponds to the alienated reality which was characteristic of the nineteenth century, but which lives tenaciously (among other places, on all the Broadways and boulevards of the world). The 'dynamic' attitude corresponds to the twentieth-century tendencies toward de-alienation, although some of its champions may also be found in a long tradition; since, say, Epicurus and Lucretius, and including, notably, isolated oppositional figures in the nineteenth century such as Marx, Büchner, and Rimbaud – all of them, logically enough, Brecht's favourites.

2

The basic strategy of 'dynamic' aesthetics is to observe the possibilities realized at any given time and compare them with a fuller realization of the same possibilities – looking at the present from a point of comparison located in another epoch. 'The "dreams" of the poets are addressed to a new spectator, who relates to experience differently from those of earlier times,' wrote Brecht in a planned conclusion to *Der Messingkauf*; he followed this with the statement that poets themselves are men of such a new epoch. From this position, 'The question of the

didactic becomes an absolutely aesthetic question, solved, so to speak, in an autarchic way' (*SzT*, V. 304). From the vantage point of this projected new world, a scientifically questioning look at man sees the present as a historical epoch, all of whose events (especially the most 'normal' ones) are remarkable. 'As empathy makes an everyday occurrence out of the special, so estrangement (*Verfremdung*) makes the everyday occurrence special. The most general happenings are stripped of their tiresome character by being represented as unique. No longer does the onlooker escape from the present into history; the present becomes history,' says Brecht (*SzT*, V. 155). And further: 'He who has looked with astonishment at the eating customs, the jurisprudence, the love life of savage populations, will also be able to look at our eating customs, our jurisprudence and our love life with astonishment'; only the spiritually impoverished Philistine sees everywhere an Everyman adaptable to all roles: 'Like Lear, he has reaped ingratitude, he has raged like the Third Richard. He has sacrificed all sorts of things for his wife, like Antony for Cleopatra, and he has treated her more or less like Othello. Like Hamlet he hesitates to wipe out an offence with blood, and his friends are Timon's kind of friends. He is absolutely like everybody, and everybody is like him' (*SzT*, V. 106–7). If this petty bourgeois is wrong in his empathizing, if his motivations are not eternal nor his standpoint and epoch normative, then it is *his* actions and *his* world which are shown to be catastrophic and savage:

> I am a playwright. I show
> What I have seen. At the markets of men
> I have seen how men are bought and sold. This
> I, the playwright, show.
>
> How they step into each other's room with plans
> Or with rubber truncheons or with money
> How they stand and wait on the streets
> How they prepare snares for each other

Full of hope
How they make appointments
How they string each other up
How they love each other
How they defend the spoils
How they eat
That is what I show . . .

I see avalanches appearing
I see earthquakes advancing
I see mountains straddling the way
And I see rivers overflowing their banks.
But the avalanches wear hats
The earthquakes have money in their pockets
The mountains have alighted from cars
And roaring rivers command policemen.
That is what I reveal . . .

(The Playwright's Song)

If such a period as ours obviously cannot be historically privi-
leged, then all its surfaces are 'period', historical exhibits
before the evoked jury of spectators 'differently related to
experience' – that is, posterity (*die Nachgeborenen*, to whom
Brecht's sincerest and most significant poem is addressed).
Another poem of his is entitled 'How future times will judge
our writers': those times and generations are the supreme
arbiters of the Brechtian world. Friendly and inexorable, they
sit in judgement on this age, like the plebeian Shades on the
great Lucullus, consigning its vivid criminals into nothingness
(where Mother Courage's actions also consign *her*); they judge,
accuse, and condemn, like Azdak judging the rapacious Natella
Abashwili, like Shen Te accusing the cruel world and the bland
gods, and like Galileo's scientific 'I' condemning his weak
empirical self.

In still another fragment of the *Messingkauf*, Brecht himself
openly indicated that the external standpoint of his approach is
in the future: the key for understanding any figure in his

dramas lies 'not only outside the sphere of the figure, but also further forward in evolution. The classics have said that the ape is best to be understood starting from man' (*SzT*, V. 155). He repeated this view in the *Organon*: the proper estranging way of playing a role is as if the character 'had lived a whole epoch to the end and were now, from its memory, from her knowledge of future developments, saying those of her words which were important at that point of time, for important is as important becomes' (*SzT*, VII. 38).[4] Perhaps the most effective way of putting this is again to be found in a poem, whose date (about 1926) makes it a document of the moment when the look backwards from a happy future crystallized in the young Brecht. The poem is called 'The Babylonian Confusion' and shows how the author wanted 'slyly to tell a story' about a grain dealer in Chicago –

> To those who have not yet been born
> But will be born and will
> Live in quite different times
> And, happy they! will no longer understand
> What is a grain dealer of the kind
> That exists among us.

The impulse for this poem is biographical:

For a certain play [it was to be called *Wheat* or *Joe Fleischhacker from Chicago* and to play at Piscator's; studies for it were later transmuted into *St Joan of the Stockyards*] I needed the Chicago grain market as background. I thought I would acquire the necessary knowledge by a few quick questions to the specialists and people in that field; but the affair was to take a different course. Nobody, neither

4. Compare the Swiss playwright Max Frisch's discerning diary observations from the time of his acquaintance with Brecht in 1948: 'Brecht relates to a projected world which doesn't yet exist anywhere in this time, visible only in his behaviour which is a lived and inexorable opposition, never daunted through decades of external toil. Christians related to the other world, Brecht to this world' (*Tagebuch 1946–1949*: Frankfurt a. M., 1950, p. 287).

well-known economists nor businessmen – I travelled from Berlin to Vienna to meet a broker who had worked his whole life on the Chicago exchange – could give me a satisfactory explanation of the happenings at the grain market. . . . The projected play wasn't written – instead of that I started reading Marx.[5]

But from this true story, Brecht in his poem ascends into allegory and an Erewhonian dialogue with yet unborn listeners. The listeners, however, show no understanding, ask unanswerable questions about the world which boasted of grain dealers, and finally put the writer off –

> With the calm regret of
> Happy people.

From this vantage point of an imaginary just and friendly future of happy people, where 'man is a helper to man' (*An die Nachgeborenen*), the poet can in his plays and verse practise the classical – Marx's, Bellamy's, or Morris's – anticipatory *look backward* into his own bloody empirical times, taking in the reality of this age of strife between classes and nations, of mankind divided against itself in the social alienation of the capitalist mode of production and consumption. In this way of looking there is no sharp division between the epic and the dramatic in the sense of Aristotelian or Schillerian poetics. If the aesthetic

5. Brecht's note, quoted in H. J. Bunge/W. Hecht/K. Rülicke-Weiler, *Bertolt Brecht* (Berlin, 1963), p. 40, trans. D. S. Elisabeth Hauptmann, Brecht's collaborator at that time, wrote in her diary of July 1926 about Brecht's work on *Joe Fleischhacker*, a play planned as carrying on the series of 'the coming of mankind into the big cities' begun with *In the Jungle of Cities*: 'Finally Brecht started to read national economics. He asserted that money practices were obscure, he had to see now what money theories were like. But even before he came to important discoveries, at least for himself, he had concluded that the old (great) form of drama wasn't fit for representing such modern processes as the international distribution of wheat, the life stories of people of our times and generally for all events with consequences. . . . During these studies he drew up his theory of "epic drama"' ('Notizen über Brechts Arbeit 1926', *Sinn und Form*, second special issue on Brecht, 1957, p. 243, trans. D.S.).

uniqueness of such an attitude lies in confronting man as changeable in time, then 'Schiller's distinction that the [epic] rhapsodist has to treat occurrences as wholly past, and the [dramatic] mime as wholly present (letter to Goethe of 26.12.1797) is not quite exact any more' (*Organon*, *SzT*, VII. 37). For if man is not a temporally fixed point in Newtonian space but a future-oriented vector in Einsteinian time-space, he is not to be encompassed either by a mimic, dramatic present or by a rhapsodic, epic past. Looking at him from the author's imagined future, he is an object in the past, to be shown by epic narrative. Looking at him, simultaneously, from the author's present, he is a subject in the present, to be shown by dramatic presentation. The new view of him will therefore consist of a precisely graded mingling of the epic and the dramatic, of man as an object of cool anthropological cognition *and* as a subject of passionate dramatic sympathy. As compared with 'Aristotelian' poetics – especially as understood by the German nineteenth century from Schiller to Freytag – this kind of performing was not 'pure' drama, it was 'epic'. In fact, however, it fused dramatic presentation with epic narration, embodying this in the alternation of action with narrators, songs, titles, etc., and in the special behaviour of the dramatic figures. The whole arsenal of estrangements is the aesthetic working out of such a new epico-dramatic, dialectical mode of genre. When estranging had fully worked itself out in Brecht's practice, he was able to recognize that, although his theatre was 'epic' compared to orthodox quasi-Aristotelianism, this term did not render it justice: '. . . We can now abandon the designation "epic" theatre for the theatre we had in mind. This designation has fulfilled its duty if the narrative element, always present in theatre, has been strengthened and enriched . . . creating a basis for the particularity of new theatre . . .' (*SzT*, VII. 194). The proponents of the designation 'epic theatre' had too readily assumed that it was, 'naturally', epic compared to the existing drama and theatre: they had fallen into the trap

of looking at Schiller's or Reinhardt's dramaturgy as *the* dramaturgy, forgetting in the heat of the battle their own basic estranging standpoint.

The strategy of the look backward, then, presented the play's situations simultaneously as 'human, all too human' history for our sympathetic involvement and as inhuman, alienated pre-history for our critical understanding. It created tension between a future which the author's awareness inhabits and a present which his figures inhabit; this tension is at the root of the most significant values of Brecht's work. It is because the Golden Age is yet to come that man in this Iron Age cannot be good, try as he may, without being pulled apart either from within, as Puntila, or from without, as Shen Te:

> Your bidding of yore
> To be good and yet to live
> Tore me in two halves like lightning. I
> Don't know why: I couldn't be good to others
> And to myself at the same time.
> *(The Good Woman of Setzuan)*

3

Brecht's central aesthetic standpoint of looking backward can be analysed in his practice into two principal estranging components, which can be called the view from below and the view from above. The view from below is the anarchistic, humorous 'Schweik look' of plebeian tradition; it is inherent in the stance which Brecht's (and Hašek's) Good Soldier assumes in facing the world. Its richness stems from a constant juxtaposition of the official and the real, the sentimental and the naïve, the ideological and the practical. Figures like Azdak are obvious protagonists of this comic look. The view from above, on the other hand, is the rationalist 'Diderot look' of intellectual tradition; it is inherent in the stance which the author of *Jacques the Fatalist* (or of *Candide*, or of *The Persian Letters*) assumes in facing the world. It critically illuminates the most intimate structures of

bourgeois life and art. Brecht, as Chiarini has said, is 'the last great pamphleteer of the middle classes', who, however, turned against his own class (as he himself said in the poem 'Kicked Out with Good Reason', *Verjagt mit gutem Recht*), 'baring its secrets to the people'. The Diderot look meets the Schweik look in the politics of de-alienating the human animal.

The Schweik element in Brecht's work is evident at first glance. Equally important, however, is the patron-saint role of Diderot (in the 1930s Brecht even tried to found a 'Diderot society' for the study of theatre). Like Diderot, Brecht started from the assumption that human reason can understand and master even the most unreasonable instincts, even the most complex circumstances, even the bloodiest contradictions of this stockyard world. Like Diderot, Brecht was interested in how art relates to a new concept of nature, man, and society, to a new aesthetics. Like Diderot and his fellow theoreticians, Brecht asked from the actor 'that his tears flow from the brain'. Like Diderot, he wanted a drama which could give the *homme moyen sensible* of tomorrow insights into human relationships and the relations behind those relationships (*SzT*, III. 44–9). Like Diderot, Brecht thought of himself as a 'philosopher in the theatre' (with the distinction of having advanced from Shaftesburian to Marxian optimism). No wonder that the following fragment might have come from either of them:

In the great play, the play of the world, the one I always return to, all emotional souls occupy the stage, whereas all creative people sit in the orchestra. The first are called mad (alienated); the second ones, who depict their follies, are called sages (philosophers). The eye of the sage is the one which lays bare the follies of various figures on the stage.[6]

Brecht's artistic development can be most usefully divided into three phases: the early and the middle 1920s; the late 1920s and early 1930s; and the mature phase from the middle

6. Diderot, *Le Paradoxe du Comédien*, trans. D.S.

1930s on. The first two phases – to speak of them within the framework of this essay – abstracted and made absolute the views from below and from above. These two at last coalesced into the dynamic look backwards of his final great plays.

The first, anarchist phase – the phase from *Baal* to *Mahagonny* – is marked by a tendency towards *absolute non-consent*,[7] a self-indulgent nihilism. The author distances himself from reality without having open historical horizons or new values in sight. The estrangement takes the form of a *reductio ad absurdum*, and operates by isolating banal elements from reality. Critics have not been slow to notice that *The Threepenny Opera* works by equating the gangsters to the bourgeois (as Gay's play and much of the literature of that age did too – see Fielding's *Jonathan Wild the Great*), implying that therefore the bourgeois are gangsters too. Perhaps it has not been clearly stated that this 'opera' also *delights* in such asocial bourgeois gangsters. The gangster-bourgeois equation is, therefore, an object of uncritical admiration at least as much as of social criticism. Possibly it is just this delight in such an unsolved incongruity which led to its huge success with all shades of the middle-class audience. Brecht himself, craftily truthful, proclaimed it was still a 'digestive' play where the bourgeois dream is both realized and criticized (*SzT*, II. 89). That is also why in his next phase he so strenuously tried to change it when rewriting the scenario for the Pabst movie, and even more notably when writing *The Threepenny Novel*.

7. The term has been taken from Brecht's own use in such plays as *The Baden Learning Play on Consenting*. 'Consenting' was one of the key terms of post-war German sociology which Brecht seems to have been quite well acquainted with, especially through Fritz Sternberg and Karl Korsch (see Sternberg's memoirs *Der Dichter und die Ratio*, Göttingen, 1963, while Brecht's correspondence with his mentor Korsch is just beginning to be published in periodicals). Cf. Max Weber's chapter 'Einverständniss' (Consenting) in *Ueber einige Kategorien der verstehenden Soziologie* (Max Weber, *Soziologie-Weltgeschichtliche Analysen Politik*, Stuttgart, 1964, pp. 126–40).

Most critics would probably agree that Brecht's plays of the first phase do a far better job at the destruction of bourgeois values than at setting up any – even implicit – new values. They do not deal in transvaluation but in devaluation, similar to much that was happening at the time in Central Europe, from the Dadaists to, say, Pirandello. Therefore this phase of Brecht's vision foreshadows some essential traits of the later grotesque or 'absurd' playwrights such as Beckett or Ionesco. At least one of his early plays, *The Wedding* (*Die Hochzeit*), is almost pure Ionesco *avant la lettre*. What is here, however, perhaps most significant is that Brecht soon outgrew this uncritical non-consenting attitude. By the end of the 1920s, he was sufficiently above his 1919 playlet to change its name to *The Petty Bourgeois Wedding* (*Die Kleinbürgerhochzeit*). This apparently slight change is symbolic. Where Ionesco makes a given *condition humaine* into *the* human condition, Brecht locates it in a precise anthropological and social context. He denies it eternal status by tying it down to a sociologically alienated base, with whose change the historical human condition would change too.

The second, rationalist phase – from *Man Is Man* to *Mother*, the phase edges being, as always, blurred – is marked by a tendency towards *absolute consenting*, a self-indulgent didacticism. If the first, post First World War, phase was given to apolitical ideologizing, the second one, which came about in an atmosphere of fierce political struggle in Germany, was given to political ideologizing. This finally resulted in a kind of religious tragedy as exemplified by *The Measures Taken*. Whereas the absolutely non-consenting phase tended to deny society in favour of the individual, this play implies that the individual should deny himself in favour of the society. He should disappear into a collective *ad maiorem Dei gloriam*, it being of secondary importance whether this God is identified as such or laicized into, say, the World Revolution. The apology of an *ecclesia militans* may have been quite understandable at that high point of tension in Germany, but it has to be seen as

such when looking back at Brecht. Such a play is a poetical expression of a lay faith whose aims claim to be of this world but whose methodology is fundamentally religious, even though not theistic but political. It is interesting to note that at the time it was first produced, this play was acclaimed by some Christian critics as a great crypto-religious tragedy, and severely taken to task by some Marxist critics, although written as a glorification of what Brecht conceived to be the Communist Party. Certainly, such uncritical consent is more Jacobin or Anabaptist than humanist-Marxian.

The final, mature vision of the author of the sequence from *The Good Woman of Setzuan* to *The Life of Galileo* came when he had seriously (and joyously) accepted practical corrections against over-confidence in either plebeian anarchy or lay clericism. In the 1930s it became obvious that the gangsters of *The Threepenny Opera* led *also* to Nazism, and that the fanatics of *The Measures Taken* led *also* to Stalinism. Therefore, constantly on the alert for feedbacks from living human history, yet holding on to the significant standpoint of a future friendly humanity, Brecht fused the strengths of both the view from below and the view from above. From the plebeian view, he took a disrespectful critical attitude towards everything that claims to be an eternal value, especially towards social power structures. He also took the parodic forms used to such effect in plays like *The Three-penny Opera*, based on the puppet theatre, on street ballads and pamphlets, on fair-barkers and penny arcades, and distilled through the traditions of Büchner's revolutionary bitterness, Wedekind's provocative bohemianism, and the goon-thinking of Nestroy, Valentin, or Karl Kraus. The rationalist view taught him to search for clearly defined values which make out of understanding and cognition a pleasure, an aesthetic principle, and which were used to such effect already in plays like *Mother*.

The mature Brechtian vision then, used both kinds of estrangement, the nihilist 'Schweik' one and the rationalist 'Diderot' one, and fused them into one method, which finally

understood itself as dialectical. In a very noteworthy passage in Brecht's *Dialogues of Exiles*, the interlocutors come to agree that Hegel's dialectical method is a great humorous world principle, because it is based on switching between different levels of understanding, just like humour or wit. Thus this dialectical Brechtian vision is a new link in the classical chain of wits, the bitter or smiling debunkers going back to Lucretius and Aristophanes, Rabelais and Cervantes, Fielding and Swift; and perhaps one might mention also Brecht's favourites outside literature: Bruegel and Picasso in painting, Chaplin and Eisenstein in the movies, Marx.

Using the language of dialectical estrangement to master the alienated world, Brecht's mature aesthetic is not based on pure idea. It is in a permanent two-way relation of theory to practice, and may therefore be claimed as anti-ideological. This means that he could overcome the weaknesses of its components – the primitive and insular aspect of anarchism, still peeping out in *Schweik in the Second World War*, and the aprioristical and monochromatic aspect of rationalism, still to be found in a play like *The Days of the Commune* (both these plays, however, were left unfinished, and have to be considered as first versions only). The open-end character of Brecht's aesthetics led to a methodology of experiment or 'essays', and he accordingly called all his works after 1928 *Versuche*. (What he meant by this is perhaps clearest if one looks at the successively richer versions of *The Life of Galileo*.)

To man on the stage and the artistic representation of his relations to his fellow men, Brecht's mature aesthetic vision says at the same time 'yes' and 'no'. It says 'yes' to him as human potential, looking back at him from the vantage point of the future; from the same point, it says 'no' to him as *homo duplex*, a cleftman of this specific perverted time. All of his plays might borrow the title of one: *Der Jasager und der Neinsager*, *He Who Says Yes and He Who Says No*. They were always strategies of de-alienation, of a striving towards an inte-

grated mankind, of man concerned with what Brecht called the greatest art – the art of living. Free aesthetics finally found its foundation in firm ethics; and the demand for cognition as an ethical imperative led to the recognition that theatre art 'has to remain something wholly superfluous, which, to be sure, means then that one in fact lives for the superfluous' (*Organon*, *SzT*, VII. 10–11). Judge and Wise Fool thus met with the Princely Child: the German Chalk Circle closed.

The Intellectual Physiognomy of Literary Characters

Those who are awake have a world in common, but every sleeper has a world of his own.

HERACLITUS

I

Plato's *Symposium* owes its influence throughout the centuries not to its ideas alone. The unfading freshness of this dialogue, in contrast to many others in which Plato outlined features of his system that were at least as important, is produced by the fact that a number of famous men – Socrates, Alcibiades, Aristophanes and many others – stand before us as living individuals, that this dialogue gives us not only ideas but living characters whose feelings we can share. To what is the vitality of these people due?

Plato is a great artist who was able to depict the appearance,

GEORG LUKÁCS, a distinguished Hungarian Marxist aesthetician and philosopher, was born in 1885 and died in June 1971. He was Minister of Culture in two brief revolutionary governments in Hungary (1919 and 1956). His books translated into English include the seminal *History and Class Consciousness*, *Lenin*, *Goethe and His Age*, *Realism in Our Time*, *The Historical Novel*, *Essays on Thomas Mann*, and *Studies in European Realism*. To be consulted are G. H. R. Parkinson, ed., *Georg Lukács: The Man, His Work and His Ideas*, and George Lichtheim, *Georg Lukács*. A checklist of Lukács's translated articles appears in Baxandall, *Marxism and Aesthetics: A Bibliography*.

surroundings, etc. of his figures with genuinely Greek plasticity. But this art of portraying the exterior of persons and their external surroundings is present in many other dialogues of Plato, without making these people come to life. And many imitators of the Platonic dialogues have attempted this without achieving even a trace of the vitality.

It seems to me that the vitality of the persons in the *Symposium* lies altogether elsewhere. The vivid trueness to life of men and surroundings is of course a necessary accessory, but by no means the decisive instrument of creative portrayal.

On the contrary, Plato's creative activity makes the varied thoughts of his characters, their different attitudes to the same problem: what is love? a personal characteristic, the deepest and most vital characteristic of his persons. The thoughts of the individual are not abstract and general results, but the whole personality of each one is concentrated in the thinking process, in the clarifying of this problem and thinking it out to the end. This quintessence arising before us, this way of thinking, enables Plato to make the way in which each of his characters approaches the problem, what he assumes as an axiom not requiring proof, what he proves and how he proves it, the abstract heights that his thinking reaches, the source of his concrete examples, what he ignores or omits, and how he does it, appear as the profound characteristic property of each and every one of them. A number of living persons stand before us, marked and unforgettable in their human individuality – and yet all these people are characterized, differentiated and made individuals who also represent types by their intellectual physiognomy alone.

This, of course, is an extreme case in world literature, but not an isolated case. Take Diderot's *Rameau's Nephew* or Balzac's *Unknown Masterpiece*. There too, the personages are individualized by their living, personal attitude to abstract problems; intellectual physiognomy is again the chief medium for portraying the living personality.

These extreme cases throw light upon a problem of literary creativeness that has been rarely dealt with and yet is of great importance at the present time.

The great masterpieces of world literature always characterize the intellectual physiognomy of their characters very carefully. And the decline of literature is always expressed – possibly most strikingly in the modern age – in the blurring of intellectual physiognomy, the deliberate neglect or inability of the writer to pose and solve this problem creatively.

In all great writing it is indispensable that its characters be depicted in all-sided interdependence with each other, with their social existence, and with the great problems of this existence. The more deeply these relations are grasped, the more diversely these interconnections are developed, the greater the writing becomes, for the closer it comes to the actual richness of life, to the 'cunning' of the real process of development, of which Lenin so often speaks.

Everyone who is not hampered by decadent-bourgeois or vulgarized sociological prejudices will easily understand that the ability of literary characters to express their *Weltanschauung* in ideas constitutes a necessary and important element of the artistic reproduction of reality.

A description that does not include the *Weltanschauung* of the created characters cannot be complete. *Weltanschauung* is the highest form of consciousness; hence if the writer ignores it he blurs the most important thing in the figure he has in mind. *Weltanschauung* is a profound personal experience of each and every person, an extremely characteristic expression of his inward nature, and it likewise reflects in a very significant fashion the general problems of his age.

At this point some obvious misunderstandings with regard to intellectual physiognomy must be cleared up. First of all, the intellectual physiognomy of literary characters does not mean that their opinions are always correct, that their personal *Weltanschauung* is a correct reflection of objective reality.

Tolstoy is one of the greatest of artists in the portrayal of intellectual physiognomy. But take a figure with as marked an intellectual physiognomy as Constantine Levin, when is he right? Strictly speaking, never. And Tolstoy portrays his favourite in the wrong with merciless accuracy. Take for example Levin's discussions with his brother or with Oblonsky. Tolstoy skilfully depicts the changes in Levin's views, his erratic thinking, his sudden jumps from one extreme to another. But it is just these continual and sudden changes that reveal the unity of Levin's intellectual physiognomy: the way in which he adopts different contradictory opinions. The peculiar form that these opinions take on in his mind is always the same; it is always Constantine Levin's own way of thinking and experiencing the universe. And nevertheless this personal unity is never something that remains confined to the personality alone; in just this personal form, with all the objective incorrectness of the individual ideas, there is something that is universally valid.

The second misunderstanding that might possibly arise here is the idea that complete portrayal of intellectual physiognomy involves an abstract intellectuality. Justifiable opposition to naturalist superficiality often leads to such conclusions.

In such a controversy André Gide set up Racine's *Mithridate* as an unapproachable model, especially the king's discussion with his sons regarding their fighting Rome or surrendering to it. Gide says, 'True enough, fathers and sons have never been able to speak to one another thus – and nevertheless (or just because of this) all fathers and all sons will recognize themselves in this scene.' It follows that the abstract intellectuality of Racine or of Schiller is the most suitable form for expressing intellectual physiognomy. We believe that is not so. Compare Racine's king and his sons with any of Shakespeare's heroes with contrasting *Weltanschauung*, say Brutus and Cassius. Or compare the *Weltanschauung* differences between Schiller's Wallenstein, Octavio and Max Piccolomini with those between

Egmont and Orange in Goethe. We feel that no one will deny there is not merely a greater sensual vitality of the characters in Shakespeare and Goethe, but clearer and more pronounced contours of intellectual physiognomy as well.

The reason for this is not hard to find. The artistically portrayed connections between the *Weltanschauung* and the personal existence of the characters are much simpler, more direct, stiffer and poorer in Schiller and Racine than in Shakespeare or Goethe. Gide is quite right in opposing banal and superficial 'naturalness' and advocating a poetry of the general. But in Racine or Schiller this generality is too direct; Schiller's characters are simply 'mouthpieces of the *Zeitgeist*', as Marx says.

Take the discussion between the king and his sons so praised by Gide. In a wonderfully nuanced, fine and sententious language the pros and contras of the attitude towards Rome are weighed in three great speeches. But how these attitudes grow out of the personal life of the characters, by what experiences and happenings the concrete arguments and their grouping together have been determined, remains a secret. The sole humanly personal action that takes place in this tragedy, the love of the king and his two sons for the same woman, is only very loosely, very externally tied up with this discussion. Hence the intellectual dispute remains hanging in the air; it has no root in the human passions of the characters and therefore cannot lend them any intellectual physiognomy.

Take by way of contrast one of the many examples of Shakespeare's art of characterization. Brutus is a Stoic, Cassius an Epicurean. But how deeply is Brutus' Stoicism ingrained in all his life! His wife, Portia, is Cato's daughter, and their whole relationship is – unexpressed though it be – pervaded by Roman Stoic emotional and intellectual elements. The purely idealistic, naïvely confiding behaviour of Brutus and his deliberately unadorned form of speech, avoiding all rhetorical ornamentation, is so typically characteristic of the special nature of his Stoicism. The same holds true of Cassius' Epicureanism. I should like

to point out one extraordinarily fine and profound detail: when the tragic collapse of their revolt is already apparent, when all indications point to the collapse of the last republican uprising, Cassius, who is strong and unyielding because of his Epicureanism, forsakes his Epicurean atheism and begins to believe in omens and prophecies, which Epicurus had always ridiculed.

This is only one feature of the Shakespearean method of portraying intellectual physiognomy, but by no means an exhaustive characterization of Brutus and Cassius. And what an abundance of traits, what a complicated interweaving of the most intimate personal life with the great problems of social affairs! Contrast this with a direct, straight-line connection of the individual with the abstract general in Racine, mediated by nothing at all. The richness and the vitality of Shakespeare's creativeness and the abstractness of Racine's poetry have always been acknowledged but the philosophical conclusions have not always been sharply enough drawn from this contrast.

Here again it is a question of the artistic reflection of objective reality in all its richness and all its depth. But in reality this richness and this depth arise out of the multifold and strifeful interaction of human passions, of persons. The persons of reality do not act alongside one another but for one another or against one another, and this struggle constitutes the basis of the existence and the development of human individuality.

Plot, as the concrete epitome of such intricate interactions in human life; conflict as the basic form of such contradictory interaction; parallelism and contrast as the manifestation of the direction in which human passions act for or against one another, and so forth – all these fundamental principles of poetic composition simply mirror, with the concentration proper to poetry, the most general and necessary basic forms of human life itself.

But it is not only these forms. The general, typical pheno-

mena must at the same time be particular actions, the personal passions of definite individuals. The artist invents situations and means of expression with the aid of which he can demonstrate how these individual passions grow beyond the confines of the merely individual world.

Herein lies the secret of elevating individuality to the typical without depriving it of its individual contours, in fact by intensifying these individual contours. This concrete consciousness, like fully developed, fully intensified passion, enables the individual to unfold the abilities dormant within him, which in actual life he possesses only in a crippled form, only as a potentiality. Poetic truth in the reproduction of objective reality is based upon the fact that the only thing that is made into re-created reality is what existed in the characters as a potentiality. Poetic creativeness surpasses reality in that these dormant potentialities are allowed to develop fully.

And conversely. Created individualities' consciousness which is (at least partially) independent of these concrete potentialities of persons, which is not based upon such a rich and concrete interplay of human passions, and does not produce a new human quality solely through this intensification, as in Racine or Schiller, becomes abstract and anaemic. The created character can be significant and typical only if the artist succeeds in disclosing the manifold connections between the individual traits of his heroes and the objective general problems of his time, if the character himself experiences the most abstract problems of his time as his own individual problems that are a matter of life and death for him.

It is obvious that the created character's ability to generalize intellectually is of extraordinary importance in this connection. Generalization sinks to the level of empty abstraction only when the bond between abstract thought and the personal experiences of the character disappear, when we do not experience this bond together with him. If the artist is able to re-create these bonds in all their vitality, the fact that the work of art abounds

with ideas in no way impedes its artistic concreteness but, on the contrary, increases it.

Take *Wilhelm Meister's Apprenticeship* by Goethe. The plot of a decisive part of this great novel involves the preparations for a *Hamlet* production. Goethe attaches very little importance to the description, to the technical details of this production, which would have absorbed the interest of a Zola. The preparations are largely intellectual: they include a number of discursive and profound discussions of the characters of the various personages in *Hamlet*, Shakespeare's method of composition, epic and dramatic poetry, and so forth. And yet these discussions are never abstract in the poetic sense of the word. They are not abstract because every remark, every reply, not only contributes something essential to the subject, but at the same time reveals a new and deeper trait of the personal character of the person speaking, a trait that we would not have visualized without these discussions. Wilhelm Meister, Serlo, Aurelia, and the others reveal their most profound individual peculiarity in the way that they endeavour to handle the Shakespeare problem intellectually, as theoreticians, actors or directors. The outline of their intellectual physiognomy thus traced completes and makes tangible the re-creation of their whole individual personality.

But the portrayal of intellectual physiognomy possesses extraordinary importance from the standpoint of composition as well. André Gide, in his analysis of Dostoyevsky, points out that every great writer establishes a definite hierarchy of figures in his compositions, and that this hierarchy is not only characteristic of the social content and the *Weltanschauung* of the writer, but is also an essential means of grouping the figures from the centre to the periphery and vice versa, i.e. of composition.

We can analyse this problem only from the formal aspect at this point. A hierarchy of this sort is present in every really composed work of art. The writer gives his characters a certain 'rank', making them main characters or episodic figures.

And this formal necessity is so compelling that the reader

instinctively looks for this hierarchy in works that have not been thoroughly composed, and remains dissatisfied if the portrayal of the principal character does not correspond to the 'rank' befitting its position in the composition.

This 'rank' of the central character arises very largely out of the degree of its consciousness of its own life, out of the ability consciously to raise the personal fortuitous elements of its life to a definite level of universal validity. Shakespeare, who makes use of the parallel portrayal of similar lives in many of his mature dramas, always endows his principal characters with their 'ranks', their fitness to figure as the central character in the plot, through this ability to generalize their lives consciously. Take for example the parallels of Hamlet-Laertes and Lear-Gloucester. In both cases the hero rises above the subordinate figure because it is his deepest trait of character to do more than spontaneously experience his individual fate in the fortuitous present and react to this fate spontaneously and emotionally. The core of his personality lies rather in his striving with all his inward life beyond the merely given, in his desire to experience his individual fate in its universal aspect, in its connection with the general.

Thus a more many-sided, more pronounced, and deeper intellectual physiognomy is an essential prerequisite for a character's being able to fulfil the central role assigned it by the composition convincingly and with vitality.

Although the most clearly defined intellectual physiognomy is an indispensable prerequisite for fulfilling the central role in the composition, this figure need by no means hold correct views. From the objective standpoint Cassius is always right and Brutus wrong, Kent right and Lear wrong, Orange right and Egmont wrong. Nevertheless Brutus, Lear, and Egmont can act as the principal characters just because of their marked intellectual physiognomy. Why? Because the hierarchy discussed by us does not follow abstract intellectual standards, but is determined by the given extremely complicated problem of

the work in question. It is not the abstract contrast of true and false that concerns us. Historical situations are much too complicated and contradictory for that. The tragic heroes of history do not make fortuitous mistakes; they have no accidental defects. Their mistakes and defects are rather a necessary part of the major problems of a critical transition. For Shakespeare, Brutus, and for Goethe, Egmont, represent the pregnantly typical traits that are characteristic of the tragic clash of a definite stage, a definite kind of social conflict. If this conflict is grasped profoundly and correctly, the writer must make those individuals the principal characters in whose personal characteristics, culminating in their intellectual physiognomy, this conflict can be expressed, most visibly and adequately.

The power of thought, the capacity for abstraction, is only one of the many contrasts between the individual and the universal. In any case we have here a very important factor in real artistic production. Literary characters' capacity for awareness of self plays a major role in literature. Yet this raising of an individual's life above the merely individual can take on the most diverse forms in literature. It does not depend upon the ability of the writer alone. But in the same writer it depends upon the nature of the problem treated and the intellectual physiognomy of the character that is most suitable for the portrayal of the problem. Shakespeare's Timon elevates his fate to the abstract height of an indictment of the role of money, which decomposes and degrades human society. Othello's consciousness of his fate can only summarize the fact that the shaking of his faith in Desdemona is at the same time the shaking of all the foundations of his whole existence. But there is no fundamental difference between Othello and Timon in respect of poetic re-creation, awareness of life, the portrayal of intellectual physiognomy, and the elevation of one's own life above its merely fortuitous individual elements.

This compositional requirement of the 'rank' of the principal figures is of course more than a merely formal demand. It is,

like every real problem, a reflection of objective reality, even though not an immediate reflection. For the truly typical, purest and most extreme definitions of a social situation, of a historical-social type, and so forth, are most adequately expressed in this form of creation. This relation between compositional necessity and the reflection of objective reality is to be seen most clearly in Balzac. Balzac has portrayed an almost inconceivable abundance of figures from all the classes of bourgeois society. And he did not content himself with representing a group or stratum by one representative; he has every typical manifestation of bourgeois society represented by a whole group of figures. But within these groups Balzac always makes the most conscious figures, the most pronounced intellectual physiognomy, the central figure. Thus Vautrin as a criminal, Gobseck as a usurer, and so forth.

The portrayal of intellectual physiognomy always presupposes, therefore, an extraordinarily broad and profound, universal and human characterization of the figures. The level of thought far exceeds any commonplace potentiality, without however ever losing the character of personal expression. This presupposes, first of all, the continuous experiencing of the vital connection between the characters' personal experiences and their intellectual expression, i.e. the portrayal of thoughts as the process of life and not as its result. Moreover this presupposes a conception of the characters that makes this intellectual level appear inherently possible and necessary.

All this goes to show that the necessity for outlining intellectual physiognomy arises from the high concept of the typical. The more profoundly an epoch and its great problems are grasped by the writer, the less can his portrayal be on a commonplace level. For in everyday life the great contradictions are blunted, criss-crossed by indifferent, unrelated chance events; they never appear in their truly pure and developed form, which can make itself manifest only when every contradiction is forced to its most extreme consequences, when everything

100 Radical Perspectives in the Arts

contained within it becomes visible and apparent. The ability of great writers to create typical characters and typical situations thus goes far beyond the correct observation of everyday life. Profound knowledge of life is never confined to the observation of the commonplace.

It consists rather in the invention of such characters and situations as are wholly impossible in everyday life, but which are able to reveal the forces and tendencies whose effectiveness is blurred in everyday life at work in the bright light of the highest and purest interaction of contradictions.

In this high sense of the word Don Quixote is one of the most typical characters in world literature, and it is beyond question that such situations as the battle against the windmills are among the most typical and most successfully achieved situations that have ever been described, although a situation of this sort is impossible in everyday life. In fact, it may be said that the typical in character and in situation presupposes this extension beyond everyday reality.

Compare *Don Quixote* with the most significant endeavour ever made to translate the problems dealt with there into everyday life: Sterne's *Tristram Shandy*. We see how much less profoundly and typically these contradictions can be expressed in everyday life. (Indeed, Sterne's choosing the material of everyday life is an indication of how much less profoundly, how much more subjectively he posed the problem than Cervantes did.)

The extreme nature of typical situations arises out of the necessity for drawing the deepest and ultimate elements out of human characters, with all the contradictions contained therein. True enough, such a trend towards the extreme in character and situation is present not only in greater writers; it also arises as a romantic opposition to the prosaicness of capitalist life. But in the mere romantics the extremism of character and situation is an end in itself. It possesses a lyrical, oppositional, picturesque character. The classic realists, however, choose the extremely accentuated person and situation merely as the most suitable

means of poetic expression for portraying the typical in its highest form.

This differentiation leads us back to the problem of composition. The creation of types cannot be separated from composition itself. Considered by itself there is no type, poetically speaking. The portrayal of extreme situations and characters becomes typical only by virtue of the fact that the total context makes it clear that the extreme behaviour of a person in an extremely accentuated situation gives expression to the deepest contradictions of a definite complex of social problems. The writer's figure thus becomes typical only in comparison, in contrast to other figures, which likewise manifest other stages and manifestations of the same contradiction affecting their lives in a more or less extreme manner. Only as a result of such a very complicated, fluid and eventful process, full of extreme contradictions, is it possible to raise a figure to a really typical height. Take a figure like Hamlet, who is acknowledged to be a type. Without the contrast with Laertes, with Horatio, with Fortinbras, etc., Hamlet's typical traits could not be manifested at all. It is only by virtue of the fact that different persons display the most varied intellectual and emotional reflections of the same objective of existing contradictions in a plot that is extraordinarily rich in extreme situations that the typical in Hamlet's character can be re-created for us.

That is why the profound and energetic delineation of intellectual physiognomy plays so decisive a part in typical portrayal. The intellectual level of the hero in his consciousness of his own life is necessary primarily to mark off the extremism of the re-created situations and express the universal that underlies them, i.e., to express the manifestation of contradictions in their highest and purest level. The extreme situation itself does contain the contradictions in this highest and purest form that is poetically necessary, but the reflection of the plot's characters upon their own actions is absolutely necessary to make this available for us.

The simple, everyday, commonplace form of reflection is wholly inadequate for this. This requires the height of which we have just spoken. This height must be attained both objectively – in respect of intellectual level – and subjectively – in respect of the interlacing of reflection with the situation, the character, and the experiences of the persons in question.

When Vautrin, for example, suggests that Rastignac marry the disowned daughter of the millionaire Taillefer, while he will see to it that the millionaire's son is killed in a duel and the disowned daughter becomes the sole heir so that the two of them can share the fortune, this situation is only the point of departure for an ordinary detective story. But Rastignac's inner conflicts are the conflicts of the whole younger generation of the post-Napoleonic age. This is shown in the contrasting conversation with Bianchon. The contradictions of the society that gives rise to these problems are manifested on a very high intellectual level in the analysis of the experiences of such socially different persons as Vautrin and Viscountess Beauséant.

Goriot's fate gives Rastignac a contrasting illustration to these reflections. Only through all this does the situation, which in itself is a merely criminal one, become for us a great social tragedy. The same is true of the poetic necessity of the scene in which the mad King Lear judges his daughters during the storm on the heath. The same is true of the function of the actors' scene and the ensuing monologue on Hecuba in *Hamlet*, etc.

But the function of intellectual physiognomy in raising the extreme situation to the poetically universal, the perceptibly sensually particular, is not exhausted with this direct role. It also has an indirect function, namely to establish contact with other extreme cases in the work and to make them materially perceptible. Only thus can the total picture of a tempestuous order, of a manifested regularity of the world, be formed out of the abundance of extreme situations offered us by the great works of classical literature. This indirect function of intellectual

physiognomy appears in classical literature in the most varied forms. The contrast can be portrayed tacitly, without particular reflection, as in the contrast between the generalizations of Hamlet and the emotional-spontaneous behaviour of Laertes. But it may also be expressed directly as in Hamlet's reflections after his first meeting with Fortinbras. It may lie in the conscious realization of the parallelism of the situation and of its consequences, as in Rastignac's astonishment that Vautrin and Viscountess Beauséant think alike about society and about one's possible and necessary attitude towards it. It can constitute an uninterrupted accompanying music, an atmosphere of the whole plot, as in Goethe's *Elective Affinities*.

The feature that all these different forms have in common is again no mere formal one. Parallelism, contrast, etc., are only very generalized poetic forms of reflecting the strifeful relationship between human beings. Only because they are forms of reflecting objective reality can they be means of poetic intensification for the expression of the typical. Only because they are this can the intellectual physiognomy of the characters, accentuated with their aid, react upon character and situation and make the unity of the individual and the typical, the intensification of the individual into the intensified typical, more meaningful.

The foundation of great writing is the world in common of the 'awake', of which Heraclitus speaks, of people who struggle in society, who fight one another, act for and against one another, and do not passively react. An intellectual physiognomy cannot be created without an 'awake' consciousness of reality. It becomes blind and without contours if it merely revolves about its own subjectivity. But without intellectual physiognomy no creative figure rises to the heights where it is freed from the dull fortuitousness of everyday reality and can rise to the 'rank' of the truly typical, retaining the full vitality of its individuality.

2

In his great novel *Les Misérables*, Victor Hugo wants to show the reader the social and psychological state of Jean Valjean. He describes with extraordinary lyrical expressiveness a ship at sea from which a man has fallen overboard. The ship keeps on and gradually disappears below the horizon. The man fights with the merciless, unfeeling waves in deathlike isolation until he finally goes down, alone, desperate, hopeless. According to Victor Hugo this description characterizes the fate in society of a man who has made a mistake. The ruthlessness of the ocean waves is for Hugo a symbol of the inhumanity of the society of his time.

This description of Hugo's lyrically expresses a universal feeling of masses of people in capitalist society. The directly perceptible and experienced relationship of men to each other in the more primitive stages of society is rapidly vanishing. Man feels himself more alone, opposed to a society that grows more and more inhuman. The inhumanity of society appears to the man who is growing isolated in his own life through economic development as a cruel and fatalistic other nature. In lyrically expressing the sensation born out of this situation, Victor Hugo expresses something truly existing in the mass and is a great lyrical writer.

But the objective reality of this manifestation of capitalist society does not mean that it is objectively identical with this manifestation. The inhumanity of society is not a new nature outside of man, but the specific manifestation of the new relationships between men produced by fully developed capitalism.

Marx vividly describes the economic difference between capitalism in its initial phase and capitalism already standing on its own feet. He describes fully-developed capitalism as contrasted to the period of primary accumulation as follows: '. . . The silent compulsion of economic circumstances seals the rule of the capitalist over the worker. . . . In the ordinary course

of events the worker can be left to the "natural laws of production" . . .'

But the period of primary accumulation is not merely the history of untold acts of cruelty towards the working population. It is also the period when the feudal fetters on production and hence on human development are smashed. It is a period of the great struggle of humanity for emancipation from the feudal yoke, which begins with the Renaissance and culminates in the French Revolution. It is likewise a classical period of bourgeois culture, a classical period of philosophy, science, literature and art.

The entrance into the new, finished form of capitalist development characterized by Marx in the foregoing quotation creates new relationships between men, and hence new material, new forms, and new creative problems for literature. But the historical recognition of the necessity and progressiveness of capitalist development does not eliminate its perilous consequences for art and for the theory of art. The classical period of bourgeois ideology becomes the period of vulgarized apologetics. The focus of the class struggle shifts from the smashing of feudalism to the struggle between bourgeoisie and proletariat. Hence the period between the French Revolution and the revolutionary battles of June 1848 becomes the last great period of bourgeois literature.

The beginning of the apologetic phase of ideological development does not mean, of course, that all writers have become apologists or what is more, conscious apologists. This does not even hold true for all the theoreticians of art, although it lies in the essence of the matter that the apologetic tendencies appear more strikingly here than in literature itself.

But the beginning of the new phase cannot fail to affect every thinker or writer. The liquidation of the traditions of the heroic period, the revolutionary period of the bourgeoisie, often takes place objectively as a struggle against the prevailing apologetics. The realism of Flaubert and Zola was a struggle against the old

ideals of the bourgeoisie that had become mere phrases or decep-
tion, though this struggle differed in each of the two writers.
But objectively this struggle (even though only gradually, and
against the deliberate intentions of such great writers) meets the
apologetic tendencies of the general, ideological tendencies of
the bourgeoisie more than half-way. For what is the kernel of
all apologetics? The tendency to remain on the surface of phen-
omena, and to eliminate the deeper, essential and decisive prob-
lems from one's intellectual field of vision. Ricardo spoke
frankly and cynically of the exploitation of the worker by the
capitalist. The vulgarized economists, however, flee to the most
superficial ostensible problem of the sphere of circulation, in
order to cause production itself, as the process of producing
surplus value, to vanish from the world of economics. Similarly
the class structure of society disappears from sociology, the
class struggle from historiography, the dialectical method from
philosophy, and so forth.

In the subjective tendencies of Flaubert and Zola everyday
reality as the sole, or at least predominant subject of literature,
is an exposure of bourgeois hypocrisy. But what does this
tendency towards describing everyday reality mean for the
portrayal of the great social antagonisms and the creative pro-
cess of making us aware of them? The portrayal of everyday
reality is nothing new as a subject. Many great writers, from
Fielding to Balzac, have tried to conquer bourgeois everyday
life for great literature. The new factor in the period that
follows 1848 is that everyday reality is not merely a subject but
a limitation of literary expression to the phenomena and forms
of expression that can occur in everyday reality.

We pointed out above that the great social contradictions
tend to grow blunt in everyday reality, and only rarely can
appear in rich and many-sided form, never in their fully
developed and pure form. Proclamation of what is possible in
everyday reality as the standard of realism necessarily means,
therefore, renunciation of the portrayal of social contradictions

in their most fully developed and purest form. This new standard of realism must even limit everyday reality itself. Its necessary logical consequence is that not the rare cases of everyday reality in which the great contradictions appear as strikingly as possible are considered typical, suitable subjects, but the most commonplace form of everyday life: the average.

These tendencies which lead away from the portrayal of the great and serious social problems, culminate in the commonplace. For the commonplace is the dead result of the process of social development. For literature, placing the commonplace in the foreground turns the description of the tempestuous process of life into a description of comparatively immobile states. The plot is more and more superseded by the stringing together of such descriptions of states of things. With the development of this tendency it loses every real function in the work of literature. For its former role, drawing the deeper objective and subjective social definitions out of people and situations, has been rendered superfluous by the orientation towards the commonplace. The social definitions that are at all perceptible in the commonplace necessarily lie upon the immediately perceptible surface; they can be at once described with the methods of simple description or portrayal of everyday occurrences.

Such an everyday average as the guiding standard of production must be sharply distinguished from the great works in which everyday life merely forms the material, in which the aesthetic appearance of everyday life is employed to portray significant human types in great contexts. In modern literature we can see this antagonism in Goncharov's *Oblomov* or in any everyday tale of the Goncourts. Goncharov's total picture is more consistently drab and grey than that of the Goncourts. Superficially, the principle of plotlessness is no more energetically carried out by the former than by the latter. But in Goncharov this impression is the result of a characterization that fully conforms to the classical, based upon the rich and varied relationship of the figures to one another and to the

social basis of their existence. Oblomov's immobility is anything but a fortuitous, superficial, everyday trait. Oblomov is doubtless an extreme and consistent character, executed in the classical traditions of the predominance of one definite trait. Oblomov does nothing but lie in bed, but his story is a profoundly dramatic one. He is a social type, not in the sense of the superficial, everyday average, but in the considerably higher social and aesthetic sense. Only because of this could this figure created by the genius of Goncharov have attained such significance for Russia, and outside Russia as well.

Even Lessing pointed out the mistake of those who find no plot 'except where the lover falls at his sweetheart's feet, the princess faints, and the heroes engage in combat'. The importance of the turns in a plot depends upon the nature of the characters.

That is how Goncharov, by accentuating the typical traits of the Russian intelligentsia, can create a character who typifies and personally reproduces the most important and most universal traits of an entire epoch in his inertia and immobility. The superficially more varied lives of the characters in, say, *Madame Gervaisais*, on the other hand, are merely the succession of colourful but static descriptions of situations, in which mystified generalities (Rome as 'milieu') fatalistically tip the scales, the interaction of social forces remains unseen, and the persons always act past one another.

In this way Oblomov has a very marked intellectual physiognomy. Each of his remarks, each of his discussions with other people, reveals a typical and tragic trait of the Russian intelligentsia (and not merely the intelligentsia) under the yoke of tsarism, all at a high level of consciousness, in many-sided connection with the complicated forces of social existence. The changes in Gervaisais's *Weltanschauung*, on the other hand, remain abstract descriptions; they do not disclose the objective drama of the social processes, and therefore the heroine cannot have a personal intellectual physiognomy.

The new realism of Flaubert, Zola, and the Goncourts arises under the banner of a revolutionary regeneration of literature, of an art that really corresponds to reality. The new tendency of realism imagines that it provides a higher objectivity than any previous literature has possessed. Flaubert's struggle against objectivism in literature is common knowledge, and Zola's criticism of Balzac and Stendhal tries to prove that Balzac and Stendhal deviated from the objective portrayal of reality as it is because of their subjectivism, predilection for the romantic and the exceptional. He concludes his critique of Stendhal with the words, 'Life is simpler.' It is tacitly assumed as a matter of course that 'life' is average everyday life, which is actually simpler than the world of Stendhal or of Balzac.

The illusion of such a higher objectivity naturally arises out of the everyday, commonplace subjects and the method of portrayal corresponding to them. Portrayal of the commonplace is possible without the addition of fantasy, without the invention of peculiar situations or characters. The commonplace can be portrayed in isolation. It stands ready from the very beginning and need only be described, nor need the description reveal any new or surprising aspect of it. It does not require the complicated compositional supplementing and illuminating through contrast. Thus the illusion can very easily arise that the average is just as much an objective 'element' of social reality as say, the elements of chemistry.

The pseudo-scientific nature of modern bourgeois literature is closely related to this pseudo-objectivity of its theory and practice. Naturalism departs further and further from the living interaction of the great social contradictions, more and more setting in their stead empty sociological abstractions. And this pseudo-scientific nature assumes an increasingly agnostic character. In Flaubert the crisis of bourgeois ideals is portrayed as the collapse of all human strivings, as the bankruptcy of all scientific cognition of the world.

In Zola this pseudo-scientific agnosticism is already clearly

formulated; literature, he states, can only portray the 'how' of events but not their 'why'. And when Taine, the most important theoretician of the initial period of modern realism, endeavours to reach the real underlying foundation of society and history, he ends up with the definition of race as the ultimately existing and no longer intellectually resolvable.

Here the mystic undertones of this pseudo-objectivism come to the surface. The rigid situational structures of Taine's literary sociology resolve themselves, when we look at them more closely, into the same '*états d'âme*' as the states of society and men, say, in the Goncourts. It is no accident that the pseudo-objectivism of this literature and literary theory considers psychology to be the basic science. Taine endeavours to represent the environment as an objective factor determining the thoughts and emotions of men mechanically, in accordance with natural law. But when he begins to speak of the 'elements' of this environment he defines the essence of the State, for example, as being 'the feeling of obedience, by means of which a mass of people rally around the authority of a leader'. The unconscious apologetics of capitalism created by the sociological method here turn into clear and conscious apologetics.

The irrationalist tendencies that are often unconscious, concealed, or suppressed in the founders of modern realism become clearer and more conscious with the development of bourgeois society without eliminating the opposing tendency of pseudo-objectivity (cf. the montage fashion in post-war imperialism). This contrast between abstract pseudo-objectivity and irrationalist subjectivity is in full accord with the bourgeois attitude to life in the capitalism of the nineteenth and twentieth centuries. Especially in the period of the decline of the bourgeoisie does this antagonism appear in innumerable variants, giving rise to innumerable discussions of 'the essence of art' and aesthetic manifestoes and doctrines.

As is always the case in such situations, these contradictions are not the inventions of individual writers, but socially con-

ditioned, distorted reflections of objective reality. Here too the contradictions have not stepped out of the books into reality but have entered the books from reality. Hence this stubborn life, the difficulty in rooting out these traditions of the period of bourgeois decline.

The extreme subjectivity of modern bourgeois literature is therefore only apparently opposed to the tendency of the commonplace. The endeavours to portray the 'exceptional' man, the eccentric man, even the 'superman', that have arisen in the apparently violent struggle against naturalism remain within the magic circle of style that begins with the naturalist movement. The eccentric individual, 'isolated' from everyday reality, and the average man are two complementary poles in literature and in life.

An eccentric hero, say in Huysmans's novels, is as little in opposition to his social surroundings or other men because of great humanist goals as an average man in any everyday novel. His 'protest' against the prosaicness of capitalist reality consists merely in his mechanically doing the opposite of what the others do, in formally – almost only through rearranging the words – transforming the platitudes that they utter into empty paradoxes. His relations to other men are just as poverty-stricken as those of average men; hence his 'personality' can express itself only in empty display. It remains as abstract and without development as that of the average man; it has just as little a pronounced human physiognomy, which can develop and express itself only in practice, in the living, active relationship between men. And therefore this poverty-stricken human foundation cannot furnish a basis for the portrayal of an intellectual physiognomy. As the formal paradoxes are only inverted platitudes, the eccentric himself is only a masked philistine, an average man always standing on his head in order to be original.

Both types, the superman and the philistine, are equally empty, equally distant from the deep social conflicts, from any real historical meaning. They are pale, abstract, narrow, one-sided,

and ultimately simply inhuman phenomena. For some sort of meaning to enter them such types must be subordinated to the power of a mystifying fate. Otherwise nothing can happen in a work of literature whose hero is supposed to be a superman.

Naturalism and the opposition movements that arise on the same foundations are at bottom similar forms of composition. Both of them start with the solipsistic conception of man hopelessly isolated in inhuman society.

The lyricism of Victor Hugo's man drowning in the ocean is the typical lyricism of all modern realism. An isolated individualism (man as a closed 'psychic system') confronts a pseudo-objective, fetishist-fatalist world. This contradictory polarity of pseudo-objective fatalism and solipsistic structure of all the human 'elements' of the world can be seen in all the literature of the imperialist period. Consciously or unconsciously, it constitutes the foundation for the various types of sociology and theories of civilization. Taine's 'races', the 'classes' of vulgarized sociology transformed into 'estates', and Spengler's 'civilization circles' have the same solipsist structure as, say, the characters of Hauptmann, D'Annunzio or Maeterlinck. The 'social group' of vulgarized sociology or Spengler's 'civilization circles' can never do anything but experience or understand themselves, just as the characters created by these writers each live their own, isolated, particular life where no bridge of understanding can lead from one person to another, nor does any bridge lead from them to objective reality.

With this the individual experiencing only himself and the fatalist commonalty have brusquely isolated themselves from each other. The individual directly confronts the abstract universal. The individual is looked upon as a 'case', an 'example', and as such subsumed to the abstract universal through a fortuitous, arbitrary characteristic. This appears either as abstract-prosaic 'scientificness' or precisely this arbitrary aspect is 'poetically' emphasized. It is significant that both modes of observation can justifiably occur for one and the same

creations. Take Zola's claim to a scientific attitude as contrasted with his present effect as fantastic-mystical romanticism, as in Thomas Mann's estimate of him.

What are the consequences of this situation for the portrayal of intellectual physiognomy? It is evident that the foundations of the latter's portrayal are being more and more thoroughly, more and more consistently destroyed. Lafargue criticized Zola because the utterances of his characters are commonplace and flat compared to the brilliant content of Balzac's dialogue. And this tendency of Zola's developed far beyond Zola as time went on. Gerhart Hauptmann surpasses Zola in the humdrum flatness of his dialogue just as much as he himself was later surpassed by the flatness of the montage photostats.

This lack of spirit and of content in naturalist literature was very often criticized and an intellectual level of the characters and their utterances demanded of literature. But it is not merely a question of putting profound ideas in the mouths of the heroes of the story. The wittiest dialogue cannot take the place of the missing intellectual physiognomy of the characters. The hopelessness of such tendencies was realized by Diderot, who makes one of the figures of his *Les Bijoux indiscrets* say, 'Messieurs, instead of giving your characters wit at every opportunity, place them in a situation that endows them with wit.'

And it is just this that is destroyed by the basic tendencies of modern literature. The methods of portrayal of literature are becoming more and more refined. But this refining is limited solely to the most adequate expressions of the merely individual, the momentary and atmospheric. The philosophy and the theory of art of this age has often and clearly stated that this is the general tendency of an entire period and not a transitory literary fashion. In his commemorative book on Kant, Simmel formulates the difference between Kant's period and that of his own – imperialism – thus: in both cases individualism was the central problem of the epoch, but Kant's individualism was that of freedom, whereas modern individualism is that of uniqueness.

In the past few decades therefore, the refinement of the means of portrayal has aimed at outlining the uniqueness of the individual. The individual is to be recorded in this very uniqueness of his. Artistic fantasy is harnessed to record all the instantaneous transitory traits of the 'here and now', to use Hegel's terminology. For the modern bourgeois mind considers reality to be identical with this 'here and now' period. Everything extending beyond appears to be empty abstraction, a falsification of reality. The exclusive orientation towards the average everyday life that marked the beginnings of modern realism is becoming more and more refined technically, while on the other hand it is consolidated into a cleaving to the empiric-fortuitous, given surface of life as a matter of principle, to the fortuitous as a pattern and a model in which nothing should be changed if reality is not to be falsified. Thus the refinement of artistic technique leads to sterility; it helps to give birth to the charlatan 'profundity' of the epigones of bourgeois literature.

The old writers also proceeded from the experienced or observed fragments of life. But by resolving and moulding the immediate context of these occurrences, they arrived at the creation of the real, subtle, interdependence of the characters in the work of art, the interrelationships that make possible the real development of the characters. This transformation is most necessary precisely with respect to the deepest personal and typical traits of character, especially with respect to the elaboration of intellectual physiognomy. Taking the plot from Cinthio's story unchanged would never have enabled Shakespeare to endow Othello, taking the criminal case from Besançon would never have enabled Stendhal to endow Julien Sorel with the typifying awareness of self, the intellectual physiognomy, with the aid of which they have become the figures in world literature that they now are.

André Gide is one of the few masters of late bourgeois literature who is seriously concerned with the intellectual physiognomy of his characters, and has noteworthy and interesting

achievements in this respect. But the influence of the modern realistic attitude to reality, the too narrow approach to the 'model' conditioned by it, hampers the full development of his great talent. This compels him to confine himself to the fortuitous, the objectively not fully developed, the merely individual, and sometimes to go no further than this portrayal. But it is precisely this individual as the ultimate, this 'here and now', that is the most abstract of all, as Hegel correctly realized.

And it is obvious that this hunt for the fleeting moment, this false concreteness of the Western European literature of the twentieth century, had to turn into open abstractness. Take Maeterlinck for example, in whom all the means of expression of naturalism turned directly into a wholly abstract style of portrayal. In contemporary literature this transformation is displayed in the writer who has most strikingly chosen the literary portrayal of the most extreme detail, of the purest 'here and now', as his style – Joyce. In Joyce the personages are characterized by the description of all fleeting thoughts and feelings, all transitory associations that occur to them in their contact with the outside world, with the greatest detail and exactness. But precisely this extreme individualization annuls all individuality. For example, when Joyce for pages on end describes everything that passes through the head of his petty-bourgeois Bloom while sitting in the toilet, he creates a characterization that would fit any person at all as well as it does Bloom, just because of this extreme refinement of detail.

The case of Joyce is an extreme case, it is true. But in its extreme accentuation it illustrates the *Weltanschauung* aspect of character portrayal. The extreme subjectivism of the modern *Weltanschauung*, the growing refinement in the literary portrayal of the individual, and the growing preoccupation with the emphasis of the psychological factor lead to a dissolution of the character. Modern bourgeois thought resolves objective reality into a complex of immediate perceptions. In so doing, it dissolves the character of the person, by making the ego of man a

mere collection of such perceptions. Hofmannsthal correctly and poetically expressed this feeling when in one of his poems he called the human ego, the human character, a 'dovecote'.

Even earlier Ibsen gave this attitude toward life vivid poetic expression. His Peer Gynt, grown old, thinks over his past life, his personality, and the changes it has undergone. Peer Gynt is peeling an onion as he sits there, and compares each layer with one phase of his life, finally reaching the despairing realization that his life consists of nothing but shells without a kernel, that he has lived through a colourful series of episodes, without having a character.

In Ibsen, who was still ideologically connected with certain traditions of the revolutionary period of the bourgeoisie owing to Norway's late capitalist development, the realization of this dissolution of character is expressed in the form of despair. In Nietzsche such an estimate of literary character formation is already a matter of course. He derives character creation in literature from the superficial and incomplete knowledge of man; he considers the literary character to be merely a superficial abstraction.

Strindberg, in his theoretical utterances, goes even further. With biting contempt he characterizes the superficial form that constancy of character gives average bourgeois literature in the drama, that is, the stereotyped repetition of certain so-called characteristic terms, the exaggerated under-emphasis of certain external features. This kind of criticism is not original (Balzac always ridiculed such characterization), but it fits the ineradicable tendency in modern literature towards a merely abstract, mechanical and schematic 'unity' of character. Strindberg, on the other hand, emphasizes the factor of variety and change. In this way he dissolves character, as Joyce does later on, into a Machian 'complex of perceptions'. His real tendency is most clearly exhibited in the fact that he considers Molière's manner of typical portrayal likewise a false and abstract characterization. And in one of Hofmannsthal's imaginary dialogues he has

Balzac say that he does not believe in the existence of his characters. Hofmannsthal's imaginary Balzac says, 'My persons are nothing but litmus paper reacting red or blue; the vital, the great, the real are the acids: the powers, the fates.'

And in this theory of the complete dissolution of character the complementary pole, the mere abstract unity of character, fittingly enough is also present. In the same dialogue Hofmannsthal's Balzac says, 'In drama the characters are nothing but contrapuntal necessities.' The living unity of literary character thus dissolves into an unordered confusion of the multifold momentary on the one hand, and into an abstract unity without inner movement on the other. Here we recognize the well-known motifs of idealist epistemology.

This is a matter of tendencies and principles rather than a plus or minus of literary ability. Richness and profundity of the created characters depends upon the richness and profundity of the conception of the total social process. In real life (and not in the lyrical reflection of the surface of capitalist society) man is not an isolated being, but a social being each of whose vital manifestations is bound up through thousands of threads with other men, with the whole social process. The general tendency of modern bourgeois art leads the artist – even if he is talented – away from the essential problems of our age, the age of the great social revolution. In literature the ability to express all that is inessential – the fleeting manifestation of mere individuality – increases, and parallel with that, the great social problems are reduced to the level of banality.

Take so significant a modern writer as Dos Passos. He describes, for example, a discussion of capitalism and socialism. The place in which the discussion takes place is excellently, vigorously described. We see the steaming Italian restaurant with the spots of tomato sauce on the tablecloth, the tri-coloured remains of melted ice cream on a plate, and the like. The individual tones of the various speakers are well described. But what they say is perfect banality, the commonplace for and

against that can be heard in any philistine conversation at any place and at any time.

Pointing out this complete failure of modern writers to create intellectual physiognomy does not mean a denial of their literary mastery, their extremely highly developed literary technique. It must be asked, however: What does this technique start with and what does it aim at? What can be expressed with such a technique? The central object that this literature wants to portray, for whose adequate portrayal it has developed precisely this technique to the point of greatest virtuosity, is the unknown and unknowable man. The endeavour to portray this central object as adequately as possible changes all the means of expression as compared to former literary periods. The invention of situations, description, characterization, dialogue and the like acquire an altogether new function. It is now their task to see through the illusion that things and men are known to us – an illusion that is considered superficial – and to make us experience their sinister unknowability. Everything is veiled in a portentous fog.

> ... all these things
> are different, and the words we use
> are again different,

one of Hofmannsthal's characters says.

The chief function of dialogue thus becomes the portrayal of people talking past each other, their aloneness, their inability to come in contact with one another. Dialogue ceases to be an expression of conflict, of discussion, of people clashing with each other. The stylized form of speech evolves along these lines. Everyday speech is no longer transformed in order to raise the quintessence of men's individual pursuits to the emotionally and intellectually highest point, to exhibit the core of the relationships between the innermost personality of man and the great social problems in all their rich diversity. Instead, the transient everyday elements in speech are stylized and

intensified, with all their outward casualness: speech is made even more everyday, more transitory, more fortuitous. Attention is diverted from the words themselves, from the content of the dialogue, to what lies behind them: the lonely soul, the necessarily unavailing efforts to overcome this loneliness.

Of all modern dramatists, Strindberg is perhaps the greatest master of this kind of dialogue: he diverts the reader's attention from what is said to the secret feeling of loneliness. In *Miss Julie*, for example, he skilfully constructs this scene: the betrayed daughter of the count tries to get her father's cook (who is the former sweetheart of her lover, the lackey) to flee together with her, and fails. Strindberg displays extraordinary virtuosity in solving the problem he set himself. He expresses the hope, the tension, the collapse of hope solely in the tempo of the heroine's speech. Her partner makes no objection, but her silence reacts on the tempo of the other's speech, thus fully expressing Strindberg's aim. There is a deliberate endeavour to treat the content of the dialogue as unimportant, since what the writer is really interested in cannot be expressed in words at all. Paul Verlaine formulates this tendency succinctly in his *Art poétique*, telling the poet never to choose his words without contempt.

The idea underlying this tendency is obvious: it tries to stylize speech so as to express these ideas without any universal content.

This basic line of development remains unchanged, despite uninterrupted refutations on behalf of an 'abstract art'. For the abstractly universal is always complemented by the coarsely empirical, the narrowly commonplace and fortuitous. We are fully justified, therefore, in saying that all the media of expression of the different literary schools of the bourgeoisie of today, some of which are doubtless employed with considerable technical skill, serve only to portray the superficial phenomena of everyday life in capitalist society, doing so even more humdrumly, more fortuitously, more arbitrarily, than is the case in reality itself.

Naturally enough, this exclusive preoccupation with detail is clearly expressed in reflections upon literary activity. An exceptionally striking example is Verlaine's declaration of principles in his *Art poétique*, cited above:

> Since we want more nuance,
> No colour, nothing but nuance!

This confrontation of colour and nuance, this rejection of colour, that is, of the definitions of reality that go beyond the momentary, this reduction of the art of writing to a tangle of nuances is quite characteristic of modern literature. We get an uninterrupted vibration, a restless flickering that never comes to rest, which contains no real motion, however, but actually represents a standstill, a stationary condition.

This contradiction is the point where overemphasis of the experienced, exclusive preoccupation with the experienced, annuls the experienceability of poetic creative effort. Exaggerated proximity to the surface of life, identification of this directly experienced surface with reality itself as a matter of principle, actually deprives literature of the conditions for real experienceability.

When we hear someone speaking in real life, the first effect is the explicit content of what he says. For the listener, this content is closely related to earlier experiences and knowledge of this person, confirming or contradicting them. Moreover, in actual life the listener is very rarely merely a passive listener; listening is usually rather a part of the mutual interactions of men upon one another. Seen in this light much can directly affect the listener convincingly; intonation, gesture, facial expression, and the like can convey to us the impression of genuineness, of the sincerity of his speech.

'Recent' literature uses for its portrayals almost nothing but such impressions. It fails to realize that even the most accurate description of such characteristics, say sincerity, gives us only the results of a process unknown to us, and not the process itself.

In life, where we are ourselves a part of the process, these characteristics can act upon us directly and convincingly. In literature, where they are the bare results of a process unknown to us, it is impossible for them to take the place of portrayal of the process itself. 'Older' literature always left the surface of everyday reality in order to make the actual results of the process experienceable; 'recent' literature gives us a series of such ostensibly experienced results, which are actually dead, rigid and cannot be experienced.

Plot and situation in 'recent' literature correspond, of course, to these trends. The great situations of 'older' writing always served to clear up a state of affairs that had been confused, impenetrable and unclear up to that point. The significance of the so-called recognition scenes in Aristotle is this clarifying of a situation that had been unclear. And the great writing of the past always composed with a view to using the important nodes of the plot to clear up what had gone before and to create what was to come, with the delineation of the rich fullness of what transcends the personal in the plot as its chief problem.

'Recent' literature is unable to create such dramatic moments, at which quantity changes into quality. It does not build its compositions up in accordance with the motion of the great antagonisms in objective reality, since these antagonisms never make themselves felt to the very end in everyday life, and in life the false, even the 'untenable' situations can maintain themselves for an extraordinarily long time. The portrayal of sudden explosions and catastrophes, so popular of late, does not run contrary to such a manner of composition – on the contrary, it corroborates it. For such explosions and catastrophes are always of an irrational character, and after the irrational eruption life proceeds on its usual course.

In the old writers such explosions were episodes at most, but never a substitute for the dramatic unfolding of the actual plot. For them the turning points were the points where the friendly and hostile interactions of the characters crossed. But in books

where one person has nothing in common with another, such turning points of the plot are superfluous and impossible. Linking up this immediate surface of life with the grand social processes can be effected only abstractly. Hence the penetration of symbols and allegories into naturalist literature is no accident, but a profound necessity of style arising from social existence. Even Zola can depict the fate of his Nana and that of the Second Empire only by means of the crass symbolic contrast of Nana lying sick and forsaken in her room while the deceived and drunken mob down in the streets below cries 'To Berlin!'

Symbolist contrast and the confrontation of a number of individual 'pictures' more and more supplant the old methods of developing the composition. To an increasing extent the scheme of the composition becomes the portrayal of a lonely feeling one's way in the dark. The impossibility of explaining even a comparatively simple situation, because the characters, grown completely lonely, have lost all capacity for understanding *how* every solipsistic egoist is locked within a world of his own, is, for example, the essence of the plot in the most typical dramas of Gerhart Hauptmann (*Fuhrmann Henschel, Rosa Berndt,* etc.). This scheme is diametrically opposed to the old plot, where the unclear is made clear. In later writing the fundamental scheme of the composition throws a veil over everything, lets that which is apparently clear turn out to be impenetrably dark, ostensible clarity be exposed as superficiality, and irrational staring at impenetrably dark fate be glorified as the profundity of man. Wassermann's novel *Kasper Hauser* is perhaps the crassest example of such type of composition, such leading into the dark, but this tendency is likewise very pronounced in the later novels of Hamsun, for example.

This *Weltanschauung* has been given a paradoxical intellectual formulation in several modern philosophies, such as Scheler's 'importance of the mind', Klages's struggle of the 'soul' against the mind, and others. Literarily at any rate it results in incapacity for conscious expression, inarticulateness becoming not merely

a means of copying the commonplace everyday sameness of the surface of life, but given the function of expressing this 'profundity' in lack of knowledge of the causes and effects of human action, in resigned acceptance of the 'eternal' loneliness of man.

In full conformity with the openly irrationalist tendencies, which must become more and more widespread as imperialist development progresses, all these trends tend towards limiting the importance of the intellect, blurring and deforming the intellectual physiognomy of literary characters. As objective reality is turned into a 'complex of sensations', a chaos of immediate impressions, and the philosophical and compositional-artistic foundations of character portrayal are destroyed, the principle of clearly portrayed intellectual physiognomy must vanish from literature. This is an ineluctable process.

3

In no period in the history of the world has man's *Weltanschauung* been of such decisive practical importance as today. Around us, within us, and through us, there is taking place the greatest transformation of the social world, and this is taking place with a correct awareness of this change. We do not need to explain in detail the importance of correct foresight in this process of changing the world. The extraordinary practical importance of Marx's brilliant foresight in regard to the dictatorship of the proletariat, the stages of socialism, and the like has become the common intellectual property of millions as a result of the revolutionary practice of the proletariat and the theoretical continuation of Marxism by Lenin and Stalin. It is obvious that the role of *Weltanschauung* must be extraordinarily great in the literature of the socialist epoch, a literature that reflects the development of a new type of man. And this holds true not only for the *Weltanschauung* of the writers, but for the *Weltanschauung* of the heroes of their works as well.

The significance of actually portraying intellectual physiognomy has never been as great as in our great age.

One of the central problems of our literature is the adequate portrayal of the figure of the Bolshevik. Every Bolshevik should be a leader of the masses, in all sorts of situations and the most varied conditions of struggle and work. This requires, first of all, acquisition of the revolutionary theory of communism. But since every situation is different, and the given circumstances and people are always different, every Bolshevik must apply the doctrines of Marxism-Leninism in a special way in every situation. Thus the personality of the Bolshevik, and last but not least his intellectual personality, becomes a decisive factor in Bolshevik leadership. Comrade Stalin, in his characterization of Lenin, speaks at length of the latter's 'style of work', but how can Lenin's style of work be separated from his style of thinking, that is his personal style of thinking? Take the theoretical works of Marx, Engels, Lenin and Stalin – a unified and homogeneously developing doctrine. But within the unity of this doctrine what different personalities, great, striking, sharply delineated physiognomies as thinkers. But this holds true on a correspondingly lower level for all Bolsheviks. In the endeavour to acquire Lenin's and Stalin's style of work every real Bolshevik exhibits traits peculiar to him alone, not merely in the purely psychological sense, but intellectually as well, in the way he summarizes the experiences of his political work and how he makes concrete deductions from the general principles of Marxism.

Let us clear up at this point a bourgeois misunderstanding. The personal 'style' of Marxism in the individual Bolshevik, if he is a real Bolshevik, does not mean a deviation from Marxism. It is a widespread bourgeois prejudice that the good, the correct, in a word, the positive, is monotonous, boring and incapable of variation with personality. Only mistakes, only deviations from the correct are diverse, differentiated and personal. This prejudice is deeply rooted in the bourgeois consciousness. That is why an independent thinker in capitalist society must neces-

sarily be opposed to capitalist society and to its acknowledged dogmas. And in literary creation this view gives rise to the contradictions in the creation of a positive hero in bourgeois literature, the dominant tendency of individualizing literary characters in respect of their negative traits.

With the victory of the working class in the struggle this relationship between man and society has changed fundamentally and qualitatively. At the beginning of human history, before the rise of class society, the Homeric epics could individualize their heroes wholly positively. Achilles and Hector are both faultless heroes and yet how different, how personally different is the nature of their heroism!

Our writers face the similar task. They must learn how to individualize the new man with his positive traits.

This is closely related to the problem of the intellectual physiognomy of literary characters. Correct Marxist-Leninist thinking enables everyone, precisely because of its correctness, to express his specific personal abilities in the process of acquiring and applying general revolutionary theory. In reality there are numberless Bolsheviks, with or without a Party card, in whom we can observe a rich, developed and significant intellectual physiognomy. Only the survival of the old prejudices prevents our literature from re-creating this richness in art.

Take the Stakhanov movement. What an abundance of living, pronounced physiognomies – intellectual physiognomy. We shall never be able to portray this significant type of the life about us unless we are able to individualize its intellectual element and to relate it profoundly to personality. These mass movements represent an extraordinary development of millions of working people from mere spontaneity to consciousness. And literature has done nothing to portray the new man, no matter how faithfully it copies the last conscious result, or contrasts this result directly with the wholly unconscious point of departure. If the new man is not portrayed in the process of his development he cannot be adequately portrayed at all.

Portraying the struggle for overcoming the survivals of capitalism in economics and in the minds of men also opens a vast set of problems for literature in the portrayal of intellectual physiognomy. Literature should show how these survivals are actually overcome. On the other hand it should not close its eyes to the way in which the bourgeois survivals still alive in the thoughts of men and groups of men condemn the latter to failure and political death. Comrade Stalin spoke of the people who must fall out of the wagon when a sharp turn is made. He also often pointed out concretely how the higher development of socialism forces the class enemy to hatch out new and more refined forms of combating the building of socialism. The more complicated, concealed and refined these methods of struggle become, the more important is it to delineate the intellectual physiognomy of the class enemy in literature.

The tasks facing our literature are enormous, and the most important of them are new tasks. There is no doubt that our literature has already done very much in this respect, but the question arises whether it has already solved its central problem or at least made much of a beginning towards solving the central problem, the portrayal of the new man. Let us take what the best friends of our socialist construction among the prominent writers of the West say about this. Malraux, in his speech at the Soviet Writers' Congress (1934), criticized our literature for faithfully portraying the external facts of socialist construction, but not the ethics and the psychology of the new man. He said, 'It is not enough to photograph a great epoch for a great literature to arise. . . . The world expects of you not only the picture of what you are, but also of what goes beyond you . . .' And André Gide, in his speech at the Congress for the Defence of Culture in Paris (1935), criticized Soviet literature from a very similar point of view:

Literature does not play, or at least does not only play, the part of a mirror. Up to now the contemporary literature of the Soviet Union has confined itself almost exclusively to this role. . . . It must not stop

at this. . . . In the newer Soviet books I have seen works worthy of admiration, but no work as yet in which the new man whom Soviet life produces and whom we are awaiting has taken on corporeal form. It still shows us the struggle, the origin, the birth.

' Malraux and Gide are right in emphasizing the fact that our literature, with all its achievements, has still not furnished a fully adequate portrait of the new man. We are obliged to consider this authoritative and comradely criticism of our work.

What are the obstacles hindering our literature from portraying the new man? First of all, no doubt, the survivals of bourgeois consciousness. Our literature grew up in the environment of bourgeois culture. The harmful influence of the various tendencies of this period of decline are evident in various stages and in various forms in our theory and practice.

Let us take a few major factors of our past theories, some of which are still influential today. First the theory and practice of the so-called *Agitka* – as a reaction to bourgeois hyperindividualism and art for art's sake. But this reaction itself took place ideologically on bourgeois soil; it is only ostensibly a reaction. The abstract 'community', which is set up in opposition to bourgeois individualism, the endeavour to overcome bourgeois isolation of art from life by means of direct empiricism, remain abstract and do not lead beyond the confines of the bourgeois. Numberless examples could be cited to show how these ideas have been utilized by the reactionaries.

The same can be said of the bourgeois abstractness in the concept of society in vulgarized sociology, which is closely connected in point of epistemology with the subjectivism and relativism of recent bourgeois thought. The same is true of the theory of the 'living man'. Here too the human individuality is defined merely psychologically, narrowly subjectively, and the contrast between personality and society so characteristic of bourgeois society remains wholly intact.

Unfortunately very much of our literary practice corresponds to these theories. Many of our books are populated with

a silhouette gallery of lifeless stencils instead of with living people. And on the other hand, as an ostensible overcoming of this schematicism, there appears a private 'human' life, vigorously described, which must remain within the bourgeois horizon, however, because it is in no way organically connected with the great problems of socialist construction, with the *Weltanschauung* problems of the origin of the new man.

All this of course does not apply to the prominent representatives of socialist realism. But even in its most significant works up to now our literature still remains below our reality. Our reality is more heroic, more spiritual, more conscious, clearer, more differentiated, richer, more human and more personal than even the best works of our literature.

Our writers are realists, but they remain behind reality in richness and significance. If they do not attain to the greatness and richness of the reality depicted by them, it is not the fault of realism, but the kind of realism they employ. And this kind of realism of ours is much more deeply permeated with the traditions of the realism of the declining bourgeoisie than we realize.

We have discussed in detail how the realism of the great writers disintegrated in the course of the nineteenth century. The new realism was not a literary fashion but the necessary adaptation of literature to the falling cultural level of bourgeois life, to the bourgeoisie's unwillingness and inability to look its own reality in the face. That is why that kind of realism had to fall, in spite of all virtuosity of technique, and the culture of realism and literary culture in general had to decline.

Nor with us is the continuance of the literary traditions of the period of bourgeois decline a literary fashion. It is a part of the great complex of bourgeois survivals in the minds of men that are unavoidable in the period of transition. Overcoming them, however, is a complicated and difficult task. They can be overcome neither by vulgarized sociological labelling nor by formalist criticism. Vulgarized sociological phrases are of very little

help, especially since vulgarized sociology usually makes the most devoted obeisances to the formal perfection of contemporary Western art. In opposition to this we must not tire of disclosing and explaining the real culture of realism in a concrete historical fashion; we must point out how this culture today has changed into its diametrical opposite, the so-called virtuosity that impresses many of our writers so much.

That is why we must speak of the culture of realism in contrast to the superficiality of this virtuosity – culture in composition, characterization and so forth. A culture that is based upon a concrete sensibility for what is great in life, for the portrayal of human greatness as a reality. The classic writers of realism possessed this culture.

Different though our aims be from theirs, and different though our concrete means of portrayal therefore must be from theirs, it is only from them that we can learn in respect of this culture. For the new realism has arisen out of the destruction of human greatness by fully developed capitalism; it reproduced this process of destruction and developed means of portrayal that were adequate for its reproduction. It was historically necessary, therefore, that it reduce literary culture to a lower level.

Clinging to the commonplace arises from the lack of faith in the exceptional as a real manifestation of human greatness, which was historically unavoidable at that time. Capitalist society suppresses and cripples the abilities of man. That is why a fully developed man, such as Napoleon, evoked such admiration on the part of great writers; Goethe called him 'compendium of the world'. But poetic understanding of the exceptional as typical social reality, a literary culture of composition, the invention of situations, through which this exceptional can be truly, personally, and typically expressed in created figures, are required to portray such a fully developed man. If a Joyce were to seat Napoleon upon the toilet of the petty-bourgeois Bloom, he would emphasize merely what Napoleon and Bloom have in common.

This liking for the immediate surface of life sometimes conceals the tendency to expose the false greatness of the so-called heroism of today. But in reality this merely boils down to the undisputed rule of everyday dullness.

Confining oneself to the faithful description of a 'segment of reality' (Zola's '*coin de la nature*') likewise arises as a matter of historical necessity from the inability to grasp reality intellectually and creatively as an entity in motion. But the more faithfully it is taken as a model the more fortuitous, poorer, stiffer, simpler, and more rectilinear must every 'segment' seem than the reality to which it corresponds.

This poverty cannot be overcome by any subjective addition or Zola-esque 'temperament'. And if the Soviet writer voluntarily puts on such shackles he cannot break them even with a Bolshevik temperament, provided he has one. Only the writer in whom life is reflected as an entity in motion and not as a dead mound of fragments will portray a segment of life so that all the essential elements of the theme are present in mobile many-sided unity. Only reality in its living unity can serve him as a model for this, and not any 'segment' of reality no matter how faithfully described.

In our time Maxim Gorky is the great model of real literary culture. The revolutionary labour movement restores to him faith in the future greatness of man and fills him with clear-eyed hatred of capitalist society because of its degradation and crippling of man. This faith and this hate give his compositions their boldness: the discovery of the typical in the exceptional.

Let us take a very simple example. Nilovna, the heroine of his puritanically simple novel *Mother*, is expressly portrayed as an exceptional case. Gorky eliminates the external obstacles to her development; her husband dies at a fairly early age; he provides this development with the most favourable conditions: her son lives only for the revolutionary movement. These favourable conditions allow Nilovna to grow out of her semi-conscious condition, beaten into unconsciousness, and follow the road

from spontaneous human sympathy with the individual revolutionaries through ever clearer sympathy with the movement, culminating as a conscious revolutionary. This career, as the career of an old illiterate working man's wife of peasant descent, is no doubt an unusual one. And Gorky emphasizes the exceptional factor in this. He shows how youth is the standard-bearer of revolutionary ideas in the factory and in the suburb. The old hesitate to join the socialists, even though much pleases them. As Rybin says, 'Nilovna is perhaps the first one to follow her son along his road.' But this very exceptional element makes Nilovna's road so profoundly typical from the standpoint of all of Russia's revolutionary development – and this is a very important feature of Gorky's composition. Here the great road that was later taken by millions of workers and peasants, the typical revolutionary road of liberating the toilers, is portrayed in a profoundly individual life full of personal vigour.

This high culture of realism pervades the entire structure of the novel. The parallel and the simultaneous contrast between the development of Nilovna and that of the Rybins is done extremely well, richly and carefully balanced. The same is true of the friendship of her son and Andrei, their joint influence upon Nilovna's development, and the difference in their intellectual physiognomies which finds expression in every question, though they are both equally bound up with the revolutionary labour movement. Gorky lets his revolutionaries be wholly preoccupied with Party work, but it is by means of just this that he characterizes their personalities, from their spontaneous emotional life to their intellectual physiognomy. The labour movement forces them to approach all the problems of life, from methods of agitation to love, personally, that is, in closest devotion to the revolution. And their personalities are differentiated precisely through the personal experiencing and personal mastering of great objective social problems. Hence Gorky is faithful to the truth in a profound and great meaning of the word. But that is just why he does not let himself be limited in

his poetic expression by the petty commonplace superficial truth of everyday life. He creates situations in which this essential element can find expression freely; he creates people who are personally and socially characterized by the fact that they strive towards this essential in every situation; and he has the people speak in such a way as to make this essential as adequately apparent as possible through them.

That is why every character of Gorky's culminates in the portrayal of vivid intellectual physiognomy. Gorky is as equally great an artist in preparing for an unconscious, slow growth in a character, in the clear and true emphasis of the turning points in this growth, and in the portrayal of their becoming aware of these turning points. And he elevates each of these turning points to the highest awareness level of expression that is possible here. When Nilovna, after her son is arrested, lives with his comrades and discusses her life with them, she says in conclusion:

> Now I can say something about myself and about people, because I have begun to understand and because I can make comparisons. Before I just lived and had nothing to compare with. We all live so alike. But now I see how others live; I remember how I lived myself, and that is bitter and hard!

Both situations and expressions are deeply and poetically true. The high literary importance of such works as *Mother* is closely related to the fact that they go beyond the bourgeois approach to life both in form and in content. Only people who are very closely connected as personalities through their social activities, and no longer speak past one another but to one another can find situations in which such words can be spoken and be adequately spoken, as the words of Gorky's heroes.

This culture must be lacking in late bourgeois realism; this culture of realism is lacking in our writers up to now. But the culture of realism and the possibility of portraying intellectual physiognomy are inseparably interlinked. The tradition of

standing still in the everyday commonplace prevents our writers from portraying intellectual physiognomy in two ways. First their characters are not so designed that a truly elevated intellectual expression of the entire situation could sound on their lips as their really personal expression. Second, our situations are almost always so designed that such discussions become impossible. The stuff of life itself provides great turning points, but the writer is as yet unable to accentuate them in composition; indeed they usually dilute them.

It is typical of our literature that the decisive conversations break off at decisive points and the writers or their characters discover that what ought to be the essential part of the conversation, its actual point in a personal, social and *Weltanschauung* sense, remains unsaid; there is 'no time' for that, as they usually say. But this merely conceals the widespread tradition prevalent in modern Western literature, that fundamental discussions between people, and 'intellectualism' in their collisions, is superfluous. According to the modern bourgeois writer, such 'clever' conversations are carried on only by naïve enlighteners, Nihilists or old-fashioned littérateurs. The modern hero, writer, and reader have no time for such conversation. This is a matter of course for bourgeois literature in the period of capitalist decline. Where no turning points of development can be portrayed, there can be no need for portraying them on a higher level through awareness. But in our literature these turning points are of decisive importance.

And therefore, when our literary characters have 'no time' for this essential element, it represents merely a lack in culture of composition, no matter how much the author may be able to find a reason why the figures really had no time at that time and place in that given situation. In a composition of great compass, of real literary culture, as in Gorky, the characters always have enough time for everything that is necessary for their characterization and for working out the problem in all its richness and all its variety. This is true even when the writer

wants to emphasize the extraordinary speed with which things happen.

Unfortunately this evading of the decisive discussions in which the problem and the figures are raised to the height where they really attain the level of our reality, is a typical phenomenon. This evasion of the essential occurs very naïvely in Pogodin's very successful drama *Aristocrats*. The dramatic turning point of the whole play is the hour-long discussion between the chief of the GPU and the thief Sonia. After this conversation Sonia is a new person. This is one of the sublime features of our reality. But how much of that is re-created in the drama? It is intimated on the stage that Sonia was a stubborn thief before this conversation and is completely transformed afterwards. But Pogodin gives us nothing of the conversation itself. He simply mounts the result into his drama. In such a case reality must of course be richer and higher than literature. For such conversations actually took place in reality, really exerted a revolutionizing effect upon people and made really new people out of them. In real life this result was not presented to us, but important people gained this result in difficult struggle. It is quite understandable that the audience applauds enthusiastically at this point. But it applauds the real heroes of the White Sea Canal and not the montage result, the *deus ex machina* of the play.

Such mistakes do not always lie so naïvely obvious on the surface as here. But they are very common nevertheless. Let us take so important a work of our literature as Panferov's *Brusski* as an example. The subject of the second volume is the extraordinarily interesting and profoundly typical contrast between two phases of the struggle for communism in the village. Panferov correctly sketches the two representatives of these phases, Ognev and Shdarkin, in their typical features. But when the great clash between the two principles, the transcending of the war-communism, abstract idealist commune, comes, Panferov plans the action in such a way that a discussion between Ognev

and Shdarkin becomes impossible. First Ognev accidentally overhears some of Shdarkin's remarks about him, 'These people did their duty at the front. There we needed this – what do you call it? – this enthusiasm. . . . But now something else is necessary.' Ognev is despondent and from his despair there follows, almost suicidally, his behaviour in the defence of the dam against the ice. After Ognev has been crippled and Shdarkin takes over the commune, the latter itself feels that an objective analysis of the mistakes of the Ognev period is absolutely necessary. 'If Stepan were healthy, Cyril would tell him to his face what he thought of Brusski. But Stepan was sick . . . and Cyril respected Stepan . . . and couldn't bring himself to call the communards together and tell them out loud that they had not done things as they should have . . .'

Panferov himself feels that he has failed to make use of an important and fruitful opportunity. Of course it is possible that in actuality things happen so that such a discussion becomes impossible. But such reality is unsuited for the purposes of great literature and must be modified correspondingly, as Shakespeare changed his chronicles and Italian stories, and Balzac changed the occurrences of the life about him, for their purposes in order to be able to portray reality in its highest form precisely through this transformation.

Ognev's accident and sickness are thus typical of literarily unsolved, bad, fortuitous happenings. In any event this motivation of the main line of development contradicts the unfolding of the theme. Literature cannot avoid the portrayal of the fortuitous, of course. But the accidental in literature is something else than in everyday life. In reality millions upon millions of accidents occur, necessity crystallizing out of their sum total. In literature this extensive infinity must be concretely portrayed by making the dialectic relationship between accident and necessity apparent in a few actual cases. In literature only those accidents are permissible that emphasize and outline in a complicated and 'cunning' manner the essential features of the

plot, the problem, and the characters. If they perform this function it does not matter how crassly fortuitous they are. Take the handkerchief in *Othello*, where the crassness of the accidental events, the coarseness of Iago's intrigue, serve to underline the noble traits in the characters of Othello and Desdemona, their complete lack of suspiciousness, and so forth. Take the boldness in Tolstoy's use of the accident that brings Nehkludov together with Maslova again in a court trial, with him as a juryman and her as a defendant.

In Panferov's novel the accidental has an opposite compositional importance. It has wholly opposite consequences for the delineation of Ognev's and Shdarkin's characters, and especially for the portrayal of what is typical in them, with the aid of the clear outlining of their personal intellectual physiognomies. Here accident loses its artistically rational character and lowers the level of the work to that of the individual and pathological. The illness is merely an illness and nothing more.

There are situations, of course, in which the characters' inability to understand each other, the necessity for their talking past each other, arises from the material itself, as in Fadeyev's *Last of the Udegeis*. Here Fadeyev portrays Lena's development in the home of the capitalist Himmer. He shows how she grows emotionally closer to the revolutionary proletariat in this capitalist environment. This lonely isolation of hers necessarily involves a literary technique that is based upon the people acting and talking past each other. And even in her first approaches to the proletariat, where the workers display a justifiable suspicion of her, this method of representation is likewise justified and yields such good scenes as Lena's participation in the elections.

However, this mode of representation involves certain difficulties for the writer in the complete development of his characters. He says, 'Lena was unafraid in her thinking and honest with herself to the extreme. She never tried to hide a truth once discovered, no matter how bitter, behind any fetishes,

no matter how dear.' But Fadeyev has merely expressed the intellectual physiognomy of his principal character, and not re-created it. And in the first part of his novel he employs the same method of description in portraying the relationship between the communists, Sonia and Sergei, in their long conversation. The result of this is that the human characteristics of these figures, their personal relationship to each other, appear before us with great tenderness and living reality. But as communists they are not differentiated from each other and again have more or less blurred intellectual physiognomies.

If this weakness is manifested even in such eminent writers as Fadeyev, it is no wonder that in the minor writers, in the mere imitators, it leads to inarticulateness of expression in their heroes or, more precisely, to an inability, accentuated to the point of the absurd, to express the development of their thoughts interestingly and succinctly in conversations, discussions, etc.

All this leads unavoidably to the intellectual physiognomy of the characters losing all distinctness of feature. The negative traditions of modern bourgeois realism, insufficient artistic culture, and weakness of composition all tend to weaken the ability of characterization and render the original and artistic portrayal of the new man of socialist society more difficult.

These false traditions are most strongly expressed in the problem of relating private and public life. We have already pointed out how this antagonism dominates bourgeois literature. But socialist society posits this problem in a totally different manner. Although our writers understand this in a general way, our literature still makes but little allowance for this intimate interlinking of public and private interests, which of course does not preclude conflicts in the individual case, but on the contrary is often expressed in and through such conflicts. The bonds between the personal, private life and the public life of our literary characters very often remain accidental and are very often schematically abstract and single-tracked. That is, an

accidentally chosen feature serves to connect the two. And in very many cases the feeling of the new, the intuition of the correct relationship, exists – all that is lacking is boldness in positing the literary problem, depth of literary culture, to make a real, full-bodied portrayal out of this intuition.

Thus in Panferov's novel the human development of Cyril Shdarkin is illustrated, with a correct emotional intuition, in the development of his love affairs, his relations with three women. And we even feel that these three women actually represent three different stages in Shdarkin's human and social development, and that the beginning and end of their love affair is not fortuitous by any means in a high literary sense of the term.

But in the portrayal itself Panferov cannot overcome this fortuitousness.

It is here that the importance of portraying intellectual physiognomy comes to the fore. Why are love relationships so deeply and movingly inevitable in old literature? Because we always experience how the whole personality must be seized by this kind of love at a concrete stage of development. The love between Goethe's Werther and Lotte would never have affected us thus if Goethe had not succeeded in portraying the typical necessity of precisely this love. But this portrayal follows a very intricate path. We must get to know Werther's particular admiration for the Greeks, his attitude to Klopstock and Ossian, etc., not merely to recognize him as a type of the rebellious intelligentsia before the French Revolution, but also to see that the character and the circumstances of Lotte were precisely what young Werther had to expect from life in view of this psychology of his, this social situation, and this attitude of rebellion against society. The love of Werther and Lotte is no mere emotional eruption in the life of two young people; it is an intellectual tragedy. Here love can illuminate the most sublime and darkest features of social life with its brilliance.

Here we have the 'intellectuality' that our writers are unable to give the private lives of their characters. And that is why the

lives portrayed by them remain private, accidental, dull, spontaneous, individually limited, or simply uninteresting.

We believe that all these phenomena have their roots in the traditions of late bourgeois literature. And therefore, if one critically examines these traditions, he cannot reconcile himself to the limitations of coarse naturalism, which we have imposed on ourselves and which contradict the whole development of socialist culture in literature.

It is not simply a matter of raising the intellectual level of our literature. Much, and much that is correct has been said regarding that. What we wanted to do here was to emphasize the intellectual aspect of form itself, and its importance for mastery of composition, and character development. Genuine literary culture demands a deeper and more allied, less schematic grasp of the relationship between individual and society, as well as between individuals. Only such a culture makes it possible to be truly bold as a writer, to free oneself from the bounds of everyday life, and resolutely to confine oneself to the exceptional that is produced in such quantity by our socialist reality.

It is a good sign that very many of our writers, and particularly our readers, feel this lack. But it is not enough for the writer merely to feel this lack emotionally – he must clearly understand the *Weltanschauung* and literary foundations of this state of affairs. Ehrenburg, for example, feels that none of his positive figures measures up to the overwhelming greatness of the process of construction. But how does he intend to eliminate these mistakes up to the present? By presenting a number of representative men and lives in each case, as in *The Second Day*, in order to make quantity take the place of the missing quality as it were. But this is a useless endeavour. For if each of the ten or twelve persons linked to the process of construction are bound up with the general cause merely by a loose and abstract thread of his personal life, the summation of twelve abstractions can never yield one concrete and rich bond. And yet it must be emphasized that in Ehrenburg the 'intellectual' factor plays a

large part in the portrayal of his heroes' characters. But in these characters, unfortunately, a merely cinematographic series of pictures is substituted for the genuinely dramatic development of ideas.

Emerson once said that 'the whole man must move at once'. This is a succinct expression of the secret of great character portrayal. The character portrayal of the very great realists, Shakespeare, Goethe, and Balzac, is founded on the fact that their characters, from their physical existence to their highest thoughts, constitute a unity in motion, in motion all at once, even though moving in contradictions. This unity of the portrayed character, which is impossible without the complete portrayal of intellectual physiognomy, gives the figures of the great writers their inexhaustible richness. They stand before us as rich and many-sided as reality itself; they are always more many-sided and 'clever' than our cleverest ideas about them. The kaleidoscopic and iridescent pointillism of later literature, on the other hand, is merely a masked poverty; their characters are rapidly exhausted for us – we can always encompass them fully and exhaustively with one glance, one idea. We cannot use this pointillism, either in large or small doses, for the truly artistic reproduction of our socialist reality. Only a realism, only a culture of realism in the sense of the classics, though possessing wholly new content and new form, new characters and new ways of portraying the characters, new plots and new compositions, corresponding to the new reality, can adequately express our great reality.

In our reality the millions of the masses have awakened to life, to awareness, to conscious community for the first time in the history of the world. Our reality has left the evil dream of the isolated solipsist pseudo-personalities far behind it, economically and ideologically. It is time that our literature, too, turn with all its energy and boldness to those who are awake, that it portray their common world in the really experienced community, personal, emotional and intellectual, and that it make a

radical break with the sleep of the period of decline where each turned only to the world of his own, to his own limited, narrow and poverty-stricken interior.

Translated from the German by Leonard E. Mins 1936.

6

Carlos Fuentes **Prometheus Unbound**

Moby Dick is the tale of the struggle between Captain Ahab and
the white whale.

This terse remark may say everything and nothing about the
most extraordinary work of nineteenth-century United States
literature.

What is *Moby Dick*? It is a great sea yarn. A great piece of
reportage on the whaling industry. A great hymning of nature,
labour, and man's dignity. A great symbolic work on the human
condition. A prophecy of events impending in our time. A deep
slice across the spiritual and political grain of the United States.

But we finally shall defeat our purpose by itemizing in this
way. An accessible, imperishable work of art, *Moby Dick*
manifests its worth at every step on an infinite scale of significant
perspectives. It offers us today a multiplicity of meanings, which
may not be the same as those recognized in the novel in the past
or to be discerned in the future. We will attempt without ado to
talk about what is most plainly at the book's core – the struggle
of Ahab against Moby Dick.

CARLOS FUENTES is an outstanding Mexican novelist and essayist. His
translated novels include *Where the Air is Clean*, *Aura*, *Change of Skin*,
The Death of Artemio Cruz, and *The Good Conscience*. His great-grandfather
was a Lassallean Socialist from Darmstadt, who exiled himself under the
Bismarck régime and landed in Mexico to plant coffee in Veracruz. The son
of a career diplomat, Fuentes passed his youth in various Latin American
capitals and in Washington, D.C., and his mastery of English is complete.

It happens on the most immense, fathomless, and naked of stages: the sea. Water and meditation are always joined, as Ishmael, the narrator, says at the very outset. Melville brings us before the eternal spectacle 'and yet somehow so young'. The tradition of Homer and Camoens, authors who with Shakespeare cast the light of their language on Melville, is given continuance in this open, munificent nature imbued with a chromatic susurration. Benefactor sea, alluring route: 'There's a soft shower to leeward. Such lovely leewardings! They must lead somewhere – to something else than common land, more palmy than the palms.' But, not less, fearful and destructive sea which rises up 'like the erected crests of enraged serpents', to destroy its own children, even the most mighty whales, smashing them against rocks and shipwrecked vessels' hulks. The sea is the place of ceaseless poetical re-creation and of human assimilation, whose infinite whispering was held at his ears like two shells by Jonah, before the Lord. It is, in brief, man's mirror, before which he can discern all the world or only Narcissus' tomb.

Men go down to the sea to hunt out the whale and wrest light from its oil. Laboriously, with the patience of Job, Melville gathers exact information about the animal, how it is hunted, and its assimilation to industry aboard ship. After giving a detailed classification of whales and their historiography, he proceeds to the internal and external description of individual examples of the species. And from the particular specimens he passes to their sociology – the schools of whales, their love life, collective customs, the birth of the animal in an Indonesian lagoon. Man comes face to face with the whale in the hunt, which provides scenes of an Homeric beauty:

The red tide now poured from all sides of the monster like brooks down a hill. His tormented body rolled not in brine but in blood, which bubbled and seethed for furlongs behind in their wake. The slanting sun playing upon this crimson pond in the sea, sent back its reflection into every face, so that they all glowed to each other like red men.

The whaleboats, the technique of harpooning, the line, the securing of the whale alongside the vessel, the pursuit by the sharks, the removal on to the deck of the useful parts of the cetacean, the monster's funeral, all are handled in a rich, precise prose. The men now go to work. The thick sperm oil is drawn from the head, which hangs like a giant Holofernes from the prow. Hooks rip the oily strips from the body. The workers roll up the muslin in the sperm chamber. The refineries begin to labour between the foremast and the mainmast. The whale's remains burn in their own grease, and the ship seems a sheet of flame.

Melville writes an epic prose. But it differs from the classical epic which acclaims a martial, ethical or political virtue. His is an industrial and democratic epos which sings of the domination of nature through technique. In this new world, *areté* – nobility – is not an hierarchical convention, but arises from brotherhood among men of differing races and origins. A common work puts them all on a common footing. Indians, Tahitians, Dutchmen, Chileans, Spaniards, and North Americans make up the crew of the whaler *Pequod*, sharing the tasks of an industrial enterprise. *Areté* – this democratic nobility – Melville asserts, is to be found among captains of industry, explorers, hunters. Thus it is not accidental that in a very beautiful chapter, he compares the sea and the prairie. It was on the prairies that the epic of the United States in the nineteenth century unfolded. Bunyan, Houston, Crockett, its heroes, were just common men who possessed the gift of *areté*, in their boldness, economic vision, and capacity for organized work. They gave direction to an expanding *mestizo* population eventually made up, as in the case of the *Pequod*, of the most diverse immigrant elements.

Ishmael is the incarnation of the dignity of the working man. As a sailor, no more and no less, he goes to sea accepting his fate with clearheadedness, 'right before the mast, plumb down into the forecastle, aloft there to the royal masthead'. His

dignity consists of the freedom in his destiny, in his plain but fixed view, 'A'whaling I must.' It is a fate embraced with humour. Thinks Ishmael: 'There are certain queer times and occasions in this strange mixed affair we call life when a man takes this whole universe for a vast practical joke, though the wit thereof he but dimly discerns, and more than suspects that the joke is at nobody's expense but his own.' Humour yes, but without illusion. 'Who ain't a slave?' immediately thinks the narrator, conscious as he is at the same time of his material scarcities and of his spirit's freedom. The solution for Ishmael lies in solidarity. The early chapters describe the firm friendship struck up by the young sailor with Queequeg, the cannibal harpooner. Within a few pages Queequeg gives a practical demonstration of solidarity, by saving this insolent man from drowning only moments after he had mocked the savage. '"It's a mutual, joint-stock world, in all meridians. We cannibals must help these Christians."' The theme having been established, the great chapters concerned with collective labour become but a development *in vivo*. Let us bear this in mind, then, that it is a world built in democratic solidarity that envelops Captain Ahab and that goes with him on his mad pursuit of Moby Dick; it is a microcosm comprised of all races that allows itself to be pulled to its destruction.

The *Pequod* sails from Nantucket in New England, on a lengthy voyage which will take it across the South Atlantic, round the Cape of Good Hope, through the Indian Ocean and the Straits, to the waters of the Pacific where Moby Dick has his domain. The ship's captain wastes no time in imparting to the crew that the real aim of the voyage is not to pursue whale in the greatest possible number, but to kill Moby Dick. The demagogic fire of Ahab communicates a crusading mood to the crew. The sailors' appetites are whetted by the offer of a gold doubloon, nailed to the mainmast, to whoever should sight the white whale first. Has Ahab perverted the mission of the *Pequod*? That is what would be thought by the ship's owners, the

Captains Peleg and Bildad. In their avariciousness, these pharisaic Quakers represent the world of a superficial individualism that the whaling ship and its heterogeneous crew have left behind. Melville makes us understand that, for the likes of Peleg and Bildad, a man's religion is one thing but the practical world is something else again. Nor is this so in the sense that they practise an inner religiousness, coupled with an outer worldliness: Peleg and Bildad are not Mediterranean Catholics. They are rather Nordic Puritans, which is to say that the equation is inverted, their religiousness is external and their worldliness is internal. Thus Peleg for example has travelled from North America through the world with his Quaker's cart while preserving himself from all foreign influence: 'all his subsequent ocean life, and the sight of many unclad, lovely island creatures, round the Horn – all that had not moved this native born Quaker one single jot, had not so much as altered one angle of his vest'. These tourists of the nineteenth century, 'businessmen' who have gazed upon the world and seen nothing of it, believe themselves mandated to preach sermons to Queequeg incomprehensible to the pagan's conscience. The Polynesian is disquieting. He does not comport with the aseptic world in North America. Peleg exclaims:

'Son of darkness, I must do my duty by thee; I am part owner of this ship, and feel concerned for the souls of all its crew; if thou still clingest to thy Pagan ways, which I sadly fear, I beseech thee, remain not for aye a Belial bondsman . . . turn from the wrath to come . . . oh! goodness gracious! steer clear of the fiery pit.'

Heedless of all else, this Queequeg must be saved, brought into the world of the 'good' North Americans in spite of himself. Latin Americans are only too familiar with this admonitory style, this soulful outburst of the co-owner of the *Pequod*. Later, Melville will make fun of the blind utilitarianism of Peleg and Bildad:

'Don't stave the boats needlessly, ye harponeers; good white cedar plant is raised full three per cent. within the year. Don't forget your prayers, either. . . . Don't whale too much a' Lord's days, men, but don't miss a fair chance either, that's rejecting Heaven's good gifts. . . . If ye touch the islands, Mr Flask, beware of fornication . . .'

This admirable satire casts into relief the faults of an attitude which, eager to exonerate itself and appear blameless, would confuse the infinite with the finite, and the grace of heaven with the price of cedar planks. Nonetheless, Melville is himself guilty of the very lack of understanding that he condemns. One would believe the battles of Ayacucho and Maipu never happened. For in his version, only thanks to the generous deeds of United States whalers was 'eternal democracy' established in Peru, Bolivia, and Chile; such instances of deformed truth do not lend themselves to a prophetic accuracy.

Howsoever, Starbuck, the first mate, expresses distrust of Ahab's intentions: '. . . I came here to hunt whales, not my commander's vengeance. How many barrels will thy vengeance yield thee if thou gettest it, Captain Ahab? it will not fetch thee much in our Nantucket market.' Yet Ahab's fire is not to be quenched by Starbuck's pragmatism so deficient in moral force. Void as it is of an integrative content, the virtue of Starbuck is as irresponsible as is Flask's mediocrity or Stubb's sportive indifference. His convictions are those of a good person, and he has a deepgoing common sense; and nevertheless he lets himself be led toward vengeance and death by Ahab. Starbuck points a musket at the sleeping head of Ahab one night. Yet he is an irresolute Brutus when confronting the North American Caesar. 'But is there no other way? no lawful way?' he asks of himself. Memory has pushed him toward this murder – the memory of wife, children, home. Memory stokes his desire to return to them. But the moral order is the stronger, and Starbuck desists. Ahab, on the other hand, is indifferent to morality, memory, or desire and he continues his headlong plunge toward disaster.

Not a mediocre goodness, nor selfishness, nor sensible thinking will be able to avert the tragedy.

The voyage of the *Pequod* has begun plagued by premonitions. Still moored at the dock, the ship's dire fate is foreseen by the old man Elias. For Starbuck, the Ecuadorian doubloon reflects the *writing of Balthasar*. The fanatic Gabriel forecasts disaster from the 'Jeroboam'. Queequeg orders the making of his own coffin. Like the spout of a whale, the searing steam of the forge wherein the harpoon intended for Moby Dick is being hammered shoots up into the face of Ahab. 'Wouldst thou brand me, Perth? ... Have I been but forging my own branding-iron, then?' asks the captain. The biblical allusion is unmistakable. A team of savage Parsees, with Fedallah as their chief have been smuggled aboard by Ahab and held in reserve for the hunt of the white whale. Fedallah brings all of the premonitions together when he speaks, for Ahab's ears, of ' ... a hearse and its plumes floating over the ocean with the waves for the pall-bearers ...' As predestined, Ahab destroys the quadrant. The white flame of Saint Elmo's Fire plays along the tips of the masts, and this is, at last, a sign to all. Finally the mood of the imminent tragedy comes to be focused around the madness of the jester, Pip, the Negro cabin-boy, 'the imbecile child of the sun hand in hand with the northern monomaniac, captain and master' (D. H. Lawrence). Lawrence's image is telling. The innocent, the mad Pip, is indeed the fatal companion to Ahab, the proud, the white Prometheus. And as with King Lear's jester we hear prophecy and truth from his mouth. 'Oh! Pip,' the author exclaims, 'thy wretched laugh, thy idle but unresting eye; all thy strange mummeries not unmeaningfully blended with the black tragedy of the melancholy ship, and mocked it!'

Then it surges up, the enormous white whale, desired by Ahab, created by Ahab, seeking nobody but floating eternally, ubiquitous in space, immortal in time. His flank a forest of spears; his striped body stained in the tones of a shroud; his twisted jaw; his white and wrinkled forehead; his pyramidal

hump and the white, abstract, amorphous, innocent and corrupt, the immense body of a colour that contains all colours: colour without colour . . . 'this antemosaic, unsourced existence of the unspeakable terrors of the whale, which, having been before all time, must needs exist after all human ages are over'.

Still, everything – the vast stage, the microcosm that is the *Pequod*, the mood of premonition, the detailed reporting – swirls through the pages of *Moby Dick* in the manner of an ever tighter close-up on the galvanizing character of Captain Ahab. Ahab, intrepid and damned, a tragic hero, inescapably condemned, unifies and gives meaning to the work. From his first appearance, the extraordinary, almost heroic, being is revealed. 'A grand, ungodly, godlike man.' The face burned, like a chunk of wood the fire has found itself unable to consume. The thin, livid mark traversing it; grey hair; ivory leg. 'His whole high, broad form, seemed made of solid bronze, and shaped in an unalterable mould, like Cellini cast Perseus.' And more than human: 'Oh, Ahab! what shall be grand in thee, it must needs be plucked at from the skies, and dived for in the deep, and featured in the unbodied air!' Without a doubt, we have before us a personage, who, aside from all the paraphernalia of characterization, does summarize a human style, an extreme circumstance of man.

At first, Ahab seems a wilful, independent, positive man; as Emerson would say in suggesting the North American ideal, 'self-reliant'. Dependent for his actions only upon himself, this man commands a shipload of men who need each other. The comings and goings of Ahab about the vessel, his monologues, make a strange sound, as though his inner vitality were rumbling. He is a practical and competent commander, suited for his mission, used to every vicissitude of a protracted and dangerous voyage. So it is above and beyond his pragmatic task – his know-how, technical proficiency – that Ahab courses through the seas in search of Moby Dick, the whale that mutilated him. 'Sweeping his sickle-shaped lower jaw beneath him, Moby Dick

had reaped away Ahab's leg, as a mower a blade of grass in the field.' Ahab's voyage is for vengeance and hatred – a hatred and vengeance communicated with fevered lucidity to his crew: '"Drink, ye harpooneers! drink and swear, ye men that man the dreadful whaleboat's bow – Death to Moby Dick! God hunt us all, if we do not hunt Moby Dick to his death!"' Having no other propaganda than his own fiery presence, Ahab imparts a mystical and savage emotion to the crew; each sailor feels the captain's implacable hate to be his, too.

Naught can allay Ahab's thirst for revenge. Not the premonitions, not Starbuck's common sense, not the terrifying descriptions of the foe as given by crews from other ships. The will of Ahab follows only his own dictates. The individualist enterprise must achieve its extreme affirmation: the death of the white whale, of the 'other one'. What better proof can there be of the existence of the ego, than to eliminate the other-than-ego?

Who then are the antagonists? Who is Ahab? Is he – as has been said – the embodiment of the human will opposed to blind nature? Of the zeal to vanquish the irrational on the behalf of man? This would lead one to equate Ahab with good and the whale with evil; which in turn plays into the interests of Manicheism, the very basis for the captain's own policies.

'They think me mad . . .; but I'm demoniac, I am madness maddened! That wild madness that's only calm to comprehend itself! . . . I rush! Naught's an obstacle, naught's an angle to the iron way! . . . Gifted with the high perception, I lack the low, enjoying power . . . damned in the midst of Paradise!'

Ahab does confront himself in this monologue, but his desire to know is unable to overcome the intoxicated pride his individualist self-sufficiency begets in him.

Against what is this wilful action directed? What is Moby Dick? Just as Ahab is not an incarnation of good, Moby Dick does not represent evil. Melville takes care to point up the white

whale's essential ambiguity, as various as nature itself, beautiful and terrible, source of wealth and destruction, the mansion of a tame joy as well as of an unspeakable horror. Starbuck rightly says that the whale is not looking for Ahab; it is he who seeks the whale, a background upon which are projected the symptoms of his fatal illness.

All that most maddens and torments; all that stirs up the lees of things; all truth with malice in it; all that cracks and sinews and cakes the brain; all the subtle demonisms of life and thought; all evil, to crazy Ahab, were visibly personified, and made practically assailable in Moby Dick. He piled upon the whale's white hump the sum of all the general rage and hate felt by his whole race from Adam down . . .

The sickness having been revealed in the words of the man who knows, the superior being, no course is left him but to dedicate his life to its eradication. What matter if this entails the death of the prophet and of his flock? The predictions of the voices of wisdom will not be heard. Ahab? He is Gnostic, Manichean, and Puritan. He is the conjuncture of the individualistic, the anti-integrationist currents of modern times. Ahab is Calvin and Locke. He will be Hitler and McCarthy.

As a Gnostic – one gifted with a higher perception – Ahab reveals the programme for redemption: we have come into the world to kill the white whale. And if evil is an ignorance, the messenger of knowledge is good incarnate, the mediator of grace. This man who knows is likewise the predestined, the one whose salvation is *a priori*; child of God, his election makes him divine upon earth. As a Manichean, Ahab divides the world between the good and that which is evil beyond redemption; to the struggle against this designated evil he subscribes all of his strength. Be it the white whale, witches, the Jews, the Reds. . . . As a Puritan, Ahab will take upon himself the labour of God upon earth. Divine grace is insufficient if the active participation of the Gnostics or chosen ones is not enlisted, to suppress evil and assure the victory of good. And good is the very ego

that is armed with the knowledge to distinguish good from evil. And last, Ahab also is a romantic, who proposes his subjective ideal as a universal value.

In fact, the hated goal pursued so hotly is but a phantom projected by the leader's madness. As Melville writes,

> Ahab had cherished a wild vindictiveness against the whale, all the more real for that in his frantic morbidness he at last came to identify with him, not only all his bodily woes, but all his intellectual and spiritual exasperations. The white whale swam before him as the monomaniac incarnation of all those malicious agencies which some deep men feel eating in them.

We have touched the root of the question: the white whale does not exist. It is a spectre that undulates in the imagination of Ahab . . . a projection of Ahab's. It is the evil of Ahab, provided a material form so to justify his deed of hatred and of madness. It is Ahab *contra* Ahab. Precisely as Starbuck says, '. . . but let Ahab beware of Ahab; beware of thyself, old man'. The evil within the captain he has transferred on to the whale. Ahab would vindicate his pure, North American innocence. He is agent of God, enemy of evil. Ahab wants to feel himself beyond evil, and to be rid of guilt feelings, he attributes all evil to the whale.

For indeed, Ahab also is – and this is the key of keys to the North American – a Calvinist, whose very origin, whose entrance into the world he senses to have been tainted with sin. Now the man conscious of sinning has but two paths. To assume guilt and to feel thereby that he has taken on a common condition of mankind. Or to deny the guilt and to justify his innocence. His condition of sin could provide a kind of link to the world and brotherhood. But the Calvinist finds it a particular means to divide man from man. It serves to isolate each from each, through a salvation that always must be individual: *my* salvation, never *our* salvation. Here is the ethical ground where Melville has set his drama. He has brought to life in Ahab not

only the predicament of the North American, but of modern man. He presses us for a choice between the path of man's self-assertion as an individual, and that of his solidarity as a social being. Ahab takes the former.

What is the evil within Ahab, that he identified in Moby Dick? And what is its inevitable result? The evil is pride. Melville names it loudly: 'fatal pride'. Ahab's primary situation – as the captain of a whaler – suffices to alert us in this respect. The quest of Ahab is for light... for whale oil; this notwithstanding, in defiance of everything, he hunts the white leviathan. Here Melville's allusion to myth is explicit:

God help thee, old man, thy thoughts have created a creature in thee; and he whose intense thinking thus makes him a Prometheus; a vulture feeds upon that heart for ever; that vulture the very creature he creates.

Ahab is grandiose, like the god of myth he would lend a voice to man; but in so doing, he has exceeded man's limits. He knows the temptation of identifying himself with God. But this is only to be done by performing an inexorable, superhuman deed, tinged with the vengeance of the God of Calvin. He has to kill Moby Dick.

Owing to pride, this Prometheus of North America, imbued with a messianic concept ('I am the Fates' lieutenant; I act under orders,' he tells Starbuck), zealous to vindicate his purity through a fantasy of evil that reeks of his own guilt, this Prometheus who embarks with all the races beneath his sheets in the chase of his personal delirium, this Gnostic and Manichean militant, has lost his ability to distinguish between the objective world and his own ego. This is at once the authentic reality of his life and the evident result of his pride, of his transgression. Melville takes care from the earliest pages of the novel to bring forward the myth of Narcissus, who, unable to grasp 'the mild, tormenting image' he espies in the spring, plunges into it and is drowned. Narcissism – or, as it may be defined most generally,

an imbalance between the personality and the objective world – is the outcome of Ahab's pride. Melville takes care to demonstrate the attitude. Ishmael, in his lookout post, at one point in the novel feels the attraction of the vast sea which reflects, in the waves and out of the darkness, a series of minute images of him. He is seized by dizziness and is about to fall, when he recollects the difference between his own being and the world, between Ishmael and the ocean. Ahab fails to remark this difference. Pride has isolated him from the world. His world has become one of imagination feeding upon rancour. He no longer observes the real world. He has isolated the infinite within the most finite of containers, the life of a man. At the back of the mirror, he can make out naught but his own image or, darkly, the shadow of the whale that has taken possession of Ahab's individuality. With the sense that he is the world, he likewise will sense the need to dominate it. Thus hypnotized by his ego, the captain will utter this exclamation in gazing upon the symbol of the doubloon nailed to the mainmast: 'The firm tower, that is Ahab; the volcano, that is Ahab; the courageous, the undaunted, the victorious fowl, that, too, is Ahab; all are Ahab.' The self-same symbol causes the Parsee, Fedallah, to think of the fire of his rites; the Negro, Pip, to conceive the impossibility of knowledge; Ishmael, to reflect on the divisions of a dualistic world. Stubb thinks of how much tobacco the gold would purchase. But Ahab identifies only with himself.

Pride and solipsism are natural twins. From this standpoint, the novel provides a profound criticism of the individualistic and anti-social philosophies that serve, in part, as a foundation for the modern world, and for the United States in particular: Locke, Berkeley, Hume. For if reality is no more than my perception of it – if my perception defines the world, if the personal stuff of mind is the only basis of consciousness – then I am at liberty to impose my perception on everyone; I have no other guarantee of truth. Ahab thus stands upon the liberty of his ego, and he ends with transgressing the liberty of others, who

exist only because Ahab perceives them to exist. All men become in this way no more than the activity of Ahab's mental substance. In the event, Ahab may dispose of the life and death of men.

"'... and Ahab stands alone among the millions of the peopled earth, nor gods nor men his neighbours! Cold, cold – I shiver!'" So, Melville sums up the captain's pride and the punishment it incurs. Thus does *Moby Dick* acquire a resonance that places it within the richest ethical-literary tradition. The sickness of Ahab is the Greek *hubris*, the excessive pride that undoes the harmony between man and the world. For the Greeks, *hubris* was synonymous with transgression and injustice, and an antonym for *dike*, the spirit of justice and of *sophrosyne*, that spiritual stance which does not lose sight of man's limitations. If the damaging of one's fellow men is implicit in *hubris*, so is a challenge to deity. The words of Darius in Aeschylus' *The Persians* might well serve as an epigraph for *Moby Dick*:

Since, when *hubris* flowers, blindness will be the fruit, and the harvest heavy with tears. . . . Zeus does punish excessive pride with vengeance, and asks for exact accounts.

Still and all, *hubris* does raise an optimistic spirit of enterprise among the masses, writes Thucydides in *The Peloponnesian War*. Let us try out the measure of this classical wisdom within the *Moby Dick* context. Melville is the author who tears from the North American his innocence, who displays his capability for evil, pride, and transgression. But at the same time, his taste for optimistic enterprise is whetted. Can one doubt that if, for us, Ahab bodies forth a negative extreme of the human condition, nonetheless in Melville's homeland numerous readers, more 'Ahabistic' than Ahab himself, will most certainly see in this figure the splendid affirmation of individualistic values, while in the white whale they will see the symbol of some dark evil? Melville is, nevertheless, the first writer in the United States to contradict the optimism upon which the

country was founded. And we are not overlooking Poe – whose vision proved so excessively private compared to Melville's scope. These cases apart, the writer in the United States joined in the chorus of hosannahs to optimistic individualism transmitted by Emerson, Thoreau, or Whitman. To a nation described by Jefferson as the chosen of God, to the nation heady with the notion of itself as the prime mover of the future, Melville responded with the image of the excesses to which such a clustering of certitudes may lead. Power without responsibility. Pride which blinds. Substitution of false objectives, mere fetishes of the individual, for man's true goals. Sacrifice of the common good on the altar of an abstract individual liberty. Schematic reduction of the life of history to a Manichean combat between the good side (the USA) and the inevitable nemesis, the bad side (enemies of the USA). The 'loneliness of the crowd'. Inorganic atomism. Confusion of private opinion and general truth. Fundamental bewilderment before the truth of others, inasmuch as this does not confirm the North American's peculiar mode of looking upon the world . . . with the result that this truth of others is suspect and may be destroyed. Indeed, Captain Ahab remains alive in our day.

At the midpoint of the nineteenth century, the Melville book did not accord with the cosmology of the North Americans. It failed dismally. The author pursued his life, but in obscurity, and, forgotten, died the most solitary of deaths. Not until our own century, after the North American had been prodded into a bad conscience by Dos Passos, Faulkner, Dreiser, Anderson, Lewis, Beard, Veblen, and Mills, was *Moby Dick* permitted to rise from the ashes, the phoenix book of the nation that is bidding a permanent farewell to innocence.

Considering the literature of the nineteenth century, Dostoevsky is the single writer who went beyond Melville in the perception of the extreme dangers of Manichean, Gnostic, and Promethean individualism. By no accident is transgression always to the fore, and crime the profound and recurrent theme,

in the Russian's work. And by no accident is *hubris* the culture in which crime is nourished (Raskolnikov, Stavrogin, Verhovensky, Ivan Karamazov). Dostoevsky presents his transgressor as capable, at the end, of assuming his guilt and being redeemed in punishment; likewise, the purgation can always be borne partly by someone else or maybe the overall populace (Sonia, the Russian nation). But in Melville nobody assumes the burden of guilt, and the entire crew of the *Pequod* will be smashed up against the flank and the jaw of the whale, to drown beneath the vast shroud of the sea. We are all responsible to everybody for everything – that is the ethos of the Russian author. The world of *Moby Dick* lacks this great, Dostoevskian vital centre. Still, Queequeg had said no less, in his own broken tongue; and Father Mapple speaks of it in his magnificent initial sermon, where, describing the difficulties of obeying God's commandments, he states that to follow Him we must disobey ourselves. In common with the greatest spirits of the past century Melville sweeps to one side the heavy veil of positivism and of good bourgeois conscience, to open once again the way to mankind's basic questions. He is – like Marx, like Dostoevsky and Nietzsche – our contemporary.

Who steps forth from the disaster? Ishmael, he alone, conscious at once of his personal dignity and of its finiteness. Ishmael, the opposite number to Ahab's demoniac pride. Ishmael the voice of solidarity. He is picked up clutching on to the floating coffin of Queequeg, by the *Raquel* which, in zealous search for the sons of shipwreck, 'only found another orphan'. To the darkening necessity that impels Ahab, Ishmael opposes three strands of human liberty – chance, free will, and necessity – which, far from proving contradictory, interbraid. Ishmael's friendship with the savage Queequeg, arising in daily work, opposes to the captain's self-sufficient individualism the supreme good of solidarity: here is the capacity to share the vicissitudes of man's precarious condition with others. The intelligence of Ahab is too piercing to have overlooked this fact.

The innominate whale having splintered his ivory leg, the proud captain has no choice but to rely upon the ship's carpenter, and he exclaims: 'Oh, Life! Here I am, proud as a Greek god, and yet standing debtor to this block-head for a bone to stand on! Cursed be that mortal inter-debtedness which will not do away with ledgers!' Still, pride blocks the intelligence from functioning appropriately. The *hubris* of Ahab manufactures but contempt for man, the captain believing that the constituent condition of mankind lies in sordidness. The destroyer of the great North American dream of brotherhood is – Ahab.

At the last Ahab's pride takes on a fixedly demoniacal cast. In forging the harpoon meant for Moby Dick the trio of pagan harponeers, at the behest of Ahab, open their veins to baptize the iron in their blood. His sacramental words: '*Ego non baptiso te in nomine patris, sed in nomine diaboli.*'

Melville confronts us with his dilemma. Choose – the author of *Moby Dick* says to us. Choose between yourself and your brothers. The first path, draped with seeming egoistic gratification, will conduce you to irreality, to a dispersion of the world and of yourself. The second leads toward genuine salvation from your precarious state, toward recognition of the world and of men, to your reliance upon them and to theirs upon you. This is the double watershed that life holds. Choose. This is the dividing equator upon the gold doubloon.

This is the story of Captain Ahab's struggle against Moby Dick, the white whale.

7

Arnold Kettle

The Progressive Tradition in Bourgeois Culture

I want to take as my texts two very pregnant sentences: (i) that famous statement of Lenin's: 'There is no Chinese wall between the bourgeois-democratic revolution and the socialist revolution', and (ii) a remark of Gorky's in his speech to the First Congress of the All-Union Association of Soviet Writers: 'There is every reason to hope that when Marxists will have written a history of culture, we shall see that the part played by the bourgeoisie in the creation of culture has been greatly overestimated, especially in the sphere of literature.'

It is about literature, primarily, that I want to speak. What does Gorky mean in the remark I have just quoted? Does he imply that the culture of the last four hundred years – the period of bourgeois ascendancy in the history of human society – will turn out to have been greatly overestimated? No, I do not think so. Nor does he mean that Shakespeare and Milton, Goethe and Heine, Balzac and Tolstoy and the other great writers of the bourgeois period, are not, after all, such great writers as has been assumed.

What Gorky is calling into question is the view that what

ARNOLD KETTLE, after many years at the University of Leeds, is now Professor of English at the newly organized Open University in England. He recently taught at the University of Dar-es-Salaam, Tanzania. Dr Kettle has written widely on fiction; *An Introduction to the English Novel* is his best-known work. He is a prominent member of the Communist Party of Great Britain.

gives the great art of the bourgeois period its long-term value is some specifically *bourgeois* quality, a specifically *bourgeois* contribution: the view, for instance, that Milton is a great writer because he is 'a representative of the bourgeoisie'.

I think this question is important, for a number of reasons. It raises, in the first place, some interesting *theoretical* problems. It raises the question of exactly what we mean when we speak, as Marxists, of culture or art as a 'reflection' of reality. Isn't 'reflection' too passive a word to indicate satisfactorily the nature and function of art?

Again, it raises the question of the relevance of the historical theory of 'progressive classes' to problems of art. Generally speaking, in our view of history, we speak of a class as being 'progressive' if it carries through a revolutionary change necessary for the further development of human society. Thus, in England in the seventeenth century, the capitalist class was 'progressive' because it carried through the necessary task of destroying feudal relationships which had become fetters on the development of the productive forces. Can the epithet 'progressive' usefully be transferred to an analysis of the art of the period?

Gorky's statement, the more one thinks about it, raises also *practical* questions which affect our day-to-day political work. On our interpretation of it depends our whole attitude to what we often too glibly refer to as 'our cultural heritage'. In precisely what sense is the culture of the past *our* culture? Upon the answer we give will depend our attitude to the defence of that heritage. Clearly we shall not defend with any great enthusiasm a culture we conceive to have little to do with our own values and aspirations. If bourgeois society can be considered progressive only in a historical sense and bourgeois culture is but a reflection of that society in a passive sense, then the defence of the culture of the past is unlikely to arouse in us any deep enthusiasm. This whole question links up with the vital political problem of the defence of our national independence – a concept

of which most of us have, in my opinion, as yet a very inadequate understanding.

Perhaps the first consideration which will help us towards a greater clarity on this subject is to recall the nature of the bourgeois revolution itself.

It was not, in the commonplace sense, a sudden revolution. England was not a feudal country one year and a bourgeois one in the following year. If we take certain dates as decisive – 1649, 1688, 1832 – it is to indicate that at these revolutionary points the bourgeois class (or sections of that class) became established as the dominant force within British society. But that does not mean that there were no other forces. The feudal landowners, for instance, remained a very important power *after* their defeat in the Civil War and their ideology remained a power too. In bourgeois society the bourgeoisie is the ruling class; but it is not the whole of society.

It is necessary to see society, to see Britain, the whole time as something changing. Struggles are always going on, even if under the surface. In class society there is *always* a social ferment, even though the casual observer (who generally turns out, incidentally, to be more closely associated with the ruling class than with the exploited) may not be aware of it. Even in periods like the Middle Ages or eighteenth-century England, which historians often refer to as static and secure, the ferment goes on. We must not forget that eighteenth-century England is the era of Swift and Hogarth, artists whose work expresses in the most violent and extreme terms an intense and bitter social ferment.

If we realize that 'society' (i.e., for our purposes at the moment, Britain) cannot adequately be described in terms of its ruling class, and that the English bourgeois revolution was itself not a sudden, simple, decisive event, we shall not expect the cultural manifestations of that revolution to be simple and static.

The first great cultural expressions of the bourgeois revolution in Europe were the painting and architecture of the Italian renaissance and the literature of Elizabethan England.

Elizabethan literature reaches its height *before* the English commercial bourgeoisie achieves political power. The Elizabethan period is one of tension, of a gathering and intense struggle between the old, feudal, landowning class and the new traders, the men who were opening up the trade routes of the world and making the towns the centre of English economic life. Elizabeth herself and the Tudor monarchs in general attempted to hold a precarious balance between these two opposing classes.

Marlowe's plays are the first great artistic expression of the class struggle of the Elizabethan period. The most obvious and striking thing about these plays is the emergence of the individualist hero. Tamburlane, who seeks limitless power, Barabas who seeks limitless wealth, Faustus who seeks limitless knowledge: they are the new men of the sixteenth century, the men who reject and despise the limits, the morals, the science, the sanctities of the medieval feudal world, and yet who break themselves against the still dominant forces – material and spiritual – of that passing society. They embody in themselves the inmost aspirations of bourgeois man.

Marlowe's plays are an interesting example of the way cultural change comes about. Marlowe takes an old *form* – the medieval morality play, crude, old-fashioned, yet in the real sense popular – and injects into it a new *content* – the clash of ideas involved in the struggle between feudal and bourgeois man. Through this injection the old form is changed, a new form is achieved. What is new in *Faustus* is the poetry, the 'mighty line', and the poetry isn't something laid on like icing, a decoration. The poetry is the expression of Marlowe's passion, the passion of the new bourgeois ideology. The poetry *is* the passion.

> Is it not passing brave to be a king
> And ride in triumph through Persepolis?

Within Tamburlane's words is an assertion of the splendour of the new nation state. The king is not merely the barbaric Asiatic khan but Shakespeare's Henry V and Gloriana herself. The national tradition is somehow taken up and enriched.

Just as Faustus' vision of Helen of Troy transforms every medieval figure of the Virgin and shatters the medieval conventions of courtly love, so does his vision of the limitless horizons of science and knowledge express the new possibilities opening up for mankind with the bourgeois revolution.

> O what a world of profit and delight
> Of power and honour and omnipotence ...

The passion behind the words bursts the bounds of the old medieval verse-forms.

Marlowe's colossal individualists are all defeated. There is a limit to his confidence in them. Yet the motive-force of passion behind the plays dominates and negates the defeat. Marlowe is a real bourgeois poet, and significantly the artistic limitations of his plays are bound up with this very fact. Their weakness lies in a certain lack of humanity. It is ideas rather than people which set alight his language.

With Shakespeare it is different. With him the inadequacy of describing the poet as 'a representative of the rising bourgeoisie' becomes clear.

For Shakespeare is not a bourgeois. Witness his attitude to Shylock. Witness those remarkable lines which Marx analysed to such effect, when Timon describes the effects of gold:

> This yellow slave
> Will knit and break religions; bless the accurs'd;
> Make the hoar leprosy ador'd; place thieves
> And give them title, knee, and approbation
> With senators on the bench ...

No bourgeois could utter such words and remain a bourgeois.

Nor is Shakespeare a 'representative of the decaying feudal

ruling class'. It is true that he sometimes reflects a nostalgic looking back to the days of feudal relationships (e.g., in *As You Like It*) and that he often emphasizes the virtues of stability, order, and degree (Ulysses in *Troilus*, the gardeners in *Richard II*); but such emphases do not mean that the positive driving-force of his plays can be described as 'feudal'. Indeed, to turn Shakespeare into an amiable reactionary is to drain the very life-blood from his plays. A 'feudal' dramatist could never let his characters talk like Hamlet with a supreme insolence of 'a king going a pilgrimage through the guts of a beggar'. Shakespeare's central subject is the killing of the king. The very core of *King Lear* is an exposure of the inadequacy of feudal concepts of kingship.

The positives in Shakespeare's work are neither the feudal values nor the bourgeois ones. Nor can they be the values of the masses – not yet a conscious class – though his attitude to the common people is more ambiguous than has sometimes been suggested. How, then, can we describe Shakespeare's positive values? I can only say that they are the values of *humanity*. Again and again at the supreme moments of emotion in the plays it is as a man or a woman – divested of ruling-class attitudes – that the chief characters have to stand or fall.

> He was a man, take him for all in all.
> I shall not look upon his like again . . .

says Hamlet of his father. Cleopatra, after the death of Antony, is approached by her women with the titles of majesty and rejects them:

> No more but e'en a woman and commanded
> By such poor passion as the maid that milks
> And does the meanest chores.

King Lear, a Tragedy, is yet a Triumph: Lear's progress from kingship to manhood, foolish and fond yet noble and serene.

There is, I know, a danger in thus formulating humanity as

the positive value behind the plays. Humanity, abstracted from actual situations, becomes an idealist conception of no validity. Humanity does not exist in the abstract; Man is always a particular man. What I mean then by humanity in this context is *man in his fullest aspirations realizable in the concrete situation of England of the sixteenth and seventeenth centuries*, remembering always that England of the sixteenth and seventeenth centuries is the England not only of the feudal landowners and the Puritan businessmen but of Sir Thomas More and Francis Bacon and the New Model Army.

This means that Shakespeare's conception of man, no less than ours, is bounded by the limitations of a historical period. This is not, of course, to debase Shakespeare, but merely to insist that he was human. Nor is it to debase him to note in his plays elements (absolutely inevitable) of defeatism or utopianism.

It does not lessen the status of *Hamlet* to point out that Hamlet cannot solve his problems. For what are Hamlet's problems? Nothing less, I would suggest, than history itself. The court of Denmark in the play is the very epitome of a Renaissance court, governed by the typical feudal/bourgeois power values. Politics are corrupt; the counters played with are the lives of men; war is a ruling-class adventure; the morals of the court are those of a refined brothel; murder is a weapon of state; the people is a 'mob' somewhere outside the palace, thought of only in terms of political expediency. All this the young man Hamlet sees. Through the profound experience of his father's murder and his mother's infidelity, a veil has been torn from the life around him. To others life merely 'seems'; to him it 'is'. He has seen the reality of the world he lives in. And because he lives about the year 1600 there is almost nothing he can do about it, except (and it is an enormous except) *express* his vision. He cannot find actions commensurate with his experience because action which would transform class society and its values was in 1600 impossible. And so there is in *Hamlet* a certain inevitable defeatism. On one level, at least, Fortinbras gets Hamlet's voice. But the

defeatism is countered all the time by honesty, by a total lack of sentimentality, a moving, humane confidence which the defeat of the hero cannot destroy.

> In my heart there was a kind of fighting
> That would not let me sleep.

Hamlet is a hero and it is the hero's function to express the inner possibilities of a situation, to express men's aspirations even when history will not, at that moment, permit their successful achievement. *(+rayedr)*

What I have just said about Shakespeare applies, I believe, to bourgeois realism in general. The great artists of the bourgeois period are all highly critical, in some way or other, of bourgeois society and its values. This criticism is not always consciously formulated and seldom has an explicitly *political* slant. What the realist artists of the bourgeois period were doing was, above all, telling the truth; telling the truth about – among other things – aspects of bourgeois life which from the class interests of the bourgeoisie are highly inconvenient, not to say seditious.

The novel – that great popular art form of recent centuries – arose precisely for the purpose of telling the truth critically about the life of the time. Cervantes was no more a bourgeois than Shakespeare; but *Don Quixote* had as its explicit purpose the destruction of certain central attitudes and ideas used by the feudal ruling class to maintain its ascendancy. Hence the welcome given by the bourgeoisie to *Don Quixote* and its immense influence. Hence, on a very different plane – both socially and ideologically – the tremendous popularity of Bunyan. It is worth remembering that the outstanding representative of the bourgeoisie in Bunyan, Mr Badman, is a villain, not a hero. Bunyan, who could not have written as he did but for the bourgeois revolution, speaks with the voice of the small, independent journeyman, the artisan (the 'Left' of the Revolution) *against* the capitalist. Once again we have expressed the paradox of art, that it can resolve imaginatively issues which cannot yet be

resolved fully in action. And we have also here the core of the paradox which Gorky was discussing: that the greatest art of the bourgeois period is the *least* bourgeois, thrown up by the bourgeois revolution but transcending it.

The word 'transcend' is dangerous, too, because it very easily acquires an idealist slant. There are few less helpful approaches to this whole question than the attitude expressed in such phrases as 'not of one time but of eternity', or 'the great artist rises above his time and expresses eternal truths'.

The artists of the bourgeois period can only transcend the view of life of the bourgeoisie in so far as they can find a standpoint – realistic and coherent – which does in fact transcend bourgeois ideology, i.e., can solve the human problems the bourgeoisie cannot solve. This standpoint we know to be that of the class-conscious working class. Until such a time as the development of the productive relations makes the formulation of the standpoint possible there are bound to be limitations to the ability of even the finest artists to produce a fully realistic art.

These limitations we can see, as we look back on history, to be isolable in particular works of art as the expression of some residue of idealism remaining in the artist's outlook. It is an idealism which takes many forms. There is, for example, the utopian tendency expressed – in their several ways – in Shakespeare's last plays, in Botticelli's painting, in Fielding's paternalism, in Rousseau's elevation of the primitive, in Shelley's anarchism. There is the idealism of religion which substitutes a mystical resolution for a materialist one; we think of Donne's poetry, of Milton's acceptance of Christian mythology, of Gerard Manley Hopkins's Catholicism. And besides these forms of idealism there are a hundred others: the pantheistic nature cult of Wordsworth, the aestheticism of Henry James, D. H. Lawrence's obsession with sex – all in their ways alternatives to a complete and balanced realism.

I should like to take one fairly detailed example of the

strength of the finest bourgeois realism and also of the nature of its limitations. Fielding's *Jonathan Wild*, written in the middle of the eighteenth century, is one of the most devastating exposures imaginable of the nature of bourgeois society. It is the story of a criminal (based on an actual case), an eighteenth-century super-spiv, the organizer of thieves and receiver of stolen property, Jonathan Wild, who lives on and – in the most precise sense – exploits the lesser fry of humdrum criminals. But Fielding's novel is in no sense an 'exposure' of criminality of the Sunday newspaper or 'crime doesn't pay' type. Fielding is interested in Wild not as a social exception, an outcast, but as a social type, a type indeed whom he does not hesitate to identify with the greatest in the land, Walpole the Prime Minister in particular. The whole point about *Jonathan Wild* is that it is a satire striking at the very heart of British eighteenth-century society. Fielding pulls no punches and his attack is often staggeringly profound:

Mankind are first properly to be considered under two grand divisions – those that use their own hands, and those who employ the hands of others. The former are the base and rabble; the latter, the genteel part of the creation. The mercantile part of the world, therefore, wisely use the term *employing hands*, and justly prefer each other as they employ more or fewer; for thus one merchant says he is greater than another, because he employs more hands.

Jonathan Wild expresses his philosophy very fully when the highwayman Bagshot expects a half share in the booty he has obtained from a robbery (Wild's part in the affair has been to tip off Bagshot of the movements of the traveller who has just won money by dishonest gambling). Bagshot, who has had all the sweat of the little enterprise, feels that he might justly be entitled to at least half-share in the profits and asks, 'Is not the labourer worthy of his hire?'

'Doubtless [says Jonathan] he is so, and your hire I shall not refuse you, which is all the labourer is entitled to, or ever enjoys. . . . It is

well said of us, the higher order of mortals, that we are born only to devour the fruits of the earth; and it may well be said of the lower class that they are born only to produce them for us. Is not the battle gained by the sweat and danger of the common soldier? Are not the honour and fruits of the victory the generals who laid the scheme? Is not the house built by the labour of the carpenter and bricklayer? Is it not built for the profit only of the architect, and for the use of the inhabitant, who could not easily have placed one brick upon another? Is not the cloth, or the silk, wrought in its form, and variegated with all the beauty of colours, by those who are forced to content themselves with the coarsest and vilest part of their work, while the profit and enjoyment of their labours fall to the share of others? . . . Why should you, who are the labourer only, the executor of my scheme, expect a share in the profit? Be advised therefore: deliver the whole booty to me, and trust to my bounty for your reward.'

When Wild, at one stage of his career, lands in Newgate jail, Fielding uses the opportunity for a brilliant satire on the party system in bourgeois politics. Wild himself becomes leader of one set of prigs (thieves), another rogue, Johnson, is the present leader of the party in power. Both sets of skalliwags play on the interests and hopes of the unfortunate debtors, who are not criminals at all, who form the majority of the population of the jail. The convicts organize an election:

Newgate was divided into parties on this occasion; the prigs on each side representing their chief or great man to be the only person by whom the affairs of Newgate could be managed with safety and advantage. The prigs had indeed very compatible interests; for whereas the supporters of Johnson, who was in possession of the plunder of Newgate, were admitted to some share under their leader, so the abettors of Wild had, on his promotion, the same views of dividing some part of the spoil among themselves. It is no wonder, therefore, they were both so warm on each side. What may seem more remarkable is that the debtors, who were entirely unconcerned with the dispute, and who were the destined plunder of both parties, should interest themselves with the utmost violence, some on behalf of Wild,

and others in favour of Johnson. So that all Newgate resounded with WILD *for ever*! JOHNSON *for ever*! And the poor debtors re-echoed the *liberties of Newgate*! which, in the cant language, signifies *plunder*, as loudly as the thieves themselves. In short, such quarrels and animosities happened between them that they seemed rather the people of two countries long at war with each other than the inhabitants of the same castle.

Wild's party at length prevailed, and he succeeded to the place and power of Johnson, whom he presently stripped of all his finery; but when it was proposed that he should sell it, and divide the money for the good of the whole, he waived that motion, saying, it was not yet time, that he should find a better opportunity, that the clothes wanted cleaning, with many other pretences; and, within two days, to the surprise of many, he appeared in them himself; for which he vouched no other apology than that they fitted him much better than they did Johnson, and that they became him in a much more elegant manner.

It seems to me absurd to describe such a writer, who pierces so deep and with such devastating wit into the lies and pretences of bourgeois society, simply as a bourgeois writer. What Fielding was saying two hundred years ago about British society has still today an urgency and a power which make *Jonathan Wild* anything but a museum-piece, a relic of the days when the bourgeoisie was a rising class. To treat it *merely* historically is therefore to do it less than justice. Like *The Communist Manifesto*, *Jonathan Wild* emerged out of history; that does not mean that it is dead.

On the other hand, of course, we must not pass over Fielding's limitations, the qualities in *Jonathan Wild* which prevent its achieving that complete realism and insight which it so nobly attempts. There are two main weaknesses in Fielding's book. The first is that while the negative, 'bad' characters – Wild and his friends – are magnificently alive and convincing, the positive, 'good' people are rather dim. Heartfree, the 'hero' of *Jonathan Wild*, the honest jeweller, is a poor sort of hero who is quite incapable of putting up an effective fight and who accepts his tribulations as god-given. This wouldn't matter if it were part

of Fielding's plan to show the honest man as indeed hopelessly corrupted by the gangsters. Then, though *Jonathan Wild* would be a depressing work it would at least be consistent. But Fielding (and it is part of his genius that he should reject a pessimistic, despairing view of life) cannot bring himself to let Jonathan win outright. Therefore the weakness of Heartfree is artistically a fault in the book. And it is bound up with another weakness, which significantly tells us just why Fielding, for all his honesty and genius, could not – living as an enlightened eighteenth-century gentleman in the England of his time – create an absolutely realistic masterpiece. Since Heartfree, the hero, is too weak to defeat Jonathan Wild, and yet Jonathan has to be defeated, a new force is introduced into the book, a *deus ex machina*, 'the good magistrate', enlightened and wise, *above the State which the novel has so ruthlessly exposed*, who manages to put things right, save Heartfree and send Wild to the gallows.

Fielding was himself an enlightened magistrate who had a good record in fighting corruption. And it is not hard to see how the *artistic* weakness of *Jonathan Wild* is bound up with the limitations of Fielding's own social position. It is pointless to say 'What a pity Fielding couldn't have gone further . . ., etc.' Fielding, like the rest of us, lived in a historical situation. He also, through his writing, helped to change that situation, which is all any man can do. This is what ultimately gives his writing its vitality and makes *Jonathan Wild* not a historical curiosity but a part of the heritage of the British people, today fighting in a very different historical situation.

One final example of what we mean by our cultural heritage: a famous poem of William Blake from the *Songs of Experience*, the poem entitled *London*:

> I wander thro' each charter'd street,
> Near where the charter'd Thames does flow,
> And mark in every face I meet
> Marks of weakness, marks of woe.

In every cry of every Man,
In every Infant's cry of fear,
In every voice, in every ban,
The mind-forg'd manacles I hear.

How the Chimney-sweeper's cry
Every black'ning Church appalls;
And the hapless Soldier's sigh
Runs in blood down Palace walls.

But most thro' midnight streets I hear
How the youthful Harlot's curse
Blasts the new-born Infant's tear,
And blights with plagues the Marriage hearse.

I find it difficult to talk about this wonderful poem, so immensely powerful that to read and think about it is, literally, almost unendurable. It is a poem written a hundred and fifty years ago but still capable today of burning its way into our consciousness. Indeed, like much of Blake's poetry, history *adds* to its power. (I believe that only after many years of socialism and communism will the full richness of this great poet come to be understood.)

The immediate, down-to-earth impact of the poem is established in the first two lines. 'Charter'd' means, of course, sold, let out by charter as a monopoly. And the whole poem is a hideous picture of what bourgeois society involves. No one has ever produced a more magnificent phrase for the power and significance of ideas than that image of the 'mind-forg'd manacles'. We talk of the battle of ideas, of the power of the ideology of a class to be a weapon – even a deadly weapon – in its hands: but it is the power of this poem that it can give a content and intensity to phrases that are often a little abstract and theoretic.

Again, the images of the chimney-sweeper and the soldier are effective not because in a general, theoretical way they link exploitation and suffering with the ruling class and its ideologists

but because the images they create are concrete, many-sided ones, as full and rich as life itself. The 'black'ning Church' – linked at once with corruption, the soot of an industrial society (the soot the chimney-sweeper is condemned to seek), the spire and the factory chimney brought together unforgettably. Blake does not say, abstractly, 'the rulers are responsible for the suffering of war': in a superb image he smears the palace walls with blood. As for the final stanza, the power here is quite overwhelming. For Blake is not saying, what anyone can easily agree with, that prostitution is bad; he is making us know that prostitution is an integral part of London – bourgeois London – and that its horror is not simply what it does to the harlot, but what it does to us. The marriage hearse: the symbol of love turned into death.

Is it a limitation of this poem that it does not 'point the way forward'? I do not think so. In a sense, of course, it does point a way out, for in making us understand more profoundly the nature of capitalism and arousing our deepest, most human indignation it organizes us spiritually, making us better able to play our part in the destruction of capitalism. To respond fully to Blake's *London* is to respond to the nature of reality and hence to come nearer to its mastery.

It is right and necessary that we should understand the limitations of the work of the great artists of the bourgeois epoch, should recognize the virtual impossibility within the framework of class society and ruling-class thinking of the achievement of a total realism. History before the achievement of socialism is, as Engels said, pre-history, with the limitations that implies.

But the men and women of pre-history cannot be brushed aside as sub-men. We must never fall into the easy, abstract temptation of adopting a patronizing attitude to the masters of bourgeois realism, any more than to the other great progressive fighters of the past. There is something insulting and essentially inhumane about treating great artists as mere pegs to hang our

judgements on. The assumption that we know the truth and they, poor creatures, were merely groping, is not one which does us or them any kind of credit. Before we glibly say 'Yes of course *we* know John Donne really meant Necessity when he says God . . .' or talk too easily about 'elements of utopianism in Botticelli' let us remember with humility that no working-class poet has yet expressed with a quarter of Donne's intensity the paradox of social giving and taking, the relation of the individual to the whole, the dialectical sense of advance through conflict; nor has any modern painter expressed with the insight of Botticelli the potentialities of what Blake called the Human Form Divine.

Let us not forget that for us it is comparatively *easy* to see the limitations of, say, Marlowe's view of life or Milton's theology. But for Shakespeare to have created *King Lear*, for Fielding to have written *Jonathan Wild*, Swift *Gulliver's Travels*, Blake the *Songs of Experience*, Emily Brontë *Wuthering Heights*, a spiritual struggle was involved, a grappling with life of almost unconceivable intensity and magnitude. Before we criticize *Hamlet* for leaving problems unsolved we must be sure that we have solved our own. What gives art its value is not the abstract correctness of its message or its conscious ideology but the concrete richness of its expression of life in its full complexity.

I stress this point not, heaven knows, to play down the work of our own artists or to belittle the possibilities of socialist realism, which like socialism itself opens out potentialities hitherto unknown to man. I stress the point because we shall not be proud of our British heritage unless we are also humble about it. And unless we are proud of it we shall not defend something which, I have tried to show, is a part of our very bones and brains and a treasure which we alone can discover and pass on to future humanity.

S. Belhassen

Aimé Césaire's
A Tempest

Aimé Césaire's *A Tempest* (*Une Tempête*), which has been
eagerly awaited, did not disappoint the audience at its world
première at the Festival of Hammamet in Tunisia. Césaire, a
black poet-playwright originally from Martinique who writes
in French, had already written two successful plays, *La Tragédie
du roi Christophe* and *Une saison au Congo* (the latter about
Lumumba), but *A Tempest* is his most ambitious undertaking
thus far. Critics had feared the worst; for only the most fool-
hardy poet would dare to rewrite one of Shakespeare's most
'difficult' plays. Fortunately, Césaire is not only foolhardy, but
immensely talented as well. The result is a play that is artisti-
cally valid in its own right, even if its language never soars in
the Shakespearean manner.

AIMÉ CÉSAIRE is a native of Martinique in the West Indies, where since
1946 he has been mayor of Fort de France and a deputy to the French
National Assembly. In the 1930s he studied at the École Normale in Paris.
He met Leopold Senghor and together they created what Césaire described
as the poetry of négritude. Possibly its foremost example is Césaire's own
Return to My Native Land (Penguin, 1969), hailed by André Breton as
'nothing less than the greatest lyrical monument of this time'. In 1956
Césaire resigned from the French Communist Party, declaring that the
colonial peoples had to 'take the initiative' in the preparation of the organiza-
tional and psychological prerequisites for emancipation. Césaire's most
recent plays are *The Tragedy of King Christophe*, *A Season in the Congo*
(about Lumumba), and *A Tempest*.
S. BELHASSEN is the journalist who interviewed Aimé Césaire.

'I believe in the mixing of all cultures,' Césaire stated before opening night. 'A great work of art such as Shakespeare's play belongs to all humanity – and, as such, it can undergo as many reinterpretations as do the myths of classical antiquity.' The chief reinterpretation here lies in the characters of Prospero and Caliban. In Césaire's *Tempest* Prospero still remains the Renaissance man who has devoted his entire life to the pursuit of knowledge. But, due to his changed circumstances upon the island to which he has been banished, he has become conscious of another kind of power as well: the power of master over slave. Basically a tyrant (his earlier search for knowledge is seen to have been merely another form of exerting control), Prospero is a man who demands that others submit to his own particular desires and goals. 'I want them both [Caliban and Ariel] to eat out of my hand like baby chicks,' he says at one moment in the new version. Facing and directly opposed to him is Caliban. It takes no great subtlety to realize that the latter character now represents the growing rebellion of the blacks, indeed of all exploited peoples throughout the world.

'I continually broke away from the original,' Césaire admits.

I was trying to 'de-mythify' the tale. To me Prospero is the complete totalitarian. I am always surprised when others consider him the wise man who 'forgives'. What is most obvious, even in Shakespeare's version, is the man's absolute will to power. Prospero is the man of cold reason, the man of methodical conquest – in other words, a portrait of the 'enlightened' European. And I see the whole play in such terms: the 'civilized' European world coming face to face for the first time with the world of primitivism and magic. Let's not hide the fact that in Europe the world of reason has inevitably led to various kinds of totalitarianism ... Caliban is the man who is still close to his beginnings, whose link with the natural world has not yet been broken. Caliban can still *participate* in a world of marvels, whereas his master can merely 'create' them through his acquired knowledge. At the same time, Caliban is also a rebel – the positive hero, in a Hegelian sense. The slave is always more important than his master – for it is the slave who makes history.

At the close of Shakespeare's play, Prospero returns to his dukedom in Italy. But, according to Césaire, such a solution smacks of a 'fairy-tale'. Césaire believes that Prospero would no longer be able to leave the island over which he had exerted so much control for more than twelve years. He would have become a prisoner of his own 'creation', Caliban. So, at the last moment in the new play, Prospero decides to remain on the island with Caliban. Why? Very simply put (the play is admittedly much more subtle than this in its motivations), Prospero and Caliban are *necessary* to each other. 'Prospero can no more live apart from Caliban than whites and blacks can exist independently in today's world,' says Césaire.

Thus, the former 'happy ending' has been replaced by a more equivocal one. There can be neither pardon on Prospero's part nor final submission on Caliban's: one has dominated the world around him, and the other will some day destroy his exploiter, unless … The play ends on this questioning note. ('I offer no solutions,' Césaire has said. 'The function of a work of art is to state a problem – and that's all.')

9

John Illo

The Misreading of Milton

One of the pleasant irritations of reading is to be aware of the long-established and well-preserved misunderstanding of a classic. The frustration of observing complacent error is tempered by the warm consciousness of superior perception. Dr Johnson pretended amazement but felt triumph as he fumbled through *Lycidas*. Mencken laconically emphasized his iconoclastic certitude when he dismissed the Greek tragedy as 'that unparalleled bore'. We smile through our annoyance as we read Tennyson or the Romantics or a hieroglyphic page of Henry James.

But a second and more sober response is to examine the causes of the consecrated misreading, to discover what distortions, what limits of its own comprehension a literary culture has perpetuated in obscuring a clear original. Part of the value of a classic lies in the learned misapprehensions that scholars reveal in teaching it.

Areopagitica has been laden with such generality and enco-

JOHN ILLO served in the South Pacific and Philippines during the Second World War. He then worked as a stage mechanic in New York City, as he put himself through an undergraduate degree at Fordham and a doctorate at Columbia University. Dr Illo has been active in the Catholic Worker movement and the Milton Society of America. He published (in the *Columbia Forum*) an analysis of the rhetoric of Malcolm X which was widely remarked. He has taught English Literature at several smaller, chiefly Roman Catholic, colleges in the Eastern United States.

mium for so many generations that its case seems closed. Although modern scholars have re-examined it with new analytic apparatus and new historical evidence, the old misconceptions remain, durable as the work itself.

In the two centuries after its publication, all misread the *Areopagitica*, Tory and Whig, rationalist, Presbyterian, Anglican, high, low, and broad. 'Unbounded liberty' for 'every sceptick in theology' to 'teach his follies', Johnson wrote of it, describing just what Milton did not propose. As Johnson reprobated, so Macaulay approved what he too had not understood. Mark Pattison, John Hales, J. R. Seeley, John Richard Green, W. E. H. Lecky, Samuel Gardiner, littérateurs and historians agreed in seeing what wasn't there, and those, like David Masson and James Russell Lowell, who seemed near an understanding, could not trust their own heterodoxy. Carlyle alone of the great Victorians might have written sympathetically of the real *Areopagitica*, grimly applauding the Regicide as 'abolition of Cobwebs', and crying out for the same fearful English oligarchy for which Milton had pleaded in 1660.

In our century, to readers educated by world war, revolution and counter-revolution, the Milton of the *Areopagitica* is still largely unknown. We still read it as an 'extreme doctrine of free printing' (John Bailey, 1914) and a call for 'complete freedom of individual interpretation and expression' (David Petegorsky, 1941, in *The New Republic*), and even Alfred North Whitehead misread and platitudinized on the work though he perceived the intolerance of its author. In the Tercentenary Symposium (1944) no one, Marxist or liberal, from J. B. S. Haldane to Herbert Read to Phyllis Bentley, had read it and understood it, and the colloquists alternately praised or disfavoured what was really an illusion. Specialist literary scholars of Milton and the Puritan Revolution, like William Haller, have seen the work without seeing it, imagining that Milton was pleading for popular liberty. Historians, whether English, like J. B. Bury writing a *History of Freedom of Thought* in 1913, or

American, like W. M. Jordan writing on *The Development of Religious Toleration in England* thirty years later, have continually interpreted the *Areopagitica* as a call for an ideal of 'freedom of thought in general' or 'complete liberty' in 'the endless search for truth'. In careful text and inspirational biography, in torturous article and petrific dissertation, the corpus of British and American Milton scholarship rests in a strange obsolescence regarding the *Areopagitica*, and demurrers are offered with diffidence. Even the massive, superannotated Yale edition of the prose (1959), which scrutinizes Milton's revolutionary purposes and explains the limits of his 'tolerationist' pamphlet, elaborately misses the point. And the perceptive analyses of the Yale editor, cautious as they are, have not been widely influential.

Popularly, the *Areopagitica* is still used by whoever wishes freedom to inquire or dissent, or asserts the principle of such a freedom. College literary clubs choose passages for their constitutions. Ad men planning promotional layout detach noble sentences. The Communist Party USA cites it. Conservative politicians quote it. And the great Cave of Learning on 42nd Street and Fifth Avenue monumentalizes one of its grand clauses, separated from and contrary to context: 'A good Booke is the precious life blood of a master spirit, imbalmed and treasur'd up on purpose to a life beyond life.' Every free man is an Areopagitic, and every one of them is wrong.

The very title is misunderstood. Milton's Areopagus was not simply a judicial forum of learned and impartial Athenians, or the place where Paul converted Dionysius. The Areopagus, originally a criminal court, had become, by the time of Aeschylus, the office of Big Brother, with power to examine and regulate public and private morality and behaviour, to supervise the life of every Athenian, even in advance of suspected intemperance. It was this chilling function, abolished in the middle of the fifth century, that Isocrates later desiderated in the pamphlet-oration that gave Milton his title, a universal perplexity for

Milton scholarship. The Yale editor thinks Milton's choice of title 'curious', and then putters through St Paul to explain it. Other critics note the apparent contrast between the puritan Isocrates and the Attic Milton, and wonder.

That Milton's title was not a curious ironic contrary to Isocrates' is apparent from the *narratio* of the English speech. There was censorship in Athens, and censorship in Rome, and Milton approved of each. Does Milton regret the burning of Protagoras' books or the imprisonment of Naevius? The ancient censorship was only of 'blasphemous and atheistical, or libellous' writings, but, then, the censorship concerned most of what any censorship might concern. And the Areopagus' regulation of public and private morality is not alien to Milton's plan for a commonwealth of saints, either in the earlier *Reason of Church Government* or in the more enlightened *Areopagitica*. In the first he advocated force and presbyterial sumptuary laws, in the second he admitted the need for persuasiveness and moral censure by the magistrate, and even for 'restraint and punishment' to cure 'impunity and remissness . . . the bane of a Commonwealth'.

Though Milton rejected the censorship-before-publication of Protestant authors, which was enjoined by the Parliamentary Ordinance of 1643, he did not reject the principle of subsequent censorship of the authors of 'erroneous things and scandalous to honest life', though it were 'a disgraceful punishment'. Approving an earlier Parliamentary Ordinance that prohibited anonymous publications and required registration before printing, Milton speaks in ardently inquisitorial tones:

> Those which otherwise come forth, if they be found mischievous and libellous, the fire and the executioner will be the timeliest and the most effectual remedy that man's prevention can use.

Books are more powerful than men, and whatever the decorators of the Catalogue Room of the New York Public Library imagined about Milton and precious life blood, Milton urged superintendence of books as well as of men:

I deny not but that it is of greatest concernment in the church and commonwealth, to have a vigilant eye how books demean themselves as well as men; and thereafter to confine, imprison, and do sharpest justice on them as malefactors.

Anyone who knows Milton's way with metaphors knows the antecedent of the last pronoun.

The identity of those who can judge whether a writing is erroneous or scandalous, mischievous or libellous or malefic, is not obscure, and the epigraph from Euripides is no puzzle: 'Who can and will . . . advise the public' are the regenerate, the Protestant elect, the full participants of Christian liberty, one of whom demands, 'Give me the liberty to know, to utter, and to argue freely according to conscience, above all liberties.' The elect know who they are, even if no one else knows. Their light is the 'dark lantern of the Spirit/Which none see by but those that bear it'. But in 1644 those who did not know must yet acknowledge, for the elect had effective state power, with as yet no serious dissension between the Presbyterians in Parliament and the Cromwellian Independents of the army.

The restriction of a conditional, not absolute, freedom of expression for the elect is the main proposition of the *Areopagitica*, though most critics have called it not a restriction but an extension. It is true that the Presbyterian Parliament had curtailed such a liberty in 1643, but Milton's speech is nothing more than a plea that it be restored; it is not a plea that even such a conditional liberty be extended beyond the nucleus of revolutionary Protestant parties.

The exclusion from all liberty of 'popery and open superstition' and 'all which is impious or evil absolutely either against faith or manners', in the opinion of the Protestant elect, is not a parenthesis or a qualification: it is one half of the thesis of the *Areopagitica*. That thesis, unobserved by three centuries of English scholars, was most compendiously and accurately defined by a man who has never been regarded as a Milton specialist: 'Inside the revolution, everything; outside the

revolution, nothing.' The speaker was Fidel Castro; his competence in the field is indisputable.

To protect the revolution, revolutionary parties must rigidly exclude counter-revolutionary propaganda. In 1644, counter-revolution meant, to religionists like Milton, the left of antinomianism and the right of Romanism, and, as Arthur Barker noted, most kinds of Anglicanism. To nourish the revolution, revolutionary parties must allow, even encourage, the widest growth of ideas that are yet revolutionary; so the Cuban Revolution 'must be a school of unfettered thought', and Mao could evoke a hundred blossoming flowers. Milton saw that a seminary of the reformation of reformation must include Presbyterians, Independents, and sectaries, because from the critical association of their 'neighbouring differences, or rather indifferences', truth will at last emerge. The reason that will prevail is the gospel light of reformation; since, as the elect know, Papists and Laudians, atheists and sceptics, have wilfully deprived themselves of evangelical reason, reason decides that they be excluded from the rights of Christian liberty. But within the revolutionary citadel, dissent must flourish. As Petrograd in 1919 and Havana in 1965, so was Milton's Protestant London in 1644:

When a city shall be as it were besieged and blocked about, her navigable river infested, inroads and incursions round, defiance and battle oft rumoured to be marching up even to her walls and suburb trenches, that then the people, or the greater part, more than at other times, wholly taken up with the study of highest and most important matters to be reformed, should be disputing, reasoning, reading, inventing, discoursing, even to a rarity, and admiration, things not before discoursed or written of, argues first a singular good will, contentedness and confidence in your prudent foresight and safe governments Lords and Commons; and from thence derives itself to a gallant bravery and well grounded contempt of their enemies . . .

Seen as a revolutionary declaration, the noble and fervent utterances of the *Areopagitica*, though no less fervent, are

perhaps less noble: a little oligarchy of merchants, preachers, soldiers, and polemicists are the sole legatees of the grand spirit of freedom; and the fair body of Truth, which we must seek in labour and amid error and danger, is the truth of the reformed religion, a truth whose essence is secured before controversy, and is not to be impugned by those outside the inheritance. When Truth and Falsehood grapple, there is really only one contestant, no antagonist. 'The best part' of Milton's 'liberty' is 'our religion' (as in the *Ready and Easy Way*), which is not a question to be explored but a datum with its own limits of tolerance.

The dogmatic tolerance of the *Areopagitica* does not profoundly differ from the teaching on Christian liberty and liberty of conscience in the Westminster Confession of the previous year, a document that has seldom been considered a monument of libertarianism. The framers of the Confession, like Milton, believed that 'God alone is Lord of the conscience, and hath left it free from the doctrines and commandments of men which are in anything contrary to His word ... so that to believe such doctrines or to obey such commands of our conscience is to betray true liberty of conscience'. And Milton, like the Confessors, held that it was the duty of the Protestant civil magistrate to assure that 'the truth of God be kept pure and entire, that all blasphemies and heresies be suppressed'. And both Milton and the Confessors agreed that the elect did know 'the mind of God'. Differences between the Confession and the *Areopagitica* are differences of extent, not of principle.

Indeed, in sober appraisal, Milton's dogmatic tolerance differs little from the tolerance decreed by what was, to Milton and the Presbyterians, the Antichrist, as he spoke through the Council of Trent:

Whereas the number of suspected and pernicious books, wherein an impure doctrine is ... disseminated, has ... increased beyond measure, Fathers, especially chosen for this inquiry, should carefully consider ... the matter of censures of books ... to the end that this

holy Synod ... may more easily separate the various and strange doctrines, as *cockle* from the *wheat* of Christian truth ...

In *Areopagitica*, for cockle and wheat, Milton used the figure of Psyche and the confused seeds. He and the Catholic Synod knew that division into clean and unclean doctrines was a matter for religious decision. Only the clean, whether Catholic or Protestant, could be freely disseminated, for human freedom is moral, and the obviously or demonstrably immoral cannot morally be tolerated. All Milton's assertions of the right to inquire and know are for a right as limited as that allowed by Lambeth or the Vatican. Milton, like Lenin and Pius IV, might have agreed with St Thomas that all truth is of God; but outside the revolution or the true church there is neither godliness nor truth. 'Dogmatic intolerance and civil toleration' was as remote from Milton's mind as it was from Bossuet's.

The majority perhaps of English intellectuals, surely of European intellectuals, certainly of the English and European plebs, are excluded from Milton's tolerance, and the speech for the liberty of unlicensed printing denies the only toleration that means anything, the toleration of radical dissent. The champion of unfettered thought is no more libertarian than Sidney Hook, who defends absolute liberty of expression – within established limits, or indeed than Oliver Cromwell. That Iron Flail, who could dismiss the Magna Charta with a scatology, could agree with his Latin Secretary on the utilitarian liberty of the Commonwealth.

The most that we can say of the tolerance of the *Areopagitica* is that it reflects Milton's nearest approach to libertarianism, when he was freeing himself from the intolerant zeal of Presbyterianism and had not yet hardened into regicidal toughness and contemptuous antidemocratism. He is surely more enlightened than the Presbyterians whom he addresses; what intellectual could be less? But contemporaries like Roger Williams and John Goodwin, now obscured by Milton's later grandeur, were a century or two more enlightened than he.

Their calls for toleration extended to religionists and irre-
ligionists whom Milton absolutely excluded from toleration –
even to 'the most *Paganish*, *Jewish*, *Turkish*, or *Antichristian
consciences* and *worships*', as in Williams's *Bloody Tenent of
Persecution*, published six months before the *Areopagitica*. Con-
sistency is a harsh thing, but the disciplinarian Milton of *Comus*
and the last poems is the Milton of the Puritan Revolution.

Milton's basic intolerance was modified in 1644 not only by
his movement from Presbyterianism to the Independents, but
also by the needs of revolutionary strategy. To avoid the dis-
orders of trying to suppress sectarian but orthodox dissent,
orthodox dissent should be tolerated. 'Neighbouring differences'
are really 'indifferences'. Dissent about dietary laws is tolerable,
but not dissent about the apostolic succession or the nature of
Christ. Milton's 'neighbouring indifferences' were exactly that:
they were religious insignificances, and Milton pretended to
regard them as such. But what was not indifferent was cen-
sorable. One of the implicit illogics of the *Areopagitica* is that to
a thorough religionist there are few indifferences, and the pam-
phlet was, as the Yale editor suspects, primarily a device for
maintaining Protestant harmony, a revolutionary tactic rather
than a libertarian argument.

The Areopagitic 'condemnation of all censorship' is in fact a
rationale of revolutionary censorship. It is not liberal or liber-
tarian even in its time, but a militant and exclusivist revolu-
tionary pamphlet, something intelligible not to Hugo Black but
to Che Guevara. And the Cuban Ministry of Information more
readily allows *Time* or studies by Galbraith in Havana, than
Milton would have admitted into his Protestant commonwealth
treatises by Cardinal Bellarmine or Father Knott. (We may
notice by the way that in the popularly significant media, Ameri-
can tolerance resembles Milton's. Who has not wondered at the
breadth of the spectrum of opinion presented by those televised
debates on Cuba or China that include, on the right Senator
Dodd or William Buckley, and on the left – Adolph A. Berle,

Jr, or Max Lerner? The counter-revolution has its own boundaries of toleration.)

The *Areopagitica* was silent in its birth and never important practically. But we may use it to measure three centuries of cultural limitation and scholarly inadequacy. British and American men of letters have misread the finest prose of their greatest poet because he was revolutionary in a way that was beyond their experience. George Orwell commented on such obtuseness, remarking the incompetence of the average English scholar to edit works that treat the substantial life of most men: work, hunger, poverty. The comfortable and decent scholar is simply not aware of what his author was writing about. So, Milton's call for revolutionary freedom and intolerance is alien to the tradition in which nearly all scholars and critics have lived and moved since his time.

In the century after the Restoration, the Anglican moderate centre dominated scholarship and criticism, and from that position no man could see the revolutionary dynamic of 1644. Milton was thought to be a man of the Enlightenment, not of the Reformation, a radical tolerationist, as in Johnson's misreading, not a revolutionary exclusionist: as though Milton had read Voltaire. The English had no revolution in 1789, and the Romantics, true children of the Enlightenment, were liberal, not radical. They reinforced the image of a libertarian Milton, venerating in him the same supposed unrestrained tolerance for which Johnson had censured him. They saw Milton as a revolutionist of the order of a Jefferson, not of a Robespierre, as though Milton had read Hannah Arendt.

After the Romantics, the image of Milton's liberalism was ratified by Whig liberalism and was fixed and laid aside, much as his last poems were reverently deposited in the Victorian shelf of unimpeachable classics. It would have required a radical scholarship of strength and authority to challenge that image. But England had no revolution in 1848, and there has never been

a wide and responsible Marxist or radical intellectualism in England or America.

Catholic critics, the heirs of a continuous culture and belief antipathetic to post-Reformation liberalism, might have come nearer than Anglicans and later Protestants to the truth of Milton's prose. But Catholics in England, long disenfranchised like the Puritans, had slight scholarly influence in the eighteenth and earlier nineteenth centuries. And they have been, until very recently, understandably antagonistic to Milton. Studying the *Areopagitica*, British and American Catholics, pathologically sensitive, have read the popery passage as a specific and unique intolerance, rather than as a logical complement to the Tridentine Index, and so have missed Milton's hostile affinity with Catholicism. The modern Catholic community, from which a profound humanistic revaluation of the English renaissance might grow, is still, in spite of hopeful signs, remote from cultural radicalism: the Catholic marriage to the Protestant ethic must first be annulled.

All reputable scholarship in Britain and America has taught or accepted a Milton seen from a stable and civilized centre that conceives revolutions to be liberating but not militant, as though there could be a valid revolution without counter-revolution, or, in the bland assurance of the *New York Times*, 'peaceful and democratic'. The civilized centre can easily contain Johnson and Macaulay, Whitehead and C. S. Lewis and the American university professors. None of them could be expected to know the *Areopagitica* or John Milton. 'The most cultivated man that has ever lived in England', wrote Sir John Robert Seeley, in the year of the Paris Commune, of the man who had called for the blood of Charles Stuart.

The Milton of the Enlightenment is transmitted from scholar to teacher to student, and seminar directors close their eyes to the observation that the *Areopagitica* was intolerant in an intolerant age. Milton experts continue to publish eulogies rather than analyses, or they write analyses little more pene-

trating than the paragraphs in the college study guides ('impassioned defence of freedom of the press'), preferring the old imperceptions to the plain language of Milton. And he is really a most plain and direct author, in prose and in verse. Radicals and Marxists reading Milton, whatever their instincts and common sense, accept the professional judgement of the scholars who, after all, must know the conventions and the context of Milton's work. Perceiving the relation between Milton and Marx, an English socialist historian and Balliol scholar can still imagine the Puritan aristocrat declaring that 'censorship, in this new freedom, is an insult to the common people'. The certified British-American misreading is revered even in the Eastern Bloc. A Soviet scholar, knowing Milton's aristocratic republicanism and repugnance for the masses, recently wrote like a Victorian don when he came to the *Areopagitica*, imagining that the poet of the bourgeois revolution 'went beyond his contemporaries in demanding freedom of conscience, of speech, and of press, for all'.

The torrential majesty of Milton's prose, and the relevance of *Areopagitica* to *Paradise Lost* mislead the inexpert as well as the scholar, and Milton's superb classicism seems incompatible with revolutionary eccentricity. But the grand libertarian generalities are the great distraction. Milton, like every humanist revolutionary from St Paul to Fidel Castro, is indeed a libertarian: but the counter-revolution, religious or political, is outside the limits of reason and tolerance, for to every revolutionist, the revolution is reason and salvation, purpose and morality, the threatened tabernacle which alone preserves genuine human freedom. So certain and obvious must this truth have been to Milton that he needed little more than parentheses in which to recall it.

The preponderance of English scholarship has drawn Milton into its own liberal centre, which claims a Western and ultimately an Attic heritage of universal freedom. Milton, no sentimentalist, knew what the heritage really was: that Athenian

liberty was restricted to an Athenian elect; that the Areopagus was an instrument of moral discipline; that its loss of control was, as Isocrates saw, an omen of national decay; and that the Hill of Mars where Paul freely preached the strange doctrine of an unknown God, was the court of a degenerate people subjected to barbarian rule.

But Milton stood only partly within the Hellenic inheritance, conditional though it was. Learned readers since the seventeenth century have not seen that the Milton of the *Areopagitica* is Hebraic and Pauline, not Greek. The revolutionary Paul who had been permitted to speak at the Areopagus would not have returned the indulgence to those outside the Body of Christ, though he encouraged discourse and diversity within, and the tolerance of the Epistles is exactly that of the *Areopagitica*. Imagine a Milton for whom Catholic or Laudian idolatries were abominations and atheism an obscene dread, tolerating their public expression in the reformed Christian commonwealth! The three centuries of misreading are three centuries of withdrawal from Christian dynamism and its spirit of dogmatic but charitable intolerance, and three centuries of a cultural protectionism in which the fierce needs of revolution have been unimaginable.

An Afterword

'The Misreading of Milton' was sent to the Columbia University *Forum* as 'The Hill of Mars', a title which the *Forum* editor, Mr Peter Spackman, wisely suggested be changed for non-Miltonic readers. When it appeared I expected the angry attention, if not the instantaneous conversion, of that forbidding panoply of learning called Milton scholarship. Mr Spackman, hoping for rather than expecting such responses, asked me for the names and addresses of the Milton scholars who might be most interested and readiest to excitement, and to those he sent copies of the article. None replied to the *Forum* or to me; no

Milton scholar subsequently replied or responded to the article. Letters in the *Forum*, from Columbia alumni, attacked the article as depreciatory of Milton (because it asserted his revolutionism at the expense of his liberalism!), though one reader agreed with my thesis and observed that a similar position had been taught at Columbia by William Haller in the 1930s (the position is not Haller's in his *Liberty and Reformation in the Puritan Revolution*, 1955).

But the article has made no impression in Milton circles. The *Milton Newsletter*, the only frequent and regular Milton publication in America, has continued to use the familiar *Areopagitica* epigraphs on liberty, with the familiar implication. *The Year's Work in English Studies*, the authoritative and comprehensive epitome of English literary criticism and scholarship, did not include the usual summary and comment or even a notice of the article, though it has faithfully recorded the most exiguous philological trifles that I have published in *Notes and Queries*. The meticulous French scholar of Puritanism, M. Olivier Lutaud, with whom I have corresponded since 1965, did not include the article in the bibliography of his recent edition and translation of the *Areopagitica* (*Pour la liberté de la presse sans autorisation ni censure: Areopagitica*, Aubier-Flammarion, 1969), and in his extensive and careful introduction, repeats the same libertarian imperceptions about Milton's work: 'Dès le titre nous baignons dans une atmosphère de liberté: idéal et exigence.' 'Milton alors de prêcher la "liberté chrétienne" contre le fantôme des conformismes exigeants et des traditions, – et une large tolérance (catholiques exclus) des terrestres désaccords . . .' Yet M. Lutaud recognizes that Roger Williams's somewhat earlier work 'aboutit à une largeur de vues encore plus totale' and that the '*Areopagitica* ne fut donc qu'une voix parmi d'autres, et une des dernières . . .'

The scholarly inattention to 'The Misreading' might be attributable to the unimportance of the subject, to the insignificance of the thesis, to the feebleness of the demonstration,

or to the obscurity of the publication. But 'The Misreading' was a radical revaluation of the major political work of the greatest English poet, published in a highly respected academic journal with a circulation of more than 100,000. And, I am still convinced, the demonstration was irrefragable – and indeed, the main thesis is obvious to anyone who allows himself to 'see the thing as in itself it really is': Milton, in the *Areopagitica* and in his whole life and work, was not a tolerationist but a revolutionist.

The article and its inconsequences suggest of course that we have laboured under a misreading not only of Milton but of Milton scholarship. And I think that the failure of the article to impress Milton scholarship is its very validation: its other thesis, that established scholarship cannot understand revolutionary contexts, is demonstrated by the refusal of established scholarship to recognize it.

John Berger: *Problems of Socialist Art*

1. Zadkine's monument shows Rotterdam as ravaged by the Germans in May, 1940, and, simultaneously, its resistance. The figure both collapses and advances; the living contradictions of war are expressed in this sculpture, whose very basis is dialectical. (Photo Netherlands Information Service)

2. Cézanne, *View of Mont Sainte Victoire* (1897). Cézanne tried to paint this landscape from more than one viewpoint.

3. Braque, *Houses at L'Estaque* (1909). Braque took Cézanne's principle further, painting this village from many viewpoints simultaneously. They were forging a new visual language to express dynamic relationships, not fixed appearances.

4. Picasso went further in *The Girl with the Mandolin* (1910), each part seen from a different angle. Zadkine's *Rotterdam* is in the line of direct descent.

Lee Baxandall: *Spectacles and Scenarios: A Dramaturgy of Radical Activity*

5. Honoré Daumier: *Most Humble, Submissive, Obedient . . . and, Mostly, Voracious Subjects.* Daumier here epitomizes the show of deference towards 'legitimate' authority by those who, having economic authority, hold the fundamental power, but know they have need to dissimulate it.

6. The *New York Times*, 18 June 1970, page 1: 'Bankers Hear President's Speech. Officials of the Chase Manhattan Bank watching Mr Nixon on television yesterday'. The Daumier updated. On the left, next to the television screen, is David Rockefeller, Board Chairman of Chase Manhattan Bank. Two weeks earlier – while the stock market plunged in defiance of Keynesian law – he urged President Nixon to make this speech so as to reassure the public. Note that the Chase Manhattan sought to propagate this image ('*Most Humble . . .*'), made by Mr Devine of its own photographic staff; and the *New York Times* chose to run it front page. Mr Rockefeller is also instrumental in an arts-and-business partnership venture called Experiments in Art and Technology (E.A.T.). (Photo William Devine for the *New York Times*)

7. March 1970, a cafeteria, University of Havana: 'The communist attitude towards life is to show, by examples, the road to be taken' (CHE). Few in modern history have equalled the Cuban Revolution leaders in understanding the exemplary aspect of radical activity. Perhaps no state has matched the Cuban in structuring its survival, and the people's welfare, on emulable scenarios of action instead of to fit into repressive spectacle. However Che has said he had to learn sorely such conduct. He relates in *Episodes of the Revolutionary War* that 'a spontaneous and somewhat lyrical decision' was what he started with; which only in experience of struggle became 'a more serene force; one of an entirely different value' and which led him to regard situations in terms of 'protagonists in the drama'. This terminology of

aesthetics is not extrinsic. It does express Che's irreducible judgement. Hence 'Socialism and Man in Cuba', wherein he describes the 'strange and moving drama' enacted between Fidel Castro and 'the individual, the actor' within the new society. Fidel Castro paid this tribute to the conduct which had made Che an unsurpassed leader and soldier and which drew the admiration even of ideological foes: 'Che was an artist of guerrilla warfare; he proved it a thousand times over. The artist can die, especially when his art is the dangerous art of revolutionary warfare, but what cannot possibly die is the art to which he dedicated his life and his intelligence.' (Photo J.B./Red Star/Liberation News Service)

8. Vallegrande, Bolivia, October 1967: A spectacle of counter-revolutionary hegemony. Can you 'kill' a socially-originated scenario? The Bolivian Army believed it could; it murdered Che Guevara while he was a wounded captive, then asked photographers to make pictures like this one. The spectacle is to show the futility of revolutionary action. But as John Berger has noticed, the spectacle failed. To succeed, it would have to compress the whole meaning of the revolutionary tendency represented by Che Guevara in the instant of mortification. This it could not do. Moreover Che Guevara had quite foreseen that moment. A decade earlier he came to terms with the likelihood of death in combat and this consciousness and resolve had indeed released in him the possibility of a conduct so exemplary as to cancel the intended iconography of the generals. 'Either the photograph means nothing because the spectator has no inkling of what is involved, or else its meaning denies or qualifies its demonstration.' (Photo United Press International)

9. Grinnell College, Iowa, 1969: *Playboy* representative Brice Draper encounters the Women's Liberation Front. A *Playboy* promotions man spoke in the college's sex education series early in 1969. Ten students, four of them men, stripped in the confrontation. 'Pretending to appreciate and respect the beauty of the naked human form,' their leaflet said, '*Playboy* in actuality stereotypes the body and commercializes on it. *Playboy* substitutes fetishism for honest appreciation of the endless variety of human forms.' The *Playboy* man chuckled: 'I think you're pretty swinging.' Challenged to join the protesters with a woman photographer in attendance, he declined to desert his employer's empire of repressive desublimation built upon the spectacle of the monthly gatefold-girl, and missed the whole point when he said: 'I came here to talk, not to pose nude.' (Photo Henry Wilhelm)

10. 20 October 1967: the Pentagon besieged. Since this photograph was taken, the situation has recurred times beyond numbering. Sometimes with mortal outcome (Kent State). More often with an increasing fraternization of the young conscripts with the demonstrators. Until 1968 the spectacle of the US Army struck fear into the brain of the recruit and the political opponent alike. The fear was tempered as, through GI coffee-shops and by actions on army bases, anti-war movement scenarists built contacts with unhappy conscripts. Undoubtedly represented in this picture is the quintessential event in a radical political dramaturgy – its *sine qua non*, its ultimate moment of truth. 'Will they shoot?' a political activist asks of another. To a soldier: 'Will you shoot?' A general whispers pompously to an aide: 'Are

these troops reliable?' And so vies spectacle mentality with a scenario social creativity. (Photo Joe R. Crock)

11. Chicago, August 1968: Saint-Gaudens's memorial to General 'Black Jack' Logan (1897) is criticized and redefined. In what might be termed living art criticism, some of the battered, indignant demonstrators at the Democratic Party Convention mount the equestrian statue near the Hilton Hotel where H. Humphrey and other architects of American politics were quartered. Logan won his ambiguous nickname in the Civil War and the erection of a bellicose memorial three decades later must be linked with the nation's new era of foreign acquisition. Far into the twentieth century, most United States cities and towns invested in 'monumental propaganda' (Lenin's term) encouraging of America's adventures abroad. The caesura to all that is marked by irreverence to Augustus Saint-Gaudens's contribution. And by Claes Oldenburg's tractor-mounted 24-foot lipstick tube, a 1969 gift to Yale University (which the Trustees however failed to accept permanently). William Burroughs, author of *The Naked Lunch*, has a similar proposal for England: a massive crowd ought to be gathered around the Trafalgar monument to launch an insistent overwhelming chant of 'Bugger the Queen!' (Photo Malloch, Magnum)

12. A 'patrol' of discharged, anti-war soldiers in white-face enact on the streets at home their crimes in Vietnam. By the 1971 Spring mobilization of Americans against their government's war in South-East Asia, many of the actual veterans of the war had become convinced protesters. Some 1,500 adherents of the Vietnam Veterans Against the War camped on the green around the Washington Monument. Their combat history and their wounds enabled them successfully to defy and 'overrule' even the US Supreme Court's order that they must not make camp. The national capital had seen nothing like it since 'bonus army' Vets marched on Washington at the start of the Depression; that group however had lacked this generation's instinct for audacious dramaturgy. Respectful, camped out of the way on a mud flat, they had been readily dispersed. The Vietnam Vets made by contrast a 'limited incursion into the mental and physical space surrounding Congress'; in a symbolic but possibly ominous way they 'brought the war home'. Ten Vets dressed in combat fatigues, their faces painted white, their purple hearts and silver stars pinned to their chests, toy guns in their hands, marched solemnly two abreast through the streets of Washington crying, 'Where are our dead brothers?' 'We're looking for our 50,000 brothers. Have you seen them?' Their voices were distorted with emotion till they sounded only half alive; it was as though the genius that had touched Irwin Shaw's anti-war play *Bury the Dead* in the thirties now spread through a generation and so of course was more directly expressed. Onlookers were deeply moved. Other troupes of Veterans paraded mock Vietnamese prisoners, hands tied behind their backs, past government workers and visiting tourists. They did it for real. The prisoners were kicked, screamed at, slapped and shoved. At the end of a week, the Vets threw their medals and papers on to the steps of Congress. (Photo LNS Women's Graphics Collective)

2

◀ 1

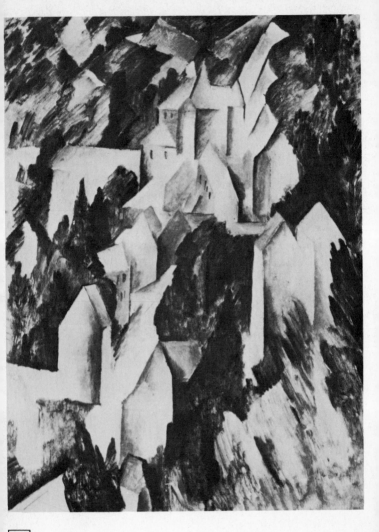

3

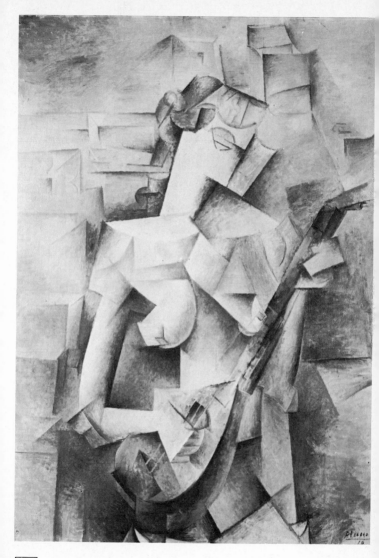

4

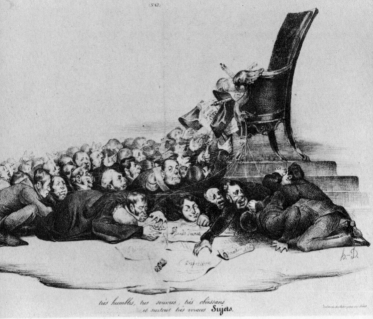

très humbles, très soumis, très obéissans
et surtout très vrais Sujets.

5

7

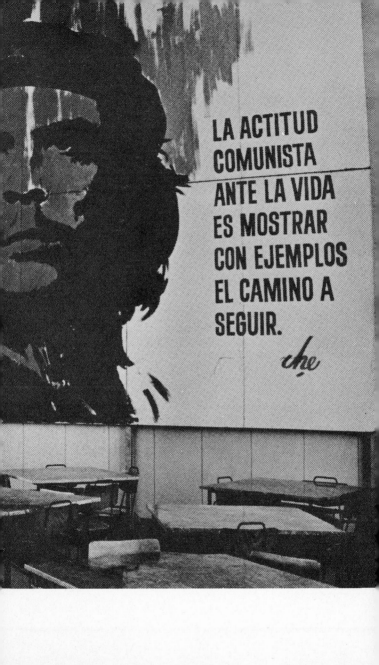

LA ACTITUD COMUNISTA ANTE LA VIDA ES MOSTRAR CON EJEMPLOS EL CAMINO A SEGUIR.

che

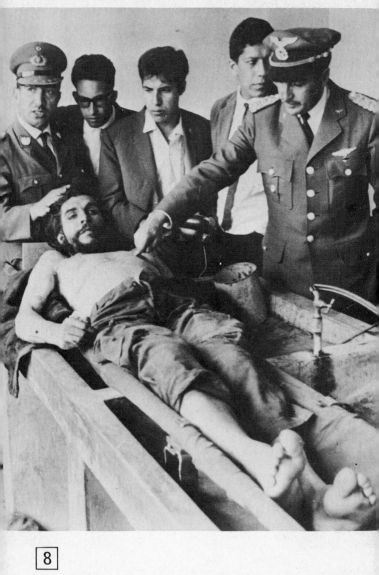

8

9 ▶

10

The Arts and
Socialism

**Involved Writers in
the World**

I have recently had to do research on Daniel Defoe, whose *Robinson Crusoe* and *Moll Flanders* are perennials. A number of years before he published these best sellers, Defoe stood in a London pillory three times on successive days – one day in Cornhill by the Exchange, the next in Cheapside near the Conduit and the third in Fleet Street by Temple Bar – with a paper above his head that read, 'Daniel Defoe, for writing and publishing a seditious libel entitled "The Shortest Way With the Dissenters" '.

That was in 1703, long ago. Perhaps it isn't quite as bad as that, today.

In Moscow, at the foot of the monument erected to the poet Mayakovsky, young poets declaim to the youth of the city. Soviet books are printed in huge editions and sell at low prices; the collected works of the classics are oversubscribed; every village has its public library; museums are crowded; lectures

STEFAN HEYM fled Germany for the United States when Hitler came to power. He fought in the Second World War; but when the McCarthy era dawned, as Heym later wrote, 'my position as a naturalized citizen made me particularly vulnerable to persecution; my exodus had been preceded by that of Charles Chaplin, Thomas Mann, Bertolt Brecht'. Resettled in East Germany, Heym has published a series of novels which he composes in English. They include *The Crusaders*, *The Lenz Papers*, *The Eyes of Reason*, and *Goldsborough*. Heym has done a stage adaptation of Mark Twain's *Tom Sawyer*, and remarks on a greater affinity for Twain, Hemingway and Dickens than for Thomas Mann or Fontane as his mentors.

and discussions popularize literary works; the state subsidizes cultural activities.

Yet Mayakovsky ended a suicide. Not many years afterward, writers died in penal camps.

What was it that marred the hopes for happy harmony between the writer and a society run by and for the common man?

Perhaps you recall that line in the old *Internationale*: ''Tis the final struggle . . .'

Rightly or wrongly, that line contains a pledge: once this is won, it's over; men will be brothers. That is pure idealism; but along with Marxist analysis and Leninist tactics, ideals are needed to fight, and win, a revolution.

The revolution victorious eliminated one very basic contradiction – that between the exploiters who owned the means of production and those other classes who owned little more than their bare hands and were being exploited. But then new contradictions arose whose manifestations are noticeable from the China coast to the shores of the Elbe River.

The new contradictions add excitement to the socialist writer's life. Wherever he looks: new conflicts, new situations, new characters – and new difficulties. That bureaucrats may take bureaucratic measures against his work and sometimes against his person is the least of these.

His main difficulty is the conflict in his own heart. To the writer, the gulf between the imperfections of socialism and the promise it holds poses a question of ethics: does he do more harm than good by a full reflection in his work of the new and often cruel and crude contradictions?

The writer's conflict of conscience is the more painful because of the new responsibilities, which the new society places upon him. He is called upon to help in the construction of the new order.

I sometimes wonder what would have happened if a Zola had risen in socialism and thundered his *j'accuse* against the trials of

the Stalin period, compared to which the trial of Captain Dreyfus was a harmless diversion. Would his voice have been choked? Or would others have joined his protest, and prevailed?

Frederick Engels once defined freedom as insight into necessity. But people do not ordinarily see freedom in Engels's terms. They want to be free of something, mostly of hunger and oppression, and also, within the accepted set of morals, free to speak out and to act as they please.

That's the freedom for which men have made revolutions. But in its absolute application, this freedom means also freedom to those who want to destroy the revolution and, along with it, freedom itself. The revolution, made for freedom, therefore must limit it in order to maintain itself. This immediately raises the question of who is to limit freedom, and how far to limit it?

History, in coming up with a Bonaparte or a Stalin, has not always answered that question in a satisfactory manner.

But whatever happened to Daniel Defoe, standing in the London pillory and waiting for the rotten fish and the brickbats to come flying?

Three times, on successive days, the same thing happened. People came pouring from their shops and from the inns, because it was noontime, and they toasted the writer with tankards of beer, also with wine, and cheered him; women, some of unsavoury reputation, garlanded the pillory with flowers, and instead of brickbats, nosegays were thrown; and at the foot of the pillory printers' apprentices and newsboys hawked copies of a new poem he had written in jail and in which he concluded:

> Tell them. The men that placed him here,
> Are scandals to the times!
> Are at a loss to find his guilt,
> And can't commit his crimes!

11
Jorge Semprun

Socialism and Literature

What is literature capable of? No sooner is the question asked, than I seem to hear a whispered susurrus from voices deep in the warmth of literary circles: authoritarian voices speaking – often with authority – in the name of a valid, strong and rich literature. A quite simple answer ends the debate before it has begun: *literature is capable of nothing*.

Listen to Pasternak, who speaks with authority. One day, according to Yevtushenko who tells the story, a worker said to Pasternak: 'Lead us towards the truth.' Pasternak replied: 'What a strange idea! I have never aspired to lead anyone anywhere. A poet is like a tree whose leaves rustle in the wind; he has no power to lead anyone . . .'

Pasternak was either too modest, or too proud. In either case, he was unaware of himself. For his intention was always, at the very least, to lead men towards themselves. The power of his poetry was immense. His literary power perhaps lay precisely in the fact that he refused to make concessions to political power – to that form of circumstantial political power that was Stalinism.

JORGE SEMPRUN is a Spaniard who fled to France as a Republican refugee in 1936. He fought with the French resistance during the Second World War and was imprisoned in Auschwitz. Semprun's life has in part resembled that of the character played by Yves Montand in *La Guerre est finie*, for which he wrote the screenplay. His other films include *Z* and *The Confession*. He was awarded the Prix Formentor in 1963 for the novel *The Long Voyage*. Semprun now lives in Paris.

Listen to Robbe-Grillet. In an essay written in 1957, he declared: 'No matter what his political convictions, or his personal militancy, the artist cannot reduce his art to a means in the service of a cause – even the most justifiable and exalting cause – which transcends it. The artist puts nothing above his work – and he soon perceives that he can only create *for nothing*.' There are two ideas in this passage. They seem to derive from each other, but in reality they cancel each other out and return us to the confusion of a poetic rustling of leaves. There is first of all the idea that art cannot be utilitarian, that it is not a means. This is an entirely correct idea, which echoes one of the themes of Marx's thought. 'The writer,' Marx wrote, 'in no way considers his work as a *means*. His work is an end in itself. It is so far from being a means for the writer himself and for others that he is ready to sacrifice *his* existence to *its* existence when the need arises . . .'

But from this immaculate premise, Robbe-Grillet deduces an indefensible conclusion: that the artist creates *for nothing*. This is a purely theoretical conclusion, which his own work contradicts at every step. For as a form of literary investigation and reality, the *nouveau roman* is moving and developing, and this is a good thing for us all. Because for a Marxist critic all research is valuable *a priori*. Freedom of investigation, including investigations that may appear to lead to a dead end, is one of the conditions of a true cultural life – a life that is organically linked to the whole of society. It is especially necessary in those socialist régimes that are founded, for historical and therefore transitory reasons, on a single-party system. This research can only be formal. The content is not a matter of research: it is imposed on us. Either by the world or by our ideas, our personal obsessions about the world.

However, for Marxism, a critique of the utilitarian conception of art – a critique which is essential, especially within Marxism itself – does not lead to 'gratuitousness'. It leads to a quite different perspective. Such a perspective must start from the

fact that Marxism is not only a theory, a critique, a method. It has also given birth to a certain form of society, to a specific type of political power. These are historical realities that no one, least of all Marxists, can overlook. This means that one cannot talk about literature from the innocence of 'pure' Marxist thought: the often terrible weight of a certain historical practice precludes this innocence. Thus, first of all, one must examine the relationship of literature to socialist power.

What Marxist attitude is the most valuable in considering that part of the socialist movement which – simplifying somewhat, but so as to be clearly understood – I shall call Stalinism? It seems to me that the crucial need is for a consciousness of our own responsibility for the past, or if you prefer, of our co-responsibility. Real or pretended lack of knowledge justifies nothing, and serves no purpose. There is always a way of knowing, or at least of questioning. We have too frequently denounced the attitudes of people of good conscience and bad faith who were unaware of the extermination of the Jews and of colonial wars, for us to be able to claim any excuses for ourselves.

Even without knowing, without really knowing, we remain co-responsible, because this past is ours and nothing can change it. We cannot refuse this past. We can only deny it in the present, that is to say, understand it through and through in order to destroy what remains of it, in order to create a future which will be radically different.

We need, in other words, to have an active, not a hapless, consciousness of our responsibility. We are responsible for this past because we accept responsibility for the future, for the socialist revolution throughout the world. These are the kind of feelings evoked by reading *One Day in the Life of Ivan Denisovich*, for example. Solzhenitsyn's book destroys any possible innocence for my generation. We came back from Nazi concentration camps, we were the just, the evil had been punished, Justice and Reason returned with us. At the same moment, however, some of our comrades – perhaps even men we had known,

with whom we had shared our fifteen grammes of black bread in the camps – were being sent to join Ivan Denisovich somewhere in the extreme north, to build a desolate socialist city whose uninhabited, concrete carcasses stretched out like spectres over the snow. This novel ends innocence for anyone who tries to live – really live – within a Marxist vision of the world. What remains is a heightened awareness of responsibility, not only for the past, but for the present and the future as well. We are responsible for Solzhenitsyn's voice. I give it only as an example, for it is not an isolated voice, it is multiple, perhaps immense – a voice which reminds us that truth is always revolutionary. It depends on us that this voice should never fall silent: if it ever should, we should cry out in its silence.

This brings us to 'social realism', not that of Solzhenitsyn, but of Zhdanov. Because we must re-read Zhdanov. We must re-read him to measure the distance that separated us from ourselves, which separated Marxism from Marxism, its critical and revolutionary truth from its bureaucratic carapace. For twenty years, from the First Congress of Soviet Writers, in August 1934 – which ended the period of cultural research and debate in the USSR – a certain type of relationship prevailed between authority and literature in the Soviet Union. It is impossible to analyse this relationship in detail here, but its fundamental traits are simple enough to define.

First of all, there was administrative direction of culture, by decree and Resolution. As Zhdanov said in 1946, it was necessary to 'align all the sectors of our work on the ideological front'. The consequence was that all cultural debate, all possibility of contestation, all ideological struggle was suppressed. In brief, the opposite of Marxism. And the opposite also of literature, which needs all these in order to live. We cannot reassure ourselves by saying that all this was an accident which sprang from the specific circumstances in the development of Soviet society. The roots go deeper.

Read the report of Lin Mo-han, one of the officials respon-

sible for culture in the Chinese People's Republic. It dates from
1961, and is entitled: 'Let us raise still higher the banner of
Mao Tse-tung's thought over literature and art.' There are the
same formulas, based on the same quotations, the same con-
ception of culture and of the role of the party, the same ana-
themas against decadence, formalism, revisionism. And the
same imperative conclusion: 'The present task for writers and
artists is to develop and create a socialist literature and art in
conformity with the directives set out by comrade Mao Tse-
tung.' All that needs changing is a single name. In the transi-
tional period opened by the Twentieth Party Congress, the
relationship between power and culture in the USSR has been
marked by contradictory shifts: advance and retreat, empirical
approaches and reprimands, brutal or paternalistic interven-
tions. But no coherent theory of culture, of the party's role in
this field, of the criteria of freedom for research, has been
organically developed. It is this theoretical work, however,
which we most need; without it, practice will be, and will
remain, purely pragmatic.

The publication of a book like *One Day in the Life of Ivan
Denisovich* should not be imputed to the sole, praiseworthy
initiative of one man in power: it should be the spontaneous
product of the whole of Soviet cultural life. Correcting the
excesses of the past cannot possibly satisfy us. Enlightened
despotism – or more or less enlightened, depending on those
in power – is not enough. A developing socialist society demands
something more.

It is time to question, once and for all, the idea which has for
so long had currency and which Lin Mo-han expressed succinctly
in his report when he said: 'Literature and art, which make up a
part of the whole revolutionary cause, must naturally accept the
party's direction and control.' Gramsci replied to this in advance,
from prison, when he wrote:

The politician exerts pressure to make of the art of his time a given
cultural world. This is a political activity, not an artistic critique.

If the cultural world for which we are struggling is a living and imperative reality, its expression will be irresistible. It will find its own artists. If, in spite of political pressure, it does not find its own artists, this means that we are dealing with a factitious cultural world, a pastiche, a paper lucubration by mediocrities ...

I quote Gramsci because in my view it is largely within the Gramscian tradition that there are to be found the most coherent and valuable elements of a Marxist theory of art – a theory that finally ceases to consider art simply as an ideological superstructure, and as a utilitarian instrument.

12

Roger Garaudy **Budapest Interview**

In 1966 Roger Garaudy visited Budapest, where he delivered a
lecture and met leading personalities of Hungarian letters and
art. This interview with him by the poet György Timár was
published in the weekly *Élet és Irodalom* (Life and Literature),
November 1966, No. 39. Garaudy says:

My book *Réalisme sans rivages* ('Shoreless Realism') has been
translated into fourteen languages. In all fourteen, it has been
attacked heatedly, mainly because the majority of my critics
misunderstood the expression 'sans rivages' and interpreted it as
'without principles'. For this reason I omitted from the new
enlarged French edition of my book, which is just leaving the
press, the earlier polemic postscript, and replaced it with a new,
more systematic review. The text of this makes it obvious that
my 'shorelessness' is in fact a theory that rests on firm prin-
ciples.

ROGER GARAUDY was for long on the Central Committee and the Politburo
of the French Communist Party. He served as its philosophical spokesman,
as in the post-war *Literature of the Graveyard* which attacked Sartre,
Mauriac, Malraux and Koestler. Also in English is his *From Anathema to
Dialogue: A Marxist Challenge to the Christian Churches*, and *Marxism in the
Twentieth Century*. Garaudy was expelled in 1970 as the result of increasing
disagreement with the Party and the Soviet Union over Czechoslovakia and
other matters. He had been Director of the Centre for Marxist Studies and
Research. Garaudy is a professor at the University of Poitiers; his most
recent book – now translated – is *The Turning Point of Socialism*.

Q.: How did you conceive the necessity of a new view on realism? What did you consider the weaknesses of earlier views?

A.: The point of departure of my investigations was not aesthetics. I originally sought general arguments against dogmatism. I considered that the dogmatic interpretation of Marxism was inclined to view history as something pre-ordained, ready-made, almost prescribed, although Marx, of course, in emphasizing historical determinism, did not tire in stressing the tremendous importance of human activity. In his 'What is to be done?' Lenin too called our attention to the role of the subjective moment. This was how I realized that artistic creation was not a luxury that was tolerated within the stream of a pre-determined fate but a part of the subjective formative activity just mentioned; in this context, I also discovered that our theory of reflection contained a goodly share of mechanical elements. The problems of realism did not become important and interesting for me in themselves, but as part of the theory of reflection. In the course of our investigations we must set out from the Marxian concept of *the real*, and this concept does not denote something that is given once and for all, but a thing that is changing constantly. Only the French philosophers of the eighteenth century were of a different belief, and their errors still haunt us here and there. Marx showed that *the real* in our consciousness is reflection and creation at the same time. In other words, in my view, dialectical materialism is a conception of the world that makes the elaboration of the methodology of the historical initiative possible.

Q.: The Hungarian writer Lajos Mesterházi also argued with your studies on the arts, which have become famous. He explained in his 'Play and Magic' that you 'were unable to resolve the erroneous dogmatic contradiction because you did not dare to declare that the non-realistic does not equal the non-artistic, decadent, or decayed'. According to Mesterházi and others, Kafka and Picasso occupy an important place in the arts, yet this does not necessarily mean that these artists are realists. Do

you believe that it is necessary to be a realist in order to be an epoch-making artist?

A.: Unfortunately, I have not read Mesterházi's article, I first heard about it here in Budapest and I shall have it translated immediately. As far as the argument you mentioned is concerned, I believe it derives from a narrow definition of realism, which demands from the work of art some kind of copy of reality. But in realism, in its fullest interpretation, it is the attitude and the actions of the man that count. This is the most important part of reality. Can we then say that Kafka is not a realist? Or let us take, for instance, the paintings of Bazaine. In his works we would look for the copy of an object in vain: he captures reality at a certain abstracted stage. He depicts, for instance, the rhythm of a river or of a sea without painting the waves or the ripples of the water. Has he then turned his back on reality? On an immediate reality, by all means; but only on this. Does this matter? Lenin said: 'A good abstraction does not remove us from reality, on the contrary: it brings us nearer to it.'

Q.: Are there then in your opinion important non-realistic artistic works?

A.: There are none. There is no work of any importance which would not contain reality. Sentimental trash fiction, the gaudy picture, these are non-realistic. The criterion of realism is whether the work reflects adequately the relationship of man to reality. This may be enthusiastic, adverse or frantic; but the emphasis is at all events on this relationship.

Q.: Does it follow from this that a work which in one way or another contains reality – and according to you all contain it in some way – is already to be considered realistic?

A.: That is right. There are of course degrees. In my opinion the peak of realism is achieved when the work cooperates actively in the continuous 're-creation' of man by man. Kafka's *The Trial* is, for instance, such a work, because it is a protest of elementary force against alienation. Picasso's *Guernica* falls in

the same category; in my view this is perhaps one of the greatest works of art of our century, because it represents realistically war's contrariness to nature, and not only man's protest against it but also his power and even victory over it.

Q.: There are many people who believe that the conception of art as a working activity is not opposed to the conception that considers art a tool of perception. You who stress the action side of art, do you agree with this view?

A.: Most decidedly. Art is work, that is, the transformation of the world (and of man himself); but it is of course perception too at the same time. But let us stop here for a moment. The particularity of artistic perception does not consist in what Hegel saw it to be – that art 'translates' into a picture what is a concept in scientific perception. I have to point this out most emphatically because it is here we find the source of all the aesthetic muddle of our times. How do we stand on this question? In my view, conceptual perception approaches a thing that already exists while artistic perception approaches one that is only under preparation. Thus, not only methodological differences known until now exist between the two branches of perception, there is a difference between their object too. In other words, the reality of the two kinds of perception is not the same reality speaking two languages: there are two different kinds of reality. In the new postscript to my book I mention a third system of communication; this exceeds the second Pavlovian degree, the communication system of words. The first two systems of communication advise me of a reality that already existed before me; but the system of artistic symbols is different. The latter is not interested in already existing things that have been captured or may be captured formally, but in the new reality that is taking shape. Faust too is a symbol and not the copy of an actual person. Or let us take, say, the world of Cézanne; this seems mostly to totter on the edge of some catastrophe (incidentally like Klee's world too), as if a breath at the still life would be sufficient for everything to collapse; and this is exactly when the painter

reaches the peak of his realism. As a matter of fact, Cézanne realized already that to watch was to act. And every action is something responsible. However much something may be a matter of necessity, it will always behoove man to validate that necessity actively. I understand that in your country there is a lively argument among historians about the role of the subjective and objective moments of history. In France too, there is such an argument going on between myself and Althusser.

Q.: A few years ago you firmly criticized Sartre for his book about the dialectic mind, in which he strongly emphasized the role of the subjective moment. What then is your opinion: may we learn from the existentialist philosophers?

A.: Not at all. Sartre was right to direct our attention to the role of the subjective element in philosophy. But the way he put the question was wrong, and it is therefore obvious that he could not find the correct answer. It is the task of those of us who are Marxist thinkers to elaborate satisfactorily the non-subjectivist theory of subjectivism. Do not think for a moment that the classics have already done everything for us once and for all. Far from it. What they gave us are extraordinarily important directives, but life puts new questions daily in all domains, and to these we have to give the answers today.

13
John Berger

Problems of
Socialist Art

I wrote this article over ten years ago, in 1959. It was commissioned, in London, by the editor of *Isskustvo*, the principal
Soviet journal devoted to the visual arts. Khrushchev was then
in power in Moscow, and it seemed just possible that the Stalinist dictatorship of the Union of Artists on all matters and
standards relating to art in the USSR might at last be broken.
I wrote the article as an argument to support those Russian
artists and thinkers who understood the necessity for such a
breakthrough and its wider implications. The article was never
published. And when a few months later I was in Moscow, the
editor of *Isskustvo* did his best publicly to disassociate himself
from me and from my opinions, whilst warning his colleagues
in the Ministry of the Interior of my presence there. Some while
later I gave the article to *Labour Monthly*, London, who published it.

JOHN BERGER began his career as a painter and art teacher, and was much
influenced by the distinguished Hungarian Marxist art historian Frederick
Antal, then exiled in England. Since 1958 he has published a succession of
novels (*A Painter of Our Time*, *The Foot of Clive*, *Corker's Freedom*); art
monographs (*The Success and Failure of Picasso*, and *Art and Revolution*, a
study of the sculptor Ernst Neizvestny and the art situation in the USSR);
essay collections (*Permanent Red* (American title: *Essays in Seeing*), and *The
Moment of Cubism*); and a study of a doctor's role (*A Fortunate Man*).
Berger has been regular art critic for the *New Statesman* and has written
articles for many periodicals; in recent years he has appeared often on BBC
television. He now writes regularly for *New Society*.

Certain points I make in the article I elaborated elsewhere later (notably in *The Success and Failure of Picasso* (Penguin) and *The Moment of Cubism* (Weidenfeld & Nicolson; Pantheon)). I now take a more radically critical view of the whole European pictorial tradition (see various essays in *John Berger: Selected Essays and Articles* (Penguin)).

But the main lines of my thinking here still seem to me to be valid and, unfortunately, as relevant today as in 1959 to the practice of the arts in the USSR.

*

The critical question is how do we regard the art produced in or around Paris between about 1870 and about 1920; the period that includes among others Manet, Monet, Degas, Cézanne, Gauguin, Van Gogh, the Fauves and the Cubists. Can we dismiss the work of the Impressionists and those who followed them as little more than an expression of the decadence of bourgeois culture – which is roughly what Plekhanov did? Or can we find in such works, arising dialectically out of their contradictions, positive and progressive possibilities which once revealed cannot be ignored?

Let me admit straight away that the direct social meaning of the art of this period is often weak and ambivalent, although most of the artists concerned thought of themselves as revolutionaries. They were fully aware that they were living at a time of profound change and crisis and they realized that past explanations and past solutions were no longer adequate. But they saw this only in general cultural terms or in terms of their own art, whose crises were being precipitated by such things as the disappearance of private patronage, the invention of photography and the inevitable reactionary backsliding of the official *salons*. They were not political revolutionaries: some were even political reactionaries. They were unable to see the connection between the cultural crises which they themselves faced and the crises that were accompanying capitalism in general as it

entered its imperialist phase. They hated the bourgeoisie and were opposed to its values. During the Commune Manet was elected to the Fédération des Artistes de Paris, along with Courbet and Daumier. Pisarro was an anarchist. Cézanne was a friend of Zola and a great admirer of Flaubert. Gauguin as he left for the South Seas wrote: 'A terrible epoch is being prepared in Europe for the coming generation: the reign of gold.' The Fauves and the Cubists were profoundly hostile to and contemptuous of the whole bourgeois establishment. Nevertheless, the protests of these artists were directed primarily against the philistinism of the bourgeoisie. They hated what the bourgeois stood for in his culture, rather than what he stood for in terms of the class struggle. And so, for the most part, they were quite unable to see their way to joining the proletarian struggle for socialism. They fought only with their paintbrushes and only for painting.

As a result of this their works were not addressed to any particular class or section of the public, neither to the bourgeoisie nor to the working class. They were comparatively unconcerned with didactic communication. Their subjects became increasingly personal. Their language was sometimes obscure. Their lives became eccentric, bohemian, and in some cases self-destructive. And so Plekhanov (who, incidentally, on other subjects is so instructive), could write with apparent justification:

Extreme individualism in the period of bourgeois decay shuts off the artist from all sources of real imagination. It makes him quite unaware of what is going on in society, and condemns him to barren preoccupation with his own private and empty experience and sickly, fantastic inventions.

Yet is this the whole truth? Was it not precisely this unpromising attitude that actually forced the pioneers of contemporary art to make their most significant discoveries? Discoveries which, as we shall see, could not be fully developed because of the limita-

tions of their situation: but discoveries which nevertheless are of immense potential value?

How did the art from 1870 to 1920, which began with Impressionism and continued until about the time of the first successful socialist revolution, the Soviet Revolution – how did this art in fact differ from that which preceded it? The methods of painting changed. The Impressionists' use of broken-up marks of colour was new. Gauguin's use of flat colour and heavy outlines was new. Van Gogh's direct drawing in paint was new. Cézanne's use of simultaneous viewpoints was new. The Fauves' use of pure colour to suggest energy was new. And so also was the Cubists' use of planes to analyse structure. (Each of these innovations requires, of course, an essay in itself to describe properly, and you must excuse my cursory treatment here.) The subject-matter of painting also changed. The new subjects were drawn very much more directly from the artist's own daily life; the street in which he lived, the café he frequented, the fruit in his studio, the new landscapes he saw as he travelled by train.

But the most important difference of all was that the artist's new and extreme isolation now compelled him to cease relying upon any conventions of meaning. Since he had no guaranteed public, he could no longer depend upon anyone interpreting a given object or incident in a given way. Paintings could no longer illustrate or comment directly upon any general system of ideas. Their interest became centrifugal. A painting simply gave evidence now that its subject had been seen in a particular kind of way. Vision itself became the new *content of art*.

For the Impressionists their method of seeing, dependent upon their theory of light, became as important as the particular themes in front of which they set up their canvases. Van Gogh, Gauguin, Cézanne, the Cubists, all constantly refer in their letters to new ways of making themselves and other people *look*. *Thus the painter began to paint in order to prove something rather*

than to describe something. This was the most distinctive characteristic of the new art.

Now obviously such a development could open the door to the grossest subjectivity. The artist could now paint in order to prove the 'reality' of his own private world at the expense of the actual one. But it also opened the door to another possibility. The artist could now paint in order to prove the dialectic that inevitably exists between any subject and any way in which it is seen. Nature was no longer something laid out in front of the painter. It now included him and his vision. Consciousness was now seen to be subject to the same laws as Nature. Thus the new art offered on one hand an excuse for every kind of subjectivity: and on the other hand the possibility of creating – for the first time in history – a truly materialist art. (After all one does not produce a materialist work of art simply by illustrating an anticlerical satire.) These two opposite trends – the subjective and the objective – have existed side by side ever since.

When Cézanne repeatedly said that he must be faithful to his 'sensation' in front of nature, he was not indulging in subjectivity: far from it. He was realizing that his own senses with which he apprehended the Mont Sainte-Victoire were no less part of the material world than the light on the mountain. He must be equally faithful to both and his faithfulness would be the measure of his objectivity. But when Jean Dubuffet, a now very fashionable Parisian artist, says 'Observation destroys what it touches', he clearly represents all that Plekhanov condemned. Indeed Plekhanov's condemnation is starkly proved by one of Dubuffet's apologists, who writes:

Dubuffet appeals to the imagination of the spectator who will give to each painting the meaning he wants, according to his nature and the play of his fancy ... for those who like to let their imagination loose in the greatest liberty, how enchanting Dubuffet's work is!

This is indeed the liberty of zero!

What, however, I want to stress is that the historical develop-

ment which I have very briefly outlined did also lead to a reali-
zation of true revolutionary significance. Certain artists came
to realize that appearances are not fixed, and that the appearance
of any given object is merely one stage in several processes: the
process of the object's own development, the process of its
being seen by a particular individual in a particular situation.
Different artists approached this new discovery from different
sides. The Impressionists emphasized the way appearances
depend upon light. Degas and Rodin emphasized how appear-
ances can be changed by movement. Van Gogh emphasized how
appearances can be changed by the emotional meaning of the
scene for the spectator. And Cézanne himself, overwhelmed by his
realization that appearances are limited by the viewer's position,
set out to transcend this limitation and to show the table or the
mountain in front of him from several viewpoints simultaneously.

Now, I imagine that objections to what I have said so far may
run along two lines. Some may say that what people normally
and habitually *see* is the reality: anything else is a subjective
imposition on that reality. Others may point out that the whole
way in which I am approaching the subject is over-cerebral: a
painting is not just an exercise in discovering a physical or
philosophical truth; it is a work, as Blake said, 'of love and
imagination', and its humanity, its expression and its soul are
there to appeal to our hearts, to move us.

But surely what we perceive when, say, we look out of the
window is an amalgam of what we see with our eyes and what we
already know. We do not simply rely on the image mechanically
recorded on the retina; we also rely on our experience. One man
will look at a mountain and observe certain facts about it;
another man, no less objectively observant, will observe a dif-
ferent series of facts and carry away in his memory a different
image from the first one. Furthermore, each of their views
will only include certain aspects of the total reality of the
mountain, not all. From the valley beneath, the mountain may
appear triangular in shape; from an aeroplane above, it may

appear as a flat, squarish table: and to a climber on its peak it may look like an irregular cone. And even all these examples leave out of account the factor of movement, which is actually always present. The light moves, the subject moves, and so do the spectator's eyes and head. Our area of intense optical focus is very small and we relate one object to another by glancing between them and by using our memory. We do not see as a camera records, intercepting all movement, instantaneously; which is why a photograph can often appear to us to be distorted.

I emphasize like this the relativity of what any one of us sees at a given moment, not in order to allow everyone to claim their own 'reality', nor to suggest that reality itself is unknowable, but rather to emphasize that reality is far more complex than any single view of appearances. No work of art can do justice to the whole complexity of reality. Every work of art is a simplification based on a convention. The convention itself emphasizes a particular aspect of nature in accordance with the interests of the particular social group or class that has created it.

If all that we have to do in front of a painting or sculpture is to *recognize* it, then clearly we are only being reminded of what we already know. In fact we need to look at every work of art as if it were a new object; it is its final comment, not its immediate appearance, that we need to relate to and judge by the rest of our experience. The works of Raphael or Michelangelo contain distortions that are as radical as those in the best works of contemporary artists like Léger or Matisse. The all-important difference is that we are by now familiar with the conventions of Renaissance art, but are not familiar with the conventions of the art of our own time. Indeed, our familiarity is so great that there is now the danger that we accept the convention for the reality. Take, for example, the Renaissance use of drapery. We now look at the way Botticelli or Mantegna painted drapery and we marvel at how convincing it seems. Yet the laws by which these painters arranged their folds and swirls of material were very arbitrary. No actual robes or materials could ever fall or arrange

themselves as they do in their paintings. These painters used drapery in order to explain and emphasize the structure and movement of their figures. Their folds served a not dissimilar purpose to the planes of the Cubists four hundred years later.

Again, I do not say this in order to justify all distortions. It is here that the whole problem and danger of Formalism does indeed arise. But Formalism is not primarily a question of the degree of distortion. Formalism can exist within the most naturalistic tradition. The portraits of our Queen are no less formalist than many abstract paintings. The key question is to decide about the purpose of the simplifications and distortions that the artist has made. If their purpose is merely to solve a pictorial problem or meet an outdated convention, then they can be condemned as formalist. Reality is being traduced for the sake of art. If, on the other hand, their purpose is to isolate and underline an aspect of the truth about the subject, then they may well be justified. It is possible of course that the emphasis of one aspect of the truth may falsify other aspects that are more important. Imagine, for example, a painting of a docker: to emphasize his physical strength to the point where he appears to be all brute force and no mind, is obviously a mistake. But that is a problem that has to be considered in relation to each particular case and has nothing to do with the principle of distortion as such.

Let us remember that all art is artificial. It offers us images and not facts. A bronze statue never breathes. A painting of a running figure never moves. Art cannot reproduce reality in its entirety. Instead it can do one of three things. It can accept our habits of looking (habits that have been largely formed by the art of the past and today by photography) and, building upon these, it can remind us of what we have already seen, offering us at the most only new combinations. This is the way of Naturalism. Alternatively, it can build upon the belief that art is in some way superior to reality and so select, distort and simplify aspects of nature for the sole purpose of making a pleasing arrangement of

forms. This is the way of Formalism. Or lastly it can turn its limitations to advantage. It can select an aspect of reality and within its own artificial limits make a unity of that aspect, so that we are able to recognize its truth more clearly than we can in life itself and thereby extend and deepen our habits of looking. This is the way of Realism. But – and this is the point – all these three ways, judged in relation to the comprehensive physical reality of the world, involve an almost equal degree of distortion.

I sympathize with the view that all this is too cerebral. Such an impression is of course partly the result of my having to write in terms of compressed arguments and generalizations. But such a view is also partly justified by the character of the actual work to which I am referring. The great pioneering works of Cézanne, Picasso, Braque, Juan Gris, etc., were all produced in an atmosphere of social isolation. Their studios were somewhat like laboratories, from which the traffic of life was excluded. Their attitude of mind was a little like that of pure mathematicians. The application of their discoveries to great human themes was beyond them because such themes belong to the people from whom they were cut off. In the latter stages of capitalism art has developed in a similar way to science and other branches of knowledge. On one hand specialization has become more and more intense; on the other hand, the results of the pursuit of specialized knowledge have become more and more difficult to apply for the benefit of society as a whole. But in art, as in science, this does not necessarily mean that the laboratory discoveries are valueless. Rather it means that their full application to human life and happiness awaits the establishment of socialism.

And so I agree with the contention that much of the art that I am discussing is over-cerebral and over-theoretical. But I believe that this means we must develop it, rather than deny it. In actual fact we cannot deny it; for to some extent tradition in art, as in science, is continuous, and these discoveries and examples to which I have referred have now become part of our tradition. The invention of nuclear weapons was an unmitigated

evil. But even when we have succeeded in banning them, we will not be able to *lose* the knowledge which makes it possible to manufacture them. How much more true this is of discoveries which, whatever their limitations, also have a positive usefulness! It is impossible for any painter in Western Europe now to paint as if Picasso had never existed. And that is not a prejudice: it is a fact.

*

There is one aspect of the problem which I have not yet mentioned and which by now may well be in the very forefront of the reader's mind. 'You have sketched in,' he will say, 'the development of modern Western European art in relation to certain aesthetic theories, but what about its effectiveness? How accessible can this art be to the people? How can it play its part in creating the new socialist man? What is the *social* function of such art?'

To answer these questions fully I would need another article. (And here I would like to emphasize that the whole of this article should be seen as no more than the beginning of the beginning of a discussion.) But briefly I will answer the question in two ways.

First, by countering with a question of my own. Have any of us yet fully worked out how the social function of painting has been changed by the inventions and development of other media? Painting originally developed as the primary means of communicating ideas to publics who were illiterate. Consequently literacy gives to literature functions which previously belonged to painting. And if the visual image is by its nature more vivid than any written description, then now the film, with all its greater possibilities of movement and development in time, has certainly taken over some of the other functions which painting once had. Certain bourgeois critics deduce from this that painting has no future at all. This, however, is an argument based on their profound contempt for the people. Painting is not

just a way of illustrating stories – any more than poetry is simply another way of telling stories. A great painting is a revelation in visual terms of how man can bring order to reality. Artists and those who have been closest to them have realized this, if not from prehistoric times, then at least from the beginnings of civilization. *Painting is the means of extending and sharpening the meaning of our sense of sight.* In the past only the privileged few or the unusually gifted have been in a position to appreciate painting in this way. In a classless society every man has the right to develop his senses beyond the demands of necessity to the point of full self-consciousness. Thus the fact that other media have taken over some of the functions of painting does not mean the end of painting. What it does mean is that in an expanding classless culture painting will probably become a more contemplative art, and that in our present bourgeois cultures painting has already inevitably ceased to be a directly effective means of propaganda. How many people can look at a painting compared with the number of people who can read a book, or see a film?

The second point that I want to make is that there is no evidence to suggest that Naturalism is the style of the people. The true popularity of a visual art cannot be measured in an inverse ratio to its degree of deviation from photographic appearances. The poster and the cartoon prove this – as does also modern Mexican painting. The essential of popular art is that it reveals the truth, and makes the people more aware of the potentiality of the world in which they live. The styles it can use are variable and largely a question of convention.

It is for this reason, as well as for the others I have already given, that it is so important to distinguish between the different kinds of work produced in Western Europe today and yesterday, and so misleading to judge them all simply by the criterion of how far they stylistically depart from a single stylistic canon. Again, I have not the space now to analyse in detail the fundamental differences between Surrealism and Cubism, between

abstract art and the great works of Picasso, between Futurism and its connections with Fascism and the magnificent, truly socialist works of Fernand Léger. In the end the people will not accept lies; but there are truths which are at first so amazing that it is hard to believe them, and there are lies which sound far more plausible than any truth. One must search very hard. Let me give you an example of how one must look.

Zadkine's monument to the port of Rotterdam [Plate 1], destroyed by the Germans in May 1940, stands on the water-front of the new city, commemorating the ordeal of the old city. The scale is big. Two or three large gulls can perch on the hand that appears to be flattened against the surface of the sky. Between the outstretched arms the clouds move. When a ship's siren sounds on the other side of the water, the sculpture for a moment reminds you of a huge bronze anchor, but buckled and trailing not over the sea bed but over the moving clouds. At night it looks different. Then only the silhouette remains, and a man stands, arms raised to hold off an invisible load between himself and the stars.

What is the meaning of this image? Or, rather, what are the meanings – for the whole point of this sculpture is that it expresses development and thus has simultaneous meanings. The figure represents the city. And the first dominant theme is that of the city being ravaged, razed. The hands and the head cry out against the sky from which the man-aimed bombs fall. The torso of the figure is ripped open and its heart destroyed. This wound, however, is not portrayed in terms of flesh. The man represents a city and the sculpture is of bronze and so the wound, which in fact is a hole right through the body, is seen in terms of the twisted metal of a burnt-out building. The legs give at the knees. The figure is about to fall.

The second, simultaneous theme is very different. This is *also* a figure of aspiration and advance. The arms and hands are not only held high in anguish and a vain attempt to hold off, they also raise and lift. The knees are not only collapsing, equally they are bent because the figure is moving forwards. From

every direction as you walk round this figure, it appears to be stepping towards you. Literally it has no back, so it cannot retreat. One week after the German attack, plans were made to rebuild Rotterdam as soon as the Germans were driven out. The curses became a rallying cry. Defeat forged the new forces of Resistance. The dead made the living more determined. All these – the bitter, living contradictions of war – are expressed in this sculpture whose very basis is therefore dialectical.

The people of Rotterdam are now almost unanimously proud of this monument. Why? Because its style derives from Cubism? No, of course not. But because it reveals the truths they have experienced. Unlike many war memorials, this one is neither gruesome nor patronizing. It does not try to turn defeat into victory, nor does it resort to the false comfort of philosophic dualism by separating the spiritual from the physical. It shows that the words Defeat and Victory can be used to describe exactly the same incident, whilst the reality which is actually suffered is something continuously developing and changing out of that apparent contradiction. And it shows this in terms of pain, effort, courage.

It would, of course, have been possible to hint at the same dialectical meaning by sculpting two quite literal, entirely representational figures, one dying and the other fighting. But how much less powerful and moving and true that would have been! It would then have represented one incident, involving two lives. As it is, this is a single image representing four years in the whole city's life. After all, when we talk of the dialectical process we refer to forces opposing one another and thus leading to a new development *within a single structure*. The process is internal and not directly visible. And so if a visual artist is to express a dialectical process, he cannot simply externalize it and return to the old theory of the straightforward opposition of separate forces. And if he cannot do this, and yet at the same time must make the contradictions of the process visible, then inevitably he must adapt and transform superficial appearances. Which is

what Zadkine has done here with such unique artistic and popular success.

If I have persuaded you that this work of Zadkine's answers at least some of our socialist demands, I want now to show you how much it owes to Cézanne and the Cubist discoveries of Picasso and Braque.

Look at the sequence from the Cézanne landscapes painted in 1897 [Plate 2], through the Braque painted in 1909 [Plate 3], the Picasso figure painted in 1910 [Plate 4] – to the Zadkine nearly forty years later. Purpose, mood and quality may vary, but the visual language is in a line of direct descent: the same emphatic sharpness of the edges from which the planes change direction, the same kind of corkscrew twist as the shapes build up to the top, the same juxtaposing of straight lines with curves. This, however, is to talk about language in the abstract, and the connections are in fact far more profound than that. (Indeed if they were not, none of these works would consist of anything more than mannerisms.)

It is not by magic that Zadkine has modelled a figure which simultaneously collapses and advances. It is by learning from the analytical discoveries of Cubism which in their turn were suggested by Cézanne's effort to visualize a scene looked upon from more than one viewpoint. Zadkine has learnt to observe what is constant in all the ways in which a human body can move and retain its balance. He has been able to see the points of physical coincidence between a man falling and a man going forward. And having established these points and the precise relationship between them – round the wrists, at the pit of the neck, under the shoulders, along the thighs, near the knees – he has constructed the form of each limb to suggest, given these fixed points, all its possibilities of movement. The figure is like a dance, yet unlike a dance it does not require time to develop, but only space.

Cézanne sat there in front of his favourite Mont Sainte-Victoire, perplexed as only the pioneer allows himself to be. If he

moves his head a few feet to the left or right, he sees the scene in front of him slightly differently. To the left? In the centre? To the right? Which reveals more of the truth about those trees and that mountain? None. Each is equally true. But any two combined would reveal more of the truth than any of them singly. And so very hesitantly – for temperamentally Cézanne was a conservative character – screwing up his eyes in perplexity and concentration and thus ignoring all details, he began to try to combine on the same canvas what he saw when he looked from the left with what he saw when he looked from the right. If we now look down any path in this picture – between the trees on the extreme left, straight ahead towards the peak, or between the trees on the right and the flat right side of the mountain – it seems as if each is the path Cézanne's eye has travelled down. Everything is approachable from all sides. For the first time in the history of art a painted landscape is not centred on the spectator's eye. The landscape is there, regardless of the eye.

Braque's painting, which is far more startling to look at, is less original. Braque is only extending Cézanne's principle. But this extension involves a qualitative change. Whereas Cézanne only combined views of the scene which he himself could see from his clearing among those trees, Braque combines views of the village which are theoretically but not actually possible. He is painting as much from what he knows as from what he can see. He looks down on the village from several points in the air simultaneously, as though he were flying over the village in an aeroplane and afterwards painting a composite picture of what he had seen.

In his *Young Girl with a Mandolin* Picasso departs from immediate appearances even further. Here each composite part of the body – the neck, the shoulders, an elbow, a hand – is seen from a different angle. It is as if he has taken the body to bits, as one might a machine, and has then tried to show how the parts structurally fit together; but instead of using several diagrams – one in plan, another in elevation, a third in perspective – he has

combined all these together because in reality they are thus combined.

Of course if art had remained at this stage, which I have already called its 'laboratory' phase, its experiments could never have been justified. Art is not a branch of science, for it does not depend in the same way on measurable observations. But it did not remain at this stage. Here Picasso, like his fellow Cubists, was generally trying to forge a new language. By following up Cézanne's experiments in simultaneous viewpoints, he was trying to paint dynamic relationships and processes instead of appearances fixed to one position and one moment. This new language could only become vital when applied to themes and conclusions drawn from deep human experience rather than purely theoretical analysis. Yet this is precisely what Picasso, Léger, Zadkine and a few others were later able to do. The *Girl with a Mandolin* is a beautifully neat piece of theoretical speculation about structure, movement, space and time. But the monument in Rotterdam is an expression of profound human experience which increases our understanding of that experience precisely because it uses a visual language that can describe those dialectical developments which are hidden beneath superficial appearances and which only become apparent when the subject is thought of as something unfolding in space and time.

I must finish, even though there is still so much that I have not said. I have not talked of what Soviet artists can teach us, above all perhaps in their attitude to their vocation. Much of what I have said may be over-simplified. All of it amounts to only the opening remarks in what I hope will be a continued discussion. All that I would like to re-emphasize is that it is not blindness, perversity, ignorance or lack of social and historical understanding that makes many of us in Western Europe insist that we can now only construct an art of the future from what is best in our modern tradition, established between 1870 and 1920. My warmest wishes and fraternal greetings to all socialist artists everywhere.

14

Jean-Paul Sartre
Ernst Fischer
Edouard Goldstücker
Milan Kundera

**Symposium on the
Question of Decadence**

JEAN-PAUL SARTRE

I will gladly speak on the problems of decadence, but we must
first dispel certain misunderstandings, not among yourselves, but
among some of our communist friends – I am thinking of certain
Soviet writers who, in the conference of European writers in
Leningrad last year, dealt with the question of decadence in the
art of capitalist countries. I should like to explain why the con-
cept of decadence creates great problems in our work. It is
indeed necessary to deal with it very seriously – we must not
evade the issue. You have said quite correctly that Czecho-
slovakia is the meeting place of great cultural traditions and
Marxist thought. Here then we will be able to determine the

JEAN-PAUL SARTRE is the distinguished philosopher, novelist, dramatist,
editor, essayist on cultural and political themes, and activist, who came to
fame after the Second World War as the leader of existentialist thought in
France. During the next two decades he moved towards the view, which he
put forward in his massive *Critique of Dialectical Reason*, that existentialism
was but an 'enclave' within Marxism, the 'insurpassable' body of thought
of our time. Sartre's many other books include *Being and Nothingness*,
Saint Genet, *Situations*, *The Words*, *Nausea*, *The Condemned of Altona*, *No
Exit*, and an astonishing work-in-progress on Flaubert.

ERNST FISCHER was born in Austria, studied philosophy at Graz, and did
unskilled work in a factory. In 1927 he joined the staff of the *Arbeiter-
Zeitung*, where he remained until 1934. Having helped to initiate the left-
wing opposition within the Social Democratic Party, he joined the Com-
munist Party as the socialists acceded before fascism. He was Minister of

role that decadence might play. In the West there are also people who, individually or collectively, are conducting the same kind of investigation – these are the radical intellectuals, communist or not. Among the many schematic examples I could bring up, here is my own case:

I was born in 1905. I was raised by my grandfather, who was a professor and who held many ideas current in the nineteenth century. I grew up in a world where symbolist literature and 'art for art's sake' were the dominant tendencies. I adopted all those ideas of Western philosophy, which I studied. But I became progressively detached from it, although I have retained certain elements of that culture. Thus I slowly came to Marxism, bringing with me everything I had acquired until then. I think that it was my reading of Freud, Kafka and Joyce (I bring up these three names because they were the ones most often mentioned in Leningrad) among other things, which led me to Marxism. But when certain Eastern intellectuals in Leningrad condemn all three indiscriminately as 'decadent' because they

Education for a time in the post-war Austrian government. A strongly positive force in attracting young people to Austrian communism, Fischer published a number of literary studies in the 1960s, including *Art Against Ideology*, *The Necessity of Art* (highly successful in its English translation), and an autobiography. He has also written several plays. Fischer characterized the August 1968 troop entry into Czechoslovakia as Panzer Communism, and was expelled from the Party.

EDOUARD GOLDSTÜCKER was the originator and the key speaker of the famed Kafka Conference in Liblice, Czechoslovakia, in 1963, which can be seen in retrospect as the decisive action in Eastern Europe to start a reconsideration of the nature of literary realism, and, for that matter, of literary controls. Goldstücker was in jail in the 1950s as the result of a Stalinist frame-up. In 1968 he was Vice-Rector of Charles University and chairman of the Writers' Union when the Warsaw Pact tanks swept in, sending him into exile.

MILAN KUNDERA is a well-known Czech novelist, whose novel *The Joke* has been translated into English. He studied at the Film Faculty of the Prague Drama Academy, where he now lectures. He has published several volumes of short stories and a play.

belonged to a decadent society, I am led to think that my personal cultural background is outlawed, and that I must therefore excuse myself before my Soviet friends for having read these three authors, for having known and loved them. When certain persons apply the concept of decadence to Joyce, for example, their criticism assumes a ritualistic character for those who have not read Joyce. Right now what is important is not primarily to study the problem of decadence in depth, but to analyse it from a tactical point of view. But those who have raised the question of decadence – those writers from the West who have been invited here – have lost their usefulness. This is because they themselves have already tried to eliminate anything that could be considered bourgeois in these authors, anything that a socialist society would be unable to accept. They have done this and at the same time they have tried to maintain their relevance. And this relevance is indeed valuable to all of us today.

I do not think that progressive Western writers have contracted a special disease as a result of reading certain authors such as Proust and Kafka; on the contrary, it is precisely in spite of this or rather because of it that, being either progressive or Marxist, they are qualified to conduct this discussion. This does not mean that we accept everything that these writers have written – nor does it mean that a true Marxist could not show us how to study these authors from a different point of view. On the contrary, this would be still further proof that a vital synthesis can result only from differences and discussions. I think that in our discussions we should not dismiss the people whom I represent, if we truly wish that the Marxist have mediators at his disposal when he confronts the anti-Marxist bourgeois. By mediators I mean people who have the same bourgeois culture, but who are opposed to it.

I think that before anything else we must reject *a priori* the concept of decadence. It is evident that decadence has existed. There was a period at the end of the Roman Empire when one

could talk of the decadence of art for the simple reason that artists stagnated in an exclusive concern with the formal development of their art. The great sculptors of this period were incapable of attaining the technical level of their predecessors. One of them would say: I know how to make a man, I know how to make a horse, but I do not know how to place the man on the horse. All this was related to the division of society into classes and the inability of that society to create anything new. It is only on a strictly artistic basis that the concept of decadence can be defined and applied. To the question: Can art be decadent? I answer: it can be, but only if we judge it by its own artistic criteria. If we wanted to show that Joyce, Kafka or Picasso are decadent we would have to do this primarily on the basis of their own works. Only then, and this is the great Marxist problem, could we understand – within the historical context and global structures of society – how such phenomena develop.

If we apply this method to a given author or to a given period, it becomes obvious that the concept of decadence is only rarely relevant. To say that the authors we are speaking of are decadent because they belong to a decadent society is putting the cart before the horse, for every day we see more and more clearly that capitalism is a strong beast. Can we truly say that capitalism is bankrupt? I don't know, we would have to study the question further. Capitalism is supposed to perish for the simple reason that there is a contradiction between the decline of buying power and surplus production. But we can see that the trusts have adapted themselves, and that they have survived. Capitalism seems to me to be just as inhuman and vile as before, but I see no reason why we should consider it decadent if we compare it to the 'family capitalism' of the nineteenth century. I would by no means say that scientific Marxism has failed just because of the schematic way in which it has been applied in the socialist countries during the period of the cult of personality. I would say instead that it was warped, dogmatized. Why should one use the term 'decadence' here, where there is no justification for it?

Simply because Marxism, in certain cases, in certain persons, or in certain groups, for certain practical and political reasons, has lost its wind? There are other areas where it has developed. There are other persons who have developed it, and it is certain that day by day its strength grows. This has nothing to do with the decadence of Roman art, which meant absolute decay. Barbaric art grew on the ruins of Roman art, but here again there is no similarity to the present case. This is why I would suggest that the concept of decadence be systematically omitted from the dialogue between East and West, and that it be used only where artistic decadence has really been confirmed; we must refrain from using any demagogic slogans. Otherwise, I would think that this is not truly a Marxist concept, and that it serves no purpose in our discussion.

We, Western radicals, cannot accept that certain authors moulded by the same society that has shaped us, and whom we shall not renounce, for example Proust, Kafka or Joyce, be considered decadent, because this is at the same time a condemnation of our past and a denial of any value of our participation in the discussion. At the Institute of Philosophy in Moscow, I have been told that in a decadent society several directions may be taken by an individual, one of which is a progressive direction. Therefore if an artist forms a progressive movement he is not decadent; otherwise he is. This is an enormous simplification. Because if there exists a progressive direction in a society which one calls decadent, it must necessarily influence a certain number of artists who are not progressive in their practical lives, but who are conscious of contradictions and must adapt themselves to them as best they can. I repeat: I would suggest that the concept of decadence be eliminated from our discussions; I insist on this because a collaboration with the Western left depends on this. To accept the concept of decadence means in effect that our right to speak is taken away, or at least that we are not clearly committed to Marxism, as I have been myself, for example, for the last fifteen years. If we reject

this concept, or at least if we reserve it for serious and detailed studies, using the best criteria, this will mean that one progressive culture will be able to come into contact with another progressive culture. Finally why should we conceal it? There is a certain contradiction in coexistence. The real problem is not to contrast a reactionary writer to a progressive writer – they have no points in common. The real problem is to find out if the Western left can or cannot come to an understanding with the Eastern socialists, and whether it will be possible to establish a common front.

ERNST FISCHER

Jean-Paul Sartre has drawn our attention to decadence in antiquity. I am very glad of this because in my own study of decadence, I have dealt with modern and ancient decadence. The differences: ancient decadence was true decadence, because no new creative force emerged, and no class in society was interested in what it formerly was. That was a time which was absolutely without perspectives or hopes. The Roman Empire took a defensive position and there was nobody who could find a solution to the social conflicts of that period. The church fathers have depicted it in the most sombre tones, as did the pagan writers of the end of the Roman Empire; they described it as a prison where only the windows looked at the world. Since the Industrial Revolution, however, the productive forces have developed uninterruptedly. In my opinion, the continually recurring contradiction between the means of production and the obsolete relations of production, a contradiction to which Marx gave great emphasis, is of vital importance to art and literature. We are witnesses to the enormous growth of the productive forces of capitalism in the stage of imperialism, and it is unthinkable that such a situation remain endlessly unchanged. It is true that humanity is menaced by the possibility of an atomic war that would destroy it, but there also exists the

possibility of avoiding such a catastrophe by putting these modern productive forces to the service of humanity.

Moribund capitalism – that is how Lenin described imperialism. But this agony is a long historical process, which does not necessarily include the decline of art and literature. At the turn of the century, which Lenin analysed in his study of imperialism, it was really the decadent elements which were dominant; at the same time the dominant social type was the rentier. But even then there were contradictions within the bourgeois world. There was the absolute decadence of Huysmans who became a devout Catholic at the time of the Dreyfus affair; the decadence of D'Annunzio, who celebrated 'dandyism' and the idleness of the ruling class; the decadence of the cocottes that we see idealized in the paintings of academic artists. But there was also Zola, Rodin's statue of Balzac, Cézanne, Cubism, all of which were opposed to the decline of art. For purposes of documentation, one could multiply examples showing how the opposition forces made their voices heard in a period of decadence. And then one forgets that Lenin made the following remark, in his analysis of imperialism: 'It would be false to believe that this tendency towards disintegration excludes a rapid growth of capitalism. . . . In many ways it grows even faster than before.' The uninterrupted development of the means of production permits no stagnation. Especially in the last decades, when capitalism, because of the competition with socialism, has been forced to search for new methods of expansion.

An analysis of modern industrial society would show that socialism constitutes its invisible structure and its unavoidable necessity. This new reality provides new impetus to art and literature. We have many friends who, unfortunately, see this mechanically rather than dialectically: here we have a decadent society, and therefore its art and literature are also decadent. This formulation loses sight of the essential and constant contradiction of our epoch: the contradiction between the forces of production and the relations of production. The essential social

polarization, that which will be determining, is that of the working class and the bourgeoisie. This necessarily influences the impressions and the consciousness of all good artists and writers; the means of production will triumph again and again over the relations of production. From obsolete ideas we shall extract the new reality. An evocative example: the World's Fair of 1889 in Paris opened at about the same time that Lenin designated as the beginning of imperialism. On the one hand we have the Eiffel Tower, the Palace of Industry, the spectacle of fascinating technical constructions, the immense perspective of enormous new methods of production – we all know what enchantment, what impetus and scope this gave to art. On the other hand, we have the scandal of the Panama Canal, the decay of the relations of production. The development on one side of the productive forces, which contain the seeds of the future, and the decomposition and corruption of the relations of production on the other have an effect on art and literature. He who, without foregone conclusions, observes the dialectics of the evolution of art and literature, arrives at the conclusion that there has never existed and that there never can exist a period of absolute decadence. In the periods when decadent currents have been predominant, there emerged each time a defensive movement which in the end has always proved to be the strongest. An important artist or writer always creates starting from reality in its entirety, and the future is always more influential, more vital than the past.

We should therefore approach the problem of decadence as dialecticians. Writers like D'Annunzio, who were infamous apologists for an infamous state of affairs, are often confused with writers like Samuel Beckett. Beckett is a moralist, who is not at all enthusiastic about the state of affairs he describes. This is not, like in D'Annunzio, a complacent acceptance of decadence, but fear and desperation. The absolute 'No!' of Beckett is explosive, full of an alarming anxiety which can change into healthy disgust and action. Had Beckett introduced a single

positive character in *Endgame*, that would have reassured us and the desired effect would have been lost.

It is paradoxical that Beckett shows 'the bourgeoisie in its death-throes', or even having already died, as the sectarian and dogmatic communists would have it, and that it is precisely the latter who attack him as decadence incarnate. There never existed in antiquity such a total negation with so few pathetic overtones. And yet, there are those who repudiate this negation. Confronted with the passive characters of the plays, the public is the active force which demands that one make a decision. One could legitimately object: 'In reality, the situation is not so desperate.' But nothing can be done with such a reply. The shocked audience could just as well ask: 'Is the situation so dark? Can we prevent such an "endgame", such a disaster?' To raise these questions and bring about such attitudes is, in my opinion, the duty of Marxist critics. If we tell young people that from Joyce to Beckett there is nothing but decadence, we will be guilty of disarming the youth of the capitalist countries, for they will swallow the poison without having secreted any anti-toxins. We must point out the differences not only between D'Annunzio and Beckett, but also between Beckett and Ionesco, the difference between a glorifier of the bourgeois world, its court jester, and its desperate repudiator. We must have the courage to say: if writers describe decadence in all its nakedness, and if they denounce it morally, this is not decadence. We must not abandon Proust, nor Joyce, nor Beckett and even less Kafka to the bourgeois class. If we allow them, they will turn these writers against us. Otherwise, these writers will no longer aid the bourgeoisie – it will be us that they aid.

EDOUARD GOLDSTÜCKER

I have to think over what Jean-Paul Sartre said on the subject of decadence, but on first hearing it seems to me that I do not agree with him. It will be the first time that I do not agree with

him since he came to Prague. I do not think that one can say that there is no decadence in modern art. The evolutionist picture which comrade Fischer has so marvellously painted for us – I would like to add to it by remarking that the evolution of capitalist society has been, from the industrial revolution to the present, a continual process of elimination of certain social classes from positions of authority. First it was the aristocracy, then different strata of the bourgeoisie. This first became evident during the Romantic period when one sector of the aristocracy, while producing a literature of great value, shows undeniable signs of decadence – we need only cite Chateaubriand, Novalis, or even so great a figure as Kleist. In the nineteenth century it is the highly cultivated petty bourgeoisie which becomes disillusioned, because all the great hopes of the revolution of 1848 resulted in nothing but a base mercantile capitalist society. The reaction of the artists of this class is one of disgusted retreat from society, and this is manifested in their art by a marked 'decadentism'.

The greatest and most typical example of this type is Charles Baudelaire. In the period of transition which ends in imperialism, there is a bitter struggle within the bourgeois camp itself. The old class of liberal capitalism is eliminated from economic life and replaced by a new type of capitalism – imperialism. The great bourgeoisie, the trusts and the financiers come to the forefront while a great part of the petty bourgeoisie is eliminated from the front line of development. I don't want to apply this mechanically to the field of art, but we should note that elements of decadence have resulted from this process. The brilliant Franz Kafka is one of the many examples of this. Since I speak about 'elements of decadence' I think it will be better if I define what I mean. Briefly, these elements are: a pronounced depletion of vital energies resulting in the rejection of practical life in favour of contemplation, an aesthetic hypersensibility, a lack of will to live, pessimism. This is what I mean by decadence; I am sure there are other aspects to it.

The most important thing about artists of the last century and a half is that precisely by their pessimistic and nihilistic attitude they have succeeded in analysing more profoundly the secrets of life and that they have discovered new ways of giving artistic expression to their world. Here we are dealing with the dialectical unity of the elements of decadence and with new discoveries in the method of artistic creation. These discoveries are then taken up again by some other artist, however progressive he may be in his conception of the world. I consider it absolutely necessary that we, as Marxists, take a stand concerning the problem of decadence, and that we do this on the basis of the dialectic which runs through it. That means: to distinguish the elements of decadence in the 'philosophy of life', to critically examine and deeply appreciate the new techniques of artistic creation which this decadent and pessimistic vision of life and of the world has brought with it. This kind of artistic progress demonstrates what Ernst Fischer emphasized, which is that every great art, even that of the capitalist era, always makes a contribution, even for us, and that one cannot summarily reject it.

I would like to add simply that in the discussions among communists that Jean-Paul Sartre mentioned, it is the mechanical distinction made between optimistic and pessimistic artists which is most harmful. The literature to which I briefly referred is purely and simply rejected because it is pessimistic and propagates pessimism. Because we, as the argument goes, in our society which has socialist and communist ideals, we cannot have any use for pessimism; therefore we should reject this literature. I hold this attitude to be mechanistic and dogmatic, and I think that it is time that we do away with it once and for all.

MILAN KUNDERA

I am glad that we are united in the desire to make correct and scientific use of concepts. Here in our country we have often

used concepts such as: decadence, formalism, modernism, etc., in such a way that they became empty and could mean anything, or nothing at all. Because thought in the time of dogmatism did not really evolve, all sorts of meaningless terms were comically used to give the impression of an evolution. This was so much so that reading an article from that period, we could determine its date not from its ideological content, but from the terminology employed: formalism or decadence, revisionism or liberalism, etc. The terminology played a role similar to topical jargon: it characterized this or that transient period. The comrades present here have definitely noticed since their arrival that we have arrived at a truly dialectical position in regard to what is called decadent literature, and that we have understood that ideological struggle is not contained in the denial but in the overcoming of obstacles. I think that here historical circumstances have been in our favour – we have been able to reject the schematic cliché according to which the avant-garde is equivalent to reactionary politics. These circumstances are the very history of the Czechoslovakian avant-garde. I want to draw the attention of our friends to it, because in the international discussion on the avant-garde, above all between the Italians and Lukács, the study of the Czechoslovakian avant-garde could provide an important example. First, because this avant-garde, whether linked to surrealism, symbolism, or refusing to be categorized, was closely linked to the Communist Party. Secondly, because the greatest figures of the Czechoslovakian avant-garde demonstrated that it is absurd to make of the avant-garde an absolute antithesis to realism; it is precisely thanks to them that one can show how to arrive – by way of the deep currents of modern art – at a type of art that can grasp the world in its totality.

Sartre has spoken, in a preceding interview, of Camus's novel, *The Plague*. He had been to a certain extent surprised by the fact that this book was so enthusiastically received in our country. I think that this is indicative of our situation. In the fight against dogmatism, we have often gone to the point of

defending without qualifications what the dogmatists refused, in order to hasten the publication and distribution of all these works. The result today is a certain eclecticism. At the time in our country when one simply 'refuted' Western literature, a true criticism of this literature did not exist. That is why sometimes, even today, our attitude when we read it shows very little of the critical attitude, whether in praise or in blame.

There is something paradoxical in the fact that we find stimulating things in the critical work of Jean-Paul Sartre, who formerly was rejected in our country as a bourgeois author having nothing in common with Marxism. I am thinking specifically of what he has said of the ideological and stylistic foundations of the American novel, of his essay on *The Stranger* by Camus, and of his essay on Faulkner. I think that Sartre helps us in this way to adopt a sufficiently sophisticated critical position in regard to all the ideas and works to which we now, after the era of dogmatism, want to open our doors.

ERNST FISCHER

I would like to make two more points concerning the question of decadence. We frequently forget, or so it seems to me, one of the fundamental forms of decadence: the corruption of art by the cliché. I perceive a thorough decadence in the imitators of the great Delacroix, and I could support this opinion by presenting numerous paintings as examples. One cannot deny that in paintings such as *The Birth of Venus* and other similar ones there is a contradiction between the social situation and an ostentatious, gaudy consumption which lusts insatiably after female flesh. The cocotte of the Third Empire is a heroine, at times dressed as Truth, sometimes as Liberty, or even as Luck, and it is this idealization of Nana, this façade which has taken the place of reality, that I consider to be decadent. In Germany, decadence manifested itself in a different manner. There the symbol of imperialist decadence appeared, in my opinion, in the

form of monuments celebrating war, with their pretentious simplicity, their architectural charlatanry. Just as France idealized the cocotte, German imperialism idealized the Valkyrie. Both of these examples show the disparity between appearance and reality, and glorify societies doomed to failure. This is what is meant by decadence. We often forget that decadence is characterized not only by dehumanization, by the return to barbarism, by the flight from reality, but above all by circumlocution, insincerity and flattery.

A few more words on the subject of absolute repudiation. I would under no circumstances like to propagate the idea that we must create works of absolute negativity, but I would strongly oppose putting the absolute and moral negativity of someone like Beckett on the same level as pure decadence, which glorifies that which is bankrupt. I do not hold by any means that this absolute negativity should become the principal artistic trend, but I believe that the influence of Beckett on our culture depends on us – our attitude, our critical wisdom. We must learn to distinguish artists and writers who celebrate dehumanization, brutality, aggression, obscenity, and all manifestations of decadence, and even more those who, while having a conscience, remain indifferent, from those who, like Beckett, desperately reject all that. Let us then not consider decadent those who depict decadence, but rather those who adapt themselves to it.

JEAN-PAUL SARTRE

I will only say a few more words. I still maintain that the category of decadence is useless. But other terms which were introduced here are better: pessimism, dehumanization, and others. And I am entirely in agreement with what Mr Fischer has said, for we have shown that the concept of decadence is totally isolated, and irrelevant to society as a whole; that this concept, used to designate groups or rather individuals, results from a specific and transitory situation in society. Furthermore

we have both demonstrated that decadence can only be seen from a dialectical point of view, which means that, if we call for example Baudelaire decadent, this is at the same time the prelude of a future scope, for all poetry after him owes him something.

It is not my duty to close the session, but I take the floor again to thank you. I would like to tell you – and this is not part of the usual compliments – that this is the first time in an Eastern country that I have been able to have such a fruitful conversation with socialists and with party members, that is a discussion in which the points of view are so close that, even if there are differences, it is interesting to discuss them. This is the first time that I observe a desire to give new life to Marxism, to restore its theoretical strength, and at the same time a determination to persevere on the basic principles of Marxism. This is what has surprised me here, this is what has given me confidence, for in my opinion the only hope is in these discussions. I am sure that this rapprochement with the West will not be harmful, that the basic principles are just as essential for us as for you, and that these discussions are fruitful when we express ourselves freely. And this is why I would like to thank you.

Translated by Maro Riofrancos

15

Cultural Theory Panel
attached to the
Central Committee of the
Hungarian Socialist
Workers' Party **Of Socialist Realism**

A discussion on some of the fundamental problems of socialist
realism was recently conducted by the Panel on Cultural Theory
attached to the Central Committee of the Hungarian Socialist
Workers' Party, which finally arrived at a number of conclusions.
An account of the long debates within the panel was published
by the periodical *Társadalmi Szemle*; this paper, which in turn
serves as a basis for further discussion, is reproduced in part
below.

THE ORIGIN OF THE CONCEPT OF 'SOCIALIST REALISM'

In 1932 a decision of the Central Committee of the Communist
Party of the Soviet Union dissolved all the workers' organiza-
tions for literature and the arts. The organizing committee of the
first National Congress of Soviet Writers was set up at the same
time, and proceeded to review the work which had been done
up to that date on the development of a Marxist theory of art.

THE CULTURAL THEORY PANEL ATTACHED TO THE CENTRAL COM-
MITTEE OF THE HUNGARIAN SOCIALIST WORKERS' PARTY, and György
Aczél, the principal author of its document, clearly exerted much thought
and effort. The result is almost unique among officially anonymous, col-
lectively edited Party utterances: an analytical statement which helps to
clarify problems in the writings of major radical aestheticians like Fischer,
Garaudy and Lukács, while at the same time claiming, gently but firmly,
the post-Leninist prerogative of administrative literary control.

It was then that the concept of 'socialist realism' was born, and its first definition was included in the charters of the Association of Soviet Writers: 'Socialist realism, which is the fundamental method of Soviet literature and letters, requires the artist to present reality in its revolutionary course of development, in a true and historically concrete manner.'

An article on socialist realism which appeared the same year, written by Fadeyev, gave a more detailed explanation of this definition. It made consistent use of the term 'socialist realism', describing it as 'the new, revolutionary method in the arts'. It stressed that Marxist-Leninist ideology was the precondition of socialist realism, which, however, could only be transmuted into genuine art through talent, experience and professional skill. The essence of the theory was defined as follows:

... the true revolutionary style in the arts means above all an accurate and artistic representation of reality in the course of its development, its basic tendencies, its wealth of colour and variety, and in the diversity of the new problems and questions of importance to mankind which it presents.

This was how he interpreted the historical position of socialist realism, the most advanced form of realism yet reached:

The dominant form of Soviet literature is socialist realism. Why? Because, according to the Marxist-Leninist view, the true realism of art is creative work which comes as close to historic truth as possible, and is able to represent the trends indicating the real lines of development in the struggle waged against outdated forces.

As far as forms of art are concerned, 'the canonization of certain genres, forms and attitudes, artistic processes and modes is alien to socialist realism. Socialist realism is characterized by diversity'.[1]

At the beginning of the thirties in the Soviet Union, the authoritative view on the theory of art – even if in some respects

1. *A proletár irodalom országútján* ('On the Highway of Proletarian Literature'), Budapest, 1962, pp. 80–90.

it represented features of an earlier stage of socialist realism – provided an adequate basis for a conscious promulgation of the principles of realism, for the direction to be taken by the arts, as well as for further theoretical development.

DOGMATIC AND REVISIONIST DISTORTIONS

During the period of the personality cult, however, the official policy on the arts, although designed to encourage socialist realist art, distorted it in theory and even more in practice. Through its insistence on subjectively conceived injunctions and prohibitions, it disrupted the union of party commitment and objectivity, through its administrative measures – the union of party commitment and creative freedom; it narrow-mindedly identified the educational role of the arts with its exercise in the direct service of day-to-day politics; the atmosphere it generated inhibited the active exploration of real conflicts in the building of socialism; too often it identified the optimistic and humanist approach of socialist realism with the illusion of solving the conflicts themselves; the claim of a true perspective led to a distortion of the real shape of things, and the demand for a faultless hero to a false representation of human character; it limited the demand for totality to a demand for extensive totality; it took the category of the 'typical' and made it a theoretical pretext for obligatory optimism, or confused it with the statistical average, etc. Students of the principles of Marxist aesthetics did not in fact attempt to justify in theory the distortions which occurred in practice. (Or only incidentally, as, e.g., when Zhdanov expressly contrasted the understanding of reality as 'objective reality' with the representation of reality 'in its revolutionary development'.[2]) On the contrary, there was hardly a work to be found on aesthetics in the Soviet Union or Hungary which did not lay stress on the union of party commitment and objectivity, of party commitment and the freedom of art, which did not

2. Zhdanov, 'Questions of Art and Philosophy'.

demand 'men of flesh and blood', the courageous exploration of social conflicts, which would not have differentiated between typical and average, between extensive and intensive totality. Although it is true that certain distortions of the theory of socialist realism also made their appearance, the principal effect of these abusive practices was to arrest its further development by making it repetitive and dogmatic.

These distortions undermined the credit of socialist realism in terms of genuine art, and provided matter for revisionist attacks. The revisionists pointed to the gulf between theory and practice, and identified the abuses of dogmatism in practice with the fundamental theoretical criteria of Marxist aesthetics, in order to destroy the latter altogether. It followed that the repulse of revisionist attacks could only be successful where, and to the extent that, dogmatic practice had been discarded. In Hungary, after 1953, only half-hearted steps were taken in this direction, and the equivocal position which ensued was one of the reasons why revisionism in aesthetics could gain so much ground. Revisionism attacked the sense of party commitment and within this it questioned the right of direction by the party; it claimed for the arts – and for literature in the first place – a leading role in politics; it emphasized bourgeois spontaneity as against the conscious awareness of Marxist-Leninist ideology; it attacked the realist demand for totality by invoking the theory and practice of naturalist and symbolist literature; and in general it impugned the achievements of Hungarian and international socialist art. Although they still exist, direct revisionist attacks of this nature have somewhat receded into the shade as a result of the double campaign against dogmatic abuses on the one hand and revisionist misrepresentations on the other.

LUKÁCS'S THEORY OF 'GREAT REALISM'

The category of realism in Marxist aesthetics has attracted international attention. Questions of realistic content and form

are now subject to more subtle discussion than was the case when distorted and restricted revisionist and dogmatic views held sway. Exchanges of ideas on the subject brought shortcomings in Marxist aesthetics to the surface, shortcomings which arose from its state of stagnation, and started a fertile, creative discussion of neglected problems.

Why has the category of realism in Marxist aesthetics, and with it numerous other aspects of the interpretation of socialist realism, achieved for itself such a privileged, continuing and characteristic position in the centre of the debate? Because György Lukács's theory of 'great realism' – in spite of giving the correct answer to a number of questions on the Marxist interpretation of realism – provided at the same time a theoretical confirmation for both the misrepresentations of revisionism and the restrictive tendencies of dogmatism. It thus blocked the way to the healthy development of aesthetic theory, and as the dogmatic approach was abandoned and revisionism relegated to the background, it became increasingly obvious that his theory was incapable of answering the new questions arising in the development of socialist realism.

The essence of Lukács's theory is the application of Lenin's theory of reflection in the field of the arts, and in this respect it is creative and useful. The essence of the Marxist view of realism is that realist art reflects reality accurately, in all its complexity and totality; it penetrates the world of phenomena to seize and express the enduring laws of the internal dictates of social reality. One of the most important categories of this theory of realism is what is called 'intensive totality', meaning that realist art succeeds in fitting the particular social phenomena represented in a work of art into a coherent system of social reality; the category of the specific, harmonizing dialectically the particular and the general; and anthropocentrism which reveals the humanizing nature of realism. This theory helped to reveal the general criteria of realist representation, and produced one of the decisive criteria in judging the value of artistic

representation: faithfulness to reality. In principle, György
Lukács understood by realism the reflection of trends of reality
in their interrelations, and many of his conclusions are evidence
that, in theory at least, he did not connect this concept of
realism with the characteristics of nineteenth-century realist
style. 'The great writers of past periods,' he wrote in 1934,

Shakespeare, Cervantes, Balzac, Tolstoy, reflected their period in their
art fully, adequately and with vitality ... this is what we have to learn
from the great writers of past eras, not the outward form and the
technique. Nobody can or should write today like Shakespeare or
Balzac. The important thing is that we should discover the secret of
their basic creative method. And that secret lies precisely in the objec-
tivity, the living and moving reflection of the period, in the connec-
tions between its most essential features, in the unity of content and
form, and in the objectivity of the form as the concentrated reflection
of the widest interrelationships of objective reality.[3]

On the other hand – contradicting his own theoretical view –
Lukács in fact linked the intensive, true representation of reality
closely to the aesthetic construction of the great works of nine-
teenth-century critical realism, in point of fact, to the literary
movement of critical realism. In practice, therefore, he adopted
a theory in which the interpretation of realism was linked with
the ideals of style of the nineteenth century, and the two together
formed his critical yardstick. It must be pointed out that even
this theory of realism, bound as it is to set forms, contained
many positive features. To a very large extent Lukács was able
to institute a successful comparison of his own views with the
'*proletkult*' anti-traditional approach of early proletarian litera-
ture, and more especially with bourgeois decadence. And des-
pite its drawback, after liberation his theory was capable of
demonstrating the fundamental truths of the Marxist theory of
art, and providing a theoretical foundation for the comprehension

3. György Lukács, *A realizmus problémái* ('The Problems of Realism'),
Budapest, 1948.

of the essence of realism, the change from the non-realistic approach in art which had prevailed till then.

But György Lukács did not only abstract the most general characteristics of realism, of the aesthetic reflection of reality from the great works of earlier periods, especially the period of critical realism, but he became transfixed in their one-sided idealization. As was pointed out in the great Lukács debate of 1949–50, and even more in that of 1957–8, in the last resort his conservatism was closely connected with his rightist political-ideological views. Just as the (increasingly out of date) conception of 'real', or 'pure' democracy loudly propagated between 1945 and 1948 found itself in opposition not only, in fact, to fascism and formal democracy, but also to the dictatorship of the proletariat and the prospect of socialist revolution, so Lukács did not only oppose critical realism to bourgeois decadence, but implicitly to socialist realism as well. In many of his formulations, he left the class content of the concept of democracy undefined; its equivalent aesthetic quality, on the other hand, he clearly indicated as what he called 'great realism'. Just as in his discussion of basic ideological questions, he drew the line between democracy and fascism, so in the field of literature he thought almost exclusively in terms of the opposition of critical realism to bourgeois decadence. Essentially he made no criticism of critical realism at all from the socialist point of view. As the works written then simultaneously neglected the achievements and theory of socialist realism, above all of Soviet literature, they implied the inferiority of socialist realism to critical realism.

It was a characteristic of his theory that the emphasis he placed on the 'triumph of realism' was one-sided; he separated the objective representation of reality from ideology, he was in fact on the verge of opposing the one to the other. He consequently provided both the means to evade ideological transformation, so important in the development of socialist realism, on the one hand, and a basis to maintain the argument for spontaneity in art on the other. His theory restricted the sense of

commitment in literature in the main to lyric poetry, and by ignoring Marxist ideology as the essence of commitment he obliterated the demarcation line between bourgeois plebeian commitment and party commitment: in this case between Petőfi and Attila József. By describing the relationship of the artist to the party as 'partisanship', he created a terminology which – in the context of his article – justified the maintenance of bourgeois individualism and the rejection of the arts.[4]

That this was not merely an error of the moment is shown by the fact that in his subsequent writings Lukács has almost entirely evaded any discussion of revisionism, indeed, by stressing the necessity for critical realism in a socialist society, he gave added strength to the revisionist tendencies which at that time were playing an important role in literary life.[5] In his aesthetic study entitled 'The Specific', he continued to evade any analysis of the difference between an ordinary commitment and party commitment, and works of literary criticism he has written since 1957, defining the direct artistic criticism of the personality cult as the central task of literature, are evidence that he has retained the revisionist and biased views which set forth critical realism as a model to socialist realism.

Lukács's views, idealizing nineteenth-century realism, also impeded the unfolding of socialist realist art and theory in a further, indirect way. Since his interpretation of realism, combined with the literary standards of the nineteenth century, together formed a standard of evaluation, he was consequently unable to give a realistic and subtle picture of the bourgeois literature of the *fin de siècle* and of the twentieth century in his work. In relation to the absolute criterion of 'great realism', not only was socialist realism relegated to the background in his work, but the relative values of the various twentieth-century

4. György Lukács, *Irodalom és demokrácia* ('Literature and Democracy'), Budapest, 1948 (the chapter entitled 'Party Poetry').

5. 'The Struggle between Progress and Reaction in Contemporary Culture', *Társadalmi Szemle*, June–July 1956.

isms also became vague. In all the different and contradictory schools, from naturalism to expressionism, he saw only the decline of critical realism, the sign of bourgeois decadence. The problem is not primarily to what extent this limited the validity of what was basically justified criticism. His bias entailed the much graver consequence that it impeded the growth of that socialist realism which from its origin was not exclusively attached to the tradition of critical realism, but also drew on certain avant-garde ventures including humanist protest. From the beginning of the thirties Lukács classified as bourgeois or petty-bourgeois all those socialist experiments, regardless of their content, and purely on account of their abandonment of traditional forms, which attempted to make use of some of the twentieth-century experiments in the cause of socialist realism (his bias against techniques of montage and simultanism, the summary dismissal of German proletarian literature, the reduction of Brecht's art to no more than a formal experiment, etc.).

It was not through their own inherent powers that these defects in the theory of György Lukács came to wield such an influence on the theory and practice of socialist realism. If we remember that, within the boundaries of Marxism, a number of other opinions existed which in part corrected his errors (e.g., Brecht, Anna Seghers, and others), it becomes obvious that the dominant position achieved by Lukács's theory was due to certain historical factors.

In the first place, it must not be forgotten that socialist realism developed in the Soviet Union, where its theoretical aspects were first adumbrated, and was thus constructed organically on the great nineteenth-century traditions of the Russian realist novel and pre-Bolshevik art. This coincided with one of the primary tasks and achievements of the Soviet cultural revolution – the communication of this classical heritage to the masses, which in turn orientated their taste towards an easy acceptance of the art of Balzac or Stendhal. This and similar reasons (their investigation should be undertaken in a future history of socialist realism)

may clarify the historical reasons for the theoretical linking of socialist realism and 'great realism', though they do not excuse the theory itself. All this not only led to an ungenerous estimate of the traditional and the bourgeois art of the twentieth century, but also held back the development of a new socialist culture.

In the second place, some of György Lukács's conclusions were supported in sectarian practice. It is characteristic that – though, in the course of the 1949–50 Lukács debate, in which some of the arguments were designed to provide an ideological foundation for the personality cult, the Hungarian party leadership were able to uncover numerous rightist features in Lukács's views – they continued to build, even though only implicitly, on other erroneous conclusions of his. The aesthetics of 'great realism' accorded with the sectarian practices which isolated our theory and practice of art from the branch of socialist realism represented by the works of Brecht, Aragon and others; which declared Petőfi to be the aesthetic ideal instead of Attila József, and which, because of political suspicion and through administrative measures isolated the public not only from such twentieth-century bourgeois writers as Joyce, Proust and Kafka, but even from the majority of its works of critical realism (Steinbeck, Martin du Gard, O'Neill, Hemingway, the works of Sartre and Dürrenmatt, etc.).

In addition to distortions in theory and practice, a number of problems arose through the absence of an appropriate atmosphere for discussion, which would have enabled a few fundamental questions of the Marxist theory of realism to be clarified. The application of the theory of knowledge in aesthetics failed to pay sufficient attention to the attributes of art, to transitions in the process of reflection, to a proper analysis of the dialectical relationship between objective reality and the creative subject, to the emphasis to be laid on the active aspect of reflection, etc. Nor was it capable of clarifying its relationship to various movements and styles in art. The historical application of this theory not only treated the entire history of the arts as a struggle

between realism and anti-realism, in the strictest sense of the concepts, but led to the introduction of a specific terminology (classical realism, romantic realism, Shakespearean realism, etc.), which concealed the aesthetic characteristics of the different trends and movements in art, constituting objective facts. This attitude in truth either left it entirely to bourgeois critics to investigate and analyse these historical schools of art, or rejected false bourgeois concepts of art history in a manner which tacitly removed it from a Marxist analysis of the objective relationships on which it was based. Because of the stagnation in theoretical thinking, the problems which arose in certain branches of art (e.g., music, architecture) and even certain genres in literature itself (lyrical poetry) remained unexplored.

THE CONTEMPORARY DEBATE

With this background in mind, our questions today must be: what is the true object of art, or what – in the process of creating a work of art – is the relationship between the writer (creative artist) and objective reality; what is the relationship of realism to representation in art; what generally are the limits of art, and specifically those of realist art; what is the relationship between realism and various historical styles; is realism a method or a historical style? That these questions have now come to the fore undoubtedly marks a new period in the history of Marxist aesthetics. This new period is characterized by the fact that following the repulse of direct revisionist attacks, the debate is now between different Marxist views, or at the least between subjectively sympathetic views based on a Marxist outlook; it is therefore a fundamentally creative debate.

The new policy of book publication in Hungary, the application of a fresh critical eye to the history of art, and above all the actual practice of socialist art, have already decided the most important questions, i.e., the recognition of socialist realist works that do not fit into the category of 'great realism', the 'indepen-

dence' of style in socialist realism, the appreciation of certain bourgeois values. This makes it even more urgent to draw the necessary theoretical conclusions, the more so since the confrontation of realism and socialist realism within Marxism is inseparable from the struggle of Marxist and bourgeois art, and finally from the ideological struggle between the two world systems.

Let us, therefore, glance at contemporary Marxist views, or views prompted by Marxism, on the subject of realism and socialist realism.

'RÉALISME SANS RIVAGES'

One of these trends is represented by Roger Garaudy and Ernst Fischer. Primarily they oppose a rigid identification of the concept of realism with that of aesthetic value. The position they take up, however, extends the concept of realism to the point where it deprives the category as such of any aesthetic meaning, and makes the struggle against bourgeois decadence theoretically impossible.

It is one of the principal features of Roger Garaudy's study on the subject[6] that, in opposition to the vulgarized version of the theory of reflection, he lays great emphasis on the subjective presence of the creator, on the active, productive character of the creative process. If he had gone no further than correcting the passive interpretation of reflection, there would be no grounds for disagreement. But he went further in that, interpreting the work of art as the dialectical relationship of the subjective activity of the artist and the objective reality, he failed to understand that in this relationship the latter was finally decisive, and transposed it in favour of the creative subject. He emphasized the formative power of the artist and his creative activity to such an extent that objective reality, which exists independently of our

6. *D'un réalisme sans rivages*, Paris, 1963. (Published in Hungarian in the volume entitled *Parttalan realizmus?*, Budapest, 1965, Európa Publishers.)

consciousness, and which is after all the final object of any work of art, in fact took a completely secondary place. To him art meant primarily creative transformation; to all intents and purposes he ignored the fact that such an artistic 're-creation' of objective reality could equally well mean a falsification of reality on the one hand, or a more profound analysis on the other; finally the work of art had to be confronted with and checked against the objective reality. In one of his most recent articles[7] moreover, he relegated the cognitive role of art to the background. He defined the work of art as a model 'connecting man with the world'.[8] But despite his explanations the nature of this connection remained obscure, particularly in what the yardstick of the authenticity and reality of the model consisted. He wrote that 'priority of practice is what distinguishes dialectic materialism from all pre-Marxist manifestations'. But he never understood the cognitive, controlling function of practice, but only the notion of 'the creative initiative'. According to Garaudy it is the creative, formative activity of the artist that is the actual reality. It was on this theoretical foundation that he justified Cubism, or more exactly the 'realism' of the Cubists, and generally provided a theoretical foundation to justify all abstract art without a pictorial-functional connection with reality. (See especially his speech at the 'Week of Marxist Thought' in 1964.) And by his assertion that 'there is no art that is not realist, i.e., that does not refer to an external reality independent of the artist', he finds himself on common ground with the dogma he contests, since he likewise identifies art with realism. The dogmatic concept of realism excluded a number of works which had artistic merit from qualifying as works of realism and therefore as art. According to Garaudy, however, each of these works was realist and therefore qualified. This is how Garaudy put it:

7. 'Ernst Fischer and the Debate on Marxist Aesthetics', *Lettres Fran-çaises*, 29 July 1964.

8. This and subsequent quotations are translated from the Hungarian.

From Stendhal and Balzac, Courbet and Repin, Tolstoy and Martin du Gard, Gorky and Mayakovsky we can take and analyse the criteria of 'great realism'. And what do we do if the works of Kafka, Saint-John Perse or Picasso do not correspond to these criteria? Do we have to exclude them from realism, or from art? Or do we, on the contrary, have to open up and extend the definition of realism, and discover new dimensions of realism in the light of works characteristic of our century, thus enabling us to attach these new contributions to the heritage of the past?

Even if the good intentions of the writer are manifest, directed as they are against both a narrow exclusion of other values and a refusal to accept the possibility of contradictions, the form of the question bears witness, paradoxically, to a hidden persistence of dogmatism, i.e., the rigid identification of aesthetic value with realism. The author was under the influence of dogmatism in the question he raised; he assumed that a limited recognition of artistic value was unimaginable unless accompanied by the '*laisser passer*' of realism. But such an expansion of the concept of realism, amounting to its destruction, is not worth the advantage gained, nor does it in fact require this sacrifice of principle.

The position adopted by Ernst Fischer[9] is very similar to that of Roger Garaudy and leads to the same theoretical conclusion. It is in connection with Kafka that it can most clearly be seen that the dilution of the notion of realism leads inevitably to impugning the very existence of decadence. Interestingly enough, we have to make a distinction between the analyses of Kafka made by Garaudy and Ernst Fischer (as well as many other participants in the Kafka debate) and the theoretical conclusions which they respectively drew. Both Garaudy and Fischer pointed out Kafka's limitations. The idea running through Garaudy's thesis is that Kafka presented 'alienation within alienation'. Fischer wrote: 'Nor can the satirist Kafka rise above

9. Contribution by Ernst Fischer to the Kafka Conference at Liblice, May 1963, and his answer, 'Spring, Swallows and Franz Kafka', to A. Kurella, in *Tagebuch*, 1963, No. 11.

the world which weighs on him so oppressively', a statement which, incidentally, is a contradiction in itself, since satire presupposes from the outset a distance, a certain remoteness from the matter at issue. Yet both of them are anxious to include Kafka within the frontiers of realism. Fischer attempted it on the grounds that Kafka offered no way of escape, just as certain great critical realists of the nineteenth century offered no way of escape, and he could therefore be considered the critical realist of his period. As many studies[10] have pointed out, Kafka made alienation absolute, gave it a metaphysical character, and projected one aspect of reality on to the totality of human existence. It is beyond doubt that his work, taken as a whole, was not an apology for imperialism or for alienation, but it is also certain that the sole content of his protest was fear, pessimism without the essentials of tragedy, and these are the marks of decadence. It can and must be distinguished from realism aesthetically on grounds of intensive totality, and ideologically on account of its absolute subordination to the atmosphere of imperialism, since the aim of realism is to analyse causally and to take possession of phenomena through the recognition of relationships – by no matter what means, whether myths or symbols – but not to accept them as mysterious. And this is quite independent of the undoubted fact that Kafka expressed a certain state of consciousness with great artistic intensity, and that his works are of aesthetic value.

What are the positive and the negative aspects of the approach by Garaudy and Fischer, and what are the lessons to be learnt from them? They focused attention on the fact that it is not correct to establish a strict identity between realism and value and that the correction of this error necessitated the 'taking into possession' by Marxists of many formerly neglected works of

10. J. Knipovich, 'Franz Kafka', *Inostrannaya Literatura*, 1961, No. 1; Erwin Pracht, 'Clarification or Abandonment of the Realist Concept', *Sonntag*, 1964, No. 10–11. See also the volume entitled *Parttalan Realizmus?* referred to in footnote 6.

art; their criticism effectively revealed certain concrete values which we cannot afford to ignore; they drew attention to the importance of the creative personality, of the active nature of creation, and to the need of a more careful theoretical investigation of these points; and by raising some of these questions, and their comments, they have made a valuable contribution to the whole subject. But the theory of '*réalisme sans rivages*' is incompetent either to eliminate the distortions of dogmatism, because it is itself affected by these distortions, or to provide a basis for the critique of bourgeois art; in fact, it prevents it.

REALISM AS A METHOD

There is another point of view worth selecting for discussion from the extraordinarily complex and rich discussion revolving around the subject of realism. It follows in the footsteps of György Lukács's theory of 'great realism', with the essential difference that it attempts to avoid all those theoretical distortions which have sprung from the limitation of the Lukács concept to nineteenth-century literature. According to this view, realism is a creative method, a category which is a criterion of aesthetic value, and must be understood to mean what we have already described as the essentially correct aspects of Lukács's theory of 'great realism' (the exploration of the inner relationships and enduring laws of reality, intensive totality, specificity and an anthropocentric approach). It lays particular stress on the fact that the content and structure of realism changed in the course of history, and that at one and the same time different qualities have been attributed to them (e.g., Nyadoshivin, who has changed his earlier views).[11] And within this general thesis, there are essential further differences of opinion more particularly concerned with the historical and concrete character of realism. A number of art critics speak of historically concrete

11. *Voprosy Literatury*, 1957, No. 3.

manifestations of a realist method which appeared only with the bourgeoisie.

According to this thesis, socialist realism based on Marxist-Leninist ideology is the highest form of development of a realism which existed alongside or came into existence with bourgeois society, and which, if not on direct and formal, at any rate on methodological grounds of similarity, is closer to the realist traditions of the nineteenth century and to the general history of the arts than to the non-realist, mainly twentieth-century avant-garde schools, from which it has taken certain elements. This view does not link the concept of realism to the style of the nineteenth century, and this indicates a further separation from 'great realism'.

Realism does not dictate any compulsory method of representation, style, form; it enables reality to be presented in a number of ways; what is essential is that it should give a true picture of life, of human ideas and emotions.[12]

This view, therefore, even if some of its protagonists roundly maintain the theory of the struggle between realism and anti-realism, interprets the latter far more subtly. This finds expression also as regards terminology in the preference for the term 'non-realism' over 'anti-realism', but above all in its view of the history of art as the interplay between realist and non-realist trends. It abandons the principle of the rigid identification of artistic value with realism, and acknowledges that non-realist works and tendencies have a relative value affecting development and that these values may be incorporated into realism. It also recognizes that socialist realism may transform and utilize elements of non-realist or avant-garde schools. It is thus in a position to differentiate in its judgements on contemporary bourgeois art, by clearly recognizing which are the critical realist trends, but not denying aesthetic value to its non-realist schools. At the same time, on the same basis – and this is where

12. V. Shcherbina, 'Of Socialist Realism', *Voprosy Literatury*, 1957, No. 4.

its main importance and its partial justification lie – it has been in a position to take a very definite stand against the art, and the theory of art, of bourgeois decadence.

This concept of realism, however, also failed to investigate in depth the problem which had been correctly posed but only ambiguously solved by Garaudy and his adherents: the dialectic relationship between objective reality and the creative subject, mainly in connection with the active aspect of reflection and its expressive and aesthetic role. This is primarily why it recognizes the relative values of non-realism, and the role it has played in development, only in a theoretical declarative way. The theory thus remains too general, and its application to the history of art provides no inducement to examine more closely the relationship of content and form, and even less to explore the different schools and styles revealed in such an analysis. This theory is undoubtedly faced with the problem described by Timofeyev as follows:

If we concretize the concept of realism in this way, we are compelled to take the path leading to the inevitable separation of the concept into differentiated elements, and so to the individual realism present in the work of every great artist. But if, on the contrary, we prefer to integrate the concept, and try to define its most common, most universal attributes, then we arrive at abstract definitions which we may discover, in their simplest shape, even in works of primitive art.[13]

This point of view is also open to challenge in its concept of the relation of socialist realism to tradition. In the context of this theory it is impossible to claim, without inconsistency, that socialist realism is entirely 'open' and 'unbiased' towards tradition, because analogies of method, if not of style, link it more closely with earlier realist trends than with non-realist schools. It is in its passive recognition of the assimilative force of socialist realism and its power to synthesize styles and move-

13. 'Fundamentals of the Theory of Literature', Moscow, 1963, p. 87.

ments that the application and critical practice of the theory – especially in the discovery and acknowledgement of socialist realist works which also draw on the formal solutions of bourgeois art – proves itself over-timid.

It is obvious that what is here needed above all is that the truths of this theory, in the course of its application to the history of art, should be checked and its scope widened. It is only thus that one of the very important points of this theory, namely, what is understood by realism as a method, may be properly worked out. Theoretical explanations on this point[14] are rather obscure and too general.

These unsolved problems invite reservations not only on the possibilities of the historical application of this theory; they also touch directly on the questions of the ideological-artistic orientation of socialist realism.

THE THEORY OF REALISM AS A STYLE

Another view, that crystallized itself in the course of the debate, regards the evolution of the arts as the process and interplay of historically concrete trends of style; its objective is to describe the characteristics of the styles of the various periods, of the different schools of art and changing trends, and to interpret and systematize them in terms of Marxism (mainly from the economic and the socio-historical angle). This approach is descriptive, analytical and historical. Realism is regarded neither as a method nor as an aesthetic category, but as a style with a historical development. (In so far as the principle is concerned, it is irrelevant when it is supposed to have begun and how long it lasted.) For the time being, this school of thought maintains that socialist realism has no special link of style with earlier bourgeois realism. In theory it is independent of traditions, it makes use of everything equally; its relation to tradition

14. J. Boryev, 'Of the Nature of the Artistic Method', *Voprosy Literatury*, 1957, No. 3.

lies in its power of deliberate synthesis. According to this view (or rather according to some of its proponents), periods and styles of art are only closely linked to the ideology of a class in their initial stages, and it is only in those stages that they have a definite ideological content; in the course of further development they lose their class character (as language does) and are capable of conveying various and even contradictory ideological contents. Again, according to this view socialist realism likewise divides into a 'realist' and a 'non-realist' trend in so far as style is concerned, and in contemporary bourgeois literature both tendencies may be found. The ideological struggle, therefore, is or may be conducted within each of the individual schools or movements in art. Socialist realism, consequently, does not do battle with this or that movement or style, but with the non-socialist or hostile ideologies which may make their appearance in one or the other, and are distinguishable from them. If this approach is carried through consistently, the term 'realism' within 'socialist realism' loses all meaning.

This view has successfully opposed the dogmatic theory and practice which gave a given style or movement the authority of an aesthetic standard, or made it an indispensable element of it. But it frequently failed to note the danger that in the struggle against distortions in the theory of realism, it might not only make the necessary correction but, by regarding realism as no more than a category in the history of style, throw overboard a basic evaluating principle of Marxist aesthetics, a principle which led to confrontation with reality. As a result this view of socialist realism, despite its many achievements, reveals a certain indecision, for the time being, in the criteria of evaluation. It correctly opposes the imposition of arbitrary aesthetic norms to styles of art, but as a general rule it avoids any positive expression of an objective aesthetic criterion or refers in only a formal way to the necessity of confronting reality; through a more sensitive observation of the attributes of art it contributes towards overcoming the philosophical-epistemological bias of Marxist

aesthetics, but it does nothing to encourage the further elaboration of aesthetic criteria and yardsticks of aesthetic value. On occasion it oversimplifies the economic-social explanation of the different schools of art and has the effect of justifying their existence indiscriminately, and so obliterating the difference in aesthetic value between contemporaneous phenomena and making the concept of evolution largely relative, etc. From the point of view of socialist realism, it is inclined to identify socialist realist art (and within this: party commitment) with the Marxist ideology. This may indeed result in a valuable correction of the bias in the attitude previously described, which treats realism as a method, but it abandons any examination of the laws governing the optimum reflection of reality, and exposes itself to the charge of aesthetic relativism.

The discussion of all these views and opinions has set the long stagnating theory of Marxist aesthetics in motion, and made it clear that more work on the history and theory of socialist realist art is indispensable to its further development. The debates have drawn attention to areas of Marxist aesthetics which had formerly been neglected – the individuality of the creative artist, the role of ideology in the process of creation, the relation of realism as a method to other trends and styles – and have achieved concrete results in the criticism of a number of theoretically incorrect views; they have consequently aided in the further development of the theory of socialist realism and also in creative and cultural-organizational work.

The fact that the debate is not closed, and that its continuation is desirable, does not mean that we cannot abstract from the process of socialist realist art – through utilizing the cream of Marxist aesthetic thought – such fundamental aesthetic principles of socialist realism as may serve as a correct guide to art, criticism and the general public. This must be stressed since these debates have given many people a false impression of an uncertainty or even 'crisis' in Marxist aesthetics.

*

The paper goes on to discuss the connections between art and ideology. Socialism is the first society of which the decisive criteria may be scientifically conceived before it has come fully into existence. Socialist realism is the reflection in art of the conscious formation of a society.

Marxism-Leninism knows human existence to be essentially rational, and the social practice of the workers' movement is motivated by the realization that the harmonious development of man, his complete freedom, only become possible through the radical transformation of the material foundations of life and the social order through the construction of socialism. Socialist realist art is imbued with a humanism which is more active and more communal than any existing heretofore and expresses the best efforts of, and desires to exert an influence on, the broadest masses. Party commitment – according to Lenin's definition of 1905 – is the conscious, direct and open acceptance of the general class position of art, the support of the struggle conducted by the working class for the victory of socialism, and its expression through the medium of art. This separates socialist realism not only from general commitments in the arts, but also from the outlook on poetry of today's bourgeois humanist alignment, and opposes it to bourgeois art and the bourgeois theory of art which declares that the arts should be impartial, above the classes, and uncommitted. The principle underlying the connection between party commitment and socialist realism is that the discovery of reality, the mastery of reality, and the uninterrupted overtaking of reality represent the vital interests of the working class.

In the period of the personality cult the connection between the party and the masses broke, and it could be asked whether the artist should adhere to the party or to the people, whether he should serve the means, declared to be the end, or the end itself.

Art that identifies itself with the objectives of the working class cannot dispense with direction from the party, primarily

in the form of ideological advice. In its struggle for socialism the party cannot dispense with such an effective medium as art for the discovery of truth, the formation of consciousness and the education of taste. Direction by the party is primarily ideological direction; in its narrower sense it merely serves to express the artistic needs of the people, of society, of socialist construction, and to fulfil the obligation to engage in ideological critique. The removal of all ideological, cultural and aesthetic obstacles standing between art and the masses is a further part of the task of party direction.

The paper then passes to the critique of contemporary bourgeois art. In the period of imperialism the role of the bourgeois artist has been increasingly reduced to defence of the subjective freedom of the isolated 'self', and this has gone hand in hand with a strong movement towards art as the expression of an interior and private world, the abandonment of any demand for a comprehensive aesthetic picture of the world, an abdication by the arts of the acquisition of social reality. Bourgeois art – states the paper – is only secondarily apologetic in so far as its subjective intention is concerned; in what is decisive it betrays the malaise of the person living in the world of imperialism. But its protest increasingly loses its critical character. Or, if the protest is maintained, it is – through the intermixture of a form of acquiescence – at the same time combined with such historical scepticism and pessimism that the attitude which emerges objectively serves the interests of those wishing to maintain the status quo, and negatives the humanist tendencies of its starting point. In the twentieth century those bourgeois writers who have been able to continue the inheritance of critical realism and offer a humanist critique of bourgeois society are those who sought the path of humanism in the direction of socialism or who were influenced by Marxism in their picture of social reality (France, Dreiser, Roland, Jack London, H. G. Wells, Martin du Gard, Thomas Mann, Hemingway, Sartre, etc.).

Socialist realism expresses reality in all its various contexts –

the paper states. But this in no way means a demand for extensive totality, that the work of art should in fact show all (or a great number of) the relationships, or all (or a very large number of) the aspects of life. It does not mean a limitation in the choice of subject or genre. But it does demand the practice of intensive totality, the obligation that the smallest movement of life, which may have been selected almost at random to appear in the form of art, should, in its treatment and context, connect with the totality of social reality, that the movement selected should play a part in the work of art which is in fact determined by the totality.

It is mainly its social-historical concreteness which opposes socialist realism to those abstract tendencies which characterize bourgeois decadence and which deprive the subject-matter of art of its social-historical content. The illusory abstraction of the 'eternal in human nature', of the 'universally human', is a milder form of this; and the elimination of all social aspects, carried to the extreme, leads to the dehumanization of art, to the supremacy accorded to questions of technique, to anti-aesthetic abstraction. Socialist realism bases itself on concrete, social-historical foundations in opposing every kind of academic, pseudo-contemporary and dogmatic art, all of them different variations of bad abstract art. But socialist realism does not exclude, it even presupposes a certain aesthetic abstraction which serves the better recognition of the essential reality and which therefore always maintains a functional connection with it.

Critical realism was mainly concentrated on the distortion of man by society; its conflicts were the tensions aroused between noble sentiments and the immorality of the social structure, between a man's longing for a full life and the restrictive restraint imposed on him, between the need of the individual for freedom and his isolation; its heroes were caught in insoluble dilemmas, in the net of a thousand hostile contradictions. It is true that these contradictions do not disappear in the struggle for a socialist society, nor even after its realization; but with the

struggle of the workers' movement for power and even more
with the coming of a socialist society which alters property
relations, the objective possibility of actively surmounting them
is created and the historical process of their solution begins.
Socialist realism, therefore, is quick to react in a sensitive
manner to new aspects of the interrelations existing between the
individual and the community, to all constructive aspects of
character and situation pointing towards socialism and in line
with general progress. All this does not mean that the diffi-
culties, the negative aspects of problems, the mistakes which
occur in the construction of socialism on new levels and in new
forms are not to be fairly presented. Socialist realism maintains
the critical function of bourgeois realism, but goes beyond it.

Dealing with the question of the personality cult as the sub-
ject-matter of art, the paper points out that with the progress
of events, socialist realism is now less devoted to direct, imme-
diate criticism of the personality cult expressed in terms of art,
and more to its factual, objective criticism – to the description
of socialist construction advancing beyond the personality cult
and freed from its shackles. The constructive process of socia-
lism has freed itself from the personality cult and escaped from
the quagmire in which it was caught. The aesthetic representa-
tion of contemporary reality is distorted and realism is violated
if the critical tendency of art is not accompanied by manifesta-
tions of the actual dynamism of social progress, if criticism of
difficulties and mistakes is undertaken by means of the old
method of critical realism, and not by the intensive confronta-
tion of the new and the old which characterizes socialist realism.

In socialist realism, conflict can only be interpreted in terms of
the representation of reality in process of development. Certainly
the conflicts, the contradictions, the struggle between old and
new are to be laid bare, but at the same time, in accordance
with the objective dialectic of reality, it is the duty of artists to
show the history of mankind as a process of development. Con-
flict is essentially the struggle between the old and the new. In

socialist realism there can be no conflict without giving a sense of the direction followed by progress; on the other hand, without conflict the development of reality cannot be represented. Socialist realism is not to be interpreted as the art of some far-off period when conflicts have 'withered away', since it is the art of a given period, the period of proletarian revolutions, of socialist construction, and the number and intensity of the historical conflicts of this period are undeniable.

Discussing the connection between literature, art and the masses, the paper points out that socialist realist art, closely in contact with the masses, aligned with the struggle of the working class, represents the best efforts of the whole people. Its expressive and descriptive functions accord with the socialist formation of emotion, thought and taste, and their social role. Its educational role consists in conveying a sense of social-historical reality to the hidden depths of the personality, through a wide-ranging education and the harmonious development of the whole person and by the aesthetic influence it exerts. This sense of social-historical reality is conveyed, in terms of Marxist-Leninist ideology, by socialist realist art, which at the same time gives a further impetus to its transformation. Bourgeois art is incapable of dissolving the contradiction between an aristocratic art directed to the few and the low aesthetic standards of mass production offered to the masses.

In conclusion the paper lists some of the problems of socialist realism still awaiting theoretical research. These are: the application of the theory of socialist realism to what are known as the 'non-mimetic' arts (music and architecture); the clarification of the problems of that 'revolutionary romanticism' which was stressed in the thirties by Gorky, Fadeyev and others, but has lost its importance today; the question of the positive hero, the socially active man; the concrete and historical investigation into relations of content and form; the establishment of general criteria applicable to the socialist realist arts developing in different national societies; socialist realist theory applied to the aesthetic

branches of technical developments (film, radio, TV); and finally the application of socialist realist theory to contemporary processes of art, the elimination of the biased and anachronistic standards of the nineteenth century, and the further work on the history of socialist realist theory itself.

16
Fidel Castro

Words to the Intellectuals

On 16, 23, and 30 June, meetings were held in the auditorium of the National Library in Havana, in which participated the most representative figures of the Cuban intelligentsia. Artists and writers had full opportunity to discuss and expound their points of view on different aspects of cultural activity and problems related to creative work. Present at the meetings were the President of the Republic, Dr Osvaldo Dorticós Torrado; the Prime Minister, Dr Fidel Castro; the Minister of Education, Dr Armando Hart; members of the National Council of Culture, and other representatives of the government.

Comrades:

After three sessions in which various problems related to culture and creative work were discussed, in which many interesting

FIDEL CASTRO is the organizer and the inspiration of the Cuban Revolution, which achieved state power at the start of 1959. The text included here dates from 1961, and consists of Fidel Castro's remarks to a meeting of artists and intellectuals in Havana after hearing diverse viewpoints on cultural policy for the Revolution. It should be said that the principle of tolerance for all points of view, so long as these are not plainly partisan to counter-revolution, has been maintained, although the circumstances in the brief jailing of the poet Heberto Padilla, as this volume was prepared for the press in early 1971, caused widespread apprehension that an unhappy new situation might arise.

questions were raised and different points of view expressed, it is now our turn. We shall not speak as the person best qualified to deal with this matter, but because we feel it necessary to express certain points of view.

We were very interested in these discussions, and I believe we have demonstrated what might be called 'great patience'. But actually, no heroic effort was necessary on our part, because for us it has been an enlightening discussion and, said in all sincerity, a pleasant experience. Of course, in this type of discussion we, the men of the government, are not the most qualified to express an opinion on questions in which you are specialists. At least . . . that is my case.

The fact that we are men of the government and revolutionary leaders does not mean that we are obliged (although perhaps we are) to be experts in everything. It is possible that if we took many of the comrades who have spoken here to a meeting of the Council of Ministers to discuss the problems with which we are most familiar, they would feel the way we feel now.

We have been an active force in this Revolution, in the socio-economic Revolution taking place in Cuba. That socio-economic Revolution will inevitably produce a cultural Revolution.

On our part, we have tried to do something in this field (although the beginning of the Revolution presented more pressing problems). We might criticize ourselves by saying that we had somewhat neglected the discussion of a question as important as this. That is not to say that we had forgotten it completely; a discussion like this was already being thought of by the government. Months ago we intended to call a meeting to analyse the cultural problem, but important events kept taking place in rapid succession, preventing an earlier meeting. However, the Revolutionary Government has been taking measures that express our concern with this problem. Something has been done, and several members of the government, on more than one occasion, have brought the question up. For the time

being it can be said that the Revolution itself has already brought about changes in the cultural field, that the artists' conditions of work have changed.

I believe that some pessimistic aspects have been somewhat over-emphasized: I believe that worries have been expressed here that are without foundation. The actual changes that have occurred in this field and the present conditions of artists and writers have been almost passed over in the discussion. Comparing with the past, it is unquestionable that Cuban artists and writers now work under better conditions than in the past, which was truly discouraging for artistic endeavour. If the Revolution started off by bringing about a profound change in the atmosphere and conditions of work, why fear that this same Revolution would destroy them?

It is certain that this is not a simple problem. It is certain that it is the duty of all of us to analyse it carefully. It is your obligation as well as ours. It is a problem that has arisen many times and in all revolutions. It is a most complicated problem, not easily solved.

The different comrades who have spoken here expressed a great many points of view, and they gave their reasons for them. The first day there was a little timidity in broaching the subject; it became necessary for us to ask the comrades to tackle the subject squarely, to say that everyone here should say openly what worried him.

If we are not mistaken, the fundamental problem that hung in the atmosphere here was the problem of freedom of artistic creation. When writers from abroad have visited our country, political writers above all, these questions have been brought up more than once. It has undoubtedly been a subject of discussion in all countries where profound revolutions like ours have taken place.

By chance, shortly before we returned to this hall, a comrade brought us a pamphlet including a brief conversation between us and Sartre on this subject. It was taken from Lisandro Otero's

book *Conversations at the Lake* (*Revolución*. Tuesday, 8 March, 1960).

A similar question was asked us on another occasion by Wright Mills, the North American writer.

I must confess that in a certain way these questions found us a little unprepared. We did not have our Yenan Conference with Cuban artists and writers during the Revolution. In reality, this is a revolution whose period of gestation and arrival to power took place in what we might call record time. Unlike other revolutions, it did not have all the principal problems resolved. One of the characteristics therefore has been the necessity of facing problems under the pressure of time. And we are like the Revolution, that is, we have improvised quite a lot. Therefore it cannot be said that this Revolution has had either the period of gestation that other revolutions have had, nor leaders with the intellectual maturity that the leaders of other revolutions have had. We believe that we have contributed as much as we could to the present happenings in our country. We believe that with the effort of all we are carrying out a true Revolution, and that this Revolution is developing and seems destined to become one of the important events of the century. However, despite that fact, we who have had an important part in these events do not consider ourselves revolutionary theoreticians or intellectuals. If men are judged by their deeds, perhaps we would have the right to consider our merit to be the Revolution itself. And yet we do not think so, and believe that we should all have similar attitudes, regardless of what our work has been. As meritorious as our work may seem, we should begin by placing ourselves in the honest position of not presuming that we know more than others, of not presuming that our points of view are infallible, and that all who do not think exactly as we do are mistaken. That is, we should place ourselves in an honest position, not of false modesty, but of true evaluation of what we know. If we place ourselves in that position, I believe that it will be easier to advance with confidence. If we all adopt that attitude,

you as well as we, subjective attitudes will disappear, that certain subjective element in the analysis of the problems will disappear too. Actually, what do we know? We are all learning. We all have much to learn, and we have not come here to teach: we have come to learn too.

There have been certain fears, and some comrades have expressed those fears.

Listening to them, we thought at times that we were dreaming. We had the impression that our feet were not firmly on the ground. Because if we have any fears or worries today, they are connected with the Revolution itself. The great concern of all should be the Revolution itself. Or do we believe that the Revolution has already won all its battles? Do we believe that the Revolution is not in danger? What should be the first concern of every citizen today? Should it be the concern that the Revolution is going to go beyond what is necessary, that the Revolution is going to stifle art, that the Revolution is going to stifle the creative genius of our citizens? Should it be the dangers, real or imaginary, that might threaten the creative spirit, or the dangers that might threaten the Revolution itself? . . . It is not a question of our invoking this danger as a simple point of argument; we wish to say that the concern of all revolutionary writers and artists, of all writers and artists who understand the Revolution and find it just, should be: what dangers threaten the Revolution and what can we do to help the Revolution? We believe that the Revolution still has many battles to fight, and we believe that our first thought and first concern should be: what can we do to assure the victory of the Revolution? That comes first, the Revolution itself, and then, afterwards, we can concern ourselves with other questions. This is not to say that we should not think of other problems, but that the fundamental concern in our mind should be the Revolution.

The problem that has been under discussion here and which we are going to tackle is the problem of freedom of writers and artists to express themselves.

You have been worrying about whether the Revolution will choke this freedom, whether the Revolution will stifle the creative spirit of writers and artists.

Freedom of form has been spoken of here. Everyone agrees that freedom of form must be respected. I believe there is no doubt as regards this point.

The question is more delicate, and actually becomes the essential point of discussion, when one deals with freedom of content. This is a subtle matter, as it is open to the most diverse interpretations. The most controversial point of this question is: should we or should we not have absolute freedom of content in artistic expression? It seems to us that some comrades defend the affirmative. Perhaps because of fear that what they consider prohibitions, regulations, limitations, rules, authorities, will decide on the question.

Permit me to tell you in the first place that the Revolution defends freedom; that the Revolution has brought the country a very high degree of freedom; that the Revolution cannot by its very nature be an enemy of freedom; that if some are worried about whether the Revolution is going to stifle their creative spirit, that worry is unnecessary, that worry has no reason to exist.

What can be the reason for such worry? Only those who are not sure of their revolutionary convictions can be truly worried about that problem. He who does not have confidence in his own art, who does not have confidence in his ability to create, can be worried about this matter. And it should be asked whether a true revolutionary, whether an artist or intellectual who feels the Revolution and who is sure that he is capable of serving the Revolution, has to face this problem, that is, if doubts may arise for the truly revolutionary writers and artists. I feel that the answer is negative, that doubt is left only to the writers and artists who, without being counter-revolutionaries, are not revolutionaries either. And it is correct that a writer or artist who is not truly revolutionary should pose that question: that

an honest writer or artist, who is capable of comprehending the cause and the justice of the Revolution without being part of it, should face that problem squarely. Because a revolutionary puts something above all other questions; a revolutionary puts something above even his own creative spirit; he puts the Revolution above everything else. And the most revolutionary artist is the one who is ready to sacrifice even his own artistic calling for the Revolution.

No one ever thought that every man, every writer, or every artist has to be a revolutionary, as no one believes that every man or every revolutionary has to be an artist, or that every honest man, for the very reason that he is honest, has to be a revolutionary. To be a revolutionary is also to have an attitude towards life, to be a revolutionary is also to have an attitude towards existing reality; there are men who are resigned and adapt themselves to reality, and there are men who are not able to resign or to adapt themselves to that reality but try to change it; that is why they are revolutionaries. But there can be men who adapt themselves to reality and are honest men, except that their spirit is not a revolutionary spirit, except that their attitude towards reality is not a revolutionary attitude. And there can be, of course, artists, and good artists, who do not have a revolutionary attitude towards life, and it is for precisely that group of artists and intellectuals that the Revolution constitutes a problem.

For a mercenary artist or intellectual, for a dishonest artist or intellectual, it would never be a problem; he knows what he has to do, he knows what is in his interest, he knows where he is going.

The real problem exists for the artist or intellectual who does not have a revolutionary attitude towards life but who is, however, an honest person. It is clear that he who has that attitude towards life, whether he is revolutionary or not, whether he is an artist or not, has his goals, has his objectives, and we should all ask ourselves about those goals and objectives. For the revolu-

tionary, those goals and objectives are directed towards the change of reality; those goals and objectives are directed towards the redemption of man. It is man himself, his fellow man, the redemption of his fellow man that constitutes the objective of the revolutionary. If they ask us revolutionaries what matters most to us, we will say *the people*, and we will always say *the people*. *The people* in their true sense, that is, the majority of the people, those who have had to live in exploitation and in the cruellest neglect. Our basic concern will always be the great majority of the people – that is, the oppressed and exploited classes. The point of view through which we view everything is this: whatever is good for them will be good for us; whatever is noble, useful, and beautiful for them, will be noble, useful and beautiful for us. If one does not think of the people and for the people, that is, if one does not think and does not act for the great exploited masses of the people, for the great masses which we want to redeem, then one simply does not have a revolutionary attitude.

It is from this point of view that we analyse the good, the useful, and the beautiful of every action.

We understand that it must be a tragedy when someone understands this and nonetheless has to confess that he is incapable of fighting for it.

We are, or believe ourselves to be, revolutionaries. Whoever is more of an artist than a revolutionary cannot think exactly the same as we do. We struggle for the people without inner conflict, we know that we can achieve what we have set out to do. The principal goal is *the people*. We have to think about the people before we think about ourselves, and that is the only attitude that can be defined as a truly revolutionary attitude. And it is for those who cannot or do not have that attitude, but who are honest people, that this problem exists; and just as the Revolution constitutes a problem for them, they constitute a problem with which the Revolution should be concerned.

The case was well made that there were many writers and artists who were not revolutionaries, but were, however, honest

writers and artists; that they wanted to help the Revolution, and that the Revolution is interested in their help; that they wanted to work for the Revolution and that, at the same time, the Revolution was interested in their contributing their knowledge and efforts on its behalf.

It is easier to appreciate this when specific cases are analysed: and among those specific cases are many that are not easy to analyse. A Catholic writer spoke here. He raised the problems that worried him and he spoke with great clarity. He asked if he could make an interpretation of a determined problem from his idealistic point of view or if he could write a work defending that point of view. He asked quite frankly if, within a revolutionary régime, he could express himself in accordance with those sentiments. He posed the problem in a form that might be considered symbolic.

He was concerned about knowing if he could write in accordance with those sentiments or in accordance with that ideology, which was not exactly the ideology of the Revolution. He was in agreement with the Revolution on economic and social questions, but his philosophic position was distinct from that of the Revolution. And this case is worthy of being kept well in mind, because it is a case representative of the group of writers and artists who demonstrate a favourable attitude towards the Revolution and wish to know what degree of freedom they have within the revolutionary conditions to express themselves in accordance with their feelings. That is the group that constitutes a problem for the Revolution, just as the Revolution constitutes a problem for them, and it is the duty of the Revolution to be concerned with these cases; it is the duty of the Revolution to be concerned with the situation of those artists and writers, because the Revolution ought to bend its efforts towards having more than the revolutionaries, more than the revolutionary artists and intellectuals, move along with it. It is possible that the men and women who have a truly revolutionary attitude towards reality do not constitute the greatest sector of

the population: the revolutionaries are the vanguard of the people, but the revolutionaries should bend their efforts towards having all the people move along with them, the Revolution cannot renounce the goal of having all honest men and women, whether writers and artists or not, moving along with it; the Revolution should bend its efforts towards converting everyone who has doubts into a revolutionary. The Revolution should try to win over the greatest part of the people to its ideas; the Revolution should never give up counting on the majority of the people, counting not only on the revolutionaries, but on all honest citizens who, although they may not be revolutionaries, that is, although they may not have a revolutionary attitude towards life, are with the Revolution.

The Revolution should give up only those who are incorrigible reactionaries, who are incorrigible counter-revolutionaries. Towards all others the Revolution must have a policy: the Revolution has to have an attitude towards those intellectuals and writers. The Revolution has to understand the real situation and should therefore act in such a manner that the whole group of artists and intellectuals who are not genuinely revolutionaries can find within the Revolution a place to work and create, a place where their creative spirit, even though they are not revolutionary writers and artists, has the opportunity and freedom to be expressed. This means: within the Revolution, everything; against the Revolution, nothing. Against the Revolution, nothing, because the Revolution has the right to exist, and no one shall oppose the right of the Revolution to exist. Inasmuch as the Revolution understands the interests of the people, inasmuch as the Revolution signifies the interests of the whole nation, no one can justly claim a right in opposition to the Revolution.

I believe that this is quite clear. What are the rights of the writers and artists, revolutionary or non-revolutionary? Within the Revolution, everything; against the Revolution, nothing.

And there is no exception for artists and writers. This is a

general principle for all citizens. It is a fundamental principle of the Revolution. The counter-revolutionaries, that is, the enemies of the Revolution, have no claims against the Revolution, because the Revolution has the right to exist, the right to develop, and the right to succeed. And who could cast doubt on that right, the right of a people who have said, *Our Country or Death*, that is, *The Revolution or Death*?

The life of the Revolution or nothing – the life of a Revolution that has said, 'WE WILL WIN', that is, that has made a serious statement of its purposes. And respectable as the personal reasons of an enemy of the Revolution may be, the rights and reasons of a Revolution have more weight, the more so as a Revolution is a historic process, as a Revolution is not and cannot be a result of caprice, of the will of one man, as a Revolution can only be the need and the will of a people. And before the rights of an entire people, the rights of the enemies of the people do not count.

We were speaking of extreme cases only in order to express our ideas more clearly. I have already said that among those extreme cases there is a great variety of mental attitudes and there is also a great variety of worries. To be concerned about some aspect of the Revolution does not necessarily mean that one is not a revolutionary. We have tried to define basic attitudes.

The Revolution cannot be trying to stifle art or culture when one of the goals and one of the fundamental purposes of the Revolution is to develop art and culture, so that our artistic and cultural treasures can truly belong to the people. And just as we want a better life for the people in the material sense, so do we want a better life for the people in a spiritual and cultural sense. And just as the Revolution is concerned with the development of the conditions and forces that will permit the people to satisfy all their material needs, so do we also want to create the conditions that will permit the people to satisfy all their cultural needs.

Is the cultural level of our people low? Until this year a high percentage of the people did not know how to read and write.

A high percentage of the people have known hunger, or at least live or used to live under wretched conditions, under conditions of misery. Part of the people lack a great many of the material goods they need, and we are trying to bring about conditions that will permit all these material goods to reach the people.

In the same way we should bring about the necessary conditions for all cultural manifestations to reach the people. This is not to say that the artist has to sacrifice the artistic worth of his creations. It is to say that we have to struggle in all ways so that the artist creates for the people and so that the people in turn raise their cultural level and draw nearer to the artist. We cannot set up a general rule: all artistic manifestations are not of exactly the same nature, and at times we have spoken here as if that were the case. There are expressions of the creative spirit that by their very nature are much more accessible to the people than other manifestations of the creative spirit. Therefore it is not possible to set up a general rule, because we have to ask the questions: What principles of expression should the artist follow in his effort to reach the people? What should the people demand from the artist? Can we make a general statement about this? No. It would be oversimplified. It is necessary to strive to reach the people in all creative manifestations, but in turn it is necessary to do all we can to enable the people to understand more, to understand better. I believe that this principle is not in contradiction to the aspiration of any artist – and much less so if it is kept in mind that men should create for their contemporaries.

We say that there are no artists who create only for posterity, because, without considering our judgement infallible, I believe that whoever is proceeding on this assumption is a victim of self-hypnosis.

And that is not to say that the artist who works for his contemporaries has to renounce the possibility of his work becoming known to posterity, because it is precisely by being created for the artist's contemporaries, regardless of whether his contem-

poraries have understood him or not, that many works have acquired historical and universal value. We are not making a Revolution for the generations to come, we are making a Revolution with this generation and for this generation, independently of its benefits for future generations and its becoming a historic event. We are not making a Revolution for posterity: this Revolution will be important to posterity because it is a Revolution for today and for the men and women of today.

Who would follow us if we were making a Revolution for future generations?

We are working and creating for our contemporaries, without depriving any artistic creation of aspirations to eternal fame.

These are truths that we should all analyse with honesty. And I believe that it is necessary to start from certain basic truths in order not to draw false conclusions. We do not see that any honest artist or writer has reason for concern. We are not enemies of freedom. No one here is an enemy of freedom. Whom do we fear? What authority is going to stifle our creative spirit? Do we fear our comrades in the National Council of Culture? In talks we have held with members of the National Council of Culture we have observed feelings and points of view that were far removed from the concerns expressed here about limitations on style, expression, etc., imposed on the creative spirit.

Our conclusion is that our comrades in the National Council of Culture are as concerned as all of you about the bringing about of the best conditions for the creative endeavours of artists and intellectuals. It is the duty of the Revolution and the Revolutionary Government to see that there is a highly qualified organization which can be relied upon to stimulate, encourage, develop, and guide, yes, guide, that creative spirit: we consider it a duty. And can this perhaps constitute an infringement on the rights of writers and artists? Can this constitute a threat to the rights of writers and artists, implying that there will be arbitrary measures, or excessive authority? It would be the same as being afraid that the police will attack us when we pass a

traffic light. It would be the same as being afraid that a judge will condemn us. The same as being afraid that the force existing in the Revolutionary Power may commit an act of violence against us.

We would then have to worry about many things. And nevertheless, the attitude of the citizen is not that of believing that the militiaman is going to fire at him, that the judge is going to punish him, that the State Power is going to use violence against his person.

The existence of an authority in the cultural order does not mean that there is reason to be worried about that authority being abused. Who thinks that such a cultural authority should not exist? By the same token, he could think that the Police should not exist, that the State Power should not exist, and also that the State should not exist, and if anyone is so anxious for the disappearance of the slightest traces of State authority, then let him stop worrying, let him have patience, for the day will come when the State will not exist either!

There has to be a Council that guides, that stimulates, that develops, that works to create the best conditions for the work of the artists and the intellectuals. And what organization could be the best defender of the interests of the artists and the intellectuals if not that very Council? What organization has proposed laws and given rise to various kinds of measures to raise those conditions, but the National Council of Culture? What organization proposed a law for the creation of the National Publishing House to remedy those defects that have been pointed out here? What organization proposed the creation of the Institute of Ethnology and Folklore, but the National Council? What organization has advocated the making available of the allocations and foreign currency necessary for importing books that had not entered the country in many months; the buying of material so that painters and plastic artists can work? What organization has been concerned with the economic problems, that is, with the material conditions of the artists? What organiza-

tion has been concerned with a whole series of present-day needs of writers and artists? What organization has defended, within the government, the budgets, the buildings, and the projects directed at improving your working conditions? That organization is none other than the National Council of Culture.

Why view that Council with reservation? Why fear that it will do exactly the opposite: limit our conditions, stifle our creative spirit?

It is possible to conceive of someone with no problems at all being concerned about that authority: but in reality those who appreciate the necessity of all the steps the Council has had to take, and all the work it has to do, cannot ever look at it with reservations, because the Council also has an obligation to the people and it has an obligation to the Revolution and to the Revolutionary Government. And that obligation is to fulfil the objectives for which it was created, and it has as much interest in the success of its work as each artist has in the success of his.

I don't know if I've failed to touch upon some of the fundamental problems that came up here. The problems involved with a certain film were discussed a great deal. I have not seen the picture, although I want to see it, I am curious to see it. Was the picture dealt with unfairly? As a matter of fact, I believe that no picture has received such honours and that no picture has been so discussed.

Although we have not seen that picture, we have referred to the judgement of comrades who have seen it, including the President and different members of the National Council of Culture. And their opinion deserves respect from all of us; but there is something I believe cannot be disputed, and that is the right established by law to exercise the function that was exercised in this case by the Board of Censors. Perhaps that right of the government is being disputed? Does or doesn't the government have the right to exercise that function? For us, what is fundamental in this case is, above all, to determine if the government did or did not have that right; the question of procedure could

be discussed, as it was, to determine if it was fair or not, if another procedure would have been better, if the decision was just or not. But there is something that I believe no one is entitled to dispute, and that is the government's right to exercise that function. For if we challenge that right then it would mean that the government does not have the right to review the pictures that are going to be shown to the people.

And I believe that this is a right that cannot be disputed. There is, in addition, something that we all understand perfectly, and that is that among manifestations of an intellectual or artistic nature there are some that are more important than others as far as the education or the ideological development of the people is concerned. And I do not believe that anyone can dispute the fact that one of these fundamental and highly important media is the movies, as well as television. Now, can anyone dispute, in the midst of the Revolution, the government's right to control and censor the pictures that are shown to the people? Is it perhaps this that is being disputed?

And can the Revolutionary Government's right to supervise those mass media, that so influence the people, be considered a limitation or a prohibition?

If we challenge that right of the Revolutionary Government, we would be faced with a problem of principles, because to deny that right to the Revolutionary Government would be to deny the Government its function and its responsibility (and above all in the midst of a revolutionary situation) in leading the people and the Revolution; at times it has seemed that this right was being challenged, and to avoid any misunderstanding we are now stating that our opinion is that the government has that right. And if it has that right, it can make use of that right. It can make mistakes, we are not pretending that the government is infallible. The government, acting in exercise of a right or function that belongs to it, does not necessarily have to be infallible. But who has so many reserves with respect to the government, who has so many doubts, so many suspicions, who

distrusts the Revolutionary Government so much that when he believes one of its decisions to be wrong, he is terror-stricken and thinks that the government will always be wrong? I am not saying that the government was mistaken in that decision; what I am saying is that the government acted in exercise of a right. I am trying to put myself in the place of those who worked on that picture. I am trying to place myself in their state of mind, and I am trying to understand their displeasure and pain when the picture was not shown. Anyone can understand that perfectly; but they too have to understand that the government acted within its rights, and that this judgement had the support of competent men, responsible men in the government, and that there is no reason for distrusting the spirit of justice and fair play of the men of the Revolutionary Government, for the Revolutionary Government has given no one reason to doubt its spirit of justice and fair play.

We shouldn't think that we are perfect, we shouldn't even think that we are free from emotion. Some could point out that certain comrades in the government are emotional, or not far from being emotional; and those who believe this, can they assure us that they are free from emotion?

And can they attribute attitudes of a personal nature to some comrades without accepting the fact that their own opinions could also be inspired by attitudes of a personal nature? Let's say here that whoever feels perfect or free from emotion can be the one to throw the first stone.

I believe that there has been a personal and emotional element in the discussion. Did everyone come here absolutely stripped of personal prejudices and emotions? Certainly not. If a six-year-old child had been seated here, he too would have noticed the different currents and points of view, the different emotions that were confronting one another. Our friends have said many things. They have said interesting things. Some have said brilliant things. All have been very 'erudite'. But above all there has been reality, the reality of discussion and the freedom with

which all have been able to express themselves and defend their points of view. The freedom with which all have been able to speak and explain their criteria in the midst of a large meeting, which has grown larger by the day, a meeting that we consider a positive meeting, a meeting where we could dispel a whole series of doubts and worries. Have there been quarrels? Undoubtedly. Have there been wars and skirmishes here among the writers and artists? Undoubtedly. Has there been criticism, and super-criticism? Undoubtedly. Have some comrades tried out their weapons at the cost of other comrades? Undoubtedly.

The wounded have spoken expressing their resentment at what they consider unfair attacks. Fortunately, we've had no corpses, only the injured, including comrades who are still con-valescing from their wounds. And some of them presented as an evident injustice the fact that they had been attacked with large-calibre cannons without having the power even to make a riposte. Have strong criticisms been made? Undoubtedly! And in a certain sense a problem has been raised here that we are not going to pretend to be able to elucidate in two words. But I believe that of the things that have been said here, one of the most correct is that the spirit of criticism ought to be construc-tive, ought to be positive and not destructive. But in general, it is not kept in mind. For some the word criticism has come to be a synonym of attack, when it really means no such thing. When they tell someone, 'So-and-so criticized you', that person gets angry before asking what was really said about him. That is, he thinks that he was torn apart. If, in reality, those of us who have been a little removed from these problems or struggles – these skirmishes and tests of weapons – were told about the case of some comrades who have almost been at the edge of deep depres-sion because of demolishing criticism levelled against them, it is possible that we would sympathize with the victims, because we have the tendency to sympathize with victims. We who sincerely want only to contribute to the understanding and unity of all have tried to avoid words that could wound or discourage

anyone; but it is an unquestionable fact that there have been struggles or controversies where conditions were unequal. That, from the point of view of the Revolution, cannot be just. The Revolution cannot arm some against others, and we believe that the writers and artists should have every opportunity to express themselves. We believe that the writers and artists, through their association, should have a broad cultural magazine open to all. Doesn't it seem to you this would be a fair solution? But the Revolution cannot put those resources in the hands of one group. The Revolution can and should mobilize those resources in such a manner that they can be widely utilized by all writers and artists. You are going to constitute an association of writers and artists soon, you are going to attend a Congress. That Congress should be held in a truly constructive spirit, and we are confident that you are capable of holding it in that spirit. From it will rise a strong writers' and artists' association where all who have a truly constructive spirit can take part, because if anyone thinks we wish to eliminate him, if anyone thinks we want to stifle him, we can assure him that he is absolutely mistaken.

And now is the time for you to contribute in an organized way and with all your enthusiasm to the tasks that are yours in the Revolution, and to constitute a broad organization of all writers and artists. I do not know if the questions that have been raised here will be discussed at the Congress, but we know that the Congress is going to meet, and that its work, as well as the work that is to be done by the association of writers and artists, will be good topics for discussion at our next meeting. We believe that we should meet again; at least, we don't want to deprive ourselves of the pleasure and usefulness of these meetings which have served to focus our attention on all these problems. We have to meet again. What does that mean? That we have to continue discussing these problems. That is, everyone can rest assured, the government is greatly interested in these problems, and the future will hold ample opportunity for discussing them. It seems to us that this should bring satisfaction to the writers

and artists, and we too look forward to acquiring more information and knowledge.

The National Council of Culture should also have an information agency. I think that this is putting things in their right place. And this cannot be called cultural imposition or stifling of the creative spirit. The Revolution wants the artists to put forth their maximum effort on behalf of the people. It wants them to put the maximum interest and effort into revolutionary work. We believe that the Revolution has the right to want this.

Is that to say that we are going to tell the people here what they have to write? No. Let each one write what he wants, and if what he writes is not good, that is his problem. We do not prohibit anyone from writing on the theme he prefers. On the contrary, let each person express himself in the form he considers best, and let him express freely the idea he wants to express. We will always evaluate his creation from the revolutionary point of view. That too is a right of the Revolutionary Government, as worthy of respect as the right of each to express what he wants to express.

A series of measures are being taken, some of which we have mentioned. We wish to inform those who were concerned with the problem of the National Publishing House that a law is under consideration to regulate its functioning, create different editorial divisions, see to the needed diversity, and mend the deficiencies existing at present. The National Publishing House is a recently created organization that made its appearance under difficult conditions, because it had to begin working in the plant of a newspaper that closed suddenly (we were present the day that newspaper plant became the leading printing shop of the country, with all its workers and editors), and it had to attend to the publication of urgently-needed works, including many of a military nature. The National Publishing House does have deficiencies, but they will be remedied. There will be no reasons for complaints such as the ones expressed here, in this meeting, about the National Publishing House. Measures are also being

taken to acquire books, to acquire work materials, that is, to resolve all the problems that have concerned the writers and artists and with which the National Council of Culture too has been concerned. For as you know, the State has different departments and different institutions and, within the State, each is anxious to have the resources necessary for doing its job well. We want to point out some areas where we have already advanced, areas that should be sources of pride for all of us. Look at the success attained by the Symphony Orchestra, for instance, which has been completely reorganized, and not only has reached a high level in the artistic sense, but also in the revolutionary sense, for there are now thirty members of the Symphony Orchestra who are militiamen.

The Ballet de Cuba has been rebuilt and has just made a tour abroad where it won admiration and recognition in all the countries it visited.

The Modern Dance Group has also been quite successful, and has been highly praised in Europe.

The National Library too is working hard on behalf of culture. It is engaged in awakening the interest of the people in music and painting. It has set up an art department with the object of making fine paintings known to the people. It has a music department, a young people's department, and a children's section.

Shortly before coming to this hall, we were visiting the Children's Department of the National Library: we saw the number of children who were there, the work that is being done there. The progress made by the National Library is reason enough for the government to give it the means needed for continuing that work. The National Publishing House is now a reality, and with the new forms of organization it is being given, it is also a victory for the Revolution that will contribute mightily to the education of the people.

The National Institute of the Motion Pictures Industry is also a reality. The first stage has consisted chiefly in supplying it with

needed equipment and material. The Revolution has established at least the basis of a movie industry. It has established it at the cost of great effort, if it is kept in mind that ours is not an industrialized country and that the acquisition of all that equipment has meant sacrifices. If we haven't any more facilities as regards the movies, this is due not to a restrictive governmental policy, but simply to the scarcity of economic resources at present for creating amateur movements that would permit the development of all cinematic talent. This will be done when we have those resources available. Policy in the Motion Picture Institute and the introduction of emulation among the different work crews of the Institute will also be discussed. It is not possible to discuss the work itself of the Institute. There has not yet been time to do enough work to be judged, but it has worked, and we know that a number of its documentaries have contributed greatly to making the Revolution known abroad. But what we should emphasize is that the foundation for the movie industry has already been laid.

There has also been much cultural work done through publicity, talks, etc., sponsored by different agencies; but it is, after all, nothing compared to what can be done and what the Revolution intends to do.

There are still a number of questions to resolve that are of interest to writers and artists. There are problems of a material order, that is, of an economic order. Yesterday's conditions do not exist now. Today there is no longer that small privileged class that used to buy the works of artists – although at miserable prices, we know that, since more than one artist ended in indigence and oblivion. These problems remain to be faced and solved, and the Revolutionary Government should solve them, and the National Council of Culture should be concerned with them, as well as with the problem of artists who can no longer produce and are completely forsaken. They should guarantee the artists not only proper material conditions for the present, but security for the future. In a certain sense, now, with the

reorganization of the Copyrights Institute, the living conditions of a great number of authors and composers, who were miserably exploited and whose rights were scoffed at, have been improved considerably. Today writers who used to live in extreme poverty have incomes that permit them to live decently.

These are steps that the Revolution has taken: but they are only preliminary steps, they will be followed by other steps that will create better conditions yet.

There is also the idea of organizing some place where artists and writers can rest and work. Once, when we were travelling throughout the whole national territory, the idea occurred to us in a very beautiful place, the Isle of Pines, to build a place of rest in the middle of a pine forest, where we could honour writers and artists (at that time we were thinking about establishing some sort of prize for the best progressive writers and artists of the world). That project did not materialize, but it can be revived and a place can be created in some peaceful haven that invites rest, that invites writing. I believe that it is well worth while for artists, and architects as well, to begin thinking of and planning the ideal place of rest for a writer or artist, and to see if they agree. The Revolutionary Government is ready to contribute its share to the budget.

And will planning be a limitation imposed on the creative spirit by us, the revolutionaries? Because, in a certain sense, don't forget that we, the revolutionaries, who have been working somewhat on our own, are now faced with the reality of planning; and that presents a problem to us too, because until now we have had a creative spirit towards revolutionary initiative and revolutionary investments, which now have to be planned out. So don't believe that we are removed from the problem, for, from our point of view, we could protest too. That is, now that it is known what is going to be done next year, the year after that, and the year after that. Who is going to dispute the fact that it is necessary to plan the economy? But the construction of a place of rest for writers and artists fits in with that planning. Truly, it would

be a source of satisfaction for the Revolution to be able to count that project among works accomplished.

We have been concerned here with the present situation of writers and artists. We seem to have forgotten future perspectives somewhat. And we, who have no reason to grumble about you, have also dedicated a moment to thinking about the artists and writers of the future. We wondered what it would be like if the men of the government – not us necessarily – and the artists and the writers were to meet again, as they should, in the future, in five or ten years, when culture has acquired the extraordinary development that we plan for it, when the first fruits of the present educational programme begin appearing.

Long before these questions were raised, the Revolutionary Government was already concerned about the extension of culture to the people. We have always been very optimistic. I believe that it is not possible to be a revolutionary without being an optimist. For the difficulties that a Revolution has to surmount are very serious, and one has to be an optimist. A pessimist could never be a revolutionary.

The Revolution has had stages. There was a stage when different agencies took the initiative in the field of culture. Even INRA (the National Institute of the Agrarian Reform) was conducting activities of a cultural nature. We even clashed with the National Theatre, for certain work was being done there and suddenly we were off doing other work on our own. Now all that is within one organization.

In connection with our plans for the countryside, there arose the idea of spreading culture to the people of the farms and cooperatives. How? Well, by training music, dance, and drama instructors. Only optimists can propose things like this. Well, how were we to awaken love for the theatre, for example, in the farmer? Where were the instructors? Where would we get instructors to send out to 3,000 People's Farms and 600 Cooperatives, for example? All this presents difficulties, but I am certain that all of you agree that if it is achieved it will be a

positive accomplishment, especially the discovery of talents in the people and the conversion of the people from spectators into creators, for ultimately it is the people who are the great creators. We should not forget this, and neither should we forget the thousands and thousands of minds lost in our countryside and cities due to lack of opportunity to develop. Many talents have been lost in our countryside, of that we are sure, unless we presume ourselves to be the most intelligent people of this country, and I want to say that I presume no such thing.

I have often given as an example the fact that of several thousand children in the place where I was born, I was the only one who was able to study at the university. And I had first to attend a number of schools run by priests, etc. etc. . . . I don't want to anathematize anyone, although I do want to say that I have the same right as anyone else here to say what I want, to complain. I have the right to complain. Someone spoke of the fact that he was moulded by bourgeois society; I can say that I was moulded by something worse yet, that I was moulded by the worst of reaction, and that a good many years of my life were lost in darkness, in superstition, and in lies.

That was the time when they did not teach one to think, but forced one to believe. I am of the opinion that when man's ability to think and reason is impaired he is turned from a human being into a domesticated animal. I am not rebelling against the religious sentiments of man; we respect those sentiments, we respect man's right to freedom of belief and religion. But they did not respect my right to this freedom. I had no freedom of belief or religion; they imposed a belief and a religion on me and domesticated me for twelve years.

Naturally I have to speak in complaining tones about those years, the years when youngsters have the greatest amount of interest and curiosity in things, years I could have employed in systematic study that would have let me acquire the culture that the children of Cuba today are going to have every opportunity to acquire.

Before our Revolution, the one of a thousand who could get a university degree had to pass through that millstone where only by a miracle he was not crushed mentally for ever. Thus that one of a thousand had to go through all that.

Why? Ah, because he was the only one of a thousand who could afford to study at a private school. Now, am I going to believe therefore that I was the most capable and the most intelligent of the thousand? I believe that we are a product of selection, but not natural selection so much as social. I was selected to go to the university socially, by a process of social selection, not natural selection. Who knows how many tens of thousands of young people, superior to all of us, have been left in ignorance by social selection. This is the truth. And he who believes himself an artist should remember that there are many, much better than he, who have not had the opportunity to become artists. If we do not admit this, we are evading reality. We are privileged, among other things, because we were not born the sons of wagon-drivers. I think what we have said shows the enormous number of talented minds that have been lost simply through lack of opportunity.

We are going to bring opportunity to everyone; we are going to create the conditions that permit all talent, artistic, literary, scientific, or otherwise, to develop. And think about the significance of a Revolution that permits such a thing, and that has already begun teaching all the people to read and write, that will have accomplished this by the next school term, and that – through schools everywhere in Cuba, through campaigns and with newly trained teachers – will be able to bring to light all talent, and this only the beginning. All the teachers in the country will learn how to recognize which child has special talent, and will recommend which child should be given a scholarship for the National Academy of Art, and at the same time they will awaken artistic taste and love for culture in the adults. Some tests that have already been made demonstrate the capacity of the simple farmer and man of the people for

assimilating artistic questions, for assimilating culture and immediately beginning to produce it. There are comrades who have been on some cooperatives that now have their own drama groups. Recent performances given in various places of the Republic, and the artistic creations of men and women of the people, demonstrate the interest of the country people in all these things. Imagine, then, what it will mean when we have drama, music, and dance instructors on each cooperative and each people's farm.

In the course of only two years, we will be able to send a thousand instructors, for each one of these fields of art, more than a thousand.

The schools have been organized. They are already functioning. Imagine when there will be a thousand dance, music, and drama groups throughout the island, in the country – we are not speaking of the city, it is somewhat easier in the city – what that will mean in cultural advance, because some have spoken here about the need to raise the level of the people – but how? The Revolutionary Government is creating conditions so that within a few years our culture, the level of the cultural background of our people, will have been raised extraordinarily.

We have selected those three branches, but we can continue selecting other branches and we can continue working to develop all aspects of culture.

The school of Art Instructors is already functioning, and the comrades who work there are satisfied with the progress of that group of future instructors, but in addition we have already begun to construct the National Academy of Art, separate from the National Academy of Manual Arts. Certainly, Cuba is going to have the most beautiful Academy of Art in the world. Why? Because that Academy is going to be located in one of the most beautiful residential districts of the world, where the most luxury-loving bourgeoisie of Cuba used to live, in the best district of the most ostentatious and most luxury-loving and most uncultured bourgeoisie who now belong to the past. None of

those houses lacked a bar: their inhabitants, except for certain exceptions, did not concern themselves with cultural problems. They lived in an incredibly luxurious manner, and it is worth while to take a trip there to see how they used to live; but they didn't know that one day an extraordinary Academy of Art would be built there, and that students were going to live in the homes, the homes of millionaires. They will not live cloistered lives, they will live in a homelike atmosphere, and they will attend classes in the Academy, the Academy is going to be located in the middle of the Country Club district, and will be designed by a group of architects and artists. They have already begun, and they are committed to finishing by the month of December. We already have 300,000 feet of mahogany. The schools of music, dance, ballet, theatre, and plastic arts will be in the middle of a golf course, in a dreamlike setting. This is where the Academy of Art will be located, with sixty houses surrounding it, with a Social Centre at one side, with dining-rooms, lounges, swimming pools, and also a building for visitors where the foreign teachers who are coming to aid us can live. This Academy will have a capacity of up to three thousand youngsters, that is, three thousand scholarship students. We expect it to start functioning next year.

And the National Academy of Manual Arts, located on another golf course, with similar buildings, with students living in similar houses, will soon begin to function also. These will be Academies of a specifically national type. That is not to say that they are the only schools, not that at all, but they will be attended by scholarship students, the young people who show the greatest capacity, costing their families absolutely nothing – adolescents and children who are going to have ideal conditions for developing. Anybody would want to be a child now, to enter one of those Academies. Don't you think so? We spoke here of painters who used to live on coffee only. Just imagine how different conditions will be now, and we will see if the creative spirit does not find the ideal conditions for developing. Instruction, housing, food,

general culture ... There will be children who will begin to study in those schools from the age of eight up, and they will receive, together with their artistic training, a general education ... Won't they be able to develop their talents and their personalities fully there ...?

These are more than ideas or dreams; they are realities of the Revolution. The Instructors who are being trained, the National Schools that are being prepared, the schools for lovers of the arts that are also being founded, they are realities. This is what the Revolution means ... this is why the Revolution is important for culture.

How could we do this without a Revolution? Let's suppose that we are afraid that 'our creative spirit is going to wither, crushed by the despotic hands of the Stalinist Revolution'. . . . Gentlemen, wouldn't it be better to think about the future? Are we going to think about our flowers withering when we are sowing flowers all over? When we are forging those creative spirits of the future? And who would not exchange the present, who would not exchange even his own present existence for that future? Who would not exchange what he has now, who would not sacrifice what he has now for that future? And what person who has artistic sensibility does not also have the spirit of the fighter who dies in battle, knowing that he is dying, that he is ceasing to exist physically, in order to enrich with his blood the triumph of his fellow beings, of his people? Think about the soldier who dies fighting; he sacrifices everything he has; he sacrifices his life, his family. Why? So that we can do all these things. And what person with human sensibility, artistic sensibility, does not think that to do that it must be worth while to make the sacrifice? But the Revolution is not demanding sacrifices from creative geniuses; on the contrary, it says: put that creative spirit at the service of the Revolution, without fear that your work will be impaired. But if some day you think that your personal work may be impaired, say: it is well worth while if I am contributing to the great work before all of us.

We ask the artist to develop his creative force to the fullest, we want to make conditions ideal for the creative genius of the artist and intellectual, because if we are creating for the future, how can we not want the best for the present artists and intellectuals? We are asking for maximum development on behalf of culture, and to be very precise, on behalf of the Revolution, because the Revolution means just that, more culture and more art.

We ask the intellectuals and artists to do their share in the work that, after all, is the work of this generation. The coming generation will be better than ours, but we will be the ones who have made that better generation possible. We will have shaped that future generation. We, the men of this generation, whether young or old, beardless or bearded, with an abundant head of hair, or no hair, or with white hair. This is the work of all of us. We are going to wage a battle against ignorance. We are going to unleash a merciless war against ignorance and we are going to test our arms.

Is there anyone who doesn't want to collaborate? What greater punishment is there than to deprive oneself of satisfaction in what others are doing? We spoke of the fact that we were privileged. We learned to read and write in a school, went to high school, to a university, to acquire at least the rudiments of education, enough to enable us to do something. And can we not call ourselves privileged to be living in the midst of a Revolution? Didn't we read about revolutions with great interest? Who didn't avidly read the stories of the French Revolution, of the Russian Revolution? Who never dreamed of having been a witness of those revolutions personally? Something happened to me, for example, when I read about the Cuban War of Independence. I was sorry that I hadn't been born in that period and that I hadn't been a fighter for independence and that I hadn't lived at that epic time. All of us have read the chronicles of our War of Independence with deep-felt emotion, and we envied the intellectuals and artists and fighters

and leaders of that time. However, to us has fallen the privilege of living now and being witnesses to a Revolution, to a Revolution whose force is now developing beyond the bounds of our country, whose political and moral influence is making imperialism on this continent tremble and totter. And this has made the Cuban Revolution the most important event of this century for Latin America, the most important event since the wars of independence of the nineteenth century; in truth, the redemption of man is new, for what were those wars of independence but the replacement of colonial domination by the domination of exploiting classes in all those countries?

And it has fallen to us to live in the time of a great historical event. It can be said that it is the second great historical event that has occurred in the last three centuries in Latin America. And we Cubans are its creators, knowing that the more we work the more the Revolution will be an unquenchable flame, the more it will be called upon to play a transcendent role in history. And you writers and artists have had the privilege of witnessing this Revolution in person; and a Revolution is such an important event in human history that it is well worth while to live in the time of one if only to be its witness.

That too is a privilege. Therefore those who are not capable of understanding these things, those who let themselves be tricked, let themselves be confused, those who let themselves become perplexed by lies, are the ones who renounce the Revolution. What can we say of those who have renounced it? How can we think of them but with sorrow? They abandon this country, which is in full revolutionary effervescence, to crawl into the den of the imperialist monster, where no expression of the spirit can have life. They have abandoned the Revolution to go there. They have preferred to be fugitives and deserters from their native land rather than remain here even if only as spectators.

And you have the opportunity to be more than spectators, to be creators in the Revolution, to write about it, to express your-

selves on it. And the generations to come, what will they ask of you? You may produce magnificent artistic works from the technical point of view, but if you told the generation to come, a man of a hundred years hence, that a writer, an intellectual, lived in the era of the Revolution and did not express the Revolution, and was not a part of the Revolution, it would be difficult for him to understand it when in the years to come there will be so many who want to paint the Revolution, to write about the Revolution, to express themselves on the Revolution, compiling data and information in order to know what it was like, what happened, how we used to live. ... We recently had the experience of meeting an old woman, 108 years old, who had just learned to read and write, and we proposed to her that she write a book. She had been a slave, and we wanted to know what the world looked like to her as a slave, what her first impressions were, of her masters, of her fellow slaves. I believe that this old woman can write something more interesting than any of us could about that era. In one year someone can learn to read and write, and write a book as well, at 108 years of age! Things like these are fruits of the Revolution! Who can write about what the slave endured better than she, and who can write about the present better than you? And how many people who have not lived through this will begin to write in the future, at a distance, selecting material from other writings? On the other hand, let us not hasten to judge our work, since we will have more than enough judges. What we have to fear is not an imaginary authoritarian and stern judge of culture. Fear other judges far more severe, fear the judges of posterity, fear the generations to come, who will be, when all is said and done, the ones to say the last word!

The Future of Culture:
The 'End' of 'Culture'?

17
Hans Mayer

Culture, Property and Theatre

I

One's cultural coming of age began with a fairy-tale show at Christmas. At that time *Little Peter's Trip to the Moon* had been initially produced in all its horrific glory. It was the Christmas fairy-tale to end them all, for us children living then in the early 1920s. Next, good bourgeois families would send their children to see *Hansel and Gretel* at the opera. I was bored to death and can still remember how I felt. It was no different with my schoolmates. There was much too much music and it was too loud. How were we to know that Humperdinck was a Wagnerian and revered the tonal ideal of the Meistersinger orchestra? Quarrelling parents riled up children in any case. In *Hansel and Gretel* the parents quarrelled 'in tune to the music'.

HANS MAYER is the author of many books of literary history and criticism. The holder of a doctorate in law, Mayer became an émigré from Germany during 1933–46. He returned to a post with Frankfurt radio, then in 1948 was called to Leipzig in East Germany, where his scholarship and analysis won international respect. Mayer's books in German include *From Lessing to Thomas Mann*, *German Literature and World Literature*, *Georg Büchner and His Time*, and *Bertolt Brecht and Tradition*. He has also translated plays by Sartre for the German stage. After diverse harassment of his teaching and publishing activity, his collection of essays, *Views on Modern Literature* (1962), was roundly attacked by Party spokesmen, and in 1963 Professor Mayer transferred to West Germany. He now teaches in Hanover. A first volume of his essays in English, *Steppenwolf and Everyman*, translated and introduced by Jack D. Zipes, appeared in 1971.

For a first visit to the theatre Schiller's *William Tell* was pre-
ferred: this brooked no discussion. As for the first 'real' visit to
the opera, one sent the children – I don't know why – to Weber's
Der Freischütz.

This pattern was a ritual and practised as such. The Christmas
fairy-tale, Humperdinck, Schiller and Carl Maria von Weber.
Everything belonged, in Sartre's phrase, to the realm of 'one',
that impersonal. One kept up a decent bourgeois home regimen;
one obtained, from the pastry shop appropriate to one's station,
cakes and ice cream for the children's birthday parties. The
number of cakes, the pattern of the fun: this all was fixed, in a
double sense, by the society. This German middle class in the
transition from the Empire of the Kaiser to the Weimar Repub-
lic was distinctly a 'stabilized social order'.

The theatre belonged to it all. One went to theatre first nights.
In Cologne, the subscriptions to the Gürzenich Concerts – for
the gala performance, of course – were passed down the genera-
tions. Anyone merely positioned to acquire tickets for the dress
rehearsal could not be counted in the inner circle of high society.
Cologne is to be understood here as part of a larger German
reality.

One had property, and was cultured. And culture too was
looked on as property. More than just affirming that one was
well fixed for money and influence, it was added into one's real
estate. Here there was a mutual fructification as between indivi-
dual and the collective demeanour. The individual appropria-
tion of 'cultural goods' was accomplished through a library of
classics. And he who was designated a classical author was
likewise beyond the threat of rebuke. We had at home a hun-
dred and forty volumes of the classics lined up: stiff-backed,
identically bound and resplendently gold-trimmed; as at dress-
parade or military academy. Between the ages of fifteen and
seventeen I read them all and found every one beautiful. Because
of this I still remember that there was once a classical writer by
the name of Baron Franz Gaudy.

Property, all of it; secure intellectual acquisitions. In the German bourgeois home and faced with these lovely troops, one knew exactly where one stood. Have I already mentioned that Georg Büchner was not ranked there, nor were the writers of the *Sturm und Drang* movement, with the exception of the young Goethe and the young Schiller? The chronological limit that determined a writer's classical status could essentially be put at 18 January 1871 – the founding date of the Empire. Whosoever had written after this date could only count on consecration if he had produced something classical-seeming before it: this was the case of Theodor Storm and Conrad Ferdinand Meyer.

The general social appropriation was kin to the individual one. The public intellectual life stood at the service of the commemorable creative figures. One was hustled off to war in 1914 in their defence, 'and the "categorical imperative of our philosopher Kant" was the banner which Director Wulicke unfolded menacingly in every official speech' (cf. Thomas Mann, *Buddenbrooks*).

The closest ties existed between the bourgeois family, the authoritarian school, university ideology and the city and state promotion of the arts. Everything was done behind this banner of the United Kingdom of Culture and Property. And everywhere was evident the mark of the lamentable history of the German bourgeoisie – the *deutsche Misere* as Karl Marx, and later Brecht, called it. With the collection and the regimentation of a so-called classical literature in the 1840s the start was made, thus in advance of the political débâcles of 1848–9.

After the foundation of the Bismarckian Empire was laid, actually from the time of Wilhelm with its well-accepted notion of collaboration between the Emperor and his subject, the German cultural hoard was confirmed. The state official von Wehrhahn and the investor Krüger, in Gerhart Hauptmann's play *The Beaver Fur*, which shows this period of the Empire, were completely of one mind that the recent literature should

be consecrated only if it were devoted with sincerity and epigonal diligence to multiplying this cultural trove.

In no way did the Weimar Republic write finis to this United Kingdom of Culture and Property; any more than it eliminated the traditions of royal Prussian justice, the 1871 penal code or duelling fraternities. After the 1918 Revolution the court theatres were renamed state theatres. New managers – *Intendanten* – and those on good speaking terms with the Expressionist muse controlled the municipal and state agencies. However, the union of culture and property was intact. As before, the well-heeled bourgeoisie sat in the best seats. Purchasers of season tickets deferred as before to voluntary self-policing, modestly effacing themselves to the loge, mezzanine, balcony. This had rarely to do with financial considerations; rather with social ones. One was aware of one's place.

Likewise, the repertoire failed to be extricated from the grip of the cultural inheritance. One did doubt the earlier means of production and acting, but not the classical repertoire. Leopold Jessner made his directorial debut at the Prussian National Theatre in Berlin and caused a sensation with *William Tell* – minus a stone bench but adding a gigantic stairway. To probe, to relativize the play and its author, never occurred to him. Thus we in the 1920s underwent the concatenation of family and school, theatre and university. What glistened on the bookshelves at home in the uniform of classics yielded a German curriculum at school. Here, too, an entrenched pedagogy took care that the transition from the Empire to the Republic be negotiated without a 'qualitative leap'. One sent the children to see *William Tell* and *Freischütz*, and the first classical drama one read in school was Ludwig Uhland's *Duke Ernst of Swabia*, an immensely boring perpetration, which kept us busy a quarter of the year as we did it homage by dividing the roles and then by taking it methodically apart for essay assignments. All Prussian *Gymnasium*, that is, high school students of my generation had to put up with the same exact thing. In Bavaria it was different.

In place of *Duke Ernst of Swabia* one read *Louis the Bavarian*, just as boring and similarly by Uhland.

School and theatre consulted closely. In Cologne there were regular meetings between principals of high schools, the city board of cultural affairs and theatre management. They expedited 'special student series'. The teachers of German sent up complaints when Schiller's *The Maid of Orleans* did not appear in the repertoire for a time. The play was wanted as a teacher's aid.

Here, too, appeared the voluntary self-effacement of the theatre managers. Nor were the thinking and the practice different in the university seminars on German literature. If generally without knowing it, one adhered to the ideas of Gervinus, who became the real founder of German literary-historical studies around 1835, and who interpreted Goethe's death as a scientific caesura. He believed in a vital literature up to Goethe's death in 1832, whereafter there remained only to take inventory, to categorize historically, and to interpret philologically. Even Wilhelm Scherer, *the* literary historian of the Bismarck era and whose 'major disciples' took charge in the 1920s, understood German literature to commence with the *Merseburg Charms* of *circa* the ninth century and to end with *Faust*, Part II. To be noted is that the final transition after Goethe's death from the primacy of art to the primacy of research was acknowledged by Gervinus to be a political change. The new literature had as well to transcend the aesthetic realm and to help in constructing a unified German nation.

From the founding of the Empire and into the Weimar era, the Germanistics profession nonetheless took Gervinus's inspiration to mean that scientific study of contemporary literature was in principle not to be pursued, and that political concerns were also to be rejected. Gerhart Hauptmann was ignored in seminars on German literature. His work could not be the topic of a dissertation. One could write a doctoral thesis on Otto Ludwig's *The Maccabees* but not on Thomas Mann.

So the Weimar Republic let itself be dictated to. It altered not a tittle. Certainly not in the social substratum nor in the relations of power. The established property of the bourgeoisie was, to be sure, eaten away by the depreciation of currency. But the new bourgeoisie of war and post-war profiteers were only the more anxious to master the rules of culture along with the ropes of property, as they had to undergo – at theatre or concert, or the gathering of a literary society – the derisive scorn of those bourgeois circles which had lost their property following the war but not their culture.

Thus everything was as before; in the bourgeois parlour, in school, in university, in theatre. Which is not to say things were old-fashioned, or reactionary. By no means! One had a good feeling about the modern, and just because one felt that it put forth laudable, if very often fruitless, efforts to multiply the spiritual hoard. Thus, Fritz von Unruh was highly regarded as a potential twentieth-century Kleist. And at this time only a killjoy with an evil glance of the likes of Walter Benjamin, perceived a connection between the economic mentality of the profiteers from inflation and the literary fame of Unruh, the author of *Louis Ferdinand, Prince of Prussia*.

The workers' movement – in Germany too, and in the cultural domain too – had the chance to cancel the bourgeois ground rules and to launch bankruptcy proceedings against the Culture and Property partnership. Just this had been sought by Marx and Engels beginning with their first collaborative works on the *Holy Family* of Young Hegelians and the *German Ideology*. The emancipation of the proletariat meant, for Marxism, the liberation of future society from the productive relations and the way of thinking of the bourgeoisie. And yet Franz Mehring fought for decades within the German Social-Democratic movement, without success, against an uncritical and unmediated assimilation of bourgeois ideologies. He would not go along with the game of Culture and Property. Some quite unassailable classics

failed to get his nod – for he loved too much the true greatness (along with some ephemerae) in the works of Goethe and Schiller and also of the Romantics. Mehring was the first to show where and why the bourgeoisie began to struggle against Germany's bygone, bourgeois Enlightenment. With the result that today, anyone who would care to read his *Lessing-Legende* can find a copy in print – only from the Dietz Publishers in *East* Berlin.

As a founder in 1891 of the *Freie Volksbühne*, the first theatre of the Berlin working class, Mehring likewise acted as a Marxist. He had gone along in part with the bourgeois protest which was the Naturalist movement around 1890. However, he believed the *Freie Volksbühne* must not be a mere continuation of the *Freie Bühne* and its bourgeois – essentially literary – opposition, but it must rather create discontinuity. A proletarian theatre, said the Marxist Mehring, should not merely be a discount house for bourgeois culture.

Mehring's ideas could not get through. The reason is not hard to find. It is associated but indirectly with the story of the *Volksbühne*, directly however with the process of bourgeoisification of the German proletarian movement and its leading party at the time, the Social-Democrats. When Franz Mehring joined the Spartacists during the First World War, and together with Karl Liebknecht and Rosa Luxemburg formed the German Communist Party three weeks before his death at the end of 1918, he did so in the belief that the development of working-class culture was not possible as a compromise with the bourgeoisie and within the social format stipulated by bourgeois society. Instead it could only be the result of the revolutionary transformation of reality.

The *Freie Volksbühne* became the *Volksbühne*, and took another direction. It was not Franz Mehring but Julius Bab who became literary spokesman of the *Volksbühne* movement – an exponent of bourgeois thinking, a well-intentioned educator who introduced the workers to such store of arts as the bourgeoisie offered: to an ideology of Culture and Property.

The renewed initiative came once again from Marxists. Again, the contrapositioning of social reform and revolution. When toward the end of the 1920s Erwin Piscator and Bertolt Brecht seceded, supported by critics like Herbert Ihering, an anti-bourgeois theatre movement was constituted. Piscator's Theater am Nollendorfplatz mounted a theatre of revolutionary class struggle: the revaluation (*Umfunktionierung*) of all systems of value, of the historical perspective, of the relation to the accretions of culture, and especially to the classics. Brecht's thinking in this time is well known. Herbert Ihering's polemic against the 'Treason of the *Volksbühne*' still bears reading. As for Piscator, his was a theatre of paradoxes: proletarian revolution staged before a bourgeois ('culinary') public.

This had happened earlier in Germany. Heinrich Mann's novel *Im Schlaraffenland* (1901) portrayed the socially-minded spectators of revolutionary matinées of around 1890 as clapping so enthusiastically that the seams of their kid gloves split. Marx had taught that one must play the tune proper to the German conditions in order to set them dancing, thus to get them moving. Piscator had found the tune, but those who alone might have been capable of changing the all too stable conditions did not dance along. Accordingly, Piscator too could be integrated as a 'cultural experience'. He too became a 'possession' of the well-meaning. He knew this, but it never really got to him. Many mistakes made during his last years, heading the *Volksbühne* of West Berlin in the 1960s, can be explained by his attempt to repeat the 1920s when a new social analysis was indispensable.

What occurred as the history of the *Volksbühne* (and here, any question of guilt or failure should be made secondary to interpretation of the social and ideological formations) was repeated, as though on a gigantic and grotesque super-screen, in the evolution of Soviet culture. There had been a real revolution in Russia, an upheaval effected by Marxists. For almost a decade art was also able to draw the benefit. The cultural achievements of

Soviet Russia in film, in poetry, in music, in theatre, and not least in the new responsiveness of art to the problems of life, can be traced to about 1930. Then the reaction set in. A recently published photograph depicts a working session of similarly-minded artists: the poet Mayakovsky, the theatre director Meyerhold, and at the piano the young Shostakovich. Mayakovsky put a bullet through his head, Meyerhold was murdered, Shostakovich retreated to the bourgeois symphony, to the footsteps both of Beethoven and Tchaikovsky which he hoped to take somewhat further along.

The cultural activity of a Soviet State came more and more to bear the aspect of the bourgeois culture of Tsardom pulled out of the deep freeze. The restoration of the Moscow Art Theatre; apotheosis and canonizing of the late-bourgeois Stanislavskian theatre cult; perpetuation of Tsarist historical genre-painting. And on the other hand, proscription of the Expressionist heritage, which only recently and under decidedly hazardous conditions has begun to surface again on the stages of Moscow and Leningrad. And there is another canonization afoot, now: of the revolutionary and creative past. At the end of the 1950s I saw a production of Mozart's *Figaro* at the Bolshoi Theatre in Moscow. I had expected an apotheosis of the bourgeois revolution with the singing of the *Marseillaise* but experienced instead a faithful imitation of that *Figaro* I had seen as a child in Berlin during 1921 which was then a remnant of the tradition of court theatre. The same foolish pranks, the same disregard for the music and story. Thawed-out Tsarist opera. And bolstering it all up, the cultural-political State doctrine according to which the Soviet State must adopt and conserve the cultural bequest of Tsardom and the bourgeoisie.

In the German Democratic Republic, the ideology of Culture and Property likewise has been made into State doctrine. There it bears the name 'national cultural heritage'.

Culture, property and theatre. All the transformations in the German reality of the twentieth century have left this state of

affairs as before. The seminars in German literature still make the strict separation of the historical and the present substratum. As in the past, schoolchildren are inculcated with the idea of a stabilized cultural estate. German studies in the schools continue to have an aura transcendent of the terrestrial. Whoever does not measure up here, who fails to write his 'German essay', notwithstanding that 'The Guilt and Atonement of the Maid of Orleans' may no longer be a compulsory theme, can scarcely appear worthy to enter the sanctuary of a German higher education.

Who runs our theatres? Their types are swiftly sketched. In the first place, the pluralistic manager. In his theatre one may find opera and operetta, ballet, and drama on the large or small scale. He has two big houses and a workshop. The public is accustomed to pluralistic pleasure, and it enjoys Mozart and Lehar, *The Prince of Homburg* and *Waiting for Godot*. Granted, no one any longer believes in a Gospel-safe investment in a classical edition, but in recompense one makes the new, tougher texts into objects, one sees them as property. Brecht's *Good Woman of Setzuan* also becomes a commodity. And it is one's cultural duty to sit through Peter Handke's *Offending the Audience*,[1] therefore it too becomes one's possession.

Aside from the pluralist, there is the esoteric manager. He is similar to the refined art collector who has just money enough to specialize in long chances, that stop being long chances just because of this. Only Italians of the eighteenth century are collected, since they generally have a bad reputation; only graphics by Max Klinger, etc. In like fashion the esoteric manager would like most to produce the following repertoire, if allowed his pleasure: *Oedipus at Colonus*, Calderon's *Devotion*

1. Though Handke is not well known outside German-speaking countries, he has achieved status in West Germany as one of the most original and unorthodox dramatists of the younger generation. His flair for the controversial is marked. [Trans.]

to the Cross, Goethe's *Natural Daughter*, Kleist's *The Family Schroffenstein*; not to mention the more unfortunate plays of Grabbe, Claudel and Eliot; and of course, repeatedly, a late play of O'Neill, a late play of Giraudoux.

There is lastly the politicized manager. He produced Shakespeare's history plays as though they were sociograms of the power struggle; the young Schiller and young Goethe; Hauptmann's *Weavers*; and he lays plans for a cycle of dramas of revolution starting from Büchner. A great deal of Brecht, of course; also young Poles and ancient Greeks.

The pluralistic manager draws his inspiration from the theatre director in Goethe's Prologue to *Faust*. He is the pure exponent of the doctrine of Culture and Property. The esoteric manager conceives a theatre for a School of Philosophy and presents himself as the sublimated expression of a frustrated concept, whereby culture alone becomes property. Here too, commodity fetishism. The 'committed' manager, on the other hand, aspires to the role of an *umfunktionierter* Schillerian materialist, he dreams of the stage as a moral institution. He too is implicated by Dürrenmatt's nasty perception about Brecht as the legitimate successor of Friedrich Schiller in our century.

Where to go from here? We have lost faith in a stabilized cultural heritage. The canonical works in German classrooms are not those of my youth. Such names as Beckett and Proust now turn up as standards in the curriculum of German classes; Brecht and contemporary poets are read in the higher grades. Nevertheless, as to the manner of thinking, of interpreting, of taking it in, nothing has changed at all. The university departments of German arrange for poetry readings and they set up teaching posts in poetics and literary criticism. In spite of this, literature is manipulated in the old-fashioned way, as art object, as research object, as love object, as enlightenment object. In the bourgeois family of today one carefully conserves the sphere of Culture and Property. In élitist fashion, the élitist sentiment of yesterday is there deployed.

The sphere of the theatre seems to have been seized more powerfully by a radical scepticism than has the realm of the bourgeois family, the high school or university. This is no surprise, since only a crazed theatre buff would argue that a bad and superfluous theatre is always better than none at all. For the first time it is being asked openly and aggressively whether the quantity of plays in present-day Germany, East and West, assimilated as our inheritance from bourgeois history and the property tradition, can somehow still be called meaningful.

Brecht and Piscator had demanded replacement of the bourgeois substance and function in the theatre with the prerequisites and the standards of the revolutionary workers' world. However, Marx and Brecht himself have come to be props for the bourgeois world. Culture and Property in one. Fortunately they are far more than that. They also are ferment in a restored and restorative world which is exploitative, only the patterns and objects of exploitation being changed.

And because that is how it is, we cannot today limit ourselves to stating a scepticism about the function of the vast play repertoire. Simply to look askance at the pluralistic, esoteric and political theatre managers won't suffice. The more radical analysis leads us to doubt wholly that theatre, and literature generally, can bring about change. Following the theatre revolutions which were Naturalism and Piscator, we do not want a third theatre revolution which will be taken up in the repertoire and offered on the subscription series.

2

The discomfited reaction to the Frankfurt première of Peter Weiss's *Vietnam-Discourse* in 1968 was completely justified. Here was a theatrical enterprise of Culture and Property involving a 'committed' manager, and a play of an unusual kind which, notwithstanding it remains and wishes to remain a work for the theatre, cannot but cast the stage as moral institution into doubt.

In the discussion following the performance, it was the socio-logist Jürgen Habermas who best hit the nail on the head, with this statement:

The general discontent about the play this evening would stem from the circumstance that theatre appears here in a makeshift political function. The politics of Vietnam are discussed in the theatre owing to the refusal of the Parliament in Bonn to take on this – for it, legiti-mate – task.

Extract from Peter Handke's observations on 'Street-theatre and Theatre-theatre', *Theater heute*, April 1968:

Just as in football one 'runs a play' hoping to score, so Brecht with his theatre parables would 'run a play', with the aim of scoring social contradictions. But for this he was in the wrong sociological locale with the sociologically wrong means; infinitely distant from the reality he wanted to change, Brecht used the hierarchical order of the theatre hierarchically to disturb other hierarchical orders. Not one settled soul did he unsettle, to however many he surely provided a couple of beautiful hours. No doubt, he changed the attitudes of actors, but not directly the attitudes of spectators: and to argue that by means of the attitude of actors the attitude of the spectators was changed, indirectly, is disproven by history.

This view almost exactly duplicates arguments used by Max Frisch in his speech of October 1964, on the relationship between the author and the theatre – much as Handke might find that distasteful. In both cases, we have a post-Brechtian position which is conceived as a counter-position. Max Frisch questions whether the Brechtian theatre ever has changed the consciousness of the onlooker and modified his conduct. Brecht was of opinion that to his new, anti-Aristotelian dramaturgy and a new art of acting, a new art of onlooking – likewise, needing to be created – must correspond. But in spite of the aid of the Berlin Ensemble and the Frankfurt and Milan productions of Brecht this has not come about. Say what you wish in behalf of the dialectical action of consciousness and social being

mutually upon one another: but a new, and no longer culinary, relationship between the play and the onlooker is only to be expected where a community of experience has been built up which is sustained by common undertakings. This may have been the case in the Soviet theatres around 1923, or in the plays of the Chinese soldiers following the Long March, or in Cuba today. It has not been the case at Brecht's own theatre in East Berlin. The absence of a revolution could not be compensated for by the performance of a play with the title *The Days of the Commune*.

Max Frisch drew the conclusion – and the unhistorical generalizing in his thesis surely undermines it – that the theatre could never cause a change in reality. According to Frisch, whoever would pursue such an aim will provide an impure mixture of politics and poetry. And Brecht? He never offered anything but imagination, free of reality, hence poetry.

Peter Handke agrees with the polemical demarcations Frisch draws regarding the impact of Brechtian theatre, but not, as far as one can see, with his basic thesis on the relation between theatre and reality. Presumably he would like to avoid the dubious conclusions which Frisch has drawn as a dramatist. If all writing for the purpose of presentation by some kind of acting (not always by skilled stage players) is capable of producing only what already is reasoned through, remains limitlessly at hand and is wholly superfluous, then one can (and why not?) write a play like Frisch's *Biography*, in which we are shown a mediocre man not willing to change his mediocre life even after he recognizes his previous mistakes, and even were he to have the chance to change. Why should he?

It is just this sort of going off into an amorphous banality, that is into a sort of production which one could just as well forgo, that Peter Handke wants to avoid. His objection to Brecht does not lead him to conclude, from the inefficacy of Brecht's theatre in causing changes, that a transformation of reality with the aid of things written and acted must be impossible. Handke sug-

gests that Brecht's mistake did not lie in undertaking to work for change through written works, but rather in the choice of inadequate means. Brecht made his decision as between the bourgeois theatre (which he rejected) and a theatre having a new dramaturgy, art of performing and onlooking. Handke would appear to see this *umfunktionierte* theatre, too, as a theatre of Culture and of Property. As soon as someone walks up to a box office, buys a ticket, sits down in a darkened hall and finds something enacted before him by people whose names can be read in a programme, then, in Handke's phrase, 'theatre-theatre' is being offered. And at the last it has to remain, no matter what the intent, 'mere' theatre.

It is more than simply coincidental that at the same time as *Theater heute* published Handke's article in April 1968, a remarkable critical essay on the same theme was printed in Sartre's journal *Les Temps Modernes*; this was Bernard Dort's '*Le jeu du théâtre et de la réalité*'. Dort has been very close to the French popular theatre tendency, and in 1968 also participated in the Brecht Congress in East Berlin. His analysis, however, leads him to the following assertion: 'Today, the so-called New Theatre of the 1950s already seems to us an object fit for a museum.' The search for a popular repertoire which will be the ideal expression of the spiritual life of the people, is nothing but a 'beautiful myth'. This conclusion is drawn, since Dort believes the three most important dramaturgical concepts of past decades have at this date revealed the limits of their possibilities. Here he specifies the neo-naturalist theatre, the theatre of the absurd and Brecht's epic-dialectical dramaturgy. Dort also points up the distance that lies between Brecht's social ideal and the socialist realities of today. 'In a sense,' he finds, 'an assimilation and cultural integration of the teachings of Brecht has occurred, and this has led to a political distortion. The epic form still holds rich possibilities, but these must be freed from the small-change of a docile Brechtianism.'

Therewith Dort is brought back to the original question of his

essay, which also, it will be recalled, was a question posed by Brecht: 'Is the theatre able to reproduce the reality of our time? Can it put the world in which we live on to the stage?' After scanning recent English realism, the theatre of parable, documentary theatre, the experiments of Peter Weiss, Dort argues for the work of Jean Genet and Armand Gatti as holding out, in France, the greatest dramatic potential. He sees both authors initiating a new relationship to the stage and audience. Genet would demolish the illusions of his onlooker. His theatre will not bring reality on to the stage, but rather his contemporaries' dreams about the reality. Gatti, on the other hand, looks on theatre as (his own words) 'an imperishable means to liberation – not merely from bigotries and inequities, but as well from conformity and kinds of thinking which are nothing but coffins'. Dort finishes:

Henceforth we must revise the notions of creation and the dramatic work. The centre density field of the theatre's activity has shifted: it no longer is located on the stage or in the play, but is to a certain extent in a space between the stage and auditorium, or, more exactly, it is where world and theatre meet.

This without a doubt is milder than in Handke. The French critic still accepts the structure and functioning of theatre. He does not seem to look toward another kind of play than that within the stage context. However, more symptomatic than their differing deductions are the shared assumptions in the thought of a Handke and Dort. Dissension is rife: none can deny that today throughout the world and in a radical mood, the pluses and minuses of the traditional theatre are discussed. Also from Bernard Dort there issues a far-ranging negation of the prior bourgeois culture-dispensing theatre.

Brecht and the aftermath. With Max Frisch it is back to the idealism of Schiller, i.e. to the sharply dualist separation of art and life. With Handke one found originally this same idealism, in his *Sprechstücke* (Speak-ins), which sought undialectically to

shell the language from the matter, the form from the content. Yet Handke's new position also is idealist; according to it, change can be brought about by play, but only if previous means of artistic production are avoided. The street-theatre of a Fritz Teufel, and the example is Handke's, is said to offer possibilities for a new combination of change in play and reality. In this would lie, presumably, the plain rescue of Brecht from the maze of his materialist doctrine.

We ought to be clear about this, that neither the platform of Frisch nor of Handke would be comprehensible without Brecht's dramas and teachings. All present endeavours toward a new relation of art and reality – so to overcome bourgeois aestheticism – were already anticipated in the Moscow and Berlin of the 1920s. A theatre evening of the purest artifice, comparable to a production of Goldoni by Giorgio Strehler, was presented by Alexander Tairov: with the assistance of a French nineteenth-century operetta libretto. The way for all timely political discourse in the theatre – produced then largely by Expressionist means – was blazed by a Russian revue on the Chinese Revolution. *Roar, China!* was the title. Sergei Tretyakov was the author: he too was liquidated under the Stalin régime, like his director Meyerhold. Nevertheless, without all this, and Piscator's work at the Nollendorfplatz, today's particular debate could not be. The notion of 'street-theatre' was foreign neither to Brecht nor to the Russians of the 1920s. Mayakovsky wrote slogans which served as warehouse outlet publicity: poetry by a revolutionary advertising specialist. In Brecht's last years he took an event from German politics of the time – the treatment of a West German youth delegation while returning from a youth meeting in East Berlin – and he composed it as a street play, and to convey authentic information (the *Herrnburger Bericht*; music by Paul Dessau).

And nonetheless, the author of the parable play *The Good Woman of Setzuan* attached himself to the earlier forms of the theatre play in a theatre space. Furthermore: Brecht put great

importance not on the coextensiveness, but rather on accenting the contrast, between what was to be represented and the theatre framework in which this is done. The theatre of ranged seats had always been the theatre of Culture and Property. When the bourgeoisie replaced the feudal aristocracy as the ruling class, it kept the forms of courtly hierarchy, the better to introduce voluntary self-policing as the basis of outward social distinctions. The young Richard Wagner, a bourgeois revolutionary motivated by socialist utopianism, dreamt of a new community centring on pleasure in art and quite beyond the trivia of class or status. The undifferentiated amphitheatre as democratic ideal. Here everyone is human and his right to be so is assured. The celebrative opera house shaping a quasi-religious community. Even if Bayreuth did not exist, we would know the outcome. The socialist utopianism of the Expressionists of 1920 found an equivalent in Max Reinhardt's theatre of the masses at the Grosses Schauspielhaus in Berlin. Egalitarian democracy – evenings from 8 to 11.

Our recent theatre buildings reflect this lack of clarity in their objectives. Everywhere we see the attempt to build in community, to plan against hierarchies, to tear out the apron between those acting and the observers. Democracy in all things aesthetic! it being absent in the social realm.

All this left Brecht cold. In his Theater am Schiffbauerdamm the stucco-work of the previous century – involuted motifs, cherubs – was carefully preserved. Faded gold leaf was restored, the loges returned to their original condition. The founder of the Berlin Ensemble thought differently from Handke. The dialectical contradiction as between the space, form and content of the production was an essential part. In this matter too, the Russians proved consistent as the conservers both of the bourgeois and the Tsarist-courtly style. Their new theatre buildings are deliberate imitations: temples for the aesthetic religion of Culture and Property.

What then is the likelihood for theatre outside of theatres, and therewith outside of the aesthetic sphere? Max Frisch would find the very question nonsensical. But it is not. Certainly not in view of world theatre history with its Yule mummeries, rites and rituals of various cults, the Hans Wurst and marionette theatre. If everywhere today dramatists are reaching back to these ritual, plebeian, obscene primordial forms – and we see it in Peter Weiss and Jean Genet, in the Living Theatre or the theatre of cruelty, in the recourse to the ballet, the circus and the happening – shouldn't we pay attention?

What of the more recent examples? According to Handke, political theatre of today does not take place inside the confines of a theatre but in university student demonstrations, or 'when revolutionaries take their little children with them to the speaker's podium'. A very recent example from German reality also has aesthetic relevance; taking our cue from Andreas Gryphius we could describe it as the *Absurda comica of Fritz Teufel and his Judges*.[2] Here was a fully realized play for the courtroom; and that precisely because the accused negated the existing rules in play and successfully supplanted them with new play forms. This aesthetic transcendence inhered to the nature of the proceeding, for literature – a leaflet having satirical intent and not hiding its debt to Swift – had been treated as reality and alloyed into reality by the state's attorney. In turnabout the reality of the juridical jargon was displaced into literature, recast in the aesthetic realm. The play went beautifully, according to its wholly fresh playing rules, and could not have ended any other way but with a 'happy ending'.

However, it would scarcely stand repetition. The possibilities

2. This was the result of an action by a Berlin commune in 1968. Two members of the commune, Fritz Teufel and Reiner Langhans, were arrested for distributing leaflets which – satirically, they were to testify – offered the modest proposal that department stores be burnt down in order to bring the war in Vietnam home to the European public. Teufel and Langhans were defended by literary scholars and critics, and they were acquitted. [Trans.]

for reality-theatre are limited. Moreover – as no religious community is available nor will the urgency of any holy writ generate one – only materials for comedy may be had at present. Dürrenmatt has stated that comedy alone can be viable in our time. He wrote comedies: mostly, strewn with corpses.

This is permissible in the 'theatre-theatre'. In street-theatre, it will not do. One ought to guard against the role of Saint-Just who describes natural catastrophes as follows in *Danton's Death*: 'An insignificant, and on the whole scarcely noticeable, alteration of physical Nature, which might almost have passed without a trace, were it not for the bodies in its path.' Defining as analogous the natural catastrophe and revolutionary deed, he inquired: 'Should the moral universe take more consideration in its revolutions than the physical universe?'

When it comes to giving rise to the reality of dead people and not just stage corpses, the inviolable limits of the play are reached. The aesthetic and ethical spheres here separate. There is playing in reality, the playing of reality, reality playfully presented; but one cannot play around with reality. The whole aim has been to negate the bourgeois world of art in its substance and function. Alterations in social systems, we have seen, have not of themselves been able to modify the structure of cultural life correspondingly. The choice came to be framed as either conserving the art of the bourgeoisie in a post-bourgeois society or destroying the transmitted structures. And just at the point of demolition did implications become apparent, ethical and aesthetical. The time has come to reflect on these novel, radical alternatives.

It may seem that to move on ahead we either must accede to total aestheticization, a maximum play character, the cult of the artistic and inauthentic.

Or else to a total dominance of non-aesthetic criteria: information, instruction, enlightenment without the presence of specifically aesthetic means of appeal.

Neither of these conceptions is in fact new and their historical

antecedents should make us ponder. Thus, the French queen Marie Antoinette, although aware that the negation of her existence was foreshadowed by the play, caused Beaumarchais's *Marriage of Figaro* to be acted in her Trianon garden-theatre. For as we know, hardly anyone will profess to believe that a theatre piece can have any power to transform reality. Yet the outcome is also known.

And then the opposite. The Puritans with Cromwell over-throw the monarchy and behead Charles the First, then shut the theatres. More than a century later the Genevan proponent of a radical democracy, J.-J. Rousseau, justifies the decision of Genevan Calvinists who refused to permit a theatre perfor-mance. In both cases we know the inconsequence of the mea-sures. After Cromwell's death the Puritan power collapsed; Counter-Revolution opened the theatres to the Restoration plays.

Not only is the era of Culture and Property now nearing its close. Many another antithesis has been tested and, in result, found wanting. We have tried the theatre forms of a faithful imitation of reality and of non-imitation strained to the point of grotesqueness and absurdity. The stage as a moral and as an immoral institution. A theatre of cruelty and of desire. The admixture of play and of non-play. Plays as direct action and as the dusting off of theatre-theatre. But somehow, the play has always been the thing.

With the rapid de-escalation in ideologies, the boundaries of play become evident to the spectator. The angered remark of Theodor Adorno – after Auschwitz, poetry is no longer possible – has been so often heard as to belong almost to 'conventional wisdom'. But what I find justified is the rarely posed question whether in view of the Auschwitz reality, tragedies should still be written and acted. Auschwitz on the stage ... Rolf Hochhuth has unhappily demonstrated in *The Deputy* the results of that course. Peter Weiss took more precautions in *The Investigation*; he held the real occurrence at a distance through the recollective view-point, the courtroom, the oratorio format.

So it would seem that comedy alone is left. But comedy of course has no existence in the absence of laughter. And who can laugh, and about what? Bergson's famous treatise on laughter asserts that an audience laughs in comedy because it has secure possession of the rules of the social game, as against the outsider and any deviant conduct. An infamous but effective rule of thumb, from Molière up, say, to the First World War. But with Sternheim's ludicrous scenes from the life of the bourgeois hero, as one example, a new comic approach became apparent. The dramatist refused to be of a like mind with the established society, emerged as the outsider, and overwhelmed a culture-and-property public into laughing at the on-stage inanities of Culture and Property. Artaud and Genet carried this to a fine point; and we may mention Odon von Horvath and Martin Sperr. Thus has appeared a theatre of deviance, quite lacking social integration: contrived with the aim of unsettling the 'normal' audience seated in the orchestra.

Yet it has remained play. And *Endgame* too continues as play, it in particular. 'Me – to play.' This Beckett's Hamm knows perfectly well, when the servant delivers his cue as always.

Every a.m. the newspapers detail the latest doings of *homo sapiens* and *homo faber*. The coverage assigned to *homo ludens* has usually appeared on a cultural page. Of late he has managed to make his way up amid the breaking news reports. Still, the impression may linger that by way of many forms and detours we have come back to Schiller's ideas on theatre. As concerns the stage as a moral institution, indeed we have not; the claimant to that tradition must be Rolf Hochhuth: he alone.

But Schiller's profound observations on the human potential of play remain important. The more lucidly and passionately the man of today plays – without stepping beyond the play-reality – the more effectively he finds release from the condition of self-alienation. In the play he comes to discover himself. Moreover it must remain just play, so long as the prerequisites which will put an end to self-alienation are not created in reality, on the

farther side of the era of Culture and Property. Whether in the theatre space or upon the street – does it matter? We can see in play alone, what is elsewhere hidden beneath petty talk and need: Freedom and humanity.

18

Stefan Morawski

What Is a Work of Art?

Anyone today who investigates the relations among the various
arts will not, to be sure, set up any single art as the universally
valid aesthetic model, but rather will pursue the problem of a
common substratum upon which all the arts rest. By the notion of
'substratum' we mean here particular, historical situations of
conflict, which are the cause for the rise of attitudes at once
philosophical and aesthetic, and behind which are hidden those
definite socio-political and economic-social transformations
which lead to the basic revision of foregoing conceptions of man
and his world. Awareness of the problematic aspect of all
phenomena – from both the ontological and epistemological points
of view – spread rapidly at the beginning of our century. Scien-

STEFAN MORAWSKI is one of the leading Marxist aestheticians of the
younger generation in Eastern Europe. Born in Cracow, Morawski pursued
his college studies clandestinely during the Nazi occupation. In 1960, he
was given the Chair of Aesthetics at Warsaw University. In 1968, he lost
his post when Gomulka, First Secretary of the Polish Workers' Party,
charged that with four other professors Morawski 'bore particular responsi-
bility' for street demonstrations by students that Spring. In 1970, he was
accorded research responsibilities at the Polish Academy of Science.
Morawski has published many articles in leading theoretical journals in
several languages, and books in Polish on the history of aesthetic thought
and its problems in Poland, Germany, France and England, and the Soviet
Union, and the philosophy of art of André Malraux. His *Inquiries into the
Fundamentals of Aesthetics* is to be published soon in English. With Lee
Baxandall, Morawski is completing a work on the origins and development
of Marxist aesthetic thought.

tific and technical discoveries, together with political events (above all, the October Revolution), inexorably cast every long-preserved world-view into doubt. Thus it was no longer possible to uphold the earlier idea of art. The anti-mimetic trend categorically overthrew the principle, accepted by the European tradition since the Renaissance, that the existence of art was founded on an imitation of reality. Quite different if embattled tendencies of art underlay this anti-mimetic development. The push came on the one hand from the Nabis to Matisse, and on the other hand from Cézanne to the Cubists. The decorative surfaces and the new space, wherein the object could be constructed by using distinct superimposed projections and different time-coordinates, represented experiments which marked a radical break with the one-time *construzione legittima* of Alberti and Leonardo da Vinci, and also a break with the impressionistic-divisionistic method of so arranging single flecks of colour that they comprise in effect a colour ensemble. Replacing a world which resembled our normal world in the most thoroughgoing way, there arose a world of imagination, which however did not lack references to reality, and was in no sense barren of all objectivity and spaciousness. To this, Picasso and Léger give adequate testimony. The artists who only experimented with systems of colour and tried to evoke the most variegated light reflexes, for whom the symphonic expressive effect of colour was central, such as Kandinsky and Delaunay or Larionov and Goncharova, carried the upheaval in painting still further; the last consequences of an abstract art were drawn by Malevich, Mondrian and Strzemiński. Characteristically, it was in fact the Cubist revolution (the synthetic forms of Cubism especially) and not Fauvism or Delaunay's Orphism which gave the impulse to the Dadaist and Constructivist manifestoes. Now no one any longer tried to work out new visual effects, rather every effort went into a provocative and seemingly true reproduction of reality (the reliefs of an Arp) or into work on some kind of engineering project (Tatlin, Rodchenko, El Lissitsky). The

analytical Cubists and the Orphists in their painting created a singular object; in contrast, the Dadaists and Constructivists took the ordinary objects of every day as their references. The outcome has been that the boundaries have been tumbled between art in the traditional sense and the sphere of material culture. The well-known case of Brancusi's *Bird in Space*, a sculpture regarded by the New York customs officials as a mere piece of metal, is just as indicative as the Dadaist protest of the time (Duchamp's urinal entitled *Fountain*, or Picabia's inkpot as *The Holy Madonna*). Not only in this respect did Dadaism challenge the boundaries of art and non-art. It also did so by emphasizing and sanctifying ugliness. This conception excluded an absolute primacy of the beautiful, in its earlier sense and as oriented to the Greek and Renaissance models. Naturalism had already brought the ugly into art; but the Dadaists and the Surrealists with them were the first to attack frontally the cult of the isolated, harmonious and aesthetic phenomenon, the phenomenon which was held to free men from their moral and political responses. Ugliness was for the Naturalists in modern times similar to the sublime and the tragic, above all a protest against the beautiful, against its claim to exclusiveness within the realm of art. The Dadaists and Surrealists preferred the ugly in the name of life, of a new try at the social order, of an imagination which respects neither dogma nor boundary. The way led forward from Dadaism to provocative spectacles such as Yves Klein arranged in Paris. When his model climbed into a tub of blue paint, then impressed her 'pose' on a white canvas, there was more than moral scandal involved. Here was the destructive gesture of an artist whose intention evoked an illusion, the better to unmask illusionism in art. In Rauschenberg's work of 1962, *The Bed*, what one sees is the artist's own blanket and pillow which he has sprayed with colour. Here is at once a furtherance of the Dadaist protest against aestheticism, and the mockery of a civilization in which possessions are everything. In a differing yet kindred creative mode is the work of Hasior, a Pole who

emphasizes the banality of the object – old rubbish receives treatment as an interesting material – which he goes on to ornament with plebeian motifs derived from folklore. Ugliness is here given a symbolic sense owing to the tradition to which the artist relates and which he at the same time deconsecrates. A close connection should be made between the protest against such aesthetic principles as the imitation of reality and the dominance of the beautiful, and the break with the principle of real and logical necessities. The art of the nineteenth century sanctioned (quite in accord with its own thinking) the omniscient commentary of the narrator whom the reader could safely equate with the author himself, and whose legitimate task it was to explain the foundations of human existence. This art required images or sculpture whose meaning could be deduced from an inwardly ordered world. And where such art may have lost its religious trust, it still put faith in philosophy or in science, or in both. The twentieth century has undermined such confidence; art has become a terrain for independent philosophical exploration. The idols of earlier times have given way to His Highness, Accident. Now the pathways of modern art divide. To the one side go the subjective manifestations and visions, which are associated with the stream of consciousness or unconsciousness. To another side go the efforts in the fifties and sixties to play at a kind of lottery, be this with or without the aid of machines. In the first tendency, inspiration held a high place, flowing from Bergson's *élan vital*, Freud, and Breton's conception of the 'inner model' and the *écriture automatique*. The tendency evolves from Fauvism and Expressionism through Surrealism to such recent instances as Action Painting. Of essential importance for the other tendency, one must mention information theory, the discussions of an anti-entropic system of given elements and the unexpected appearance of a new combination of these elements. The terrain of experiments is occupied by Op Art as well as by all plastic-luministic-kinetic attempts to achieve a new spatial arrangement.

The Polish author Kazimierz Brandys reflects, in his book *Joker*, on the convulsions of contemporary civilization and the uncertainty of everything which could provide a foundation for the generalizations of the aesthetician. He writes that the author gives its due to an *invisible* world. This formulation relates immediately to the visual arts. Invisible can here be taken to imply: the feasibility for the inclusion of a physical or psychical phenomenon is unlimited; be such the unexpected expressions of the artistic 'ego', or be it the 'roulette' of the very material, as it responds to stochastical laws. The commencement of this protest – in the name of Accident, and counter to constant and comprehensible regularity – goes back to the initial two decades of our century.

At the same time, another tendency crystallized: Moholy-Nagy tried – according to the testimony of his wife – to execute a work of art by telephone, thus to avoid all personal intervention in the way of direct contact with the evolving work. He wished to get a cool and precise structure which might readily be duplicated; his aim was a depersonalized, purely intellectual beauty, to the extent that one can even use this concept here. Especially important was the renewed thrust of artisan and machine products into the sphere of art. This royal way led from Morris to Gropius, and aesthetics has not since been able to deny it. From here stemmed essential impulses for the revision of fundamental concepts. This revision was effected, for example, by the questions raised concerning the thesis, advanced by eighteenth-century aesthetics, carried further by Croce, which had held original expression to be the chief precondition for the execution of an artwork. To be sure the thesis is today still defended, by the existentialists and Catholic personalists, for example. But it was already cast under grave suspicion by Walter Benjamin and Lewis Mumford in the thirties. In their discussions of art in the era of technical reproduction, they were brought before the question: what indeed is the basis in original expression as regards a technically reproducible object? These interpretations

were then abetted by art historians and ethnologists who, investigating the productions of primitive peoples and peoples of the Orient as well as works of the Middle Ages, showed where previous example and canonic rule either were essential or were more essential than the expression of a given artist. Thus two more aesthetic anti-principles can be added to the three already in hand: one of these being serial production as against individual creation, which one should note has been tied in some artistic manifestoes, i.e. the Bauhaus or Prolecult, to the call for artistic collectivism; and the second of these being machine production as against handwork. This latter phenomenon entails an appreciation of serial and mass products as aesthetically valuable creations. In view of the successes of the scientific and technical revolution of recent years, it is true, the emphases have shifted: now the focus is not so much on the product as it is above all on the productive forces. The do-it-yourself machines are able to produce an object which one can and does describe as a work of art. Recent 'minimal' art, with its avowed anti-expressionistic tendency oriented to architecture, may be reckoned as a specialized continuation of the engineering-constructivist approach. 'Conceptual' art has overleapt both these boundaries and the destructive gesture of Dadaism. 'Conceptualists' occupy the furthest critical point – assuming that their work is to be properly and primarily *an inquiry* into the questionable nature of art and that their detachment should run parallel to the scrutinizing stance of the scholar. Where Dadaists sought to dissolve art into the life flux, the 'conceptualists' hope to have the same effect but while turning their backs on the markets and the public: their particular frame of reference is the general, *problematic* spirit of our time.

My purpose here is not to recount every piece of evidence leading to a new view of the visual arts. Rather my aim has been chiefly to prove that the boundaries between the artistic and the non-artistic have been blurred. In poetry a similar development occurred through the intervention of the various prose-oriented

schools. In place of the old image, palpable and clearly evoking its association with the object, there appears a grid-work of imaginative representations and of concepts, meant to create an atmosphere at once emotional and intellectual. Or a revolutionary lyricism emerges, having a blunt idiom, entirely communicative, and breaking with a melodic prosody and with the rhythm of balanced strophes defined by rules of a genre. And here, too, one finds the boundary stakes have grown uncertain: lyricism has been exercised which makes the impression of a rhymed reportage or a graphic but orderly philosophical essayism, or of a prose expression built up with a definite word order. We have no need here to recount the many avant-gardist manifestoes against this artistic conception; they have been treated often and in sufficient detail in the numerous studies on the present topic. We shall linger on just two avant-gardist movements – Russian Futurism and the Imagist school – which sharply adopt a contrasting position. Despite evident differences in the theory and practice, we should not overlook the close kinship of T. E. Hulme and T. S. Eliot with O. Brik, V. Mayakovsky and V. Shklovsky. They postulate poetry as providing, among other things, an equivalent for social and philosophical attitudes; these attitudes to be expressed, not with description, but by *signs*; in place of rhyme and the inherited construction with strophes, they establish *inner rhythm*, and instead of eidetic metaphor, which registers its impression on a listener with no psychical effort, they place abstract metaphor that appeals in a conceptual matrix to the imaginative faculty and emotions. One could likewise mention the Polish schools, the avant-garde of the *Zwrotnica* (Switch-Station) and *Linia* groups. The principle of using a minimum of words to evoke the maximum of associations, the turning away from the rhythmic-melodic and from images rampant in ordinary speech, the premium set on poetic craft, the construction of determinate structures, the pursuit of expressive means that lead off and away from the material world, the reliance on elliptical phrasing and com-

pounded effects – these are all demands that conduce toward an anti-mimetic poetics; one where poetry and prose are set apart sharply from one another, the lyrical transmission is impeded, and the listener is impelled toward an *intellectual* response. Herewith, this poetics exhibits a determinate world outlook: it speaks for culture and against nature, in favour of cognitive-intellectual effort and against intuition, for the proletariat and against the outlived social order.

To this we must add that much like painting, modern poetry has not only made the ugly its own, but has bestowed on it thematic pride of place. Of course the ugliness in Eliot's 'Prufrock' is another sort of ugliness than that in the Polish poets Grochowiak or Bialoszewski; but uniting them all is the acceptance and blunt naming of the reality, with its everyday, often repellent deficiencies. As in painting again, the lyrical writing of the twentieth century was founded strongly upon the element of Accident. And, just in passing, let us say that here, far more strongly than in painting, the catastrophic attitude has broken through. But conversely the lyric has not found the ready means for machine manufacture, although the latter has been able to produce some para-surrealistic works. Anyone seeking collectivistic tendencies will find examples enough in the first decade of Soviet power.

The examples cited above are drawn from literature and the fine arts. The process in question, however, is characteristic of every one of the arts. It seems comprehensive. As this is the case, I might now briefly survey and summarize what it is on the whole that has happened in this century, causing us to speak of the crisis in the idea of art and bearing closely on the troubles we meet as we try to give a viable definition of a work of art. In such theoretico-historical endeavours, we shall always make best headway where we have described a certain 'model', i.e. a pattern, which to a considerable extent corresponds to the artistic phenomena and the aesthetic ideas which cross-pollinate one another in our era. The most useful frame of reference we

might take, possibly, is the patterning of the aesthetic ideas in the first decade of this century. It is a very notable era: on the one hand it witnessed the deterioration of the socio-political stability of the capitalist system, which had appeared impervious through the entire industrial revolution until then; on the other hand, it saw the decline of long-held conventional precepts – philosophical, religious, moral and aesthetic – as the thought of Marx, Freud, Einstein, Nietzsche, and Bergson made strong gains. What were the entrenched precepts in the aesthetic field which were being eroded? The transmitted aesthetic doctrine rested on these five principles:

(a) There exists a definite hierarchy of values: and within the fixed ordering of the world the artist is obliged to find the means (which will be sensuous and imaginative) to express in his own way the verity which is established; in this manner he confirms and honours his own place in this order – that of Beauty.

(b) Genuine art is ultimately based on mimesis. That premise accepted, the kinds of representation may diverge; for every artist (including the composer and the architect) will ultimately convey an attitude towards the psycho-social phenomena, in rendering these accessible to the art recipient; thus, in sum, each artist in his own way will condense and intensify our way of being in the world (which also will include our feelings).

(c) The artist commands some branch of *téchne* (skill, virtuosity) acquired through years of difficult training. In this respect, his position is institutionalized, it is demarcated and anyone may see that he differs from the amateur.

(d) Art manifests an outstanding individuality: and the more we sense the individuality, the more we may be sure we have to do with genius; while the artist appears in this respect as a kind of sacred person, a prophetic spokesman.

(e) The realm of art has three interdependent yet distinct poles: the artist, the artwork and the audience (the latter being expected to respond as fully as it can to the experience of the artist, which is stored and transmitted in the artwork) – of the

triad, the artwork is surely the term that most matters. For *ars longa, vita brevis*; the artist will not want to gain less than his immortality, since he knows that the nature of the artwork can optimally crown his career and vocation with eternal life.

Now, as we notice, little remains of the certitude of the five principles. The artists stopped deferring to the philosophers and other guardians of truth; while numerous schools of religion and morality went under in the crisis of knowledge. Thus the twentieth-century artist proceeded on his own – if in the company of his colleagues – on the adventure to discover some fragile truths, which would be always relative and often obscured. As for mimesis, we have seen how its overriding status was revoked: in part, due to the upsurge of the arts-and-crafts movement into the domain of art after four centuries of denigration and exile; but more than that, owing to a new judgement – also in the strongholds of mimesis: literature, theatre, painting and sculpture – that only one of the artist's possible resources lay in representation, and at that, it was perhaps the least challenging and intriguing of the possibilities. Consider the stage experiments of Appia and Craig; the twelve-tone composition of Schönberg and the later aleatoric trend; film, where the notions of the traditional novel and drama were ingested until the fifties, by and large, but where a break with mimesis is sharply registered by Godard and Mekas and a large 'underground' movement. The dwindling of the authority of representation in the arts is to be witnessed in every sort of version. Poetry has tended to become 'concrete', almost wholly graphic. The novel is in an experimental stage where both time and characterization are submitted to shuffling and dicing, where plot and narration have scarcely kept a handhold. Theatre has turned towards ritual spectacle and happenings. These are just a few, random cases of the upheaval which reaches very far. Also *téchne* – skill – is on the defensive. The questions are not put to it by the *objets trouvés* alone, or necessarily; nor by the claims on behalf of the awkward primitive artist for a niche within the dignified Pan-

theon. Rather, the nearer approach of the artist to life events, or to natural objects, which had only to be 'arranged' in some fashion, put in particular doubt the value and honours of an academic, or otherwise distinguishing, extended cultivation in art. Also the principle of great individuality is strongly questioned, and with that, the sacred or the Bohemian-prophetic function of the artist. Has not the artist become rather, quite often, a derisive jesting Pilate towards everything sacred? A denouncer of his own expression, and one who flees from it either into tragi-ironical gestures, or to refuge in the impersonal appurtenances of our technological age? This new and most un-royal road of artists can be traced from Marcel Duchamp to minimal and conceptual art, and we can cite the similar diminution of individuality by John Cage, Merce Cunningham, Kaprow, or the *nouveau roman*. And last: the art object is no longer regarded as an immortal light for the generations to come. The avant-garde often emphasizes just the contrary. The artwork is seen as ephemeral and often as at once disposable, as in happenings. Thus too a great change occurs in the role of the art recipient. He is asked, not to contemplate but instead to co-operate. We see this not only in some happenings, but likewise in numerous examples of literature, music and the plastic arts, which assert a so-called 'open form'. Now, it may fairly be said that I focus here on the extreme cases of the current unrests in art. Yet just the stressing of these instances makes it perfectly clear that the transmitted aesthetic model is *no longer tenable*. The phenomena we surveyed have shown a vitality and staying-power which forbid us to treat them as marginal extravagances and eccentricities. We are required, accordingly, to ponder on the aesthetic categories we think we might use – even where we may decide (as I do) that there is much in the transmitted (and European, let us add) heritage that may be rescued and refurbished.

What concerns me here is to develop a conception of art which can hold its ground, despite the proven crisis in the visual

arts and poetry (and similar phenomena have appeared in music, the dance, theatre and film). Such a definition cannot but run an entire gamut of difficulties. Artists have, on the whole, a deep distaste for every sort of definition; they feel that their independence is threatened. Wrongly so, although surely some epochs of cultural history seem to confirm these fears. The art historians and art scholars will protest, in the name of the particularity of artistic genres at a given time. Wrongly so, since the definition proposed here should deny in no way the special characteristics of art at a particular moment, its aim rather being to set forth the common traits of artworks of today. Philosophers of art will no doubt harbour the deepest misgivings. The aesthetic school that has developed with the stimulus of Wittgenstein, and his last work *Philosophical Investigations* (1953) especially, holds the view that no real definition of the conception of art can be given. Thus for instance Morris Weitz, a leading American aesthetician of the middle generation, who in his programmatic essay, 'The Role of Theory in Aesthetics' (*Journal of Aesthetics and Art Criticism*, XV, i, 1956), maintains that it is meaningless to seek for any essence, since no two eventualities are ever identical, and especially so in the case of social phenomena, which are variable and non-repeatable. Of all such phenomena, precisely those of art are the most variable, the least repeatable. The definitions we commonly employ are in ultimate result but ostensible definitions, as the logicians say; i.e. one accepts according to the 'rules of the game' that such-and-such classes of objects are to be considered art, and hence one must proceed so-and-so with the objects; i.e. one ought to regard them in a certain way, drawing delight from their texture and rhythm, etc., without however permitting oneself to respond as one would to a thing meant for functional purpose or for imparting information or as a system of moral directives. By contrast, numerous other aestheticians of the analytical Anglo-Saxon school maintain that in any given field we may encounter variability of the object under investigation, nor should this

lead to doubt regarding the admissibleness of a definition. A definition is always historically conditioned; any new element can provide grounds for enlarging or for limiting the foregoing definition. In a word, art is not such an exceptional phenomenon that the concept of art must be subject at every succeeding instant to a chronic accession of ambiguity. Methodologically this problem, in my view, cannot be solved exclusively by the road of logical controversy. In this I share the opinion of J. Kotarbińska who, with her highly interesting study, 'Controversy on the Applicability Limits of Logical Methods' (in English: *Logique et analyse*, April 1965), has demonstrated the position of Wittgenstein and his followers to be too extreme. An authentic definition of art, founded on matters of fact, is at once feasible and necessary of defence, supported of course by the history of aesthetics, which one must consider in close association with the history of culture. At this point I should like to beg off from a more comprehensive presentation of this conception (which I have offered in part elsewhere).

In my opinion, a common conception of art for the diverse ethnic cultures was constituted through art's emergence from production and from magic, and the subsequent history of artistic creation has resulted in maintaining the kernel of that rudimentary conception up to the present (this is owed to certain constants of human nature as much as to the cumulative effect of cultural experiences). To be sure, the fickleness of the concept of art is what registers on us first of all. But this psychological and sociological fact does not exclude the possibility of definite invariables. Neither radical relativism nor radical absolutism can in truth be defended. For if the concept of art, together with man, his society, and the given epoch were indeed to undergo total change, what right would we have then to discuss an art history, and how should we trace its idiogenetic lineaments?

In the annals of modern aesthetics, where the tumultuous transformations in art have been debated time and again, we can

discern a number of efforts to provide a viable definition of the concept of art. Most definitions however have winged wide of their mark, since ordinarily they *absolutize* one aspect of art. For this reason one especially prizes endeavours that approach art on terms of a whole grouping of attributes. I would associate myself here with three such attempts by American scholars: De Witt Parker ('The Nature of Art', *Revue internationale de philosophie*, 1939, No. 4), Erich Kahler ('What Is Art?', *Out of the Labyrinth*, New York, 1967), and M. C. Beardsley ('The Definition of the Arts', *Journal of Aesthetics and Art Criticism*, 1961, No. 4).

The structure of sensuously given qualities (we shall see further on whether they are exclusively sensuous and directly given) is more than a necessary precondition, it is the foundation of the concept of art. By structure we mean in general a class of elements that comprise a coherent whole. The notion of 'coherent whole' needs added explanation; for it will be used here in a certain sense as a synonym for structure. According to the gestalt theorists (Wertheimer, Köhler, Koffka), the structure as a coherent whole is characterized by its elements being non-summarizable; i.e., its elements cohere by condition that the attributes of the elements are absolutely conditioned through the structure and determined by the structure; the structure is something other than the sum of elements. The gestalt conception has been affirmed and developed by the modern structuralists, for example H. Sedlmayr and R. Ingarden. According to them the structure exerts a fundamental gestalt-formative quality, whereto the elementary qualities are subordinate. Ingarden describes it as a harmonious unity. In this sense artistic structures may bear comparison with organic structures. A convincing analysis of the phenomenon is provided by Ingarden in his book *Das literarische Kunstwerk*.

Another opinion of the concept of structure is adopted by those whose premises stem from information theory, for instance Max Bense, whose four-volume *Aesthetica* (1944–60) is his most

detailed treatment. Instead of traditional macro-aesthetics he proposes a micro-aesthetics, based on determinate materials, classes of signs. These signs cannot be differentiated in the terms of content and form. The classes each themselves provide a link of a given series: the elements of the classes stand in determinate functional relations to one another that can be stated with mathematical formulas. Here the structuring process is statistically rational, and distinguishable from other physical processes in terms of the very slight probability whereby x or y will crop up. The artistic structure, like any structure, is supplied with anti-entropic signs. Its proportion – in the exact mathematical as in the aesthetic sense – is its information.[1]

Employing the examples we have chosen – which of course afford but a narrow glimpse into the discussion[2] – the fundamental differences over the concept of structure as a basic philosophical-aesthetic category could be characterized as follows:

Is the structure an enumerable (and consequently quantifiable) system of discrete elements, or a definite qualitative system?

Is the structure, if composed of a qualitative system, something which can be taken in only by an intuitive grasp of the whole, or is it accessible to analytic modes of procedure?

Is the structure an ideal-homogeneous whole, or are its particularities more clearly articulated in its so-called oppositions?

Is the structure comprehensible only in and through itself, or rather only in the context of a larger system, of infrastructure and suprastructure?

If the character of the given structure is defined by a more comprehensive system, the suprastructure, is this system then exclusively synchronic or is it also diachronic?

Is the structure a Constructum (leaving aside whether it is a natural or artificial structure) or is it an empirical given, in which case one may assume the structuring operation takes an unambiguous and constant course congruent with the given cultural system, in its synchronic as also in its diachronic aspects?

To each of these questions I would offer the same answer; of each only the second part is to be affirmed. In my view, artistic structures cannot be reduced to quantifiably rational classes, even if in the terms of certain systems this is procedurally possible and effective. Second, it is impossible to accept the intuitive understanding of the whole as Dilthey and, later, the phenomenologists would have it, since this intuitive procedure is not controllable. Third, the conception of Lévi-Strauss provokes doubts because he acknowledges only synchronic connections between the system and the structure, and, in his view, the alignment of the system with a set model may be programmatically worked out, while moreover, the model of any given structure is rooted in the recurrent systems. We may say this. Every artistic structure will signify; its significance results from the given fundamental sign system to which it appertains; simultaneously however every artistic structure is expressive, i.e., one can explain it – in terms of synchronic/diachronic norms – only by reference to the larger wholes which define its modifications and its evolutionary rhythms. Hence we adopt here the standpoint of Marx as he formulated his methodological theses and commentaries in *Capital*.[3]

One should add that artistic structures cannot be characterized by any means as precisely in terms of their particular quality and in terms of their dependency upon historical circumstances, as they can be according to the classes in mathematical set theory. K. E. Tranøy has said in this regard that the further we depart from logic and mathematics and the closer we come to aesthetics, it grows that much more difficult to trace out firmly the basic concepts (*structure*, *elements* and the relations between them), and the greater is the trend to apprehend the structure as a whole. All the same, K. E. Tranøy wrongly holds that it is harder than one can say to locate significant, decisively dominant, elements and relations in the structure of an artwork. On the contrary; generally, these coherent totalities possess a centre focus and are organized according to some defining main

principle. The elementary qualities enter thereto in differing orders of arrangement, to be sure, and in the most variegated associations with one another. We shall have more to say of this in a moment. But first another point that I believe more important, whereupon we must gain clarity in context of our discussion of the idea of structure. I am talking of the view which holds that the structure need not be harmonious. Kahler has correctly pointed out that misunderstandings can arise on this point; but he has not himself explained what shall be meant by harmony. Of course one can say harmony implies the full agreement of all elements with one another. But unfortunately, the concept of agreement has scant precision. It is nonetheless difficult to replace it with anything better. We can qualify and expand on it by pointing to its contrary, i.e. to discords or disturbances among the elements. In saying that the elements are in a state of agreement, we mean to say that in a certain sense they are of the same kind, they possess like characteristics. They have potency not owing to contrast, but owing to similarity. The totalities put together of them generally are static or barely dynamic. Such structures as this certainly have value and are necessary, but just as valuable and necessary are the disharmonious, dynamic structures. We owe to M. Wallis the distinction between two kinds of values, the gentle and the harsh, wherewith of course we can also have intermediate gradations.

The problem of the harmonious and the disharmonious systems is linked closely with the particularity of the oppositions that are characteristic of artistic structures. In systems of the first type, we mean by an opposition distinct polar points of a composition (above – below, centre – edge, right – left, etc.) or as well the unity of a whole evoked by means of a dominant key, as against the multiplicity of constituent parts. In systems of the second type, the opposition is more clearly recognizable; for it assumes the character of a conflict. Two further circumstances additionally permit us to speak of opposition as a characteristic

trait of the artwork. The phenotype appears here associated with the genotype, i.e. the individuum belongs to a class of determinate objects and at the same time stands out therefrom. And inasmuch as we encounter old and new elements coming into collision with one another in a work, the synchronic system, which is a part of a diachronic system, testifies to the stylistic transformations.

When we speak of the structure of sensuously given qualities, we think of forms, colours, tones, graphic signs, blocs, of black-and-white signals (on the filmstrip), movements (in dance), etc. which, within a great totality, comprise a totality of lower degree. Such a totality is at a lower degree, in result of the particularity of the single elements and of their partial systems; however, as a result of the association of elements and of the partial systems, and finally of the possible contrasts, dissonance and even the contrariety of the elements, it has its *own expressive power*. Hence the gravitational point shifts from the structure to the qualities which especially catch our attention, inasmuch as it is primarily the *sensuous* side of the phenomenon which holds us. In such cases we would be justified in speaking not so much of a structure, but rather far more of the hierarchically or non-hierarchically structured qualities. Yet one would be mistaken to stress the qualities exclusively or the structure only. The interrelation of these two moments is so extensive that they cannot be separated from one another. One thinks for example of the poems of Marinetti or of Mlodoženec, which are sustained chiefly by a complex sound-painting. These poets hope to liberate the word from syntax, they aim at an intuitively comprehended interrelation of the words, and this notwithstanding they at times achieve a coherent totality, determined by a peculiarly autonomous 'syntax'. Op Art provides another instance. Here, too, it should be apparent, the structure cannot be parted from the qualities. More than that – and of this we want to speak now – that coherence is directly linked with what we term the relative autonomy of the artwork. And when

poetry is understood to be a specially ordered (empowered) arrangement, i.e. a syntax or metaphor unambiguously differing from what prevails in the contemporary language system; and when the principles of the Russian Formalists are adopted and astonishment-exciting devices employed, with the aim of freshening perception; and when Brecht by way of invoking the *Verfremdungseffekt* outfits his actors in masks and demands that they play their roles with distance, so that the sense of the *Lehrstücke* will be emphasized – in all these cases, the accent is laid upon the structure with all its qualities and the structure is set apart from the surrounding world, as something relatively self-sufficient.

We have underscored here the double-sidedness of the con-figuration, to bring out the multiplexity of artistic structure and to note its characteristic attribute. This attribute leads one at a minimum through the step of laying stress upon the qualities, to the distinguishing of artistic structure from any related struc-tures. One can and must inquire nonetheless, what *concrete* properties shall be ascribed to the structure, whether one thinks at this point of rhythm, or symmetry, proportion, unity in multi-plicity, or the balancing of elements which incorporates dis-sonances, etc.; in brief, all those matters that are put forward in many studies as a nearer description of the aesthetic system. Every one of these properties seems important; yet not one of them can be considered a sufficient characterizing trait. Nor can any ensemble of these attributes be deemed perfectly charac-teristic of the work of art. One must here proceed with caution; because we are considering the most different sorts of combina-tion, of a concatenation in differing artistic genres. Only all the traits together – and we have not by any means mentioned every one – provide the axiological attributes of a genre. They are the foundation for particular modifications in the singular works. As concerns the qualities, the situation is akin to that with struc-turing. Diverse theories of art describe the qualities variously, especially in their concrete manifestations such as sonority,

vivacity, attack or their opposites. Here every single work of art modifies the axiological traits of a genre.

The problem of the sensuous qualities is especially compounded owing to their universal compass, however. In the arts which only, or primarily, function through the word (literature, the rhapsodic theatre), the sensuous qualities are 'transparent'. In some poetic works we can still elaborate a phonemic-rhythmic configuration, as with the poems of Verlaine, the 'word-melodies' of Tuwim, the 'irrational language' of Kruczonych and Khlebnikov, and likewise Schwitters's *Ursonata*. In prose, on the contrary, the graphic signs and the phonetic signs always express meaning, and a definite object world is built up through their aid. For this reason we term these qualities *indirectly evocative* – thus we indicate their mediative function in the communicating of so-called 'literary images', i.e. not what are called *Ansichten* by Ingarden – in other words, appearances (which cannot be parted from the fictive gestalt and the object) – but rather the particularized phenomena and occurrences that the imagination asserts and that either have happened or are said to have. These, as we know, are structured by dint of narrative, action, fable, etc. For certain rather exceptional readers the novel can be – like poetry – an eidetic experience, i.e., they will actually 'see', uniquely perceive (with all the senses), the events and images, while reading along. However for the great majority of the reading public – and indeed, quite in accordance with the specific medium which is basically non-eidetic, only a certain aura of semi-visual or semi-auditory correlatives adheres to the perceived complexes of statements. Thus, through the meaning of the text and thanks to the commingling with imagination, the perceptive response can still, in some degree, be stimulated. Helping to foster an almost total decline of the eidetic possibilities has been the experience with twentieth-century poetry, which mostly stems from a principle the very opposite of *ut pictura poesis*. The meaningful elements in it crowd aside the eidetic iconicity – proving much more strong

and efficacious than in the older, descriptive or narrative kind of poetry. The 'images' spring from the collision of concepts; they are more implied than they emerge directly. The concreteness of this kind of literature is due neither to the rhyme and metre nor to the similes and other devices: it is due rather to the peculiar texture of ideas in metaphoric juxtaposition. We tread here a difficult terrain, much written about in modern theories of poetry.

Indirectly evocative qualities, therefore, compose the foundation of the literary structure. What concerns us at this point is not the linguistic matter, this graphic, sonorous rhythmic medium, but rather the following fact: the qualities that arise from the semantic agglomerate afford diffused, nonetheless intelligibly tangible representations of a sensuous-plastic world. On this account a unique atmosphere similarly issues to envelop the agglomerate. In the history of aesthetics, this problem is discussed from as early as Edmund Burke's 'On The Sublime and Beautiful', Section 5. B. Christiansen analysed the phenomenon in his *Kunstphilosophie* (1901, the chapter on the aesthetic object). His observations were carried further in *The Psychology of Art* (1925; English edition 1971) by L. Vygotsky. W. K. Wimsatt Jr vindicates and elaborates the approach; he describes the hyperverbal relevance of the literary medium, by which term he points to 'the interrelational density of words taken in their fullest, most inclusive and symbolic character' (see his article in the collection of essays *Aesthetic Inquiry*, ed. M. Beardsley and H. Schueller, 1967, p. 33). The eidetic semantic world of the qualities fundamental to poetry and prose is just as crucial to producing the uniqueness of this art as is the 'empowered arrangement' which R. Jakobson has described as the crucial determinant. It is to be emphasized that while the semantic qualities may be directly attuned to values of a mimetic type, they need not be. That they bear reference to the external or the inner world is obviously not tantamount to saying – any more than one would of the iconic signs of painting – that the content

is comprised of reflected objects or these even are dominant. However, 'content' motifs must as a rule be made a component of the fundamental structure of semantic qualities, if by 'form' we mean the directly, sensuously given.*

Were we to restrict ourselves to this decisive attribute, we would be open to reproach for a partial failure to arrive at definition. For whatever be said to the contrary notwithstanding, we do encounter closed structures outside of art, possessing the qualities that concerned us here, i.e. the surgeon's table and round about it doctors and nurses standing, a crowd of people suddenly running down the street together, a report or account of something that has just occurred. The gestalt theorists have tried for this reason to establish *Prägnanz* as the particular

* *A footnote on 'form'.* The term is inescapably ambiguous and vague, but I find it difficult to avoid it in respect to some crucial aspects of aesthetic problems. Because of the vagueness and ambiguity, I wish simply to state here that in other works I have written (not translated into English), I have proposed that the term be applied within a specific context and in a specific sense: connected with its twin term, content. Now, with respect to non-representational art, I understand by content the means of expression, while form in this context is the organization (the structure) of this material; with poetry or song, content is what provides the pattern of meaning in the verbal media, while form is both the sound (or graphic) patterns and the organization of the material as a whole; with the representational arts, content consists of the ideas, persons, objects, events and their relationships given by the iconic surface or the patterns of images, and by form we can understand the iconic surface, the patterns of images, plus the organization of the material as a whole; and finally, with the applied arts (including architecture), I would suggest that by form we understand the textures, the surfaces and their shape, while by content we understand the function. Here, the construction is usually regarded as a formal aspect too, except in the constructivist version, where it becomes the content. With regard to the performing arts, I abandon the above terms and speak rather of 'design' and 'execution', each of which in its turn possesses the formal and content aspects. I do not discern material (the medium) as content in contradistinction to form, since all materials are aesthetically significant only as they are processed into the artwork or as they are emphasized (e.g., *l'art brut*, or noise in aleatoric music), where they become means of expression and hence pertain to the content in the context of non-representational art, as mentioned above.

attribute of *artistic* structures. They held such to be coherent systems in which no element is superfluous and none could be replaced by another. Above and beyond that, as Wertheimer has it, these structures are characterized by a much sharper tendency toward simplicity and regularity than are all other structures. Such terse structures thus appear to be harmonious structures only in the narrower sense, inasmuch as they evince a surprising uniformity of their elements and they entail not merely a harmonious, but an actually functional unity (changing one element means changing another element, etc.). Theorists find the affirmation of such a view seductive; one must nonetheless doubt that it is confirmed in practice. How often do we talk about works of art without setting such rigorous requirements (i.e. we also grant recognition to disharmonious structures), while conversely, far simpler systems can be found where the elements depend on each other in the tightest way, and these are not artworks. Beyond that, the terseness problem simply has no way to arise as regards complicated structures, i.e. most works of art. So that if we really want to settle this problem, we must not merely draw a demarcation line between systems whose elements closely cohere with one another and systems where this is not the case.

Accordingly, the second characteristic attribute is in my view not so much a terse economy, as it is far more a *relative* autonomy of structure. Parker and Kahler termed it the fashioning of a microcosm. This type of thesis might seem to stand in contradiction with Marxist views regarding the artwork. For, in other words, if we speak of an artwork as a microcosm, we can perhaps readily be charged with adopting the standpoint of radical aestheticism or of the absolute autonomy of artistic value. However, this would constitute a hasty and a simplistic reproach, one which cannot stand up to criticism. Nor did Kahler, nor Parker, seek to divide art from reality. On the contrary, their characterization of the artistic structure indicates a macrostructure; they wanted the socio-historical order at a

given time to be a tangible presence. The 'microcosm' is not just genetically dependent upon the macrocosm, then, but as well it can reflect, or in more cautious phrase, express it.

Lukács in his recently published work (*Die Eigenart des Aesthetischen*, 1963) adopts the same standpoint I have treated already in detail in several essays.[4] In the light of Marxist historicism I believe it is impossible not to accept the viewpoint that the work of art represents a 'microcosm', not only in the mimetic sense, i.e. as reflection of the macrocosm, but rather and indeed above all in this sense too, that by this reference to artistic unities occurring within a greater totality, one will find means to seek the determinants of these unities, whose one-of-a-kind status is only seemingly a paradox. These unities, we are saying, somehow are tied into an authentic reality and yet, simultaneously, they function as though we had exempted them from reality. Lukács has termed this strikingly an *An-sich-sein* in form only. In material substance or in use-value, for example, a part of our world, they are at the same time opposed to this world. They provide territories wherein quite apart from all their other possible functions, be they informational, moral, practical, etc., these given systems of qualities, whether immediately sensuous or indirect and semantic, subsist in themselves. A fine example here would be the objects for use, which are changed into works of art if outfitted with special outward attributes beyond the requirements of their instrumental function, like colour, proportion, etc. Even in times of radical Constructivism or Functionalism, for instance the architecture of Loos or the young Le Corbusier or the Bauhaus furniture, visual values of this nature have played their role.

We should also ascribe a relative autonomy in those cases where the objects of everyday usage or the so-called *objet trouvé* come to be looked upon as artworks. The Dadaists and Surrealists called operations of this sort (whose prototype were the *papiers collés* of synthetic Cubism) *dépaysement* – it amounts simply to putting a given work or product in a context, where as

a structure rendered conspicuous it acquires an autotelic function. Picabia's inkwell, the urinal of Duchamp, or Rauschenberg's bed, cease to be an inkwell, a toilet fixture, or a bed.

With Pop Art this problem becomes particularly important. For here one is in no way confronted with a return to figurative art, but rather with an effort absolutely to wipe out the boundaries between art and non-art. The magnificently got-up and consumed objects of everyday usage, found in interior décors, in the drugstores, or in shop-window displays, represent a wholly proper domain for artistic activity. This applies likewise to the many comics and advertising images in the works of Oldenburg, Indiana, Johns, Dine, Lichtenstein and Segal. Of course someone can ask whether we are not overly tolerant if we admit such productions to the realm of art. It seems they stem, as the cultural sociologists would have it, from a modern civilization that is determined by the mass media. Therefore one would have to do with pre-fab, die-cut productions that may not claim the name of art, a homogenized culture in which the easily grasped communication is king. However, one cannot regard this hypothesis about the emergence of Pop Art as the single correct one. Granted, its reliance upon modern civilization is too complete, countermanding Pop Art's chance to cast it wholly into question. But one has likewise to note yet other impulses essential to its appearance. Pop Art is the reaction to the art of the avant garde preceding it, especially to the later phase when Abstract Expressionism dominated. Hence in a way it takes up, too, the whole problematic area which grew manifest in the nineteenth century with the crisis of the concept of art. Above and beyond that, as we earlier put it, this art is the expression of a protest against the civilization which has made of art – even its most devilishly difficult aspects – a commodity. In sum there is no reason to deny Pop Art its status as art, its sublation of the boundaries between life and art notwithstanding. The proponents of this tendency are approximately saying: life can be aesthetic, or not aesthetic; to gain awareness of this,

one has to pick definite structures out from life. We think we are looking at objects from life; nonetheless they are differently organized, they are a mockery of life, or the poetry of their banal ordinariness is brought to the fore. What constitutes in a certain sense their own world of art is thus either maintained or asserted. It is the very same process we can observe from another quarter when the mobiles of a Calder, the wire constructions of a Pevsner, or the works of Action Painting impress us not as products of technical equilibristics, as engineering projects or as simple, accidental, blindly active organizations of material, but rather as structures of sensuously given qualities having a relative autonomy. Here let it be said again that the moment of relative autonomy coheres with qualities that are so structured as immediately to seize our attention. The calling of attention to structure plainly means, however, a focusing upon its internal field, upon the autotelic qualities which function independently of the external world. Thus the second attribute of art constitutes a *strengthening* of the first. This is no more true for the immediately sensuously given qualities than it is for the indirectly evocative, mediated (semanticized) ones. In literature, for instance, the indirectly given qualities are elements of a fictive world, constructed of course with the so-called vehicles of meaning. A reflexive relation moreover is in effect here; i.e. fields of qualities can be lifted the more readily out of their surroundings, when they have a conspicuous structural organization.

In works of prose from Gide to Camus to Max Frisch (*Stiller* and *Mein Name sei Gantenbein*), the autonomous structure rises on a footing of philosophical reflections; one can likewise point to debates on the meaning of writing itself, ironical treatment by an author of his own artistic vision, and discussions of the dubious identity of contemporary man, all this giving testimony to a most thoroughgoing scepticism. With Frisch it gets to the point of external possibilities – and not at all character – forming a human being. Self-consciousness has here become the

outcome of innumerable unknown variables which at any time may affect one's existence. The cinema offers similar phenomena: Fellini's *8½* on the one hand, the work of Godard on the other. Though in each of the works mentioned intellectual reflection prevails, and thought as it were represents the ground floor, this does not alter the artistic status; for the intellectuality here does not in the first place serve the aim of cognition; it is one part of life which, in eluding the author or hero, calls forth in consequence a self-sufficient thought, a commentary and reflections upon itself.

The problem of the relative autonomy of the work of art is tied in to the question of space. The space has continued importance, in terms of art's own world gaining a depth relief against the authentic background. In most cases we are speaking of the extrinsic, technical means of ascribing space, e.g. the contour of the picture in its mounting, the monument on the pedestal, the playing area of a theatre, not to overlook the leader-film where the cinema viewer sees who is credited with what, together with 'The End', the film's envoy. Space of this kind was made suspect by the Dadaists and the Surrealists (e.g. the paintings of Magritte). In fact the extrinsic denotators of space are not very important. Every artwork achieves its own genuine space strictly through the content of its special conspicuous structure, its intrinsic rhythm as evoked by the spatial, or temporal, or spatial/temporal dominants. A special role in the formation of intrinsic space is played by fiction, which with the aid of fable, with developed characterizations and sequences of events, creates an illusional world. And even though it be not certain where the fiction begins, the irreality of the narration demarcates it from what once upon a time was, or is. In the variety of reportage we deem artistic, from which all invented fable is excluded, the space is only to be had by means of a special language or particular construction. The conscious accenting that is common to artistic experiment is another way of winning space. After all else the artists, who in the modern theatre for

example (Eisenstein, Meyerhold, Piscator) have junked the 'fourth wall', have not been able to do without space in this sense. When the actor upon the stage walks into the audience, or he addresses the public directly (as in Brecht's theatre) these stylistic devices only modify the space. The effort indeed is stronger today than ever to achieve the relative autonomy of theatre, its functionality *qua* theatre and not as an illusory slice of life whose accidental witness – as it were – one is.

In European culture, but not only in it, art is defined on the whole as a distinctive form of activity for the practice of which one must possess a special aptitude. What Thomas Aquinas spoke of as *recta ratio factibilium* was an unimpugned axiom until the twentieth century. But with the rise of technics to a dominant role in modern civilization the axiom has lost virtually all credibility. For example when it is possible with the help of an electronic brain to produce a black and white diffraction spectrum upon a photographic plate – in other words, a synthetic hologram – which when appropriately illuminated, provides a full three-dimensional image of the object that you can study from the most varied sight-lines and perspectives, then we have at hand a phenomenon where not even the technics of correctly developing a film is a problem, for here the electronic brain (programmed, to be sure) plays the crucial role.

Accordingly, as we come to describe the third attribute of art, we must consider the modern experience with cybernetics, and reformulate the classical thesis concerning *téchne* the special ability of the artist. We will for this reason describe two kinds of artifact – the direct and the mediated. By the direct we understand, following tradition, the direct product of human intervention (which relies upon implements and certain skills), while by the mediated artifact we understand art productions achieved either with the help of programmed machines or an artificial organization of natural objects. The Japanese *ikebana* is repeatedly mentioned as the classic instance of such an artificed

organization. Flowers are tied in a distinctive fashion and distinctive light-effects are sought; and what we have is a *construction* of an artistic structure using a stressedly raw material. Notably, these flowers are often fashioned from artificial materials or from metal; it was the artist's intention to organize 'naturally abstract structures'. This interpretation applies *mutatis mutandis* to the *objet trouvé* as well. The artifact, therefore, constitutes a further valid attribute. Granted it is more dubious than the two previous attributes, yet we cannot pass over it. It is more dubious, since a raw, unworked object–i.e., an object that need not even be organized through placement in a dwelling-space or another ensemble – can yet be designated an artwork. Thus it is a peripheral count. Parenthetically let us add that here, the act of structuring the art object is passed on by the artist to the perceiver.

Hence the third attribute (the artifact) entails a twofold understanding of the *téchne* whereby an artwork can in general come into existence. By *téchne* we ordinarily mean artistry, art, or very often, a most unusual artistry, virtuosity. In other words, we will assume that X or Y has a definite talent for a field to which one must bring a thorough preparation and, most importantly, some prominent individual gifts. But we have also to understand by *téchne* the programming of artistic tasks into a cybernetic machine. And definite talent is necessary here too, even though of another sort, less individually predicated than in art. In a word *téchne* is not an attribute particular to art only; it involves not so much the work itself as far more the means of disposition the artist must have to hand if he is to make a work of art.

Having described artifact and *téchne* as the third attribute of art, we come now to the fourth and last attribute, *individual expression*. If by this we understood only the artist's means of disposition, we should have to remain as shy of this criterion as we are of the *téchne* because it is a characteristic of the creative process and not of the work itself. We are, however, of opinion

that individual expression is a feature not only of artistic creation but as well of the artistic product. In other words, we simply cannot accept that X will look at the world in a certain way, think this and that about it, in his own way select and accent definite phenomena, and that he will express *none* of all this in his work, which has only had – or to speak with more caution, partially had – this aim in being thrust into existence. Of course the question arises: how is the individual expression in an artwork to be pinned down? It isn't at all easy. We will return to this question. But first to the more urgent matter. Can in fact individual expression be called an essential attribute of the work of art, if it is not characteristic of artistic productions such as the Surrealist poems, i.e. 'Calliope' by Ducroque, or the *objet trouvé*? It is quite clear, in our opinion, that in the foregoing examples we are not confronted with any elements of individual expression. Someone hatched out a programmatic concept; this original idea is subsequently executed by the putting together of aleatoric groupings of words or colours. But yet someone is involved to bestow on the 'ready-made' objects an artistic meaning, to set them in some definite way. All the same the individual expression of a directly worked-over artifact is the greater, there is no doubt. The famous prestidigitator's turns of Tzara at the Cabaret Voltaire come to mind, when he randomly pulled newspaper snippets from his top-hat, and from them put together poems and surrealistic manifestoes. Tzara came near to achieving what is today perfected by the cybernetic machines. A type of lottery, it angled for the completely unexpected and – what is most important – the arrangement of the elements without any personal intervention. Tzara did not absolutely give himself over to Accident; that is seen in the fact that he himself made the choice of newspaper clips. In this sense he did 'encode' poems. The Surrealist practice was not dissimilar: the *écriture automatique* (much like Action Painting or jazz improvisation) at bottom is an expression of the stream of consciousness, its reliance on Accident, an expression permitting

the untrammelled personality of an artist or, more precisely said, the immediate creative process to issue. We must understand in the same way O. Dominguez's means of painting, a method lauded by Breton as the most intrinsic expression available to the painter, who need no longer hew to the fixed principles of conscious, controllable invention. In both instances we have the composition of structures the materials of which are expressive qualities: however in the first case the expression is in large degree a projection of what the perceiver brings to it, while in the second case the artist's evocation is primary.

This then is a gradual rather than a qualitative distinction; and yet, an essential one inasmuch as, for instance, one can differentiate two forms of the contemporary Happening. One form has been traced by American critics to the collages and assemblages of A. Kaprow, which cannot be called pure improvisations, and the other to J. Cage, who presupposes that the artist shall have to make good use of chance, unexpected elements and groupings in the creative process. In either case the observer has to make out the structuring of the work; either is an equally open system. Yet in the second case the artist thrusts himself on to the work much more strongly, while in the first the spectators – as in rituals, often of an orgiastic sort – may assert their own inventions within a certain schema. Events have been staged in which the totality of elements in the surrounding environment are participant: the forms, the light, the movements, the sounds. Merce Cunningham's dance company has taken part in such events, as have proponents of *musique concrète*. Art here becomes a means to playful enjoyment.[5]

We thus propose to look upon this last attribute as the weakest, in comparison with those attributes already mentioned. Still other phenomena go to enfeeble this attribute: folkloric tradition, the industrial art of today, and mass culture. Each of these frequently if not always excludes the likelihood of pinning down individual expression.

Let us then return to this problem of how one discloses

individual attributes. Of expressive properties and particularized, immediately sensuous or indirectly evocative single qualities and qualitative systems, we spoke earlier. Most often (i.e. commonly) the individual expression is embedded within what we shall here term the structural expression. We must at once add that one cannot confirm the individual expression on the evidence of *one* work of art. An entire cycle is required for a disclosure of the stylistic attributes.

In speaking of individual expression one may of course refer to something rather different. One may seek to connect it with authenticity, and with originality, thereby stressing – rightly – the unusually powerful individual expression in such instances. What precisely the two concepts mean is harder, however, to explain. By authentic, an openness, sincerity, and also something resembling freshness, immediacy, is often described. How one is to test and verify sincerity, has to remain a conundrum. Freshness entails however that an element or an entire structure is new, or gives an intimation of uniqueness. To what degree the factor of newness itself is intensively expressive cannot be answered. Though it awakens interest, novelty all too often proves at last an empty vanity. And singularity or uniqueness would plainly seem an equivalent for originality.

If I stress here the difficulties of ambiguity raised by the concept of 'artistic individuality', it is to make more understandable our conclusion which is to be drawn from these considerations. Thus I find it unwise to reduce individuality as an attribute of the artwork to newness or novelty, a concept that in turn needs more exact analysis; at a minimum novelty surely means a different content or formal means than previously was expressed or employed. Novelty is a historical category; individuality is not. Novelty is an equivalent of individuality in just one sense, that each individuality makes its bow as 'new'. From a *cycle of works*, from the global entirety of their structure, we will derive a given number of properties that distinguish the particular artist from others. The roots of this singularity are

not subject to a theoretical definition. We can point concretely at these properties, describe, even classify them in relation to the stylistic attributes (theme, content, form) that predominate in the relevant cultural sphere. What differentiates the artisan from the artist, then, is the style that is the property of the artist. This style can be discovered in the constituted structure, whereby further data accrued from the observation or reconstruction of the creative process prove helpful. Technical perfection, be it affirmed, is no standard of artistry. This property is sheerly the result of professional capacity in a given artistic field, such as a skilled copyist or gifted counterfeiter must command to perfection. So long as van Meegeren understood brilliantly how to imitate Vermeer, he was a brilliant forger and no more. However as his imitations increasingly showed their own strongly expressive properties, one could add that his work manifested an artistic mastery.[6]

If then by the concept of individual expression we comprehend all of the foregoing, it will mean we expect from the artwork a small degree, at least, of 'originality'. Granted, some aestheticians maintain that a good copy will also afford us aesthetic pleasure, just as we enjoy a concise reproduction of a painting in an album or a musical work on disc or tape recording; they forget however that what pleases us is the original not the copy.[7]

Let us try to pull together our remarks on originality as a constituting attribute of the artwork! From the comparison of the original with the copy, we see that the originality, with which we are here preoccupied, may be equated with creative individuality. In other words: if we only direct our study to genuine artists we shall confirm that *every one* embeds properties in art which peculiarly, singularly represent him. Beyond that, while some will reveal themselves to the world or discover themselves within the world, still others are capable of discovering the world itself, whereupon often they become attracted to philosophy and science. Despite all differences of individual expression the

attribute of originality is, in the sense suggested, constitutive of all works of art.

Nor is this all that originality may be understood to mean. And originality would not be identical with individual expression, if only because – beyond some evident personal modifications – the individual expression has to presume upon common artistic outlooks and emotions, a common mode of thinking, a common fund of language. In short, however much given individuals may differ from one another they have yet very much in common; and the same applies as much to works of art. Even in cases of the originality which signifies genius. But with such cases the artwork differs in degree surely, but qualitatively too from other works of art expressive of a given individuality. In works we cannot describe as being of genius, a transmitted mode of looking at the world is but modified, one or another stylistic means is reworked, this or that theme undergoes a divergent treatment. By contrast in the work of genius, the world is uniquely seen and entirely individual stylistic means exercised. In the other cases individuality is largely an affair of particulars; in works of genius the work on the whole is forged in the individuality of the artist. And thus often, a single sign, one trait is enough to distinguish the entire work from all others of its epoch and of past and future time. Genius and its unique products do not lend themselves to weighing and measurement. Nor can one be more or less unique. There can be, only, a *different* concrete uniqueness or originality. Originality, as thus understood, cannot then be imputed to every work of art; and so, as it appears, we have simultaneously come across an axiological attribute with whose assistance we will be positioned to describe hierarchies of objects we have already discerned as artworks.

Let us summarize: *We call that object an artwork which possesses at least a minimal expressive structure of qualities and qualitative patterns, given sensorily and imaginatively in a direct, or in an indirectly evocative (semanticized) way; these qualitative patterns and the definite structure enhance each other, building up*

an autotelic, relatively autonomous whole, set off more or less from the authentic reality whilst nonetheless it remains a part of the reality; this object – we have to add – is an artifact, in the sense that it is either directly produced owing to a given téchne or it is the result of some idea of arranging it; finally, this object is somehow related to the artist's creative individuality.

It is clear, I hope, from my remarks about happenings, that 'object' should be understood here in a broader sense than in traditional aesthetics. The process which has a beginning, middle and end is also a kind of aesthetic object. It is obvious too, from my definition, that the three earlier features unquestionably seem to be necessary and sufficient conditions, in this interpretation, as I described them above. The fourth and last, in the hedged formulation I have given it, can also be considered constitutive of an artwork, unless one cares to take into account certain avant-garde products in which the individual impress is deliberately eschewed – as though modern art had come back to the primeval era when no institution of the artist existed. However, one more broadly runs into trouble with a concept of individual expression among many and very able avant-gardists, who feel offended when this category is broached. All the same, I should say that even their anonymous gestures are in some way individually expressive. At any rate I do not have in mind here the intense expressiveness found among the romantics, expressionists, action painters, etc. Moreover, in putting stress on the role of individual expression, we shall not maintain that an artwork can exist only in a unique rendition. This property applies only for some arts, i.e. for painting or 'hot' jazz; further, a solution to this problem depends on an answering of ontological questions;[8] while the social context can never be ignored in matters of aesthetic axiology.

On the other hand, on the basis of the definition proposed here one can derive the thesis that, in art, we encounter a special form of the cognition of reality. If, in other words, we assume that the artist (within the structure of the particular fields of qualities)

represents his special relationship to the world, and the reader or spectator monitors this relationship with approximate adequacy, then this means that each work of art will be imbued with cognitive values. The Tachist abstraction or purely musical structure will be imbued with cognitive values to the same extent as is the genre painting or the literature of the nineteenth century. However we can and we must take care to differentiate these cognitive values; they usually are linked, in a narrower sense, with some elements proper to the representational arts. There, they are plainly in evidence and most readily can be verified. But let us consider such thoroughly modern and fascinating works as, for instance, the *Tractatus* by Krechowicz and Hajdun, performed in the Gdansk Plastic Arts Theatre, or K. Urbański's film *Matter*. Here matter is not depicted, rather a fantastic poem is created in which the continual volatility of matter, its cycles and genesis – with ever more distinct forms emerging from chaos – come before the viewer. This is certainly not *mimesis*; yet no doubt at all exists that not only are sensuous qualities presented here but their objective structuring too. This representation of the entrance of cosmic matter into our daily lives ever since the atom-bomb explosions is the more *frappant* in that the realm of physics is evoked with all the gestalt of a *quasi-reproduction*, a quasi-scientific study. Hence the special cognitive values, which are thus communicated, necessarily are ambiguous. This characteristic (it is often believed on evidence like this) seems a fixed trait of artworks in general. We should not forget, however, that philosophical works are ambiguous too, and scientific works more often than one may think.

The cognitive values of art here emphasized do not constitute a separate and distinct criterion, it should be said, for they are implicitly integrated in our structure.

Our standpoint differs from one defended by many Marxists on numerous occasions. Hence it seems of use to point out that it simply is not true – as one often hears maintained on behalf of Marxist aesthetics – that the imitation of reality is one of the

constitutive attributes of art. Such a thesis is nowhere found among the scattered aesthetic remarks, observations, and analyses in the writings of Marx and Engels. Nor does it follow from their methodological guidelines. One ought to be convinced of this on the sole basis of the discussion in the *1844 Manuscripts* by Marx of the emergence of art from the productive process. As for the later destiny of Marxist thinking on this matter, we can distinguish here four distinct tendencies of thought, which do not allow of reconciliation with one another on all points.[9] In Soviet aesthetics, which I examined in my work *Between Tradition and a Vision of the Future* (1964, in Polish), the view has until today remained preponderant that the mimetic moment is conclusive, as to whether a work will or will not be art. Likewise a supporter of this view is G. Lukács; in contrast to contemporary Soviet efforts, however, he has brilliantly worked out and explicated his standpoint.[10] Another course is taken by those whose spokesman in the USSR has for some time been M. Kagan. Their position is that the essence of the artwork is to be looked for in its effect upon all of our psychic faculties; it remains however unclear just what in the object itself is responsible for our particular reception. One may well imagine that Kagan is thinking of the individual world-view that, as embodied in art, can be expressed in the most various ways, not only with the representation of reality but also with its opposite. Another position is represented by Christopher Caudwell (*Illusion and Reality*, London, 1938, and *Further Studies in a Dying Culture*, New York, 1949), who holds art to be an individual expression of socio-historical and likewise generally-human genotypes. What shall pertain to art is, first of all, determined by the authentic emotional content, to which the author gives expression, and which can entail varying degrees of typification. The fourth conception – one very close to my own – indicates as a constitutive factor of art the formal (or non-mimetic) structure. This view was presented some time ago by Max Raphael in 'La théorie marxiste de l'art' (in his *Proudhon, Marx, Picasso,*

Paris, 1933); today it is represented by Ernst Fischer in particular. I believe such a conception to be most adequate to the general presuppositions of Marxism. For instance, as regards the data of origins, i.e. at the hour of art's birth, we can observe the formation of a special structure at once mimetic and formal, which Marx termed the measure (*Mass*) which corresponded to the object. Later during the historical development, i.e. in the course of art's general and relentless autonomization, the formal aspect took on an integrity of momentum immediate to itself, and detached, as it were, from the original structure (which embraced mimesis too). This thereafter served as the basic condition to every one of the arts, notwithstanding that such structures might prove highly compliant to concrete innovations.

Let us go back again, however, at this conclusion of our essay, to the definition we proposed.

Not any single attribute, rather the sum of all the attributes, permits us to describe a given object as a work of art. The complementary system of attributes is alterable. Only in some cases shall we be able to locate all four attributes unequivocally. There will be cases where all attributes, or some, are weakly accented. The first two attributes I consider fundamental and sufficient, though they do not occur apart from the others. The expressive structure of qualities and the relative autonomy, in other words, emblemize a most marked individuality or they are embodied in an artifact, as we have here indicated. Accordingly we are led toward an alternative definition. It is not impossible that we shall want to speak of an artwork solely owing to the weaker of the attributes (individual expression, artifact and *téchne*). Here then the necessary condition would become sufficient. Yet in the light of our discussion, such proposals must be rejected, for even though a number of objects do not immediately evidence all of our attributes, I see no reason to reject an encompassing definition. At the same time I am not enthralled to any formal prescription; for in that direction lies a failure to come to terms

with the object of study. A projective – or better, a regulative – definition can be maintained only in terms of a continuum; all the attributes we have indicated are necessary; however they may depend upon one another and relate to one another in diverse ways. In other words: *Artworks are always more or less artistic.* From our point of vantage we can maintain, therefore, that even close by the zero-point of the continuum, a minimum for a 'good' work of art has been realized. Hereby, in contradistinction to Beardsley, I make no distinction of a 'good' artwork from a work of art. Only in degree do I distinguish 'good' artworks, i.e. their fundamental artistic value. And unlike, for instance, L. Arnaud Reid, in his study 'Beauty and Significance',[11] I do not distinguish ugly from non-ugly artworks; for either ugliness is a special and degenerate variety of the artwork (in which case we must deal with it in the framework of our four criteria), or ugliness is connected with the axiological moments (poor integration, or not all criteria met) that enfeeble the artistry of the work. It thus appears we are brought back again to the continuum construed from the fundamental works that we earlier proposed. L. Arnaud Reid rather sees ugliness as the absence of aesthetic value. This standpoint we have to reject as contradictory within itself. If an object is an aesthetic object, it then entails some part at least of that fundamental value.

The definition presented here is capable of application to so-called marginal cases. When we try to distinguish an artistic and a non-artistic reportage, an architectural structure and an ordinary building, an art photograph and a plain snapshot, we come back again and again to the determinants we have described. A characteristic example, perhaps – among the older experiments – is the work of Man Ray. His 'ready-mades' are not common objects of use, although their intent was to abolish and transcend the separation of art from life. His well-known *Gift* – a household laundry iron with nails glued by their heads to its flat surface, so that they protrude – was stripped deliberately of its use function. The celebrated photographs (Rayo-

graphs) are not mere pictures, but are visual systems, where in a special way previously unappreciated light-sensitivity of the material was explored. In a sense a similar *experimentum crucis* occurs today in artistic probes such as the silent musical compositions of John Cage on the one hand, and on the other Op Art.*

However, the crux of our analysis has not been the making of a checklist of necessary and sufficient criteria but rather is the confirmation that the values here exhibited *do not exhaust* the artistic values. Any one criterion, in other words, must be seen as a groundwork value.

All these groundwork values commingle to effect a coherent whole, i.e. the fundamental value, which is based upon the first-named value primarily. Since in consequence our definition is centred upon the *fundamental value*, i.e. this value appertaining to all the arts, we have not directed attention to constitutive

* I cannot take up here the relevant question of the idea of aesthetic experience. It requires a detailed analysis of changes which parallel the modification in the idea of art. Let me only state here that the feeling of a heightened immediacy gained from the materials confined in and by the definite structure still remains as one of the distinctive features of this kind of experience. The aesthetic attitude is attentive, because directed to and interested in the given field of sensory and imaginative data (directly or indirectly evocative). One may doubt, however, whether the aesthetic experience nowadays provides a 'free play of psychic energy' – for the artworks are so often either difficult puzzles, or they direct us back into the perplexing and parlous environment. It is doubtful, too, whether we do enjoy an equilibrium, an optimal homeostasis, where avant-garde products almost never appeal to the fullest powers of our spirits, and they direct themselves rather to shocking and mocking us in the place of helping us (by whatever tragical rift) to grasp ourselves and the world about us. Among the experts and connoisseurs, too, the conventional response to modern art is one of a tense uneasiness – suggesting from another aspect that we need to modify our transmitted criteria and ideas. We can hardly doubt that what was treated as constituting the aesthetic experience in 1910–14 can no longer be accepted without serious reappraisal and a suitable alteration of this idea so that it corresponds to the extended domain of the arts in the 1960s.

values relevant only in limited sectors of art, i.e., the mimetic values germane for the representational arts (the realist category would be comprised here), or the functional values within the applied arts. Add to this that on the whole, a typical structure in the representational arts is multi-levelled, many-vectored, and requires a considerably more subtle analysis than do structures of the other arts; think of, say, the structure of an Arabian carpet. It remains to add that we have not treated from all sides the problem of expression as an aesthetic category, particularly the question of expressive values and the individual property of the artwork as a manifestation of the creative process. In other words, the expressive values embody, in at least two cases, an internalized and self-substantiated value: firstly, as the symbol or sign of a psychological (but by extension, psycho-social) attitude, i.e. in music or architecture; secondly, when they represent an accentuating of emotional factors (in all the arts).

The concepts presented here will naturally not satisfy those who expect of science an absolute precision. All the same, I believe one can make immediate operative use of these concepts, their ambiguities notwithstanding. Every science can precisely ascertain its underlying and its controlling concepts only up to a certain point. Of this Aristotle wrote long ago, in his Nicomachean Ethics. But perhaps it would be more apt to relate an anecdote passed on by Tranøy. At one time he devoted his seminar in Ljungskile to the concept of structure. To an aesthetician a mathematician spoke ironically, citing Wittgenstein's *Tractatus Logico-philosophicus*: 'What we cannot speak about we must consign to silence,' to which the aesthetician tellingly replied: 'What we cannot consign to silence we must speak about.'

We want to emphasize once again that the definition given here must be seen as an *open concept*. Art can so greatly change that the attributes here discerned will not continue to apply as a unitary group. Which attributes may require forsaking

and to which new attributes we may need to look, cannot be known.

As I have said, my aim was to attempt a definition of the concept of art such as to stand up to the contemporary critical and theoretical investigations. In this sense, the definition given here rests upon a sociological substratum. Since any single artwork is inevitably a socio-cultural phenomenon, the sociological aspect is inextricable from the substance of its overall artistic structure, appearing in all of its particular axiological properties which should then be interpreted in the context of the specific value communication of the creator and the many-sided public. It was not, however, my plan to limit myself only to this framework, i.e. to discussions of the modern phenomena of culture such as impinge upon that purview. I have tried to illuminate the problem from a more comprehensive viewpoint, by giving attention to earlier evaluations of art, to its history and the history of how it has been conceptualized since the formation of human culture. In pursuing this historical and generic hypothesis I sought for the attributes of art which, notwithstanding continual modification, have stood up until today. I harbour no illusion at all that my endeavour might sweep aside parallel efforts whether earlier or contemporary. I have failed to present proof *more geometrico* – nor, on that score, will anyone else succeed. At the most I can appeal here to the historical evidence and anthropological data, as gathered and sifted by students of the psycho-biological constitution of mankind and the variables or constants that are manifested in human culture. The alternative can only be an evasion of the constraint of all definition. Admittedly it is always possible that somebody will provide a better, more encompassing definition. Should anyone on the contrary assert that a work of this nature is entirely without meaning or application, I have to ask him how it is that concepts such as atom, race, social order, and psyche can be fixed, while when it comes to an artistic product this is not deemed possible. It is significant that a large number of the scholars most

influenced by Wittgenstein's ideas have decided that there is insufficient reason for rejecting aesthetics, nor can they find grounds for a refusal to seek the meaning of art.

A last problem must be mentioned. Our definition – not unlike every other definition in a similar framework – does not give a reckoning of each concrete value-quality. That would have to be undertaken first on grounds of the history of the particular artistic genre and its theorization; secondly, the critics in the field of the particular art are much more prepared to do it; thirdly, the concrete value-qualities cannot be fitted into a circumscribed 'aesthetic alphabet',[12] a fact which accords completely with the open character of our definition. In artistic practice ever-new qualities are produced, alloyed with one another, and transformed again: aesthetics should make acknowledgement of these new qualities, and do this without codifying them. A function of artists is precisely to transgress all definitions, which are provisional in any case and represent, necessarily, a transitional solution. Aesthetics should prove ready, above all, to integrate these new value-qualities into the field of values earlier recognized as fundamental. And if this endeavour should turn out negatively, the aestheticians will have made a most important find, in the very fact of a complete incommensurability of the present and past. I do not believe, however, that such an incompatibility would occur. It has not to date happened, at any rate.

That we are living through a total crisis of values is a dubious 'discovery'. The not less important and useful assertion that what is today in fact new represents, once more, a creative continuance of the aesthetic tradition, would be a likely result, were (optimally) the artists of every kind brought into discussion together and the full exchange of artistic, critical, and theoretical experience expedited.

Postscript

Already three years have passed since I wrote this essay. And though the bibliography on this theme has significantly grown in the meantime, and my original plans for integrating this article in a book format are altered, I am compelled to put forward these considerations unchanged.

Were I approaching the same problem today I would state, first, that expression as such does not constitute a firm attribute of every last artwork; only in the sense of an individual intervention could it be so recognized. How the two phenomena (expression, and individual mediation) are to be differentiated is a topic precisely for an amplified study.

Second, I would today give much more stress than in the foregoing to the thesis that every artwork not so much 'is', as 'happens'. In other words, every artwork actually occurs by a collaboration of the artist and his audience. The theatricalization of art is currently a major phenomenon: obviously in the Happening, but as well at every instance when art asserts an element of play. This ludic factor encourages us to speak of the quasi-ritual role of contemporary art.

The characteristics of art just mentioned are bound up closely with the 'blurring' or the 'dissolution' of autonomous art structure. Collage trends in film (e.g. Godard), and musical form whose shape is challengingly nonchalant, without beginning and ending, for the listener to hear or neglect as he wishes (e.g. the later experiments of Stockhausen), provide obvious cases in point. And yet these striking instances persuade us that a work of art without structure is unthinkable.

And last, such interesting events as Genet's 'theatre within theatre' (*The Maids*, *The Blacks*, *The Balcony*), or the novel *La Maison de rendez-vous* by Robbe-Grillet, must be analysed as the antipode of a ludic art. All the problems of an experience gained through the literary medium are highlighted rather than treated as transparent, harmless conventions. Thus for Genet,

and for Robbe-Grillet too, there is no autonomous artwork that exists apart from the perceiver, who more than ever is called upon to become engaged as a collaborator. The aesthetic experience here loses its contemplative character, very much as in the encounter with an art-as-play, and it comes to be like a magical participation in the realm of contemporary myths.

Quo vadis, ars? This nobody knows.

Notes

1. See Max Bense, *Aesthetische Information*, Vol. 2, Krefeld und Baden-Baden, 1956, pp. 32–51, and his *Programmierung des Schönen*, Vol. 4, Krefeld und Baden-Baden, 1960, pp. 17–32.

2. See also K. E. Tranøy, *Wholes and Structures*, Copenhagen, 1959; R. Bastide, ed., *Sens et usages du terme Structure*, The Hague, 1962; M. de Gandillac, L. Goldmann, J. Piaget, etc., *Genèse et structure*, The Hague, 1965; and J. Viet, *Les méthodes structuralistes dans les sciences sociales*, Paris–The Hague, 1965.

3. The same approach is taken by Lukács's notion of *Totalität* as a basis of artistic phenomena within a context of historical process, and also Goldmann's hypothesis as concerns the *vision du monde*. The conceptions of Lukács and Goldmann are however not as comprehensive as my alternative working questions in respect to the idea of structure. In result of our discussion one must reject as unfounded the effort of L. Sebag, in his *Marxisme et structuralisme* (Paris, 1964), to relate Marxist historicism to a chance and subjective point of view which he would regard, moreover, as absolutely opposed to the system-creating tendencies of human thought.

4. See my study of artistic value, 'O wartości artystycznej', in *Kultura i Społeczeństwo*, 1962, No. 4, and my *Inquiries into the Fundamentals of Aesthetics*, M.I.T. Press.

5. See the extremely interesting article by P. Restany, 'L'art-jeu chasse l'art pour l'art', in *La Galerie des Arts*, February 1967, pp. 26–30. Art as play, appearing in our time as an emphasis more and more upon the activity rather than a result (the artwork), would seem an extreme case very like the painting of the chimpanzee Congo. Certainly we cannot accept without reservation Desmond Morris's thesis that the apes possess a sense of composition and a talent for calligraphy. In contrast, it is obvious that they exercise their energies in drawing and painting very much as they do in,

say, gymnastics. It is this other sort of question – which brings out the important problem of the 'artistic creativity' of the chimpanzee – that emerges from his painting's quite factual resemblance to Tachism and aleatoric products.

6. The notion of forgery is highly relevant to our discussion of individual expression. As concerns aleatoric expression, e.g. jazz improvisations, forgery, *hic et nunc*, is excluded. Individual expression in the sense of a style or manner does to be sure entail the possibility of a counterfeit; yet not every forger can command individual expression. Therefore I distinguish artisanate from virtuoso forgery. Forgery can so evince an expression in the sense of originality, that the counterfeiter alone can accuse his work. Yet, by definition, originality eluded even the virtuoso forgers like van Meegeren or Dossena.

7. See the discussion in St Ossowski's *Fundamentals of Aesthetics* (in Polish), 3rd edition, Warsaw, 1958, pp. 246 ff.

8. This problem has much in common with that of the identity of the artwork, and requires a separate analysis. J. Margolis makes a striking distinction (*The Language of Art and Criticism*, Detroit, 1965, pp. 49–62) when he refers to more than one identity: the work of Shakespeare as a literary and as a theatrical work; so too, he treats differently the work of music (the mere score) and of painting (the one and original). The concept of 'authentic' therefore has several meanings; it can designate, first, the entirely unique, second, the duplicable (from the original work, of course), third, that which we can adequately render from the score, and fourth, something that we can trace to the score's initial rendition. Authenticity as thus understood does not of course exclude that the rendition can be creative, creative not only in respect of adhering faithfully to the score but also as regards capturing its 'spirit' or creating a wholly original interpretation. Ruby Meager in her essay 'The Uniqueness of a Work of Art', *Proceedings of the Aristotelian Society*, LIX (1958–9), pp. 49–70, has further developed the many questions that pursue the idea of identity. Not always is it sure, for example, which version of a work (e.g. El Greco's *The Healing of the Blind Man*) we should regard as authentic, and whether we have to do with a copy when, say, Van Gogh imitates Delacroix, or Rembrandt and Rubens, Dürer. The problematic zone we touch on here has occupied R. Ingarden for years. No one has penetrated the problems as deeply nor analysed them in such detail as he. However, as concerns his basic distinction between the artwork and the aesthetic object, I want merely to declare here my reservations in respect to it. The reader is referred to my analysis of Ingarden's aesthetic axiology, which has appeared in *Estetika* (Prague), 1970, No. 1.

9. The conceptions here outlined do not exhaust, to be sure, every one of the solutions advanced until today. I have not mentioned the *Czelowiekowie*

denije put forward by Gorky, some Soviet scholars' notion of art as an *ars operandi* or R. Garaudy's work *D'un réalisme sans rivages* (Paris, 1963), where art is considered not as an instrument for the cognition of the world but as a means to its appropriation through mythic-creative activity. Garaudy goes on to add authenticity and freshness as constitutive attributes of art. I shall not further examine these efforts, in as much as the first pair are overly general and the third insufficiently clear, if one considers that Garaudy holds every authentic art to be realistic. All these conceptions are tied in in some way to remarks by Marx.

10. See my essay 'George Lukács' Universal Principle – Mimesis', in *Science and Society*, Winter 1968, pp. 26–38.

11. See *Proceedings of the Aristotelian Society*, XXIX (1928–9), pp. 123–54.

12. Here I have in mind the very important fact that any definition of art as such necessarily can but embrace the generic attributes in a most abstract form and, of course, the artwork *in individuo* not at all. Needless to say, each of the described criteria appears in one or another concrete form; this being true especially of the first and last. The special quality of the particular criterion is not only a characteristic but is likewise derived from its association with the other criteria. This problem is described and analysed by R. Ingarden in his *Experience, Artwork, Value* (in Polish: Cracow, 1965, pp. 128–36, 162–94). I share his position on major points, although I reserve until another occasion, a discussion of some particulars.

19

Lee Baxandall

**Spectacles and
Scenarios:
A Dramaturgy
of Radical Activity**

[A constitutional republic] cannot forever withstand continual carnival on the streets of its cities and the campuses of the nation. Unless sage debate replaces the belligerent strutting now used so extensively, reason will be consumed and the death of logic will surely follow.

VICE-PRESIDENT AGNEW, Honolulu Address to the Young Presidents Organization, 2 May 1969

There is so much upheaval in the world, it's more theatrical than the theatre. The theatre is in a state of unrest and we're all trying to find out what its function is.

MILDRED DUNNOCK, *New York Times*, 18 January 1969

Action from principle, the perception and the performance of right, changes things and relations; it is essentially revolutionary, and does not consist wholly with anything which was.

HENRY DAVID THOREAU, 'Civil Disobedience'

In an essay on revolutionary drama in *The Drama Review* (T42), I indicated, with the term 'revolutionary', a relative handful of

LEE BAXANDALL compiled and edited the highly regarded volume *Marxism and Aesthetics: A Bibliography* (1968). He has published many critical and historical essays on literature, art, theatre, and aesthetic inquiry, in journals such as *The Drama Review, Encore, Journal of Aesthetics and Art Criticism, Temps Modernes, Partisan Review*, and *Studies on the Left*, the pioneer theory organ of the New Left, on which he served as an editor. Baxandall's theatre pieces have been performed at La Mama and elsewhere. He has also translated plays by Bertolt Brecht and Peter Weiss.

major plays which – more than depicting social life critically and in a manner to express despair or perhaps anger at the way things are – take an added and very difficult step, which is the depiction of effective revolutionary conduct upon the stage. Study of these plays suggested that their authors had become capable of producing them only under the impress of revolutionary examples in life.

Briefly the article touched on John Reed. Although his plays were performed at the Provincetown Players, the *theatrum mundi* very soon claimed Reed's attention, and his dramatic genius found realization in revolutionary action. His case appears, in today's perspective, to be anything but unique. We seem to have entered an era in which the human dramatic potential is to be realized foremostly in life, and for life. The stage once again follows along. It tries with audience participation experiments and guerrilla theatre to become more like the drama of history.

What follows is a dossier: several photo-analyses of the performance of history in terms of the essential dramatic ingredient. And two arguments – conservative and libertarian – to represent the opposed bodies of values and knowledge which now animate the actors of the world stage.

I

(Transcript of the Edmund Burke Memorial Lecture for 1969, delivered to a meeting of the Rand Corporation by a Spectacle Manager)

Gentlemen, we gather at a most difficult time. The principles and causes of the prosperity and consensus of our system are being questioned. In many cases the most promising of our young people, white and black, are responsible. I don't know, perhaps some of your children are mixed in . . . [*general laughter*]. The problem is not that the malcontents exist; for they always have, and shall. The vexation is that our radicals once obligingly

limited themselves to the spoken and printed word, for the most part. And today they do not: they *act*. They do these spectacular things which get in the press and on television and heat up others. Then they have the temerity to come into our courts claiming that to burn a draft card, or to hurl blood in the Dow Chemical headquarters, is 'symbolic speech' – a kind of communication protected by the Bill of Rights! Thus the new radicals are exploiting, or better perverting, the natural and usually wholesome tendency of our public to react strongly to events – not words, events – as a drama.

I advisedly say 'perverting'; for traditionally, as we all know or should know, the social dramaticism has belonged to us. It has been a key and vital bulwark of government. Dismay is justified, inasmuch as the New Left – how consciously is not yet clear – has discovered the performance element of politics for its own ends [*distress in the hall*].

The annual Edmund Burke Lecture honours a great theorist of the preservation of Anglo-Saxon government. He counsels us from across the years, in our latest crunch. The universality and timeliness of Burke are seen in the stress he gave the fact that a lucid theatricality is essential to maintaining the consensus. I need but quote from his *Reflections on the Revolution in France* to illustrate, for example, what flows from an undermining of our effective monopoly control of dramaticism:

Now all is to be changed. All the pleasing illusions, which made power gentle, and obedience liberal, which harmonized the different shades of life, and which, by a bland assimilation, incorporated into politics the sentiments which beautify and soften private society, are to be dissolved by this new conquering empire of light and reason. All the decent drapery of life is to be rudely torn off . . .

The radicals we face, gentlemen, speak disdainfully of 'the puppet show of state', as once did Burke's opponent, Tom Paine. They invent for themselves, and even go beyond, the tactical insights of Paine, e.g. – 'A single expression, boldly con-

ceived and uttered, will sometimes put a whole company into their proper feelings, and whole nations are acted upon in the same manner', to quote *The Rights of Man*. Our opponents thus armed, gentlemen, we must affirm and newly promulgate the rules of our traditional stagecraft. The Rand Corporation relies on you, urgently, to take and perform the dramatistic insights in your industries, military bases, universities, and other walks of life. Bear in mind that Plato termed statecraft the highest art.

First, and to take nothing for granted: *is* politics performance, and everyday activity dramatic? Our language – the American idiom especially – seems to confirm it. We speak of a theatre of war, making a scene, properly acting in the spotlight, staging an event from behind the scenes. This might merely be misleading though ornamental metaphor. That it is not is affirmed by the peers and compatriots of Burke through the ages. Plato, the Stoic philosophers, Roman authors, and medieval writers such as Salisbury, declared with Shakespeare that 'all the world's a stage'. And generally, they go on to concur with Calvin that the world is 'the theatre of God's glory' – one performs according to divine will, that is, a high or (usually) low role in the Great Chain of Being. This is an essential item, whether or not dressed out in a religious garb, from our point of view. If time-honoured thinking on this matter is correct, can we discern a *function* of theatricalizing politics not to be had by government in any other way?

Permit me to analyse this point in perfect candour. Minced words would not be respected by you, who well know *how few* in effect take basic decisions for and reap the basic benefits from the society as a whole. The importance of performance to our politics is summed up in the phrase of Thomas Hobbes: 'reputation of power, is Power'. Not merely force and status, but the skilful *show* of force and status achieves our hegemony. Those who rule are a small minority, always. They – we, therefore – have not sufficient pooled powers to maintain a right attitude

among the majority, so to prevent civil wars, unless the otherwise scant personal status and capacity for violence of those who govern are multiplied geometrically by a usage of history as theatre, to which the term *spectacle* may be applied.

Some among us may object that in the last instance not fine words nor *show* of force, but the actual violence of a police and army keep a fragile order – as in Vietnam, Watts, Detroit, or San Francisco State College. True: a governing class is finally sustained by the obedience of a host of warrior recruits. But these are drawn largely from the underclasses, and it is a caution to recall that at precarious moments the salaried legions of enfranchised violence may waver, ignore their duties, even go over to 'the people'. Thus order in a state is always more tenuous than appears, and the reputation of power especially has to be nurtured in those whose violence will be called upon, when the spectacle has faltered in the other domains.

Walter Bagehot, a founder of modern political liberalism, put it as follows in *The English Constitution*, 1867. 'The ruder sort of men', Bagehot said, must be finagled into a 'reverence' toward the regrettably 'plain, palpable ends of government' by the usage of 'theatrical elements'.

To this end the state has uncounted stages, plot-lines, and 'routines'. All of course is not pomp and intimidation. The show is sugared with entertainments; mitigated by allowance for private diversions; and indeed, best secured by seeing that many of the ruled, the armed forces especially, are assigned gratifying and in some respects commanding roles to play. The Great Chain of Being may be preserved and beautified best when most confused among tributary chains of command and obedience all mixed into one another. Thus Thomas Hobbes wrote in his *Leviathan*: 'The Athenians were taught (to keep them from desire of changing their Government) that they were Freemen.' Couple that thought with the aphorism at one time widely displayed in officer training schools, and attributed to General Eisenhower: 'Leadership is the art of

getting men to do what you want them to do, because they want
to do it.'

Neither force nor show of force, then, can of themselves and
on all occasions guarantee a pliant civil population or warrior
class; where it may be afforded the show of liberality becomes as
important. Ultimately this liberality can be defined as a spectacle
made of prerogatives left to others, which – though channelized,
few, and insufficient – owing to the apparent stability of your
system of spectacle, the ruled are led to believe they could not
equal or get in any other way.

Force or liberality, whichever the profile of power displayed:
the whole of the spectacle is distilled and celebrated in the drama
of the central authority figure, and conversely, the head of
state's example instructs authority in its conduct on the tributary
stages. The theatrical principle known as empathy coordinates
this minimizing, this harmonizing of the performance style dif-
ferences you would expect between the great stage and the many
small. Vicarious experience and emulation, as well as mystifying
impression and admiration, marry for example the man at the
head of the family to this man at the head of the state.

Admittedly we have lately hit a crisis-of-empathy snag.
Lyndon Johnson stepped down solely because his performance
was too widely jeered. Aside from the dramatistic failing, his
politics were 'functional' and are being carried on, but that is
just the point; the dramaticism is not an 'aside', it is functionally
integral. A decade or so ago this could not have occurred. The
public was not offered competing dramatistic styles and it
scarcely knew how it acted. Now the head of state must play to
divergent and competing empathy wants among the spectators
and these, in truth, scarcely may be reconciled in a single man's
performance. Look at Mr Johnson's replacement. Unfortunately,
his histrionic instinct is most expressed in the thrusting of balled
fists into the air while his head becomes lost in the suit jacket
... [*some suppressed laughter*]. Plainly the needed deference to
the drama of the Presidency continues in trouble.

As perhaps never before our supremacy on the terrain of social dramaticism is heckled and flaunted, challenged or ignored. We must not countenance any loss of our lease on this psychological property; for it constitutes the holding corporation through which our otherwise scanty personal powers secure the property order of society generally. We do at least still enact the everyday hegemony within the public school systems, the army training camps, and the like. Although even here a small if potently dangerous minority is out of hand, the majority continue on the whole to absorb their exercises in spectacle obsequiousness. And clearly we still have the greater lucidity.

The radicals, I believe, do not conduct classes in their performance problems and techniques; nor have they done theoretical work which would be of consequence, for their thinking seldom seems to go beyond vague references to life style. Where the radicals remain instinctive, we of course possess uncounted management training schools and seminars, Dale Carnegie Courses, etc., for study and rehearsal of concrete performance politics. We have sociologists who strictly write and are resource consultants on 'social integration' through dramatistic interaction – for example, Erving Goffman, author of *The Presentation of Self in Everyday Life*, a commendable work which offers radicals no guidance whatsoever in their trend of dramaticism. It is this edge in lucidity which should prove decisive for us. Normally it does, through history.

Let us get firmly in mind the asset of a monopoly on tutorship in history as theatre. During all the centuries of organized society the ruled might, and would, imbibe their outlook and demeanour unwittingly through performance opportunities within and between the classes; rulership has never taken the chance that its youth would stumble on to the precepts of spectacle, left to themselves. Perhaps the first well-ordered stratum of spectacle tutors, the Chinese mandarins, are described by Max Weber as 'keepers of the rites' who through many centuries conferred status honour on the style of life of the

privileged by teaching and refining the ceremonies which sanctified power. Plato was such an instructor, although he had to compete with philosophers more prized by the rising merchant class. We still accept uncritically the contempt with which Plato spoke of the Sophists, these tutors of a culture opposed to the Athenian aristocracy and which became, indeed, a forebear of our own establishment.

During the Renaissance, Castiglione deftly distilled the essence of performance insight in *The Book of the Courtier*. Let's not ignore Machiavelli. He became *the* publicly denounced, and avidly read, political philosopher in all civilized lands for decades, because he spelt out unapologetically both the technicalities and the show of power. For every such 'name' tutor, the spectacle has been preserved through the marshalling of many thousands of the unpropertied educated to the task of intensely instructing the sons of nobility, and later of the high bourgeoisie, in religion, deportment, and the 'science of rhetoric' (you will recall that even today most college theatre study remains located in Departments of Speech).

Education has changed, religion waned. But counterbalancing this, recall that a number of recent giants in the human sciences have actually helped reinforce the theatre of God's glory. Darwin presented himself as a religious man. Sigmund Freud argued in his later works that all but an enlightened few must be vouchsafed their sacred dramas and authority figures whom they will revere and who can essentially act for them. James G. Frazer drew from the vast study of primitive myth for his *Golden Bough* a lesson repeated by most anthropologists to our own day: men must have sacred drama if social integration is to be preserved. Gentlemen, we still enjoy the assistance of highly-skilled spectacle tutors and of thinkers of great reputation.

The arts, which become more pervasive all the time, likewise build the reputation of our legitimacy. Edmund Burke was not in error when he said, 'the theatre is a better school of moral sentiments than the churches'. Excuse me – [*a battering or*

striking without has made hearing difficult] – would someone check out the reason for that noise?

The artists nowadays conceive many 'audacities'. They quickly use the term 'revolutionary' for their work. Some want to universalize the licence permitted their stratum. These ends, however, are frustrated and art chiefly lends reinforcement to social integration, due to empathy and another psychological property noted by Aristotle, catharsis. Can't that noise be stopped? [*The beating and now yelling has distracted the audience.*] Empathy and catharsis permit the public, I say, vicariously to live and timorously to *purge*, all in one operation, their curiosity about the most dangerous kinds of denied experience. The spectacle of allowing the imaginative events to be staged, shown, or written about meanwhile builds the reputation of government for liberality and stability. Finally, a flourishing cultural scene comes to appear to the great majority as the sole terrain for the serious practice of human aesthetic capacity. This illusion diverts many radicals as well from realizing the aesthetic dimension of their politics.

I shall speak more loudly. Can art ever surmount these factors to act dangerously upon our encapsulating spectacle? To do so it would have to depict, I believe, vivid models of directly emulable conduct more viable, vigorous, and gratifying than that of spectacle society and irreconcilable with it. We know, gentlemen, how rare is the artist who manages to this extent to release himself from spectacle obsequiousness. And if he appears – probably due to the encouragement and example of a radical constituency – and can somehow get his work before the public, despite the legal and informal web of spectacle checks and pressures to the contrary: would the public sympathetic to his paradigm want to absorb itself in his surrogate of an alternative conduct? Wouldn't the public thus prone to break with the spectacle prove impatient of all fictions, however emulable and laudable they think them?

Thus the arts appear always beneficial, or at least harmless to

public order. . . . Can we have, please, an end to the commotion outside? . . . [*The doors have burst open – black and white youths shouting swarm everywhere they seem to demand . . .*]

(End of transcript)

2

(To an activist who shall be known as 'Rimbaud Vivant', our thanks for the following, and for making available to us the Burke Lecture transcript)

A fresh vision of 1984: the world's populace liberated, you and everyone performing needs and abilities with one another freely – except for the spectacle managers and addicts, who despite themselves carry on as today in theatres especially designated for them.

The Rand Corp. expert talked straight as he knew. No crap about progress through pluralism with fun politics for all, no pray together to stay together in the greatest society ever. But their understanding of 'dramaticism' ends with the grimaces they agree to pass for smiles, and Yeats's 'coat upon a stick'. They con their show of powers from the tattered promptbook of a court tragedy they do not quite understand, but even less know how to put aside. We have today the chance to grow joyous naked, to continuously discover and invent ourselves in the concerted white heat of expressive realization; and still the spectacle managers think themselves wise, as they mumble each one their paraphrases of the words uttered by Henri IV when told he had to turn Catholic to become Henri IV: 'Paris is well worth a mass.'

In the performance of yourself to others many see only a burden, if not the betrayal of an inner 'real' self. Pirandello's theatre universalizes the bafflement and rage of that sense of betrayal. Failing to recognize its origin in the spectacle genre which makes you narrow and stupid, Pirandello projected his

distress on to every mode of self-enactment. He embraced, moreover, the pseudo-alternative of the Fascist State, which was in fact more of the same.

We create the dramaturgy of radical activity.

Dramaturgy retains its dictionary sense: 'the art of making dramas and placing them properly on the stage; dramatic composition and representation'. We add that the world stage takes precedence and that most human beings, freed of spectacle obsequity, could well compose and realize in activity their root nature. *Radical* is thus to be understood in its original sense: 'going to the roots'. Class domination and its spectacle society sharply frustrate, pervert your root potential. If overcoming this material and psychological alienation requires a role condemned by spectacle managers as 'radical', i.e., 'extremist', take heart in knowing the spectacle addict to be the authentic extremist: alienated most radically from his humanity. *Activity* in our sense is therefore not a mere expenditure of energy in movement, but a unification of theory and sensuous conduct, a praxis, a free intelligent activity: a performance of capabilities, taking into account all biological and social data, which ignores no biological and social potential.

The dramaturgy is realized in scenarios, which are – rather like the *improvvisa* of the *commedia dell'arte* – projected and agreed beforehand in part, and in part created as opportunities and fortuities arise in performance. If acting among friends and the like-minded, you perform peace scenarios. The ends and means will more or less be understood and agreed. Needs and capabilities are transposed to interactive expression by an invention of specifics which strive toward universality.

The terrain for peace scenarios – found to this day most often in the love affair – is not only limited but highly vulnerable to the totality of impinging social relations and values. Thus the necessity of mounting concerted war scenarios to dismay and rout the spectacle managers. A war scenario certainly does not by definition entail bloodshed (though the spectacle managers

may seek the show of blood). It does assume the opponents' values to be irreconcilable with your own. Not cooperation and kindliness but surprise and relentless audacity can alone win through. Especially here, every tried and tired script not thrown aside is quoted merely for irony or as a diversionary tactic, or at worst used, when imagination weakens, for linking bits and pieces (others may recognize them as such to your loss). Total resource-exposure and esteem-risk occur. Certainly you elicit it of your collaborators and of the foe. For if you and the like-minded will not venture all to create and enlarge the liberated zones, your fate too is finally to perform as a spectacle husk. (Of course the spectacle too has its quiet reinforcive scenarios: but these are adjustive, not of its essence, not worth your life.)

The liberation drama of history has also had tutors. Not only Paine. Every solid radical has manifested the consciousness of dramaturgy; and many, significantly, wrote plays in going from youth to a mature identity. For instance, Karl Marx, Friedrich Engels, Leon Trotsky, and John of Leyden – who led the rebellion and Anabaptist commune of 1534 in Münster. Others like Antonio Gramsci, Georg Lukács, and Kurt Eisner, lived their transition as drama critics. Gustav Landauer was a Shakespeare authority and, with Eisner, a leader of the 1919 Bavarian Soviet (his grandson is Mike Nichols). (Peter Brook is the son of a Menshevik revolutionary of 1917.) Ernst Toller apprenticed in the Bavarian Soviet, Georg Büchner wrote *Danton's Death* as second best to carrying on the revolutionary society he'd founded, which just weeks earlier the police had uncovered and dispersed. Still others were initially actors: B. Traven, who was in the Bavarian Soviet leadership, and Sandor Petöfi, the Hungarian poet-revolutionary who died on the battlefield in 1848.

Engels's play was performed before the German workers' union of Brussels in 1847. The text has been lost, but a witness recalls the 'amazing clarity' with which the necessary course of the February 1848 uprising was foreseen. Trotsky, in *My Life*, recalls the stunning effect a visit of Christmas mummers had

upon him when he was seven. During evening tea they invaded his father's farmhouse on the South Russia steppes and recited the piece 'Czar Maximilian'. Trotsky pursued the actor of the Czar and made him dictate the part to him. 'A fantastic world was revealed to me, a world transformed into a theatrical reality.' Thereafter he recited and composed dramatic verses frequently. Sent to school in Odessa, 'my first visit to the theatre was like no other experience, and beggars description'. One summer Trotsky spent weeks rehearsing a Pushkin play. At seventeen he collaborated on a drama about the Russian Socialist movement, 'full of social tendencies, against a background of the conflict of generations'. Just months later he first transposed his consciousness to the task of founding and leading a clandestine union of workers.

He was the dramaturgical dynamo of the 1905 Revolution. To understand those skills, we may look at a strategic scenario he wrote out a few months prior to the events.

Tear the workers away from the machines and workshops; lead them through the factory gate out into the street; direct them to neighbouring factories; proclaim a stoppage there; and carry new masses into the street. Thus, moving from factory to factory, from workshop to workshop, growing under way and sweeping away police obstacles, haranguing and attracting passers-by, absorbing groups that come from the opposite direction, filling the streets, taking possession of the first suitable buildings for public meetings, entrenching yourselves in those buildings, using them for uninterrupted revolutionary meetings with a permanently shifting and changing audience, you shall bring order into the movement of the masses, raise their confidence, explain to them the purpose and the sense of events; and thus you shall eventually transform the city into a revolutionary camp – this, by and large, is the plan of action.

Brilliantly actable, this text is the result of a close analysis of the political 'factors' so often conceived as abstractions.

Lenin was in hiding during many crucial days in 1917, and Trotsky was again the most motive figure, if not quite as

predominantly as in 1905. His book on 1917, *The Russian Revolution*, is a virtual promptbook of radical dramaturgy. Trotsky remarks for example the little latitude left to the spectacle managers once things get going: 'the scripts for the roles of Romanov and Capet were prescribed by the general development of the historic drama; only the nuances of interpretation fell to the lot of the actors'. The rebels' scenario inventiveness is brought out – as during the February overthrow, when a unit of the feared mounted Cossacks appeared before a group of unarmed workers, who

took off their caps and approached the Cossacks with the words: 'Brothers – Cossacks, help the workers in a struggle for their peaceable demands; you see how the Pharaohs treat us, hungry workers. Help us!' This consciously humble manner, those caps in their hands – what an accurate psychological calculation! Inimitable gesture! The whole history of street fights and revolutionary victories swarms with such improvisations.

Lenin was not known to have taken more than a spectator's interest in theatre, and the flamboyance of Trotsky was alien to him, though he respected its efficacy. Gorky, however, has recorded that Lenin used both laughter and temper masterfully to shape an intimate discussion; and his public speaking style, if unembellished, was 'a very work of classic art'. In brief one might say that Lenin deeply distrusted spectacle and every radical tendency toward it – 'the human yearning for the beautiful, dramatic and striking', as he once wrote. On the other hand he stressed scenario action: as in his famous instructions of Summer 1917, which urge repeatedly that insurrection 'must be treated as an art, that one must *win* the first success and then proceed from success to success, never ceasing the *offensive* against the enemy, taking advantage of his confusion, etc.'.

Given a matrix of scenarist initiative, elements of radical spectacle were valuable, Lenin held. For instance: workers once having actually gone out on strike, 'the sight of their comrades

ceasing, if only momentarily, to be slaves and becoming the equals of the wealthy is infectious for them'. And finally: 'revolutions are festivals of the oppressed'.

The French Revolution of 1789 was spectacle *v.* scenarism from start to finish. George Plekhanov remarks justly that as the culture of the monarchy went under, the 'aesthetic requirements' of the citizens, 'far from stifled', turned rather toward a 'poetry of action' and 'the beauty of civic achievement'. The seizing of the Bastille, the signal event, was provoked by a show of mercenary troops deployed near Paris by the King. An unemployed actor – Camille Desmoulins – transformed an angry but aimless mood among the crowd at the Palais-Royal into a pledge by every individual to adopt armed resistance; he plucked a leaf from a garden tree as a sign of his commitment; shortly all the trees were stripped. A playwright, Maret, among Desmoulins's listeners urged the next action: close every theatre, spectacle and ball that evening. This was done, the rebels creating their own theatre of the streets. Two nights later the Bastille fell.

Indeed the theatres of Paris were barometers of the conflict of power and values, as the struggle to put Beaumarchais's *Mariage de Figaro* on the stage, finally successful in 1784, had already proved. Now Desmoulins, Mirabeau, Danton, much of the revolutionary party bent efforts to have staged *Charles IX* by Marie-Joseph Chénier. The spectacle of what lines and images would hold the stage was as nothing to the scenarios of vituperation and combat in the theatre stalls with results that reached to Versailles. 'If *Figaro* killed the aristocracy,' Danton remarked as the new play made its debut, '*Charles IX* will kill the royalty.' Mr Edmund Burke rather agreed. He was shocked the author had not been clapped in chains.

The King meanwhile had been taken virtual prisoner and brought by multitudes from Versailles to live in the Paris Tuileries, following a peculiarly inept spectacle of disrespect for the nation – actually staged during an uproarious banquet in the palace theatre! It is impossible here to give further account

of the French dramaturgy, or of its transformation into a new mode of spectacle representing the requirements of the bourgeoisie victorious.

Equally it is impossible to describe here the subtle, profound analysis permeating the books of Marx and Engels (*The Eighteenth Brumaire of Louis Bonaparte* by Marx is a good introduction). I want not to ignore, though, that Marx found the beginnings of a liberating dramaturgy in the erotic nexus. 'Love ... first really teaches man to believe in the objective world outside himself,' he wrote in *The Holy Family* of 1845. It 'not only makes man an object, but the object a man!' He adds, in *The German Ideology* of 1846: 'Philosophy, and the study of the actual world, stand in the same relation to one another as masturbation and sexual love.'

The conscious poet of this dramaturgy of one-to-one has been Louis Aragon; he calls it 'the intimate theatre'. A campaign to end its repressive privatization, and to pervade society with the values discovered in the sexual congress, is being led by the new rock groups. As Jim Morrison of The Doors says:

When I sing my songs in public, that's a dramatic act, but not just acting as in theatre, but a social *act,* real action. A Doors concert is a public meeting called by us for a special kind of dramatic discussion and entertainment. We make concerts sexual politics. The sex starts with me, then moves out to include the charmed circle of musicians on stage. The music we make goes out to the audience and interacts with them; they go home and interact with the rest of reality, then I get it all back by interacting with *that* reality. When we perform, we're participating in the creation of a world, and we celebrate that creation with the audience.

Beyond the present war scenarios and beyond the privatizing and privational peace scenarios: What Is Our Programme? It is this. To employ the now achieved material and technological abundance of our planet as the basis of a universalized peace scenarism.

Given the present and growing abundance, and the success of our war scenarios – and this unity of objective and subjective

factors spells the abolition of class society – we could live a pacific permanent revolution. Potentials and conflicts would be hassled out, and root human needs thus fulfilled, without basic recourse to violence or the repressive show of it. There seems no reason why this social dramaturgy of a creative and non-violent stamp cannot serve as, in the phrase of William James, the moral equivalent to war.

The concomitant is, of course, that the human aesthetic capacities shall no longer be relegated chiefly to the Other World of the stage play, artwork, poem, novel, etc. On the one hand, the making and contemplation of Aesthetic Objects will always have a felt function for us. Experience and expression in life can rarely be as distilled and achieved as in the compression won in this activity, especially by unusually gifted men and women. On the other hand, in our present social order the aesthetic traits of experience are clearly far out of kilter – alienated from the world of the everyday, preserved as in alcohol by museums, cultural centres, a specialized breed of men. This scarcely is normal. In so-called primitive societies, every aspect of the life of every member of the social unit is imbued with aesthetic expression, there is not even a concept or word for what we have reified as 'art'. Our lives are impoverished of the aesthetic qualities of rhythm and grace and harmony. We are sick for the lack of coherence and intensity of expression. What we want – and a return to the drawbacks of 'primitive' society is not necessary, of course – is the integration of the aesthetic with man's other capacities.

Herbert Marcuse calls for a new 'aesthetic ethos' in his *Essay on Liberation*. Surprisingly, Marcuse omits any idea of the performance of self with others; he takes his model from painting, rather than theatre which has to be the paradigm. Schiller's letters on aesthetic education were more to the point. *Homo Ludens* by Johan Huizinga is an important historical account of the 'play' element in social contest. But the best previsions of universalized scenarism are perhaps found in Charles Fourier's

notion of *cabalism*, and in Marx's passage in Volume III of *Capital* on 'the art of consuming labour-power'.

Marx, noting the introduction of 'self-actor' machines to industry (automation), believed the supervisor of complex factory production would eventually function on the model of an 'orchestra conductor'.

An orchestra conductor need not own the instruments of his orchestra, nor is it within the scope of his duties as conductor to have anything to do with the 'wages' of the other musicians. Cooperative factories furnish proof that the capitalist has become . . . redundant as a functionary in production

and may be replaced by the 'combination and co-operation of many in pursuance of a common result'. In feudal France, Marx adds, the production manager was known as the *régisseur* (still the German name for a stage director).

Fourier speaks to our time away from work and offered, said Marx, 'the presentiment and imaginative expression of a new world'. His cabalist passion – 'far removed from the insipid calm whose charms are extolled by morality' – to be realized in the future, entailed the scenarist notion in embryo:

The cabalistic spirit is the true destination of man. Plotting doubles his resources, enlarges his faculties. Compare the tone of a formal social gathering, its moral, stilted, languishing jargon, with the tone of these same people united in a cabal; they will appear transformed to you; you will admire their terseness, their animation, the quick play of ideas, the alertness of action, of decision; in a word, the rapidity of the spiritual or material motion.

The spectacle managers will believe this to be nonsense. But their show cannot survive. Not in this time when a black youth in Watts, asked his attitude about serving in Vietnam, replies: 'Man, they ain't going to put me in that movie, even if they make me the star!'

More About Penguins
And Pelicans

Penguinews, which appears every month, contains details of all the new books issued by Penguins as they are published. From time to time it is supplemented by *Penguins in Print*, which is a complete list of all available books published by Penguins. (There are well over three thousand of these.)

A specimen copy of *Penguinews* will be sent to you free on request, and you can become a subscriber for the price of the postage. For a year's issues (including the complete lists) please send 30p if you live in the United Kingdom, or 60p if you live elsewhere. Just write to Dept EP, Penguin Books Ltd, Harmondsworth, Middlesex, enclosing a cheque or postal order, and your name will be added to the mailing list.

Note: *Penguinews* and *Penguins in Print* are not available in the U.S.A. or Canada

The Theory Of The Modern Stage
An Introduction To Modern Theatre And Drama

Edited by Eric Bentley

A new anthology, edited by America's leading dramatic critic, in which Artaud, Brecht, Gordon Craig, Stanislavski, and other great theatrical theorists reveal the ideas underlying their productions and point to the possibilities of the modern theatre.

The Necessity Of Art
A Marxist Approach

Ernst Fischer

On the first appearance in English of what is probably
one of the most influential books on art to be published
since the war, Kenneth Tynan wrote:

'In this challenging new Pelican Ernst Fischer, the
Austrian poet and critic, surveys the whole history of
artistic achievement through Marxist eyes.

People have always needed art: but why have they
needed it? And what shaped the forms whereby they
satisfied their need? Fischer's answers to these questions
should be as voraciously studied and debated here as they
have been on the Continent.

The book abounds in signs that Fischer is an empirical
rather than a doctrinaire Marxist; you never feel he is
tailoring his reactions to fit a thesis. "A new art," he says,
"does not come out of doctrines but out of works.
Aristotle did not precede ... Homer, Hesiod, Aeschylus
and Sophocles; he derived his aesthetic theories from
them."

Marxism has long needed an Aristotle; and in Ernst
Fischer I suspect it has found its man.'

This book was first published in East Germany in 1959.